PARANORMAL
MERSEYSIDE

PARANORMAL MERSEYSIDE

S. D. TUCKER

With Illustrations by the Author

AMBERLEY

First published 2013

Amberley Publishing
The Hill, Stroud
Gloucestershire, GL5 4EP

www.amberley-books.com

British Library Cataloguing in Publication Data.
A catalogue record for this book is available from the British Library.

ISBN 978-1-84868-729-5

Typeset in 10pt on 12pt Sabon.
Typesetting and Origination by Amberley Publishing.
Printed in the UK.

Contents

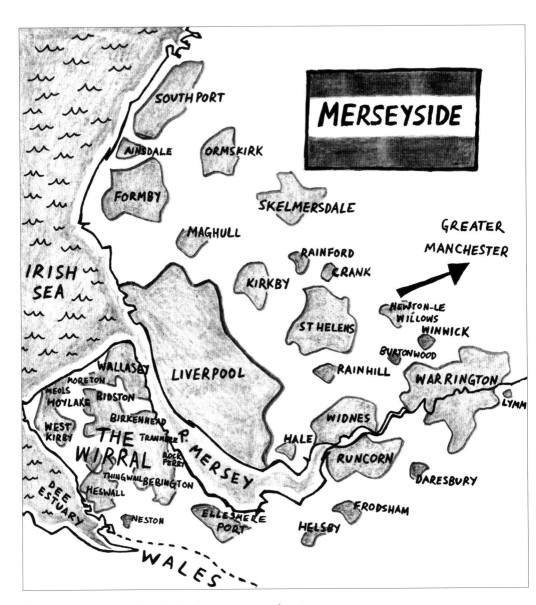

The broad area covered in this book. Is *your* town there?

Introduction
The Pool of Life

In 1927, the eminent Swiss psychologist and mystic C. G. Jung had a very strange dream. When he closed his eyes and drifted away, he saw himself standing in a dark, dirty and sooty cityscape at the dead of night, in winter. It was raining, and Jung found himself in the midst of about half a dozen of his fellow countrymen, walking through the streets from a harbour. Perhaps it was this shower of heavy rain that instantly gave it away to Jung that he could only be in Liverpool, a city he had never actually been to in real life. Eventually, he and his companions came to a broad square, dimly illuminated by lamps and filled with fog, smoke and smog, from which dozens of streets radiated out away into the various different quarters of the city. This image, he realised, was a symbolic representation of one of his beloved *mandalas* – an ancient circular Buddhist symbol of the soul, with which he was obsessed. In this dream-fantasy he stood, it seemed, at the very hub, the very 'soul' of Liverpool itself, the spot into which all its paths led.

In the exact centre of this chaotic and dirty maelstrom, however, lay a little oasis of calm and beauty. A round pool stood unexpectedly there, with a small island, radiant and blazing with bright sunlight, dead in the middle of it. On this enchanted fairy-isle bloomed a single, solitary tree, a magnolia bursting out in reddish blossoms. It seemed to Jung that the glorious sunlight was somehow being produced by this tree itself, as a kind of magic. Only Jung seemed able to appreciate the extreme loveliness of this scene, however; the others around him were simply repelled by the muck and grime that beset them and began gossiping about a friend of theirs who had settled in Liverpool, expressing surprise that he should have chosen to live in such a dark, filthy place. Jung, however, could see through the smoke and rain down to the actual soul of the city, as embodied by the magic tree blooming forth the light of life itself to the world from its sacred place on the enchanted isle upon the lake. 'I know very well why he has settled here,' he thought to himself, and then awoke.[1]

It is easy to see the meaning of Jung's dream. Even the most fervent, proud and parochial Liverpudlian must admit that people in the rest of the country do not necessarily have an entirely positive image of the city. For every mention of the Beatles, football, ferrying 'cross the Mersey and the dish popularly known as 'scouse' (all four of which I suspect

that I am contractually – and very possibly even legally – obliged to mention in any book about the city), there are corresponding perceptions of crime, poverty, union militancy and stereotypical Harry Enfield characters dressed in bright and ill-fitting tracksuits saying 'calm down, calm down' a lot. However, these are just the muddled, long-distance perceptions of outsiders; Merseyside is, overall, an extremely pleasant place to live. Those half-blind Swiss men in Jung's dream might not have been able to see through the industrial smoke and seafog down to the bright heart that was beating there right in front of them, beneath their surface perceptions, but Jung, the great visionary, certainly could.

In his view, the meaning of his dream was that Liverpool was nothing less than an emblematic image of the soul and the imaginative inner life of mankind as a whole. According to Jung, symbolically, the very word 'Liverpool' itself indicated that the place was what he termed grandly the 'pool of life'; the liver, he noted, was once thought in ancient medicine to be the 'seat of life', that which enables a human being to live in the first place – a function that the modern mind now applies popularly to the heart.[2]

However, in the view of most authorities, this interpretation of the name 'Liverpool' is actually somewhat fanciful. When the city (then most emphatically *not* a city, or anything like it) was originally mentioned in early records in the latter half of the eleventh century, it was written down as either being Lytherpool or Lyrpool; it was not until the reign of Henry VIII, between 1509 and 1547, that we finally see the place being referred to as Lyverpoole as such. The generally accepted history of the name is that it came from the Anglo-Saxon word *lifrig*, meaning 'coagulated' or 'clogged'. Therefore, the city's name is often said to have actually first meant something like 'muddy pool', a reference to the Mersey inlet around which the first settlements in the area were built, which was supposed to have been choked up with weeds and mud back in the past.[3] If this is all correct, then Jung's dream was indeed just that – a mere dream.

However, this word *lifrig* is in fact itself derived from another Anglo-Saxon word, *lifer*, which did actually mean 'liver'! Therefore, an alternative interpretation of the original meaning of the name would be to say that it meant 'liverish' or 'liver-like'. But how could a river or a pool be liver-like? The answer might well lie in the fact that our ancestors – in keeping with their view that the liver was the 'seat of life' – had some very odd ideas about medicine. Namely, they were still in thrall to the old ideas about medicine and anatomy that had been put forward by the Romano-Greek physician Galen in the first century BC. Galen believed that there were four basic bodily fluids contained inside the human body, termed 'humours', each of which was produced by a different organ. Significantly for us, according to Galenic belief, the liver was just such an organ – and it produced an inky black substance known as 'bile'. Given this fact, it might just be the case that the old name Lytherpool was actually some kind of metaphorical allusion being made by the area's original residents to the deep, dark depths of the River Mersey, which flowed on endlessly beside them. It was a liver-like pool because it was black and murky, like bile; but, at the same time, it gave forth life, in terms of transport routes, fish and drinking water.[4]

Remarkably, then, it is at least possible that Jung's famous dream had tapped in somehow to an ancient and very complex web of metaphorical associations about the city and its life-giving river of which he himself was consciously unaware. Perhaps to be expected from a man who believed in a 'collective unconscious', or 'world soul', that was shared and participated in by each and every one of us. If Jung could see down through the deep, dark

waters of mud and thick black clouds of an industrial port city to the shining soul beneath, though, then so shall we in this book. As already stated, the city of Liverpool suffers from some very negative perceptions in the world outside. However, to those who live there or know the city well, its soul is quite visible, in any number of ways. In the distinctive accent and attitudes of the people, in the magnificence of the architectural heritage of the city, and in the voice of fans in full song on the Kop at Anfield, the uniqueness and vibrancy of the area is quite evident.

However, there is another place in which the soul of Liverpool and its people can be glimpsed, and that is in its myths and legends, those tales of the fantastic that are supposed to have happened along the Mersey's shores. Some are just stories; but others apparently have some kind of truth behind them. In this book, a wide range of these will be explored, from pig-killing poltergeists, to tales of Spring-Heeled Jack, to the 'great leprechaun invasion' of 1964. Some are funny, and others are terrifying. And those claiming that both Adolf Hitler and Jack the Ripper were one-time Liverpudlians are nothing more than attention-seeking urban legends.

And yet, even these last two mentioned 'tall tales' do have a certain small basis in truth. While it seems unlikely that Hitler really did live in the city in order to try and dodge the draft before the outbreak of the First World War, as has so often been claimed, his half-brother Alois genuinely did live in a flat in Upper Stanhope Street in Toxteth, with his Irish wife Bridget Dowling and son William Patrick Hitler. Some Hitlers actually did live in Liverpool then – although it seems most unlikely that the most famous member of the family line ever set foot upon Merseyside soil. Yarns about Hitler watching Liverpool games from the Kop and drinking pints in local pubs are almost certainly just folklore – or a nice little money-spinner for some. Ironically, Alois Hitler's old house is now no longer there, having been demolished by a German bomb during Liverpool's Blitz, so there was little chance of the building being co-opted by canny natives to make money out of as a dubious tourist attraction. Instead, homemade 'artefacts' of Adolf's time in Liverpool have had to be manufactured from scratch. Hitler's alleged sojourn in Toxteth was commemorated for years after the 'event' by a display in the old ice rink that used to stand on Prescot Road. There in the foyer, locked away safely behind glass in a display cabinet, stood a pair of battered old black ice-skates. A little notice propped up beside them claimed that they had once belonged to the *Führer* himself. I suppose nobody can actually *prove* that they didn't ...5

The rumour that Jack the Ripper was a scouser also seems unlikely, yet doesn't appear to have been conjured up entirely from out of thin air. In 1993, a book entitled *The Diary of Jack the Ripper* was published, purporting to be the self-penned memoirs of Jack himself, whose real name, it turned out (according to the book at least) was James Maybrick, of Liverpool. This all seems unlikely to be true – nobody knows who Jack the Ripper really was – but Maybrick himself was a real enough person, and a genuine one-time Liverpool resident. He was a Victorian cotton merchant living in the city, whose wife, Florence, was convicted of murdering him with poison at their home in Aigburth.6 Was this Florence taking her revenge upon her husband for being Jack, as some have suggested? I sincerely doubt it, especially seeing as, in 1994, Michael Barrett, an unemployed scrap dealer from the city, admitted to having forged the diaries.7

Other supposed famous 'residents' of Liverpool who never actually set foot in the place include Haile Selassie and Martin Luther King. Selassie, the so-called 'Lion of Judah' and

Emperor of Ethiopia, is meant to have spent two years living in Liverpool during the Second World War, as a refugee from Mussolini's invasion of his country. Supposedly, he lived in a house on Alexandra Drive in Aigburth, outside which two gold-coloured statues of lions could be seen.[8] Just as laughable as this claim, perhaps, was that made recently by the authors of a tourist pamphlet about the city, who said that Martin Luther King had written his famous 'I have a dream' speech while staying in a room at the Adelphi Hotel at the bottom of Brownlow Hill. Supposedly, the first draft of this famous document was written on Adelphi-headed notepaper. It later turned out, however, that a member of the public had simply told the brochure's authors the tale as a joke and they had foolishly believed him![9]

Even if these stories are mere lies, though, they do nonetheless speak of a population who are engaged and interested in the city and landscape around them. After all, unless you love a place, why bother mythologising it? When people tell spooky or urban legend-type stories about the area they live in, it builds up a kind of 'mythic city' that hovers like a spectre over the physical map of the real one, ready to jump out and re-enchant the world around you when you least expect it. It is a desire to live in a more interesting world, to mark your own place out as being 'special' somehow, that lies behind people's desire to populate rows of ordinary, brick-built terraced houses with ghouls, poltergeists and Spring-Heeled Jacks, as much as it is anything else – and the people of Liverpool certainly do like to try and mark themselves and their city out as being different from the rest of the country, whether that be for good or for ill. As such, Liverpool is a city in love with its own legend and rumour.

Ever since King John granted a Royal Charter to Liverpool, intending to take advantage of its coastal location to create a new seaport for his navy in 1207, the city has been a bizarre mix of the intensely parochial and the surprisingly cosmopolitan. The famous ports and docks provided a window into the wider world outside while at the same time giving the city the opportunity to treat what was happening in the rest of the country with affected disdain. The place's consequent population of native Liverpudlians, Irish immigrants and foreign seafarers seems to have given the region a very distinct set of local legends and myths, some of which are quite unlike those that have taken root elsewhere in England. Certainly, it is quite hard to imagine any other place in the country whose oral traditions would proudly claim Adolf Hitler as being a past resident, for example!

This book will not only deal with hauntings, UFO sightings and legends from the city of Liverpool itself, though; the surrounding towns and settlements, places like Widnes, Runcorn, St Helens, the Wirral, Frodsham, Rainhill, Southport, Formby, Newton-le-Willows and Warrington will also be considered. Technically, some of these places are now in Cheshire, judged purely by their postcode – thanks to the annoying boundary changes of 1974 that took them all, Liverpool included, from out of the ancient county limits of Lancashire, and created the Metropolitan County of Merseyside as a specific governmental and administrative entity. But, according to more meaningful human methods of classification, they are definitely well within Liverpool's sphere of influence – mythic, cultural and economic. A good proportion of the people who live in these places either originally come from Liverpool, work there or have close relatives there, and the River Mersey itself runs directly through many of them. People from within the city boundaries themselves may sometimes look down humorously on persons from these places as being no more than so-called 'plastic scousers', but some of the stories from the city's satellite towns are just as strange as those from within Liverpool proper itself, and simply could not be left out or ignored.

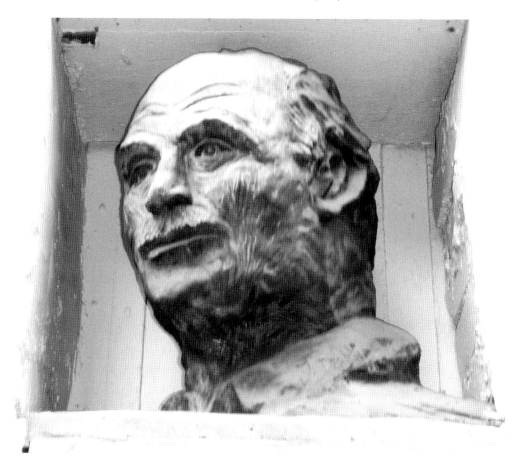

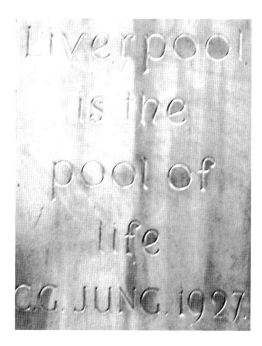

The bust and plaque of C. G. jung, which stand
outside Flanagan's apple pub in Mathew Street,
commemorating his famous dream of the city
being the spiritual centre of the entire universe.

Merseyside, then, is a region that takes its soul – as embodied through its myths, visions, ghost stories and more – very seriously indeed. And how can we know this for sure? Simple: you have to go no further than the Flanagan's Apple pub in Mathew Street in the city centre – only a few yards away from the modern recreation of the famous 'Cavern Club', where the Beatles used to play – and have a look at a big plaque that hangs prominently on the outside wall there for all to see. It reads, quite simply, *Liverpool is the pool of life – C. G. Jung, 1927*, and above it is a bust of the great man himself. How many other cities can you name that have erected a public monument to a dream about the eternal beauty and mystery of the human soul? I bet Manchester doesn't have one.

PART ONE

'My Mate Said...'
Merseyside Panics and Rumours

Rumour is a funny thing – Shakespeare famously had it as being 'painted full of tongues', and he was right. Word of mouth is one of the most potent forms of spreading strange stories and tall tales, and the people of Liverpool certainly have a lot to say for themselves. One local aphorism speaks of a chatty or loud person having a 'mouth like the Mersey Tunnel' and, given some of the bizarre scares that have taken root and spread like wildfire throughout the city and its satellites over the years, the saying is perhaps an apt one. A number of what might be termed 'social panics' have occurred in the region across the last century or so, over everything from an unlikely invasion of the Little People in 1964 to a disembodied gibbering head that supposedly went around bothering the inhabitants of Birkenhead in 1920. Few, if any, of these weird rumours turned out to have anything genuinely paranormal behind them in the end, but the terror and awe that they inspired were certainly real enough at the time. They might well be looked upon as mere historical curiosities by us now; but, apparently, they were once the night terrors and bogeymen that stopped our grandparents and great-grandparents from getting to sleep once the lights were out. In this section, we shall examine a few of the more famous ones.

1

The Great Leprechaun Invasion of 1964

The sedate sport of bowls does not often make headlines in the British press. One exception to this rule, however, came in the *Liverpool Echo* for 2 July 1964, where the immortal line 'Leprechauns Go Bowling in the Park' appeared. According to the report that followed, literally 'thousands' of children from the Kensington area of Liverpool, in the east of the city, had apparently taken leave of their senses the previous day and gone on a mad rampage through Jubilee Park (now seemingly renamed Kensington Gardens, the modern space called Jubilee Park in the area only being opened in 2010) in Jubilee Lane, hunting for leprechauns, after someone – nobody really knows who – had reported seeing 'little green men in white hats throwing stones and tiny clods of earth at one another' on the park's bowling green the previous night. It appears that this rumour had got abroad among the area's youths throughout that day in the local schools and built up to some kind of crescendo, as no sooner had the school bells rung than hordes of kids began hightailing it down to the park, desperate to be the first one to catch hold of a real, live leprechaun.

These children, who ranged in age from 'tiny tots to 14-year-olds', according to the *Echo*, caused quite some damage and bother. They ran through bushes, pulled up plants, scaled walls, got into empty houses in the vicinity, hurled stones, and just generally made the entire park into a no-go area for anyone not still in short trousers. Matters got so bad that the police had to be called in to shoo them away. Parks constable James Nolan – an Irishman, according to the report – was quoted as saying 'I don't believe in leprechauns myself', but he still saw fit to call in reinforcements. Before long, cops in squad cars and on motorcycles arrived on the scene, clearing hundreds of excited boys and girls from off the bowling green and locking the gates. The police stood guard outside this barrier, but this simply had the effect of pushing the problem out elsewhere; the children just began climbing up on top of nearby vantage points like a covered reservoir, in order to stare down on the green waiting for the fairies to appear instead. They never did, however, and eventually the park was cleared – although not until as late as after 10.00 p.m.[1]

The *Liverpool Daily Post* for that same day provided some more details about the affair. According to this report, the strange beings were first sighted the night before the invasion

of the park by swarms of leprechaun-hunters, on the evening of Tuesday 30 June. The *Post's* reporter, Don McKinley, wrote how he had spoken to a nine-year-old boy at the scene who claimed to have started the whole thing off. According to this lad's now rather quaint-sounding tones, 'Last night I saw little men in white hats throwing stones and mud at each other on the bowling green. Honest mister, I did.' Honest or not, however, the boy's name did not actually appear anywhere in the report, so we have no way now of knowing whether or not he was actually telling the truth.

The next evening, it seems, the children, perhaps made angry by the leprechauns' persistent no-show, eventually turned to acts of violence to get their kicks instead. Stones began to be

The little green men in white hats were throwing stones at one another on the bowling green – allegedly.

hurled left, right and centre, particularly at poor old James Nolan, the parks constable, who ended up having to wear a crash helmet to protect his head from missiles. The police in the park even had to set up a temporary first-aid shelter in order to treat kids who had been injured during the chaos.[2] Riots used to be so much more picturesque in the past, didn't they?

The initial source of the childish rumours in the east of the city must remain forever lost in the mists of time, but the reporting of such sensational and fun sounding events in the local press (and on the local Granada news) seems likely to have been responsible for the subsequent spread of the scare. The *Liverpool Echo* for 13 July, for instance, reported that the panic had spread to the town of Kirkby, just north-east of the city, where, between 10 and 12 July, only around a week after the original mini riot in Jubilee Park, masses of children began invading the churchyard of St Chad's looking for leprechauns until their numbers become so great that the police once more had to come along and usher them away. The grounds of St Marie's RC School and the St Mary Mother of God church in the area were also plagued by urchins seeking the Good People, apparently.[3]

Interestingly, the form of these later events appears to have been heavily influenced by the earlier press reports, particularly that of 2 July in the *Echo*. We can surmise this because that particular report ended with the following paragraph:

> And how did those little brownies who help the Irish housewife with her chores come to arrive in Liverpool? Maybe they flew from old Ireland. A woman resident in Crosby last night reported seeing 'strange objects glistening in the sky, whizzing over the river to the city from the Irish Sea'.[4]

To an adult, this might have been comprehensible as being the reporter's little joke; sarcastic references to 'old Ireland' seem to be being used to identify the story as perhaps not being meant to be taken entirely seriously. In other words, he seems to suggest, it is essentially 'blarney' – this supposed 'woman resident', after all, is not anywhere named, and the apparent reference to flying saucers is probably intended to ridicule the rumours by association, these phenomena, in the reporter's view, probably being something of a byword for 'nonsense'. However, to a child this might not all have been quite so apparent ...

After the Kirkby scare had burnt itself out, another local newspaper, the *Kirkby Reporter*, ran a story on 17 July 1964 headlined 'Little Folk – and Flying Saucers', in which it was revealed that the rumours had taken on a new tone. Prior to the *Echo*'s report, there had been no suggestion that UFOs had anything whatsoever to do with all this madness; but now, they seemed to have become an integral component of the affair. According to the *Reporter*, 'scores of excited youngsters' had 'invaded' their offices on Friday 10 July, babbling about having seen a 'strange object in the sky' that 'changed the colour of its lights from red to silver, and was moving slowly at first, then very fast'. Others, equally eager to be heard, told of having seen leprechauns, which had presumably come out of the spaceships; they were, they said, about 8 inches tall, wore red and green tunics and knee breeches, and talked with strong Irish accents.[5]

After around 12 July, however, it seemed that the panic drew to an end. And that was that – the leprechauns had gone forever. But where did they come from in the first place? There are several possible leads. Firstly, Merseyside was not the only region where leprechauns

were sighted during 1964. Another panic had broken out near Newcastle about a month beforehand, as detailed in the *Newcastle Journal* for 9 June. Reported here were strange goings-on upon Learn Lane Farm in Felling, eastern Gateshead, where, on 2 June, a fourteen-year-old boy named David Wilson claimed to have seen about half a dozen dwarf-like creatures, 2 feet high, dressed in green and with hands like lit electric bulbs, running around a haystack and digging down into it as if looking for the proverbial needle.

Before long, rumours about fairy-like spacemen flying around in egg-shaped craft were rife among the area's schoolchildren; one girl claimed to have sighted a silvery disc-shaped object, the size of a car, taking off with a spinning motion and giving off an orange glow. Another said that she had seen the dwarfs' leader; he was dressed in black and carried around a baton with pink stripes on it. Yet another little girl claimed to have seen a small man sitting on top of a barn. Another group of kids said that they had seen a tiny alien riding around the place on the back of a cow. Unlike in Liverpool, certain adults got in on the act too. The Bell family, who lived nearby, said that they had seen strange flashes in the sky a few days before the spacemen had landed, on 31 May. The son of the household, Keith, added that he had seen a big silver disc hovering over Learn Lane Farm on 28 May. The Bells' neighbours then began telling the press that they had been kept awake by a strange humming noise, 'like a swarm of bees, but about twenty times louder', coming from above during the night. Things got so bad in the area that the headmaster of the local Roman Road Junior School, a Mr M. Coates, felt compelled to make a denial to the papers that he himself had added fuel to the flames by calling a special assembly at which he had warned his pupils ominously to 'stay away from the farm'. These were, he said, just 'silly rumours'. Rumours or not, though, the original report in the *Journal* does specifically (albeit facetiously) mention leprechauns in relation to this tale.[6]

Could it be that this article was the ultimate source of the Liverpool rumours too, then? Certainly, it is at least possible that news of these events could have reached the city; it is easy enough to imagine a few people from Merseyside being in the North East in June and picking up on it all, or a few copies of the paper being brought into Liverpool by travellers. Perhaps the famous 'Liverpool leprechauns', then, were actually Geordies? Who knows? The influence of the media upon the shape the panic eventually took can quite clearly be seen in the later Kirkby manifestations, so the notion doesn't seem entirely implausible.

However, another alleged explanation for the whole affair appeared nearly twenty years later, in the 26 January 1982 edition of the *Liverpool Echo*. Here, a man called Brian Jones claimed to actually have *been* one of the leprechauns! According to Brian, he had been tidying his grandfather's garden on Edge Lane, which backed onto Jubilee Park, while wearing some old clothes; namely wellies, a denim shirt, navy blue trousers and a woolly hat with a bobble on top of it. Puffing on his pipe during a break from weeding, he said that he noticed some children sitting on top of the 10-foot tall wall that separated his grandfather's property from the park. Seeing the way that he was dressed, and noticing that he was somewhat on the small side, one of them shouted out, possibly sarcastically, 'It's a leprechaun!'

Theorising that, due to the extreme height of his grandfather's weeds a trick of perspective must have made him look like something of a midget to the kids, he decided to play a trick and scare them away by actually pretending to be a leprechaun. Accordingly, he began jumping up and down, babbling made-up words, and throwing sods of turf at the children on the wall. Scared, they ran away pretty sharpish.

The next evening, however, Brian was once again in his grandfather's garden when he heard the noise of a crowd gathered on the other side of the wall. Peering over it, he saw about 300 excited children standing on top of the covered reservoir in the park, leprechaun hunting. Seeing him, they began to shout 'There's the leprechaun!', or words to that effect, so Brian very kindly decided to put on another show for them and began jumping around, waving his fists in mock anger and throwing pieces of turf up into the air for, he says, over an hour. Then, he returned back inside his grandfather's house, changed back into his normal clothes, and wandered around the park incognito, trying to overhear what the children were

Would you mistake this man for a leprechaun?

saying to each other about his antics. He says that he heard them all trying to outdo one another by claiming to have witnessed not one, but ever larger numbers of the Little Folk.

The next day, though, Brian found that his plan had backfired. Swarms of children – and adults – kept on coming around to his poor old grandad's house and demanding to see the leprechauns, until they were eventually dispersed by the police. Several children then invaded the garden over the next two weeks, damaging the shrubbery and the shed, looking for the leprechauns' lair. Eventually, Brian began to fear for his life when he overheard two boys saying that they were going to shoot the fairies dead with air rifles and then put them into jam jars to show to their teachers. Brian says that he therefore decided to put the children off the scent by dressing up as a leprechaun again and going and putting on his act in the garden of a nearby empty house, so that the kids would start going on the rampage there instead. This he did for three nights in a row, so successfully that – he claimed – the building itself actually had to be demolished due to the children damaging it so much during their leprechaun-hunt.7

That, at least, is Brian Jones' story – but it doesn't really add up. For one thing, the clothing he was wearing clearly does not fit in with the original reports of little men wearing white hats, and neither was Brian's skin remotely green. In addition, his recollection of dates doesn't seem to tally with the original reports from 1964. Brian told the *Echo* very specifically that the memorable second day of the panic – the one on which the police had to be called in – was a Saturday, whereas contemporary sources seem to agree that it was on a Wednesday that the 'riot' took place, the entities first having been sighted on the Tuesday. Obviously, this could all be just a result of understandable tricks being played upon Brian's memory by the passage of time, but it doesn't really add to his credibility much.

Far more seriously, though, can any person *really* believe that anybody, even a group of small children, could have so loose a grasp of the laws of perspective that they would mistake a small man standing next to some tall weeds for a leprechaun? And why, if they did believe, did they not simply scale his grandfather's wall *en masse* and try to catch him? Or why didn't they just laugh at him as being an insane person? Very small children could have fallen for his pretence I suppose, but the original reports specifically say that fourteen-year-olds were there, too. Moreover, why are there no press reports about the house down the road being destroyed by rapacious leprechaun hunters? Surely it seems likely that editors would have jumped at the chance to print such a weird and amusing item? Finally, there is the small fact that the wall between Jones' grandfather's house and Jubilee Park was, as he said, about 10 feet tall; so how high, exactly, must this man have been jumping – presumably from a standing position – in order for the assembled mass of children to have been able to actually see him on the other side of it?

Another strange little man from Liverpool once claimed to have been responsible for the outbreak too, however – namely the Merseyside comedian Ken Dodd, of tickle-stick and Knotty Ash fame. He, of course, was well known for his use of the 'Diddy Men' in his act, a group of strangely dressed performing dwarves/children who used to join him on stage. In January 1965, an item appeared in the *Liverpool Daily Post*, in which Dodd professed to be the man who had started the whole thing off. According to him:

Just before all these rumours started, I did an item on television. We used a special technique by which the cameras were able to 'diddify' people. It was rather like looking

through the wrong end of a telescope. We arranged everything so that television commentator Bill Grundy (a former regional television presenter) was reduced to about four inches on the screen and I described him as a diddy man from Ireland – a leprechaun. Immediately afterwards, there were all sorts of stories about leprechauns being sighted by people all over the place. Children were running around parks and gardens looking for the little men.[8]

I suppose, if this programme had been broadcast immediately prior to the scare, then this too could have had an impact upon matters; though it has to be said that it surely cannot have been the only factor in the case. After all, if every appearance of a weird-looking dwarf on a children's TV show had led to mass riots, then surely *The Krankies* would have been banned immediately (it should have been anyway, but for entirely different reasons). This programme of Dodd's could have fed into the scare, certainly, but could not have caused it alone. Liverpool's schoolchildren *do* know the difference between television and reality, you know ...

A further attempted explanation for the events relates to Liverpool's undoubted Irish heritage. Liverpool, as is well-known, has one of the largest populations of Irish origin in England, as the Irish potato famine of 1845–52 led to many inhabitants of the Emerald Isle hopping across the Irish Sea to settle in Merseyside. The numbers were vast; 116,000 alone arrived in the city in 1847, for instance.[9] By 1851, an amazing 25 per cent of the city's population were Irish in origin, and in 1885 the Scotland Road ward of the city became the first – and only – place in mainland Britain ever to elect an Irish Nationalist Party candidate, T. P. O'Connor, to the Houses of Parliament.[10] Given these facts, it has been suggested in some quarters that the Irish-tinged cultural background of the city as a whole had made the children naturally receptive to believing in tales about such a stereotypically Irish entity as the leprechaun.[11]

This is obviously a sensible suggestion, but there are certain flaws with it. While Irish immigration to Liverpool has continued even up to the present day, the days of the real influx were over a hundred years before the events of 1964, and the children involved, even if they should indeed have happened to have had Irish blood running through their veins, would have been several generations removed from the original migrants, and thus presumably by this stage fully integrated culturally. It's just possible that some of them might have known extremely elderly relatives who had once told tales of the fairy folk to them with baited breath around the hearth of a night, but the notion that many of them would have had access to this kind of oral transmission of legend by the time of the 1960s seems unlikely at best. Their families may have remained Roman Catholics, they might well have drank in Irish pubs, but the descendents of the people who had come across to Merseyside to escape the famine in the mid-nineteenth century were by this stage clearly English in all but surname. Young Liverpudlians of Irish heritage in the summer of 1964 would probably have been more concerned with the imminent release of the Beatles movie *A Hard Day's Night* than they would have been with remembering 'the old ways'.

However, the press at the time do indeed seem to have played up this 'Irish element' in it all. Remember the original *Echo* reporter's facetious words about 'those little brownies who help the Irish housewife with her chores' flying in from 'old Ireland' in their UFOs, for instance? There seems to have been a deliberate attempt being made by the particular journalist in

question to identify the story as being inherently unreliable – or somehow quintessentially 'Irish' in its nature. Traditionally, the Irish are meant to be great spinners of yarns, or, in the realm of popular jokes, much-told still on Merseyside, not exactly the brightest bulbs in the box (which always seemed an unfair slur to me). Indeed, as if to emphasise this not-so-subtle view of his, the reporter actually specifically identifies James Nolan in his report not simply as being a parks constable, but as being an '*Irish* parks constable'.[12]

This is despite the fact that, apparently, the man was not even Irish at all, at least not according to his fellow former parks constable John Hutchinson (who, seeing as he runs a website devoted to the history of the Liverpool Parks Police, is a reliable source) in a comment about the story he posted online.[13] The *Echo* reporter 'accidentally' making up a detail such as this seems to show quite clearly that the tinge of Irishness to the whole affair was considered likely to discredit it all as simply being a bit of a good old-fashioned *craic* in the eyes of some.

However, Hutchinson then also suggests that it was a *craic* of another kind; according to him, Nolan deliberately made up the whole rumour in the first place, viewing the subsequent appearance of thousands of children in the park as being a good opportunity for him and his pals to get some easy overtime by supervising the kids running around until late at night. Supposedly, the Head Constable of the Parks Police at the time, a man named John Buchanan, got wise about this and told Nolan to stop it all and then just to keep his mouth shut about the whole affair. According to Hutchinson, Nolan wanted the overtime money for himself as it would come in handy with Christmas coming up – despite the fact that the events all happened in mid-July. And we thought that Christmas came early these days ...

There is another explanation available for all of this, though, and that is that the leprechauns were actually real. Admittedly, this is *incredibly* unlikely, but there are a few purported named witnesses who claim to have seen the Little People with their own eyes. According to a post online from a woman called Linda Tahmasebi, for instance, she and her friends attended Brae Street School (now Kensington Primary) in the area, and they all looked out of the window one day and saw about four of these beasts, 'all of them tiny' and 'dressed like a school book idea of a typical gnome', sitting on the window ledge and swinging their legs about, which is very interesting, if true.[14]

Maybe we should not be *too* cynical, however; after all, a small minority of people really do believe in leprechauns, even in the present day. For example, starting in March 2006, a panic similar in scale to that in Liverpool broke out in the small Alabama town of Creighton, where people reported seeing a leprechaun on the loose and hiding in a tree. According to several witnesses, a small man wearing a hat could be seen peering down at you from this tree after dark, which led to large numbers of local residents gathering around it at night and shining torches up into the leaves in an attempt to get the fairy to reveal the whereabouts of its legendary pot of gold. Some carried Irish flutes with them, presumably in an attempt to entice it down with music. The level of reality of this supposed 'leprechaun', however, can easily be gauged by the fact that, according to some, as soon as you shone a light on it in the darkness, it instantly disappeared. A (very) crude amateur sketch of the creature was released by one witness to the press, sparking predictable ridicule. Unlike 1960s Liverpudlians, however, twenty-first-century Americans soon saw money-making opportunities in the story, and began selling T-shirts with pictures of the sketch on to hundreds of tourists and gawkers who were making their way to the town, causing traffic

jams and general chaos. A rap song – called 'Where Da Gold?' – was even released to cash in on it all, containing terrible-sounding lyrics such as 'Who all seen da leprechaun say yeah!'[15] Somehow, the Beatles managed to resist making money in a similar way from their own local fairy-scare back when they had the chance in '64.

Ultimately, however, the evidence for the literal reality of Liverpool's leprechauns is predictably negligible. Most of the other explanations for the whole affair we have examined don't add up either, however. So what was behind it all? One plausible answer to the conundrum is likely to lie in the case's extreme resemblance to a variety of localised childhood panic known to folklorists as 'children's hunts'. These are essentially spontaneous, disorganised rampages by children through their local area in search of some ostensible – but ultimately uncatchable – paranormal entities.

The classic such instance of a 'children's hunt' took place in Glasgow on 23 September 1954, when hundreds of children – described, just like those in Liverpool, as ranging in age from toddlers to fourteen-year-olds – stormed the city's Southern Necropolis cemetery after school, some of them armed with knives and sharpened sticks, searching for a 7-foot-tall vampire with iron teeth that had been alleged to have kidnapped and eaten two local boys. The parallels between this case and that of the Liverpool leprechauns are quite interesting; quite apart from the ages and large numbers of the kids involved, it is a fact that the police had to be called out to the area to deal with it all. The scare was also spread across several nights, and seemed to have gained momentum in the city's schools and playgrounds – again, paralleling closely the Liverpool case. According to a Ronnie Sanderson, then eight, who lived in the Gorbals area of the city, 'It all started in the playground – the word was there was a vampire and everyone was going to head out there after school. At three o'clock the school emptied and everyone made a beeline for it [the Necropolis]. We sat there for ages on the wall, waiting and waiting.'

The whole affair was eventually blamed – somewhat spuriously – upon the influence of American horror comics such as *Tales from the Crypt* upon the city's youth, with the end result that the sale of these publications to minors eventually ended up being restricted by the government's introduction of the Children and Young Persons (Harmful Publications) Act 1955 the following year. A more likely explanation for the form the scare took, perhaps, was that for generations Glasgow parents had been threatening their misbehaving children with a local version of the bogeyman known as 'the Iron Man', while many local schools had apparently been teaching their pupils a poem about a monster with iron teeth – presumably Alexander Anderson's 1879 Scottish-dialect work *Jenny wi' the Airn Teeth*, which concerns the activities of a frightening witch-like character who seems to enjoy eating babies.[16]

We can't forget, however, that an additional factor must surely be that the whole thing just sounded like a lot of fun; what child wouldn't gain excitement from running through a graveyard hunting a giant half-metal vampire – or a gang of leprechauns – after all? Children, as is well known, thoroughly enjoy the excitement that comes from scaring themselves. If we can believe the testimony of an Eddie McArdle, who said that he was one of the children who went hunting the leprechauns in St Marie's church in Kirkby back in 1964, this was certainly an element that was present during the Liverpool panic, too. According to him, when the kids were all in the church, 'Some bright spark shouted that they were coming out after us. Panic ensued and we all fled quicker than we entered.' All sounds like good fun for a child, surely? (Although the fact that Eddie was hit on the head by the metal church

gate in his attempts to flee, leaving him needing stitches and with a scar for life on his head no doubt later tempered his enjoyment somewhat.)[17] John Hutchinson – who was still a schoolboy at the time before growing up to join the Parks Police and befriending Constable James Nolan – also seems to have thought that it would be a fun activity to go a-hunting fairies that day; he says that, if he had succeeded in grabbing one, he had intended to keep it in his rabbit hutch![18] The sense of childish glee in these accounts is surely palpable.

The elder siblings of the little kids in the city were going crazy over the Beatles that summer, with *A Hard Day's Night* enjoying its premiere on 10 July, right around the time of the leprechaun panic itself; and, with thousands of screaming girls lining up to greet the Fab Four as they stepped onto the tarmac at Speke Airport, why shouldn't the little boys and girls who couldn't go out to nightclubs yet have their own craze of pant-wetting excitement to be getting on with as well? Hysteria among the city's youth was rife that June, no matter what their age, it seems.

2

Spring-Heeled Jack
Comes to Town

Who was Spring-Heeled Jack? This question has been asked time and again over the past 150 or so years and numerous answers have been put forward in order to try and account for his supposed crime spree. Jack has been labelled, at different times and by different people, as being everything from a demon, to an alien visitor, to a debauched aristocrat out to get his kicks by terrifying and assaulting the poor and the helpless.

Jack's first appearances occurred in and around the then village of Barnes, south-west of London, where in early September 1837 rumours of a ghost being sighted in the form of a devil, imp or large white bull began to circulate. Supposedly, it had attacked a number of persons, mainly women. In Richmond, tales were soon abroad of something having torn apart some children (an event that didn't actually happen, as far as can be told) and the villages of Ham and Petersham were soon in a panic over Jack, too. By the time the demon had reached Hampton Wick, another of London's early Victorian satellite-villages, he was supposed to be appearing in the guise of 'an unearthly warrior, clad in armour of polished brass, with spring shoes and large claw gloves who, whenever pursued after frightening not only children but those of an older growth, scaled the walls ... and instantly vanished.'[19] This image, of a frightening, claw-fingered man with incredible jumping-type powers, is the image of Spring-Heeled Jack that we tend to have in our heads today, and this local newspaper report, from January 1838, is the first time that a description of this kind of figure – who only gained his nickname at some unknown point later – appeared in print.

An anonymous letter about the affair was sent to the Lord Mayor of London, complaining about the activities of Jack, and was reproduced in the 9 January 1838 edition of *The Times*, wherein it was claimed that some individual of, it was said, 'the higher ranks of life', had laid a bet with some 'foolhardy companion' that he could not get away with visiting the villages surrounding London disguised as a ghost, a bear and a devil, and hope to get away with it without being arrested.[20] The Victorian newspaper *The Sun* (no relation to the modern rag) began to print assertions that Jack stood to win £5,000 – a huge sum for the time – if he won, but added the condition that he had to kill or render insane and insensible no less

than thirty human beings in order to claim his prize.[21] Baseless rumours were beginning to snowball.

Nonetheless, a few real attacks, apparently perpetrated by Jack or one of his imitators, did actually take place in or near London that year. The first was on 20 February, when he knocked at the house of a young girl named Jane Alsop who lived in Bearbinder Lane in the village of Old Ford. She answered the door to a cloaked figure who asked her desperately to fetch out a lantern, as Spring-Heeled Jack had just been caught in the lane. Thinking it was a policeman, she fetched out a candle and handed it over to him – whereupon he put it to his breast, revealed his hideous true appearance and, in the words of the famous report in *The Times*, 'vomited forth a quantity of blue and white flames from his mouth, and his eyes resembled balls of fire'. He seemed to be wearing a helmet and a suit of white oilskin, and did indeed have metallic claws on his hands, as had previously been rumoured, with which he proceeded to tear at Jane's torso and head, shearing off a quantity of hair. After Jane had been rescued and dragged inside the house by one of her sisters, Jack simply stood there hammering on the door, fleeing only when the girls began shouting loudly for the police from an upstairs window.[22] A few further Greater London-based outrages followed.

The furore around Jack then died down for several years, however, before resurfacing again in Peckham in 1872, Sheffield in 1873 and then at the British Army camp in Aldershot in 1877. After this, it seems, Jack lived on as a popular character in the Victorian 'Penny Dreadfuls' (cheap pulp-fiction sheets and primitive comic books) and memories of the real Jack – if real Jack there ever was – began to fade away into the figure of a vague bogeyman whose characteristics, ill-remembered over time, could be adapted to suit whatever the situation required. Gradually, he became a kind of 'all-purpose entity', who could be invoked in order to describe various ghosts, criminals, hoodlums and other uncatchables. Even in his early days Jack seemed to have many forms, whether it was ghost, devil or simply man in a suit, and, more recently, he has been adopted by certain excitable ufologists as being a kind of alien astronaut stranded on earth. If so, then perhaps he crashed his UFO into the River Mersey – for, according to the standard story, it was actually in and around Liverpool that Jack made his final few ghastly and terror-inducing appearances.

The usual date given for Jack's first appearances in Liverpool is 1888, when he was supposedly seen causing panic in the south end of the city. The most famous account of Jack's escapades near the Mersey, however, was that of a sadly unnamed 'old man, still living', which was recorded in print by the well-known local writer Richard Whittington-Egan, in his book *Liverpool Colonnade*. According to this old-timer, he was a child at the time of Jack's appearances in the city, and was playing in the schoolroom with some of his friends at the St Francis Xavier (SFX) Boys' Guild when someone ran in and shouted that Spring-Heeled Jack was up to his old tricks in nearby Shaw Street. Running outside and up William Henry Street to the scene, the boys were too late, it seems, and saw no man-monster; although there was an excited crowd gathered around there, some of whom told them that Jack was currently crouched down upon the steeple of SFX church. Seeing as the children didn't actually see him perching up there, however, presumably he wasn't.[23] Rumours about the marks of Jack's metal talons still being visible on top of SFX church steeple[24] are, incidentally, entirely baseless. Accounts of Jack leaping off the steeple and then being encountered as a tall, muscular spaceman-type being, wearing all white and with

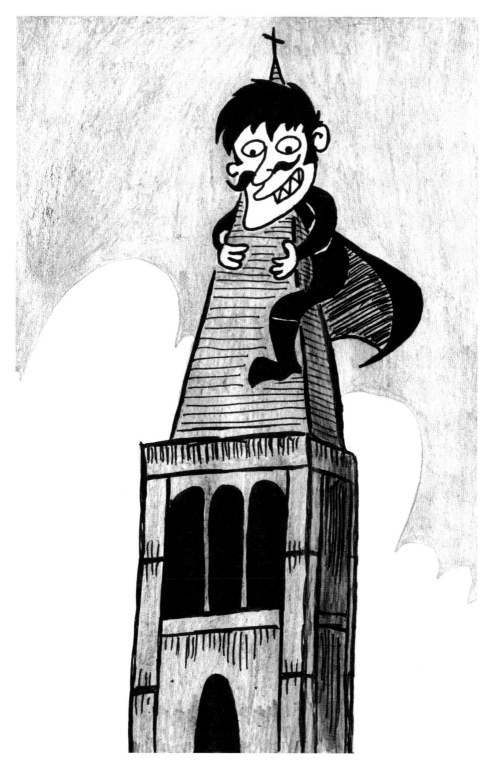

Spring-Heeled Jack atop the spire of SFX church; but did this event really happen?

an 'egg-shaped' helmet on, meanwhile, are similarly not backed up by any actual existing printed witness statements and also seem to be just hearsay and elaboration.

Within the last few years, though, new evidence of Jack's alleged activities on Merseyside has come to light, namely in terms of two articles that appeared in a now long-defunct local newspaper, the *Liverpool Citizen*, on 29 October and 14 December 1887, which were uncovered by the well-known 'Journal of Strange Phenomena', *Fortean Times*.[25] These reports, predating the account given above, seem to suggest that Jack was rumoured to be active in the area even before 1888. Newspapers in those days interspersed satirical commentary and the reporting of actual news events in a way that might seem confusing to a modern reader, and the 29 October report, headlined '£1,000 to £100 Against Spring-Heeled Jack!' is no exception. Indeed, the hack opens his piece with a humorous reference to the preceding few decades of Jack-scares in and around London by saying:

> The Cockneys have set us many a good example in their time, and we have not failed to improve the villainy they have taught us: but certainly one of the most extraordinary exhibitions of late years is that of Spring-Heeled Jack over the water on the Cheshire side [a reference to the towns and villages of the Wirral on the other side of the Mersey].

Immediately, then, the tone of the article is humorous and sceptical in its nature; but what does it actually report? Mainly, it concerns the repeated appearance of a strange figure inside and around the households of about a dozen unnamed young ladies, which frightened them half to death. One girl, it says, was sat in her parlour reading a book when she was

> fairly shocked out of her life and sent to bed for three days by a ghostly tap at the window, followed by an apparition of a fiendish form – one half white and the other black – which, with a demoniacal yell, had no sooner provoked the orthodox hysterics than it disappeared like a dread visitant from another world.

In another case, a fair maiden was playing the piano in the drawing-room of her father's house in the genteel village of Oxton when,

> with a flash worthy of the Unutterable One himself, a black figure dashed into the room, with one sweep of its ghostly hand cleared every atom of ornament off the mantelpiece, threw the terrified spectator into a fit, and – hey, presto! – was gone.

According to the original report, these incidents had led to widespread unease in the area – 'It would be tedious to repeat how many nursery-maids have said their prayers, how many grooms and policemen have repented of their sins', it says – but it is obvious that the writer doesn't believe that this disturbing visitant is anything other than a human trickster dressed up in some outlandish garb. Referring to him slyly as 'John of the springy heels', he says quite clearly that 'Mexican Joe and Buffalo Bill are really not in it with this remarkable impersonator of ghosts'. Spring-Heeled Jack in the Wirral, in his opinion, was evidently little more than a kind of 'circus act', a mere prankster.

The journalist even seems to be mocking the gullibility of the women involved for being frightened of Jack by talking about their fits of what he terms disparagingly 'the

orthodox hysterics', and having one of them 'reading Mrs Oliphant's, or some other equally distinguished lady's book, on the "Gates Ajar"' before being terrified by this weird intruder. This Mrs Oliphant was presumably Margaret Oliphant (1828–97) a fairly well-known Victorian writer and childhood resident of Liverpool, who from 1878 onwards, poured out a series of sentimental ghost stories whose unique selling point – that the dead were kind and benign in their interactions with the living, rather than horrifying and malignant, a hope to which she apparently clung after experiencing the deaths of each of her six children – seems to have made them popular among Spiritualists. By inventing such a detail as a book of this kind being in one young lady's hands at the time of her sighting of Jack, the writer is apparently making a kind of mocking reference to this particular victim being naive enough to believe everything she reads in some sensational and credulous fictional tome about ghosts. In other words, then, she is presented as being just a 'silly girl', in the idiom of the time, and not really a reliable witness to anything paranormal at all.

Furthermore, the *Citizen*'s writer claims to know the true identity of Jack; namely, a certain 'Johnny', one of Liverpool's 'young swells', who agreed to bet a hundred pounds against a thousand being offered by some unnamed but well-off local 'gentleman' that he could impersonate Jack 'on the Cheshire side of the river', going around and scaring people for six months without being caught or exposed. This explanation, of course, seems to mirror that invented by some commentators in order to account for the earlier London scares. The journalist even professes to know the precise details of the construction of this young rogue's 'Jack' suit:

> He is athletic, and a hare on his legs, as you can imagine. He wears an India-rubber suit well greased, so as to be able to slip out of the clutches of anyone who may catch hold of him. He has a mask which is quite black, and when he wishes to strike terror into the heart of his victim in the dark he pulls a string which reveals a face glowing with the very infernal illumination of the very innocent phosphorous.

How seriously should we take these assertions that the journalist actually knew who the original scouse Spring-Heeled Jack was, however? Not *too* seriously, perhaps. The *Liverpool Citizen* was a newspaper that billed itself prominently upon its masthead as being 'A Journal of Current Events – Political, Social, and Satirical' and seems to have had something of a sceptical agenda towards matters otherworldly, whether these were ghostly or religious in nature. For example, in the same report, the author makes the clearly jokey suggestion that local clergymen might actually have been to blame for the panic, using Jack to scare people into turning to God. Indeed, he specifically states, presumably satirically, that 'the Evangelical missions in Claughton, Oxton, and the neighbourhood are making rapid headway owing to the scare produced by this mysterious visitor from the world beyond' as well as mockingly suggesting that an appearance of Jack in New Brighton, dressed in a white sheet, was merely a passing vicar who had 'forgotten to take off his surplice'.

With all this in mind, it seems likely, perhaps, that the journalist did not have any specific knowledge of the actual identity of Jack, or indeed of the details of his alleged bet, but was simply providing his readers with a kind of acceptable 'rationalist' explanation for what was then going on in the area, perhaps based upon a vague recollection of the rumours that had accompanied Jack's initial appearance in London in 1837/38. Possibly he didn't even intend

for his readership to take the specific details of his explanation at face value, but instead simply to plant a seed in their minds that it was probably just 'something like that', a lot of humbug that deserved no greater consideration from the no-doubt enlightened readership of such a quality organ as the *Liverpool Citizen*.[26]

A subsequent report appeared in the same newspaper however, on 24 December 1887, referring to 'the mystery that surrounds the identity of the cowardly fool or fools whose recent escapades in this neighbourhood have caused so much unenviable comment', in which the previously humorous tone appeared to have been replaced with an altogether more serious and condemnatory one[27] – but why?

Presumably it is because another recently discovered newspaper report, from the *Liverpool Mercury* of 15 November 1887, contains details of one of the most sensational of all Jack's appearances anywhere, concerning, as it does, the undeniable fact that he had killed a seven-year-old girl in Southport! Well ... sort of, anyway. A little girl really did die, and Spring-Heeled Jack was ultimately blamed for the fact by the presiding coroner at the inquest into her death, but the case probably wasn't quite what you might at first expect.

It transpires that, on the evening of the preceding Wednesday, a certain Peter Halsall, a gardener by trade, was walking home from work when he was met in the street by his little daughter, Jane. She came up to him, evidently quite perturbed, saying that her playmates had told her that Spring-Heeled Jack – called 'the Liverpool ghost' by the *Mercury* – was on his way to Southport, where the family lived. Jane later repeated this claim to her mother, who reassuringly told her not to worry too much because Jack was actually 'dead and buried'.

During the night, however, little Jane became seriously ill, and soon entered a state of unconsciousness, only coming round briefly to say 'the ghost is coming' around six hours before her eventual death. At the inquest, held at Southport on 14 November, the jury returned a verdict of 'Death by Fright' in order to account for Jane's early demise; it was supposed that something called 'congestion of the brain' had occurred to her after she had become so terrified about Jack's allegedly imminent appearance. The coroner, a Mr S. Brighouse, had no doubt that there was a 'Jack' in the neighbourhood, but that he was a ghost-impersonator rather than any kind of real demon. Summing up, he called this prankster 'a mean and despicable fellow', hoping that he would be the 'recipient of severe punishment' if the police should ever happen to get their hands on him.[28]

Nevertheless, we need not take the recorded cause of death too seriously here. Looking at what actually happened to Jane, it appears that she simply became ill upon the same evening that she happened to have been babbling on about Jack; something that was probably entirely coincidental. The 'congestion of the brain' that supposedly killed her is just a vague nineteenth-century medical term once used to 'explain' deaths that were not properly understood in terms of more precise modern terminology such as strokes and brain haemorrhages. Mike Dash, the unofficial king of Spring-Heeled Jack research (who uncovered this report in the first place), has noted in his own discussion of the Southport case that Jane's symptoms sounded not unlike those of meningitis, another condition once sometimes described as being 'brain-congestion', so maybe this was actually what killed her.[29] Perhaps put off by the negative publicity surrounding the death of Jane Halsall, however, Spring-Heeled Jack seems soon to have disappeared from Merseyside for a while. Maybe the prankster feared harsh retribution from the police or public if he were caught?

Nearly twenty years later Jack made his return, though, and the circumstances surrounding his later appearances are clearer and easier to unravel. The first that the wider world would have known about them was in the week of 25 September 1904, when the *News of the World*, then as obsessed with lurid accounts of crime, sensation and scandal as it ever was, published a short item entitled Spring Heel Jack: Ghost with a weakness for ladies' in which it was reported that the Everton area of Liverpool was presently being scared by 'the singular antics of a ghost, to whom the name of "Spring Heel Jack" has been given, because of the facility with which he has escaped, by huge springs, all attempts of his would-be captors to arrest him.'

Crowds, it said, had gathered in William Henry Street, and were looking out for him, largely to no avail. He was, the report says, 'evidently shy' but apparently still had the courtesy to 'pay particular attention to ladies'.[30] This latter detail, however, seems to have been entirely invented by the paper; any opportunity to get girls involved in a story then, as now, being gleefully taken by the gutter press, it seems.

The *News of the World*'s original source for the story was an article in the *Liverpool Echo* entitled 'An Everton Ghost Story', which appeared on 21 September 1904. This spoke of 'considerable commotion' being caused by what the newspaper termed, significantly, 'a rumour that a sort of "spring-heel Jack" was pursuing his antics in that neighbourhood.' This narrative, the report said, 'as it passed from mouth to mouth, reached sensational proportions.' So what was Jack up to this time?

Apparently, he was playing poltergeist. The locals' gossip, according to the *Echo*, 'referred chiefly to the annoyance of the inmates of a certain house by means of various missiles being thrown in a mysterious manner and without any visible agency.' This ghostly activity, it seemed, was so great an annoyance to the house's tenants that they felt compelled to flee from it, although the police – who had attended the scene upon account of the crowds – denied that a ghost had been at work and, instead, believed that 'some foolish person has been playing pranks'.[31]

Further information about the poltergeist activity is provided by the *London Star* of 24 September 1904, the attachment of the name of Jack to the affair apparently being enough to make the story newsworthy 'down South'. According to this article 'Pieces of brick, old bottles and other missiles came hurtling down the chimneys of the haunted house. Where they came from baffled the vigilance of watchers.' This annoyance was apparently 'persistent' and caused 'terror' among the neighbours. Hundreds of people – 'mostly women', supposedly – then swarmed about the house expecting the ghost to appear at the window, once word about it had got out.[32]

The role of the police in all this is most interesting. As in other spontaneous 'ghost-hunts' that took place across nineteenth and early twentieth-century Britain (the activity was once a popular form of mass urban entertainment, though this fact has now largely been forgotten), the men in blue's main responsibility was to police the crowd, disperse it if possible, and just generally restore order. The traditional way for them to do this was to arrest a human prankster and denounce him or her as being the real 'ghost', thus sending people home disappointed that the whole thing was no more than a hoax. This pattern was followed in the Everton case too as on 24 September, three days after its original story, the *Echo* reported that the police had arrested a young boy named Hugh Morgan for causing the whole commotion. Apparently, he had turned up with the rest of the crowd on the previous

day and, in an act of bravado, had climbed up the back wall of the house, smashed a window and attempted to get inside in order to 'interview' the ghost.33 A constable carted him off, and that seems to have been that as far as the press were concerned. He had smashed a window, so young Hugh must have been the one tossing the bricks and the bottles down the chimney too, appeared to be the conclusion that was drawn.

Looking at this story of Jack's 1904 appearance in Liverpool, though, the reader may find themselves feeling slightly confused. Spring-Heeled Jack was meant to be a humanoid entity, wasn't he, leaping around from place to place, with iron claws and fiery breath? What has this got to do with poltergeist activity? The answer, on the surface of things, would seem to be 'not a lot'. However, it does go to show once again how by this time Jack was now a kind of 'all-purpose bogeyman', whose specific characteristics could be shaped and adapted to fit any alarming situation. Significantly in light of this, it will be noted that the polt-haunted house was reported to be on William Henry Street, which is, of course, just where Jack is famously supposed to have appeared a few decades beforehand in 1888, climbing up SFX church steeple. Because of this old legend, the neighbourhood's children had long been threatened with statements such as 'Spring-Heeled Jack will get you if you don't behave yourself!' adding to Jack's status as a kind of 'local devil' even further.34 Furthermore, it even seems that Jack was invoked as a euphemism for drunkenness in Everton; there is one account of a woman saying of her husband 'he's seen Spring-Heeled Jack again!' whenever he came home from the pub a little worse for wear.35 Quite clearly, then, Jack's legend was well known to the people of William Henry Street.

Given his folkloric connection with Everton, it seems highly likely that some people in the crowd must have recalled the old association between Jack and ghosts, and just applied it to the current situation, whether as a joke or in all seriousness. Remember that the original *Echo* report referred not to Jack himself appearing but, rather, to '*a sort of* "spring-heel Jack"' and you get the general idea; the ghost was probably labelled in this way largely as a means of identifying it as being something spooky and mysterious, with certain people putting it about that the poltergeist was *literally* Jack himself in order to get a cheap thrill. More modern accounts of the incident, by the way, which involve details such as hundreds of terrified residents watching on in fear while Jack made 25-foot leaps up from road to roof, do not seem to be in any way backed up by the contemporary reports, sadly.36

A 1967 interview with a Mrs A. Pierpoint in the *Liverpool Echo*, who was a schoolgirl living in the vicinity of the haunting in 1904, gives further details that help to confuse the issue somewhat, though. According to her, there was a well-known madman residing in the area who had some kind of bizarre religious mania that caused him to climb up on top of the roofs of houses and shout out the words 'my wife is the Devil!' for all to hear. Naturally, this tended to cause quite a commotion and, when the police or fire service brought ladders to try and get him down again, he would try and evade their capture by running and jumping from house to terraced house, leading to him being given the predictable nickname of Spring-Heeled Jack.

Interestingly, however, Mrs Pierpoint did also assert that the poltergeist-infested house – which she said actually stood in Stitt Street (now demolished), just off William Henry Street – was no myth. 'That existed right enough, as any Everton resident of those days will confirm. The people who lived in that house were awakened night after night by furniture and other things being thrown about the rooms, with no human hand doing the throwing.'

She well recalled the crowds that used to gather around there outside, and confirmed that the tenants eventually felt compelled to move out and abandon their residence, the windows and doors of the unquiet home being boarded up and the place just left empty to rot.[37]

Poor young Hugh Morgan, then, was apparently not really the guilty party in the case at all, but merely a police scapegoat. The haunting had already been going on before he so foolishly smashed the window of the house and, in any case, window-smashing was not what this particular poltergeist liked to occupy its time doing. Nowhere is it stated that Hugh was ever caught hurling furniture around, or throwing bottles and bricks down the house's chimney; indeed, it is specifically stated in the *London Star*'s report that the source of these missiles could not be traced, despite the beady eyes of onlookers being fixed upon the place. There never was a Spring-Heeled Jack abroad in Everton, then; but there was, quite possibly, a genuine poltergeist living there.

What happened to Jack after his supposed Everton escapades had ended, though? The standard version has it that his appearances in Liverpool in 1904 – where, as we have just seen, he never actually appeared at all – were his final outings in the public eye. However, there are a few other later accounts allegedly involving Jack from the wider Merseyside area. For instance, in 1929 a newspaper report referred to a spate of dog poisonings that had been threatened across Lancashire (in which county Liverpool was still then contained) and Cheshire by a man signing himself off in letters as 'Spring-Heeled Jack',[38] and there are several other poorly-referenced and dubious stories about him being encountered that you can find if you look hard enough. Allegedly, for instance, in 1902, after a steeplejack had fallen from the Vauxhall Chimney, a massive industrial structure on Liverpool's Vauxhall Road, a number of people reported seeing a figure standing up there on top of it. A former sea captain by the name of Burns is said to have used his spyglass on the shape and said that the man on the chimney was wearing a cape and brass armour, this latter detail being reminiscent of some of the earliest reports of Jack from the London area. As Burns watched, this strange being jumped off the structure and then simply glided away into the night, presumably making use of his cape like he was a flying squirrel – or, at least, that is the story.[39]

In fact the tale is highly dubious, as, most probably, are stories told about a flying man (with horns and bat-wings, no less) supposedly witnessed several times in Speke throughout the 1960s.[40] Indeed, seeing as the 'classic' Jack couldn't fly anyway, attempts to associate him with these alleged incidents are actually slightly confused. Equally unlikely are stories about a super-fast man seen running around Liverpool city centre in late Victorian and early Edwardian times, and sometimes known as 'Jack Nimble' or 'Nimble Jack'. Presumably the supposed relationship between Jack and this entirely fictional figure has arisen from people's familiarity with the words of an old nursery rhyme called 'Jack Be Nimble':

> Jack be nimble, Jack be quick
> Jack jump over the candlestick

But, really, the two characters have little to do with one another outside of the minds of the gullible. You can find a few more (very slight) references to Jack's supposed subsequent reappearances in and around Liverpool online, but none of them are backed up by newspaper reports or anything of that kind, and are almost certainly little more than a potent combination of fantasy and wishful thinking.

The most persistent post-1904 story about Jack, though, is that he appeared in the guise of a glowing white figure in Horsemarket Street in Warrington in 1920, jumping up from the road onto roofs before then disappearing forever by leaping over a railway station. While accounts of this manifestation are vague in the extreme, it does nonetheless seem to be a fact that Jack was as well-known a bogeyman in the Warrington area as he was in Everton. Local ghost-writer Wally Barnes (born 1924) tells us in his short account of Jack's activities in the town that as a young lad he and his friends were 'told to behave or Spring-Heeled Jack would come springing through the windows and carry us off. Every kid in Warrington was frightened of Spring-Heeled Jack.' Local theories apparently differed as to whether Jack was a ghost, burglar, murderer, circus act or even a man advertising super-springy mattresses, but he was certainly believed in by Warrington residents, at least while they were still children. Barnes even interviewed a witness, Harold Schofield, who claims to have witnessed Jack for himself in 1928 as a fourteen-year-old boy, springing up a place called Haydock Street – which, if true, appears to show that Jack was still turning up in the town nearly a decade after he had first appeared there. (Barnes gives the date of Jack's final act in Warrington, that of jumping over the wall of Central Station – and, he says, shouting out melodramatically 'You'll never see me again!' – as being 1929, which doesn't necessarily agree with most other sources.[41])

Some reports even make the doubtful claim that Jack is still with us even today. Most recently, in February 2012, a man named Scott Martin, his wife and their four-year-old son were all in a taxi heading along the Ewell Bypass near Epsom in Surrey when they, and the taxi driver himself, all suddenly saw 'a dark figure with no features', which ran across the road, jumped over the central fencing in the middle of the dual carriageway with ease and then ran across two lanes before climbing up a 15-foot bank and then disappearing, all in about two seconds. According to Mr Martin, this black figure had 'an ease of hurdling obstacles I've never seen'. This leaping phantom has already been linked with Jack himself by some commentators, showing how his name lives on in this country still – even though, really, there is no evidence that this spectre was in fact Jack at all.[42] Indeed, there is no evidence at all that Jack was actually a spectre. Even if Spring-Heeled Jack was not actually real, then – except as a man in a suit – perhaps it is only a matter of time before some other Merseyside resident claims to have clapped eyes on him once again anyway.

3

The Ghastly Galosher Man

Strangely, Spring-Heeled Jack wasn't the only supernatural bogeyman figure with incredible running and jumping abilities to be found lurking around Merseyside in the past. His close cousin, known as the 'Galosher Man', was also supposed to be abroad.

This figure is now little-remembered, and quite obscure. He is supposed to have turned up in Liverpool, St Helens, Rainhill and Warrington, among other places. But what was he? It is quite difficult to tell, as there are few meaningful written records of his alleged escapades. The one constant in the tales that are told about him, however, is that he went around everywhere wearing galoshes, those springy gum-heeled shoes sometimes worn in gym class (younger readers will know them as 'pumps'). Dressed in this almost magical footwear, the Galosher Man was able to outrun any pursuers, to jump effortlessly over obstacles in his path and, due to their soft soles, to be able to creep up behind people in the night and then do … something vaguely unpleasant to them. Quite what, exactly, is a mystery. There are certainly implications that he would perhaps rape, murder or assault those he managed to sneak up on, but no recorded instances of anything like this actually happening.

In fact, the only examples I could find of the Galosher Man actually doing *anything* to *anyone* come from the Longford area to the north-east of Warrington, and span the years 1940–43. Here, he made around thirty or so appearances, creeping up on elderly people during blackout hours before tapping them on the shoulder and then running away and vanishing. One old woman, walking home from the Longford Hotel one night, had her bottle of beer snatched from right out of her hand by the Galosher Man, who was also seen running along people's garden walls and was blamed for milk bottles going missing from doorsteps. None of this, of course, seems terribly paranormal; there were plenty of people who took advantage of the enforced darkness of the wartime evenings to play pranks on people, and the fact that he largely picked upon the elderly could account for the fact that he was able easily to outrun his victims. The only genuinely odd thing this man was alleged to have done supposedly occurred in 1948, when he had reappeared on the scene and a trap had been set for him. Being chased along Lythgoes Lane, he is said to have been cornered and then to have jumped straight over a 7-foot-high wall and onto some railway sidings,

The evil Galosher Man on the prowl and up to no good.

where he then vanished into thin air. Because of this, some people have suggested that the Galosher Man was actually Spring-Heeled Jack returning to town after several years away. But was it? This narrative certainly makes him *sound* like Jack, although the detail about him jumping over a railway just makes it seem to me as if someone, somewhere, has simply adapted the story of Jack's alleged 1920s appearance near Warrington's Central Station in order to make it fit in with the new bogeyman in town.[43]

And the Galosher Man was indeed a bogeyman. Just like Jack, he was used by parents to frighten their children into behaving.[44] He was also used by adults in order to account for objects going missing from gardens.[45] Rather than just admit that they didn't know who had stolen their stuff, they humorously blamed the Galosher Man. It seems like he was just yet another childhood nightmare, then; except that, remarkably, there are some first-hand accounts of people having witnessed him! A Patricia Speakman wrote in to a local newspaper in 2001, for example, in order to tell them about an encounter she had had with the mysterious figure one afternoon while still a child, living in the village of Eccleston, near Chorley. Apparently, buckets and washing had been going missing from local gardens, and the Galosher Man was being blamed. Nonetheless, it was still a surprise for Patricia when she looked out of the back door and saw him standing there in front of her! Patricia's

mother challenged the intruder, but he just stood still making 'weird vocal sounds' for a bit before running off. A few moments later, strange noises were heard coming from next door, even though the house was meant to be empty. Going in to check (doors being left unlocked in those days, as we are so often told by our grandparents), the two females found the Galosher Man inside, standing there burbling. Patricia's mother threatened to go and fetch a policeman, and the bizarre fiend just 'slid away silently', never to be seen in the area again.[46]

This must all have been terrifying, of course, but it is obvious that all that Patricia and her mother encountered that day was a mentally disturbed person, not a supernatural entity. However, the fact that he was labelled 'the Galosher Man' once he had been witnessed just goes to show how this name was essentially just a label that could be conveniently applied to local weirdos. The association between the Galosher Man and mental illness is, it seems, quite a long one. During the 1940s Warrington scare, for example, the most popular theories about his origin were that he was either an insane American airman from the nearby Burtonwood Air Base or that he had escaped from the local lunatic asylum at Winwick. Others said that he was simply a kind of Peeping Tom.[47]

Certainly, in St Helens it appears that the Galosher Man was associated with a curious individual, now long-dead, called Harry Ockley (or Hockley, in some versions). According to one contemporary witness, this Harry had an 'exhibitionist' nature and an unfortunate appearance, with 'curly hair, a very red face and large nose all pock-marked' and went around wearing a shabby brown suit.[48] Kids being what they are, rumours spread about Harry – of an obvious sort – and he began to be persecuted or fled from, depending upon your own personal disposition. It seems that Harry lived near the 'Kimmicks' (a series of old chemical dumps in the town) in the 1940s, and was actually no kind of danger at all, being something of a Boo Radley-type character who was 'often misunderstood', in the words of one correspondent with a local newspaper.[49] Allegations that he – in the guise of the Galosher Man – used to enjoy creeping up on young courting couples in the night speak of different, darker whispers that were abroad about him at the time, however.[50]

According to local legend, he had convictions for flashing and had spent time in the old asylum at Rainhill; rumours that led to kids legging it past places like bushes and dark alleys for fear that he would come out and get them after nightfall.[51] The myth of the Galosher Man must surely have pre-dated Harry Ockley, however, for it to have been known of in Warrington as early as 1940. Probably the most likely explanation for the term's former popularity is that it was a useful way for adults to refer to strange men of, shall we say, a 'certain disposition', whom they wished their children to stay away from without having to go into all the gory details of what precisely it was they might do to them if they should catch them. This can be backed up by the fact that other people are equally adamant that Hockley was not the 'real' Galosher Man but an imposter, the figure's true identity actually being a self-employed printer from the Thatto Heath area of St Helens who used to go around wearing, tellingly (in the eyes of rumour-mongers, at least), a long raincoat.[52]

However, looking at some other early twentieth-century 'ghost scares' from around Britain, we can find some very suggestive details that imply that the Galosher Man's origins might lie even further back in time than 1940s Warrington and St Helens. For instance, in September 1926 a very odd individual was going around Bradford dressed in some kind of all-white Ku Klux Klan-type garment and bothering the residents. Huge crowds, armed

with pokers, sticks and fierce dogs, went out hunting him after dark. However, they could not catch him; he was simply too fast to be apprehended. The following description of the miscreant, taken from a contemporary *Yorkshire Observer* report, sounds somewhat familiar: 'The witnesses are unanimous in declaring that the man wanted is at least 6 foot 2 inches in height, and that he is an extremely fast and agile runner. He makes practically no noise when running, and it is thought that he wears black dancing pumps.'[53]

There was even an earlier 'ghost scare' from Sheffield in May of 1873, when a figure known as the 'Park Ghost' was reported to be on the loose, dressed in a white sheet and frightening people, supposedly for a bet, which involved another similarity to the tales of the wartime Warrington Galosher Man. Here, one of the most bizarre alleged incidents was reported on in the *Sheffield and Rotherham Daily Independent* as follows:

> A girl was returning from the public house with a jug of beer for her parents' supper, when his Ghost-Ship made his appearance and behaved uncommonly like an inhabitant of this lower sphere, whose moral training was somewhat neglected – behaved in fact, to put it plainly, like a thief. He took the jug from the girl, drank the contents with an evident relish, and then vanished, not however into thin air, but over a wall. That, at least, is the story that reaches us.[54]

This, of course, is more-or-less exactly what the Galosher Man did to the little old lady on her way back from the pub in 1940s Warrington. The fact that the Sheffield 'ghost' is meant to have then gone over a wall to escape can be linked to the fact that, in later oral legend, he was spoken of by some as being none other than Spring-Heeled Jack himself (as, indeed, was the Bradford ghost); and we have already noted that the Galosher Man, in Warrington at least, was to a degree associated with this figure in the popular mind, too.

What can we make of these parallels, though? The fact that sneaky men who go around doing odd things at night on the quiet should have been thought of as wearing silent shoes of some sort is perhaps not that surprising, and it is presumably in elaborations of events of the kind that occurred in Sheffield and Bradford all those years ago that the character's ultimate origins lie. As for the resemblance between the Sheffield ghost's beer-stealing antics and those of the Warrington Galosher Man, I doubt that the latter was consciously modelling himself upon the former here. Presumably the real reason for this similarity is simply that both jokers, seeing a vulnerable female walking along the street at night carrying some beer, had a similar idea occur to them about what it might be funny to do in such a situation. I suppose that there are only so many pranks that can be played by a Galosher Man, a Spring-Heeled Jack or a man in a white sheet, after all.

But why 'the Galosher Man', exactly? Where does the specific name itself actually come from? I must say that I was stumped on this one for a while until, quite by chance, I came across a little-known poem from the Liverpool poet Matt Simpson (1936–2009) who was a lecturer in English at Liverpool Hope University for many years. Entitled 'An Elegy for the Galosherman',[55] I initially thought that the piece might have been an ode about the activities of our notorious spring-heeled friend. Certainly, the first stanza does sound rather sinister in its tone, and does indeed sound promising in this respect, going as it does:

Who pads the Bowles Street jigger now?
Who's pacing there on noiseless soles
Breathing the bad-blood darkness in
Between the sleeping back-to-backs?

Well – who indeed? Was it really the Galosher Man? Apparently it was – because, as reading the rest of the poem and an accompanying commentary upon it makes clear, the 'Galosher Man' was just a local Liverpool slang term for a lamplighter. In the days before electric arc-lights were first used to light our streets, local councils employed lamplighters to go around at night with lit tapers on the end of poles, which they used to ignite the gas lamps. Then, in the early morning, they had to go around and extinguish them again. The reason why this humble civic functionary was 'pacing there in noiseless soles' – i.e. galoshes – in the 'Bowles Street jigger' (a local dialect word for an alley) in this poem is presumably because he didn't want to wake anyone up while performing his duties. Hence it seems likely that, in the popular speech of local people, anyone else who went creeping about the place silently in the dark for whatever reason, whether they be a thief, a rapist or a mugger, became known as a 'Galosher Man' too. If I am right in my conjecture, then it is only a short step from this, surely, to people like Harry Ockley being given the name as well, once it was abroad in common usage in the greater Merseyside area. Disappointingly, the original Galosher Man, it seems, was not the evil cousin of Spring-Heeled Jack after all, but merely a humble employee of Liverpool City Council.

4

The Tranmere Terror and Other Merseyside Ghost Panics

While we shall have cause to examine many apparently true tales of ghostly goings-on later in this book, it might be instructive first to examine a few largely baseless ones here. Perhaps the most notorious such false 'ghost panic' on Merseyside occurred in 1920 in the town of Tranmere on the Wirral and, as such, became known to posterity as the 'Tranmere Terror'. It all started when an unnamed night-watchman, on duty guarding over some road repair material overnight at an unnamed location, supposedly woke up from a small nap and witnessed a hideous 'gibbering face' looking into his little hut from the inky blackness beyond his fire brazier. This face was entirely disembodied and such was its disturbing appearance that, allegedly, the night-watchman either ended up in hospital suffering from shock, or went completely insane, depending upon which local rumour-monger you chose to listen to.

For whatever reason, this seemingly invented yarn touched a nerve among Tranmere's populace, and within a mere day, these two competing versions of the night-watchman's fate (together with two differing descriptions of the floating head itself) were doing the rounds, causing genuine disquiet. People believed the ghost story, and bands of youths wandered the town's streets, in search of the phantom. Several times it was rumoured that the thing had been cornered, but upon every occasion this claim proved false. By the end of the week, it became obvious that there was no demonic head, and the area's inhabitants had to look for other ways to get their nocturnal kicks instead.[56]

There are, it seems safe to say, various other ghost-hunts of the same basic sort as this one which must have taken place on Merseyside at some time in the now-distant past, but few real details of most now remain about them for us to discuss. Things like this just pass on into the realm of forgotten history if they are not reported on in the press or otherwise written down at some point as, one by one, the original participants and witnesses begin to pass on due to old age, illness and sundry other assorted misfortunes. Small and vague details may remain, scattered here and there, but we can make very little of them from our own vantage point in the present. What was the true identity of the 'Tranmere Terror', then? Probably, we shall never know.

The Tranmere Terror: A disembodied, gibbering face allegedly seen by a night watchman, which caused panic in Tranmere in the 1920s

We can be entirely sure, however, about the true identity of another fake ghost that was once well-known in a certain area of Merseyside, namely the 'Red Phantom of Pig Hill', who was regularly sighted galloping around the streets of 1920s Warrington on a donkey. This bizarre figure was dressed all in red, complete with a bright cloak and scarlet mask, and was no mere rumour. He is said to have so terrified some Warrington residents, by pulling stunts such as jumping out from within bushes at them holding a sword, that they literally soiled themselves. However, the Red Phantom was no ghost; he was simply a ne'er-do-well drifter from Liverpool who went by the rather unfortunate name of Dick Harmer, and who had been employed by the Palace Cinema in town to go around dressed as the main character in one of the films it was then showing, a Zorro-like figure called the 'Red Shadow'. However, Dick asked the manager of the Palace for more money, given the success he was having in terms of his promotional activities, and was refused – so he went off with the Red Phantom disguise he had been given and began terrifying people dressed up in it

and pretending to be a ghost instead, simply to get his kicks. Eventually, a well-known local policeman by the name of Tommy Dooley (great-uncle to the former England Rugby Union player Wade Dooley) caught Dick at it but, finding it all quite amusing, let him off with a caution, policemen still being allowed to use their own discretion and common sense at the time.[57]

There have been other such fake ghosts reported from the Merseyside region over the years, too. For example, at some point during the early nineteenth century, villagers in the small settlement of Upholland, a few miles east of Skelmersdale, began witnessing a ghostly funeral procession passing through the local churchyard every night. There were several ghosts, carrying a white coffin, and all of them dressed in white, too. Finally, after much rumour had been spread abroad about this nightly appearance, a group of local men got up the courage to approach and confront the phantom funeral – whereupon the 'ghosts' immediately dropped their coffin and ran for it. Upon this container being opened, it was found not to contain a corpse, but to be full of coal. Apparently, the price of fuel being high at the time, a gang of crooks had hit upon this *Scooby Doo*-like scheme in order to steal themselves some of the black stuff, coal being too heavy and difficult to transport illegally around the countryside on a large scale otherwise.[58]

Finally in terms of our current discussion, it seems that at some point, probably in the mid-1940s, there was supposed to be a ghostly sailor haunting the old stone quarry that sat next to Delph Lane in Whiston, just east of Liverpool. It appears that some time previously a twenty-four-year-old seaman had fallen into the pit of the quarry while courting his girlfriend and then died. When a girl returning from the local cinema late at night claimed to have seen this dead sailor standing on the footpath next to the quarry before her and then disappearing, she sparked a scare that apparently led to large crowds from Whiston and the neighbouring town of Prescot spending several nights out there in the dark in search of the unquiet spirit – with, it has to be said, a singular lack of success.[59]

This is a tantalising reference, for sure, but frustratingly hard to make much out of. Exact dates are not given in the main sources that I could find for this tale, nor anywhere do names appear. Given so little to go on, it is hard to search newspaper archives and so forth in order to find out more about what sounds like a fascinating little local story; and so, as with so many of these things, it is essentially lost to us. Ghost stories often become like little more than ghosts themselves after a while, it seems, and word of mouth can keep them wandering about through the night for only so long. Hopefully books such as this might help in some small way to preserve them from fading away into mere mist and nothingness at cock-crow, though – for a little while longer at least.

5

Screeching Ginny and Jenny Greenteeth

There can be very few public plaques or monuments around the world that have been erected in order to commemorate alleged supernatural events, but at Liverpool South Parkway railway station in the Garston area of the city there stands a sign recounting the story of a scary encounter with a ghostly witch. Headed 'The Story of Screeching Ginny', it was unveiled by Merseyrail in October 2006, only a few months after the station had first opened that June, together with a laser-cut artwork showing Ginny herself, created by local artist Peter Ogunsiji in collaboration with some students from the nearby St Benedict's College.[60] The plaque reads as follows:

> On 15th November 1959, some children were playing on the railway at Garston Dock Station. An ugly witch appeared and chased the children. She flew after them screeching at the top of her voice. On St Mary's Road, she gave up the chase, but the children kept running. A local boy, aged 10, ran down Russell Road to where his gran was waiting for him. He told his gran about the witch. She told him it was Screeching Ginny. According to local folk stories, Ginny was from a strange family who people thought were witches. They had moved to a house in Cressington. It was said that people who didn't like the family died in strange circumstances. Ginny had fallen in love with a local boy, and put a spell on him to make him love her, but this was broken by her mother. The boy got engaged to someone else. Ginny was heartbroken. She followed him and his sweetheart to the station, where she ran screeching onto the tracks and was hit by a train. Her ghost is said to still haunt Garston Dock Station even after it closed in the 1940s.

Quite a story; but is it true? Well, it does appear that a folkloric figure named Screeching Ginny was indeed known and spoken of in the Liverpool area prior to the plaque's unveiling. For example in Netherfield Road, Everton, stands a small old tower that is often known as either 'the Roundhouse' or 'Prince Rupert's Tower', after Prince Rupert of the Rhine, who had led his Royalist troops into battle on Merseyside in 1643/44, during the Civil War. In fact, however, the 'tower' is actually an old bridewell or 'lock-up', a temporary jail in which

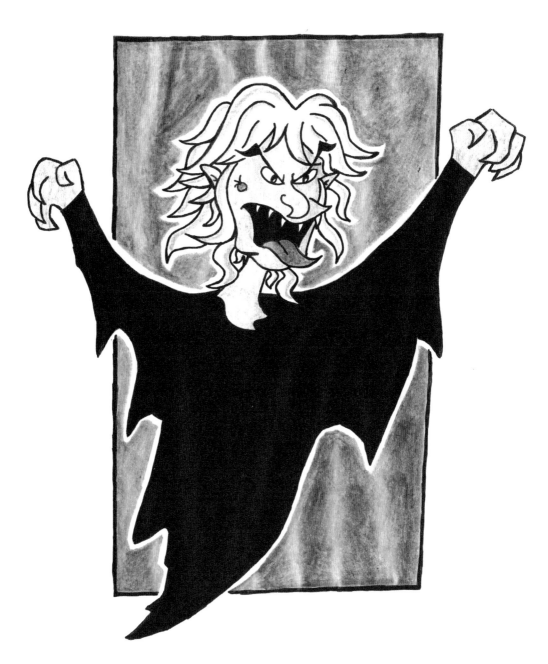

Screeching Ginny. Did she really appear at Garston Dock Station in the 1950s?

local drunkards and other minor miscreants were kept overnight in the days before we had police stations. The bridewell in Liverpool was built only in 1787, though, so could have had no actual connection with Prince Rupert at all. Nonetheless, it is probably the most famous such structure in the country, seeing as it is depicted upon the badge of Everton FC, having been adopted by them for use on club ties at the start of the 1938/39 season. In 2003, a plaque was added to the structure in order to inform people of this fact.[61]

Before this notice was placed there, though, the tower had fallen into disrepair – and, to some children of the neighbourhood, it had become known as 'Screeching Ginny's Castle'.[62] This is just a minor piece of Everton childhood folklore, of course, but it is nonetheless important, as it clearly shows that the name 'Screeching Ginny' was known of in the Merseyside area prior to the unveiling of the plaque at Liverpool South Parkway in 2006. (Incidentally, Ginny didn't *really* live inside the tower – it was actually used by council workmen to store their tools!)

Furthermore, it seems that the highly similar name 'Screeching Jenny' was known of elsewhere in the past, too; one informant online speaks of being warned to go straight to sleep when she went to bed by her grandmother – who had 'never set foot north of Cambridge', apparently – or else she would be persecuted by Screeching Jenny, who would scream throughout the dreams of naughty little girls who didn't do as they were told.[63] This strongly suggests that Jenny/Ginny was indeed an actual character from folklore, being another kind of bogeyman figure who was invoked purely in order to get kids to behave – like Spring-Heeled Jack and the Galosher Man were. All this does not in any way imply that she was actually *believed in* by anybody over the age of, say, ten, though, nor that she was an actual witch, as the plaque at the railway station claims.

However, the picture is complicated for us somewhat by the fact that there is another well-known bogeywoman from the Merseyside region known either as 'Jenny' or as 'Ginny', and that is the notorious Jenny Greenteeth. Some sensationalist sources would have you believe that this Jenny Greenteeth was an actual local witch but this is, to put it politely, nonsense. Jenny was once well known on Merseyside, but is now just as well known to folklorists, who universally deem her to be an evil personification of the plant duckweed. Duckweed (*lemna minor*) is one of the smallest flowering plants in the world, but can grow in abundance in order to form up dense, thick-looking mats on the surface of bodies of still water like ponds and ditches. As such, it is potentially dangerous and misleading to small children, who might falsely assume that it is solid enough to walk or lean upon – whereupon they would fall into the water, get tangled up in the weeds and drown. Therefore, adults made up stories about Jenny Greenteeth in order to keep their young charges away from an unpleasant watery death. The Warrington ghost historian Wally Barnes, for instance, tells us specifically that, as a child, he and his companions were warned away from going near the waterways in that town, or Ginny Greenteeth 'would come out of the green weeds that grew thickly on top of the water and grab our legs and pull us under'. This, he says quite clearly, was just the local parents' way of keeping their children away from playing near disused canals.[64]

Most of the time, Jenny was supposed to be unseen, lurking beneath the surface of the water, but occasionally her appearance could be described, as in this account of her living in two pools near the suggestively named Mosspits Lane in Fazakerley in about 1920: '[She] had pale green skin, green teeth, very green locks of hair, long green fingers with long nails, and she was very thin with a pointed chin and very big eyes.'[65] According to this

description, then, she was meant to look rather like a kind of stereotypical witch is supposed to in children's cartoons and films nowadays – with green skin, claw-like fingernails and so on. According to the folklorist Charlotte Burne, Jenny was 'an old woman who lurks beneath the green weeds that cover stagnant ponds; Ellesmere children were warned that if they venture too near such places, she will stretch out her long arms and drag them to her' before drowning them and then eating them up with her sharp green teeth.[66] This testimony makes the old hag sound as much as if she was the child-eating witch in *Hansel and Gretel* as she was a mere water spirit or freshwater mermaid.

In Warrington, a legend grew up that Ginny's/Jenny's origins lay in the story of a 'horrible old hag', who in the 1790s had supposedly once lived on a barren and desolate smallholding near Moore Lane, then as now almost all farmland. Named Jennifer Gretchley, she was said to be in the habit of luring wandering tramps into her house with the promise of kind hospitality before then strangling them and cutting their bodies up into little pieces. These she then took and threw into a nearby large pond, known as 'The Three-Cornered Pit', where the thick weeds on top of the water promptly sucked them under. When some children fishing for tadpoles saw body parts floating in this pond one day, they ran off and told their parents. Jennifer Gretchley – by now known as Ginny Greenteeth among the suspicious locals – was blamed, but was found to have disappeared when the villagers went to her house to confront her. Bundles of rags from her victims littered the floor, however, thereby proving her guilt. Nothing more was heard of Ginny for forty years – until, one day, her ghost was sighted standing on top of the weeds in the pond, beckoning a local farmer to jump in and join her there. She was then allegedly seen in the slimy pool for years afterwards, and children were terrified to go anywhere near it. Rumours soon began to spread that it was bottomless. Eventually, two men digging near the pond discovered a woman's skeleton in the soil, presumably Ginny's mortal remains. She kept on appearing there until eventually the pit was filled in during the building of the old Thames Board Mills box factory in 1937.[67] That's the story, anyway.

The tale is obviously just folklore, but it does show again how associations were once frequently made between Jenny Greenteeth and witches and old hags. Other Merseyside informants, however, described Jenny as being not a witch but 'a sort of fairy',[68] while yet others, even when still children, were of the opinion that Jenny was not real at all, but simply an alternative, 'scary' name for duckweed, as is suggested in the following account from an old woman who had been brought up in the Upton/Cronton area on the outskirts of Widnes, which was collected as late as 1980:

> Jinny was well known to me and my contemporaries and was simply the green weed, duckweed, which covered the surface of the stagnant water. Children who strayed too close to the edge of these pits would be warned to watch out for Jinny Greenteeth, but it was the weed itself that was believed to hold children under the water. There was never any kind of suggestion that there was a witch of any kind there.[69]

Times change, however, and children nowadays aren't as exposed to duckweed-infested ponds as they once were. What happens to Jenny now, then? Does her name just die out in people's memory? Surprisingly, the answer appears to be 'no'. One option available to keep Jenny's memory alive was simply to alter the location of her reputed abode. In Manchester,

for example, she was simply said to have started living down grids.[70] At Kirkby Lonsdale in the Lake District, meanwhile, once Jenny's slimy and stagnant pool of choice had dried itself up, she was alleged to have climbed up out of her pit and now to be living either down a back lane or in the nearby Lunefield Wood, from whence, in the words of one informant, she would 'rush out and gobble us [children] up if we were naughty'.[71] Her living in the woods here, of course, only makes Jenny sound even more like a fairytale witch.

The fact that she would only 'gobble up' naughty children (perhaps they just taste better than well-behaved ones do?) is also suggestive of the fact that, once the threat of duckweed drowning had been banished forever from modern childhood by increasing urbanisation and the easy availability of public swimming pools, Jenny morphed instead into a kind of generalised bogeywoman. Even in 1904, this was in the process of occurring – one informant telling the journal *Notes and Queries* that her mother and nurse had warned her that 'if I did not keep my teeth clean I should some day be dragged into one of these ponds by Jenny Greenteeth'.[72] Reflecting this process, Jenny is now invoked in modern-day Liverpool purely in order to terrify kids into brushing their teeth (as above), or to get them to come home by a certain time at night, not to keep them away from duckweed. Apparently, children were even once threatened away from playing in the dangerous building-site grounds of the then still unfinished Anglican Cathedral by her name, right down into the 1930s or even later. (It seems possible, however, that the association between Jenny and this location might initially have been down to a lonely old woman with rotten teeth who used to live inside the old lodge in St James' cemetery just behind the Cathedral, who was once plagued by youths knocking on her door and calling her Ginny Greenteeth before running away.[73])

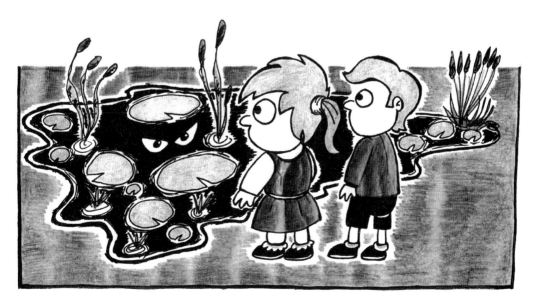

Jenny Greenteeth lay in wait for unwary children beneath the surface of dark, duckweed-covered ponds.

Jenny Greenteeth, then, seems to have been conceived of by many as a kind of witch-like figure, a resemblance that apparently grew stronger over time. She was also invoked as a bogeywoman to get children to behave or to stay away from dangerous locations, and could be known as either Jenny or Ginny. All of these facts are true about Screeching Ginny, too, as we saw at the start of this section. This strongly suggests that the two alleged entities are, to some degree, variant forms of the same basic folklore character. But what about the alleged sighting of her at Garston Dock Station in 1959? Could this possibly have been true?

Well, before we begin discussing this, let's get one thing straight; we can't even begin to know absolutely for sure whether the sighting occurred or not until the sadly unnamed 'local boy, aged ten', or one of his friends, comes forward and tells the world about it in a more detailed and on-the-record fashion. The story could be completely false, or alternatively it could well be the case that a group of kids did indeed see something very strange while playing near the tracks one night at the tail end of the 1950s. For my own part, I'm more than prepared to admit the possibility that some children once saw an apparition at the station that was then only subsequently *labelled* as being 'Screeching Ginny' afterwards, due to the reputation this bogeywoman-spirit had in local folklore. After all, as we saw earlier, this was exactly the same kind of process that occurred when the Stitt Street poltergeist was proclaimed falsely as being Spring-Heeled Jack back in 1904. However, there are a few factors about the story as told on the plaque that do make it sound rather suspicious.

For one thing, we can look at the history of Garston Dock Station itself. This only began life as the western terminus of a line between Widnes and Garston on 1 July 1852, being connected up to Liverpool Lime Street in 1873. This service kept running until 16 June 1947, when the line closed for all except freight-trains, until it was closed for good in the 1970s, then being demolished and having a road built over it.[74] This means that, if the story of Ginny running onto the tracks and killing herself over her lover is true, it must have occurred at least as late in time as the 1850s, well into the Victorian era. This, of course, was *long* after the main wave of English witch trials and scares in the 1500s and 1600s, which would seem at first sight to discredit the story somewhat; as a general rule, the later on in history you go, the less likely it is that people will believe in witchcraft. While the date of the station's opening doesn't demolish the story as such – some people believe in witches even now, after all – it doesn't exactly add to its plausibility, either. A far more serious argument against the tale's truth, however, would be that, as far as I could discover, there appears to be no record of any suicides taking place on the Garston Dock line. There were collisions on the line on 6 September 1861 and 16 April 1870, and also some kind of accident that led to a train being misrouted on 22 February 1881, but no suicide is specifically mentioned in relation to any of these incidents.[75]

Where, then, does the association between Screeching Ginny and the old Garston Dock Station come from? One possibility is that, there being some confusion between her and Jenny Greenteeth locally, her name was simply used by adults as a useful bogeywoman in order to scare kids off from playing in dangerous areas like unmanned railway stations – a far greater hazard in 1950s Garston than scum-filled ponds. People could have spread rumours about her haunting the place purely to keep their kids safe, then. There is another intriguing possibility, however – there is actually a further ghost, this time called Screaming Jenny, who is associated with tragic death on a railway line across the pond in America.

Her legend concerns the small town of Harpers Ferry in West Virginia, where some old shacks, once used as storage sheds, lay abandoned by the company that had built them beside the new tracks of the Baltimore & Ohio Railroad, which had reached the settlement in 1833. Here various people, down on their luck, made their homes, including one poor down-and-out by the name of Jenny. One night she got too close to the fire she had lit inside her tiny shack to protect herself from the biting cold, and a spark jumped up from the flames and set her dress on fire. Running out of her hovel screaming and ablaze, she ran straight onto the railway track and into the path of an onrushing night train. She was killed instantly. Ever since, train drivers passing through Harpers Ferry upon the anniversary of her death are meant to have claimed to have seen a ball of fire flying down the tracks and emitting an unearthly scream – the ghost of Jenny, making her way again down the line reliving her death, and wailing out in burning agony forever as she does so.[76]

Obviously, this American legend of Screaming Jenny isn't exactly the same as the Liverpudlian one of Screeching Ginny, but the names and behaviour of the ghosts, and the fact that both of them were meant to have died violently beneath the wheels of a train, clearly show signs of considerable crossover. Could the Liverpool fable just have been an adaption and local reworking of the older American story, then? Perhaps; but how might this have come about?

I suspect that someone, somewhere, has read about the Screaming Jenny story from West Virginia, associated her name with the Screeching Ginny/Jenny spoken of in Liverpool, and then just altered the original tale in order to fit it in more with pre-existing local tastes and legends. In this altered form it could then easily have been picked up on by the pupils at St Benedict's. After all, I can find no written references to the tale of Ginny at Garston Dock Station prior to 2006, when two showed up at once; one was on the plaque, and the other was in the eleventh volume of a popular series of local books about alleged Liverpool ghosts. It seems to me quite likely that some of the children involved in making the plaque and artwork had read this book telling Ginny's tale, swallowed it whole (as the book's author apparently did) and then told the people from Merseyrail that this is what they wanted to make their monument about on account of it being a sensational story set in their own neighbourhood. Either way, the whole yarn about Ginny being from a family of local witches and throwing herself beneath the wheels of a train seems to me to be highly unlikely to be true. As for whether or not some children really did see a hideous apparition of some kind one moonlit night in 1959 – well, that we shall perhaps never know for sure.

6

Faces in the Windows ...
and Jesus in the Dishwasher

Harrington School was one of the first public schools in England, having been established for the poor children of the Toxteth Park area sometime in the late eighteenth century. In 1878, a new school building was erected in Stanhope Street, and the establishment didn't close for the final time until over 100 years later, in July 1984.[77] It was here, on Monday 7 June 1926, that a very strange story began to spread.

A young pupil, returning home for lunch, claimed to have seen a human face peering down at him from one of the school's windows, which looked out onto Grafton Street. Rumours about the alleged face soon began to spread, and it was not long before a large crowd had gathered around outside to stare. One woman cried out that she could not only see the face in the window, but also a picture of Christ carrying his cross. Evidently, some other people gathered around there agreed, as several women dropped down to their knees and immediately began praying in the street.

As the day progressed, more and more people arrived to see the 'miracle pictures' and a whole cavalcade of religious imagery was soon being pointed out; there was Jesus, wearing his crown of thorns, the Good Shepherd gathering in His flock, and more. One old woman who had stayed around staring until midnight said she saw a star suddenly appear inside one of the windows, and even asserted that the images had temporarily become full colour and as visible as if it were daylight. In the early hours, a school janitor was ordered to go around and whitewash over all of the panes, to put an end to the scenes. This did not stop people seeing the Virgin Mary standing there in a different window come the next morning, though. Once again, crowds gathered, and the police were called out. Every visitor was allowed one glance, and then told to move along.

Harrington School's headmaster knew that this was all no miracle, however. He had seen odd images in the windows himself, previously, and had already subjected them to a detailed examination. Letters, images, even the clear imprint of a man's hand, could all be observed if you went up to them and looked hard enough. This was because the panes were all second-hand, having previously been used on shopfronts, where they had been plastered all over with painted and imprinted advertisements for various products. The school's window

cleaner confirmed the truth of this claim, and added that, the week previous to the 'miracle images' being seen, he had wiped them all down with paraffin. This had left some smudges which, combined with the ingrained old markings inherent within the glass itself, had caused people to begin seeing things in them. Christ up there on the window was not actually Christ, it seemed, but rather a man advertising bars of chocolate and brands of soap! More whitewash was then applied to the panes, and the panic soon subsided.[78]

This is not the only such scare that has occurred on Merseyside, though. Another series of sightings of a supposedly supernatural figure in a window happened in Warrington between 1920 and 1929, in a top-floor window of the old Springfield Street Post Office near Palmyra Square. Here, the first incident occurred when a lady passing by happened to look up and saw either a little old woman or a small girl peering out of the window and waving at her. Upon going inside and asking the post office manager who this person was and what exactly she wanted, she was told that the room in question was only used for storage, and that there was nobody inside there at all. Other such sightings followed, over a period of several years, but the time when a group of twenty or more pupils from Friars Green Sunday School out marching past the building on the morning of the annual Walking Day (a kind of church parade – a big tradition in Warrington) in 1929 looked up and saw an old woman perched there signalling to them through the window, was perhaps the most interesting of all. Intriguingly, the vicar who was accompanying the marchers said that he thought it was a little girl, and not an old woman at all, who could be observed through the glass. Possibly, given these clear discrepancies about what exactly was seen depending upon the witness you spoke to, the scare was actually the result of some kind of optical illusion, just like at Harrington School, whether related to a flaw or pattern inherent within the window pane itself or otherwise.[79]

Similar rumours were also abroad in St Helens in 1875 when, on 24 September, a glass engraver was working on some windows at the front of a factory now called the Engineers' Hall at the bottom of Croppers Hill on Prescot Road. Here, there had been a tale going round for years that there was a ghost which could be seen peeking its head out through one of the windows, a notion which seems to have become quite widespread in the area. That day, however, at around 3.00 p.m., the rumours came to a head as several hundred people gathered around outside, staring up into the glass and trying to see the spirit. Dozens of witnesses, it appeared, had claimed to have seen the ghostly figure looking down at them through the haunted window that day – presumably it was in fact the glass engraver, busily at work. The boss of the factory went out to try and disperse the mob, but they refused to go and began hurling stones through the window panes. Police were called in, and eventually the gathering was broken up – but still, ever afterwards, stray stones would come smashing through the windows from outside when nobody was looking, leading the management of the firm eventually to come to the conclusion that they had no other option than to board them all up.[80]

Such misperceptions still occur, even in the present day. As recently as 2010, a large number of visitors to the Walker Art Gallery in Liverpool city centre claimed to have seen a ghostly 'Hand of God' pointing down at an image of the baby Jesus in his manger in Mattia Preti's 1660 oil painting *The Adoration of the Shepherds*, which was then on display there. However, it seems that, in actual fact, there was a painting in another room in the gallery, entitled *There You Are!*, which consisted of a large National Lottery-style pointing hand daubed onto a wall. Through some freak chance of optics, this hand had been reflected back

through a glass door and onto Preti's masterpiece, giving the impression that God himself was pointing down at the Christ child. Again, there was nothing paranormal here, but it did cause people some consternation initially.[81]

Another supposedly 'miraculous' image that appeared near Liverpool in the past was reported on briefly in the *Transactions* of the British Association for the Advancement of Science in 1847. It seemed that, on the afternoon of July 28 1846, at about 3.00 p.m., two men in a Birkenhead park had looked up into the sky and witnessed a strange city floating up there, for around forty minutes in total, apparently being projected onto the clouds. Was this the mythical City of God spoken of by St Augustine and other religious mystics? Apparently not, as it bore a close resemblance not to Heaven but to Edinburgh. Bizarrely, it transpired that a panoramic model of Edinburgh was then on display at the Zoological Gardens in Liverpool, and that, through some weird quirk of physics, its reflected image had ended up being projected onto some clouds across the water on the Wirral.[82] This explanation, though, seems as far-fetched and hard to believe, as does the two men's original account of the matter …

However, no matter that most of these cases seem likely to be based upon nothing more than misperception and the peculiarities of crowd psychology, there are some instances of spontaneous images appearing on glass that are more difficult to explain. For example, the

The Walker Art Gallery, where hundreds of visitors claimed to have seen the 'Hand of God' during an exhibition in 2010.

strange case of what came by some to be known as 'Jesus in the Dishwasher', in which incredibly detailed religious pictures began appearing upon the drinking glasses of a Merseyside man named Cyril Legge in 1993, could reasonably be portrayed as being miraculous by those who honestly believe that God might wish to intervene upon our earth in this amusing and apparently unlikely way.

Mr Legge, then fifty-five and doing good work running the Margaret Roper House for the mentally ill in Birkdale on the edge of Southport, had recently gone on holiday to Kenya. While there, he visited the Portreas mental hospital in Mombasa, where he was saddened by the primitive conditions and treatment – patients were being kept naked, two to a cell, in small and squalid rooms. Back home in Birkdale, the devoutly Catholic Legge brooded upon his experiences in Africa, and began having odd dreams about the Catholic Cathedral in Liverpool. Things came to a head on Good Friday, however, when he was emptying his dishwasher. In his own words, he discovered that 'among the shiny, clean glasses was one dirty one. I held it up to the light and there was a clear image of a saint-like figure [on it]. Some say it is Jesus. I didn't know what to do, so I kept it in a box.'

Jesus Christ, or a very rude angel?

A few days later, when Cyril came to empty his dishwasher again, he found that a second glass – both of which came from the same set, bought from a local hardware shop around a decade beforehand – had another remarkable image upon it. This time it was a lion's head that appeared there on the drinking vessel in genuinely astonishing detail. He thought that it represented the Lion of Kenya, a national symbol, while others interpreted it as being the Lion of Judah, the traditional emblem of one of the Biblical twelve tribes of Israel. For his own part, Mr Legge believed that both images were a message from God, together with his dreams about the Cathedral, telling him to set up a fundraising committee in order to improve the lives of the patients in Portreas mental hospital, and other poor and underprivileged people in Kenya.

Given what has just been written about the faces on the glass at Harrington School and elsewhere, the reader will no doubt by now be highly sceptical about such a tale. However, having seen photographs of the images myself, I can confirm that they genuinely are clear depictions of what they were claimed to be. These are not amorphous blobs, which look vaguely like Christ and a lion if you squint a bit and look at them from a funny angle; they are more like the work of a professional illustrator than of mere chance. Admittedly, the figure of the man is more ambiguous than that of the lion – saying that it is Christ is a subjective statement to make, especially seeing as, in my view, the shape looks suspiciously as if it is holding up two fingers to someone with one hand, and going 'up yours!' with the other. In fact, if pressed, I would say that it looks more like an angel (albeit a very rude one) than an ordinary man, as such, due to the apparent wing-like protuberances upon its back. The lion, though, really is on a whole different level altogether; it genuinely is impossible to see it as being anything other than a lion, and a very well-drawn one at that.

Even a committee of ten scientists from Liverpool University who examined the glasses were impressed with what they saw – although, naturally, it didn't quite lead to their mass conversion to the Catholic cause. According to physicist Dr Ronan McGrath, the pictures both seemed in his view to be 'some sort of freak grease stain. The figure of Christ appears to be in layers, so some parts appear to be more opaque than others. The lion is interesting because of the detail – but I can't comment on the religious significance.' That, I suspect, is diplomatic scientists' code for 'It's a bit weird, but I don't think God did it'. To a man of faith He *might* have done; but I don't think that this can ultimately be finally proved.[83]

Either way, seeing as the discovery of the pictures spurred Mr Legge on to raise money for a very worthy cause, I think that splitting hairs about whether or not the lion came from God or from grease is rather missing the point of it all somewhat. Not only did Legge and his wife Barbara raise money to improve Portreas mental hospital after this supposed sign from above, they also helped to raise around £38,000 for other good causes in Kenya, under the auspices of the Rotary Club, and in 1999 set up a charity called Kenya Health Research Project (KHRP).[84] Never before has a humble dishwasher done so much good!

The human mind, it seems, is hardwired to find meaningful patterns in random images, and these apparently miraculously produced pictures (often termed 'simulacra' by connoisseurs) can be a real wonder to behold. As such, when they occur within a context where belief in their allegedly miraculous origin is genuinely held and encouraged, then they can very easily be interpreted by believers as being down to the Hand of God Himself. However, sceptical though this interpretation may appear, this is not to say that there might not have been some *genuine* miracles that have occurred on Merseyside over the years – as we shall see now ...

PART TWO

City of Faith: Merseyside Miracles

Liverpool nowadays perhaps isn't quite as religious a city as it used to be. The famous story about a piece of graffiti on a wall near Anfield saying 'Jesus Saves' being altered with the addition 'but Fowler nets the rebound!' underneath may or may not be true (in the 1960s this same story was being told with the name of Ian St John standing in for that of his fellow legendary Reds striker Robbie Fowler), but it does show how irreverence has largely replaced reverence in local people's attitude towards matters holy in the twenty-first century, a pattern that is mirrored across most of the rest of the country. However, it was not always so. The wave of Irish immigration into the city in the mid-nineteenth century, mentioned earlier, led to Liverpool becoming one of the main centres of the Catholic faith in England, and the fact that two of the largest and most modern cathedrals in the country are situated there (both of them built in the twentieth century) indicates that there are still a substantial number of Merseyside residents who take their faiths seriously. Given this, it is not perhaps too much of a surprise to learn that several allegedly miraculous events have supposedly taken place in the region, both holy and secular in their nature. Some of them, unlike the faces in the windows at Harrington School, are even worth taking seriously. In this chapter we shall examine a few of the more remarkable of them.

1

Satan Lives in Bootle

Teresa Helena Higginson was one of the oddest people in Merseyside history. Not content with being persecuted by Satan, she was also a stigmatic, claimed to have had visions of the Virgin Mary, angels, demons and Catholic saints, and even said that she had married Jesus Christ himself – and all of this while still a humble schoolteacher living in a small house in Bootle.

Born in Holywell, Wales, on 27 May 1844, Teresa was raised by obsessively Catholic parents who named her after two famous saints – St Helena, who is said to have found the remains of the True Cross, and St Teresa of Avíla, the famed visionary ecstatic who was supposedly able to levitate. Apparently, the Victorian Teresa took after her medieval namesake in several important ways.

It was when aged ten, and sent away to study with nuns at the Convent of Mary in Nottingham, that Teresa first began to experience the supernatural. While there, upon several occasions the entire convent began to be, in Teresa's own words, 'shaken to its foundations' so loudly and violently that 'the whole building seemed to have fallen in'. No cause could be found for these strange events, which led all the pupils and nuns to flee outside, but when the Devil came to her in Liverpool years afterwards, he is meant to have caused similar phenomena, something that caused Teresa to conclude in later life that he had actually been persecuting her since childhood.[1]

It was also while living in the convent that Teresa showed the first signs of developing some kind of bizarre religious mania. At night, once the dormitory lights were out, the young girl delighted in mortifying her flesh by lying down on top of a sack hidden beneath her bed. This sack she kept filled with a variety of sharp objects like knitting needles and tacks, so that they would stick into her body and cut her. In this way she hoped to prove her devotion to God and to Christ. One time, she even went so far as to pull some red hot cinders from out of a fire and drop them down her dress, setting herself ablaze. However, once she made the sign of the cross over the flames they instantly put themselves out – so she said.[2]

In 1865, aged twenty-one, Teresa left the convent and went back to live with her family, now based in St Helens. Soon, they moved to Liverpool, when her father, Robert, went

bankrupt after making some disastrous investments in the cotton trade. Forced by this financial misfortune to go out and make their own living, Robert's three daughters took on a variety of jobs. One of them, Louise, entered the Convent of Notre Dame Training College in Mount Pleasant to train to be a teacher under the instruction of the nuns, another, Frances, gave music lessons, and Teresa became a seamstress, wandering around shops and convents in search of work. It was only by chance that, in 1871, Teresa set out upon the path that would lead to her becoming a schoolteacher.

In this year an epidemic of smallpox broke out across the country, killing 42,000 people; it was particularly severe in Liverpool. Bootle was one of the worst-affected areas, and many of the schools there had to be closed down due to many teachers dying or quitting, not wanting to become infected by the children. One Bootle school threatened with closure was St Alexander's and, in desperation, the school's head, the Revd Edward Powell, went to the nuns at Notre Dame and begged them to give him someone to teach his classes. Sister Mary Philip, the Mother Superior, said that they had no qualified teachers to spare. However, she had heard of Teresa's natural way with children from her sister, who had previously trained at the convent, and recommended that he take her on to do the job, despite her having no qualifications. In that more innocent – and sensible – era, Powell agreed, and so it was that Teresa found herself standing in front of a blackboard for the first time. Apparently, she was a great success (her energetic classroom impressions of steam trains being particularly popular) and, once the smallpox crisis was over, she sat her teaching exams before taking up a post at the Orrell School in Wigan in 1872. She must have been good at her job, as by 1873 she had already been promoted to the role of headmistress at St Mary's School, also in Wigan.

School heads back then were not as well paid as they are nowadays however, as throughout her stay in Wigan she had to share not only a room, but also sometimes even the same bed, with another teacher, Susan Ryland. Susan came to St Mary's in late December 1873, moving into the tiny schoolhouse attached to the establishment with Teresa. The first inkling Miss Ryland had that there might be something a little unusual about her new boss occurred around two weeks after she had first met her, when she found Teresa lying unconscious on the floor, a condition that lasted for hours. A priest was called, and was able to revive her simply by splashing her with Lourdes water, a fact that suggests that these strange fits were essentially psychological in their nature. Eventually, Miss Ryland just got used to Teresa undergoing these odd trances, in which her body would either become 'quite rigid' and 'almost impossible to move', or else would appear supple while she underwent spasms of intense joy or sorrow.

Frequently, Teresa saw visions while in her trance states. Often, she said, Jesus arrived to speak to her, and even Louise Lateau (1850–83), a well known contemporary Belgian stigmatic, popped in for a chat. The Virgin Mary saw fit to stop by too, and, judging by the fact that Teresa would sometimes express a look of great fear and begin wielding a crucifix at something invisible in the room, so did some demons. While this was all going on, however, although Teresa clearly thought that she was speaking to somebody or other stood there before her, Miss Ryland and other witnesses could see nobody else present in the room to account for it.

At this point, alarm bells will be going off for the reader. Obviously, Teresa was just a madwoman – wasn't she? Maybe not. While her visions might seem suspicious, certain minor physical miracles were supposed to have happened in Teresa's presence, as well –

and these *were* actually witnessed by her companion Miss Ryland. For instance, Teresa was apparently able to make certain items magically appear from out of nowhere, in response to household need. One day, for example, there was no soap in the house – so Teresa put down the amount of money needed to pay for some on the table and, seemingly, a pound of soap then appeared there suddenly from out of nowhere in response as soon as Miss Ryland had turned her back for a second. Another time, Susan opened a cupboard in order to get some firewood – but, like cupboards so often proverbially are, it turned out to be bare. Teresa asked St Joseph to send them some, and told Ryland to look back inside the cupboard again. Allegedly, it was now full of wood. Another time, after the key to the front door of the school had been lost, Teresa got down on her knees to pray for its safe return – only to then see a white hand appearing from thin air and placing the missing item down in front of her. Once, she simply made the sign of the cross over a pile of cold cinders in the hearth in order to make them burst up instantly into flames. She was also able, on numerous occasions, to display abilities of clairvoyance (seeing distant events psychically).[3] Some of these things could obviously have been faked – but others do seem a little hard to explain, at least if recorded accurately.

It was also while teaching at St Mary's that Teresa's persecution by the Devil began. According to her, when she rose after midnight to pray, Satan would appear and 'beat and ill use' her body, before beginning to 'spit horrible filth upon me in the face and eyes, in fact completely cover me, which made me very sick, and the stench was almost poisoning.' At other times he would drag her out of bed, throw objects at her, make loud noises, imitate the crying of a child and create a smell of burning and brimstone. Sometimes, Teresa said that she could actually see the room around her being consumed by flames and smoke, though this proved to be just a demonic illusion. Normally holy water was enough to frighten off the Arch-Fiend, but once he simply threw something at the bottle and smashed it.[4]

Again, it seems likely that there was a large hallucinatory component to these events – after all, Teresa said that she could sometimes see the Devil stalking her in the form of 'a fox, and sometimes as part a fish, part a fox, and part a pig, I mean a thing with a serpent's head and a fox's head and tail and a bird's wings and head with hooked bill' (something of which she apparently rather phlegmatically 'never took much notice')[5] – but the observant reader will have looked at the above record of 'Satanic' attacks and noted their similarity with some of the most commonly reported poltergeist-type phenomena. Was the 'Devil' here actually just a poltergeist, then? Whatever he was, his actions must have had some level of objective existence to them, as they were frequently witnessed by other people, and not just Teresa.

Nobody but Teresa ever actually saw Satan himself, but Susan Ryland could certainly hear him – or, rather, a disembodied voice of some kind – speaking and laughing. Twice, he opened the bedroom window and began conversing with some unseen companion he had with him. Teresa could see him doing this, Miss Ryland could not, but both heard him talk. Ryland could also smell the flames, which only her friend could see licking their tongues around the room.[6] According to her own testimony, Susan also witnessed 'a strange light on the wall sometimes on the bed and covering Miss Higginson's face' as well as hearing 'a rushing noise as if animals were in the room' in addition to 'footsteps, knocking' and voices of people 'speaking in an undertone,' and even seems to have witnessed Teresa's throat being throttled by unseen hands. She claimed that there were marks left on the bed as though an

Satan himself – in Teresa Higginson's estimation, at least.

attempt had been made to set it on fire, as well – she even said that she had seen some smoke coming from it.7 All of these are classic poltergeist phenomena.

Another poltergeist-like element came in the fact that Satan apparently enjoyed playing practical jokes, just like polts do. For example, several times a knock would be heard at the door, Teresa would get up to answer it, and then be punched in the face by the invisible hand of Beelzebub! Whether she was play-acting here or not, her face did actually swell up and turn black and blue upon one occasion after she said that she had been thwacked. Another time, the sound of a crying child was heard coming from inside the school. Thinking that a pupil had been locked in there somehow, Teresa ran in and turned the place upside down looking for him, only to have the distressed wailing turn into peals of 'mocking laughter'

once it had become apparent that there was nobody inside – nobody other than the Prince of Darkness himself, that is.[8]

The most important thing that happened to Teresa in Wigan, however – in a spiritual sense, at least – was that she began suffering from the wounds of the stigmata, and then got married to Jesus Christ himself. These wounds – a series of spontaneously-appearing bleeding sores corresponding to the nail wounds of Jesus upon his cross – first manifested themselves during Passion Week, 1874. On Good Friday, Teresa was found stretched out on her bed with her limbs spread in the shape of a cross, with wounds in her hands.[9] Events culminated on the Feast Day of the Sacred Heart, when Jesus appeared to her in a vision and placed a small ring, in the form of a crown of thorns surmounted by a cross, on her ring finger. Teresa Higginson and Jesus of Nazareth were now, spiritually speaking, man and wife. She had undergone the most treasured of all signs of holy acceptance, that of the 'mystical marriage' with Christ, as previously experienced by other historical female Catholic mystics like St Catherine of Siena (who is said to have accepted Christ's severed foreskin as a makeshift wedding ring!). In Teresa's view, the ring on her finger symbolised the holy burden of the stigmata that she would now be expected to carry for life.[10]

In 1879, a vacancy arose at St Alexander's School in Bootle, where Teresa had first learned to teach, and she was offered the post by her old benefactor, Father Powell. This she 'joyfully accepted', and began working there again on 20 September. Initially she lodged in the house of a Mrs Nicholson and her fourteen-year-old daughter, Ellen, right next to St Alexander's church (now no longer there, having been bombed out by the Luftwaffe). Here, it seemed that many strange things continued to occur, not that this phased young Ellen much. Apparently, being a recent convert to the faith, she thought that all Catholics were afflicted in such ways! Teresa's fits and trances persisted, too, as did her stigmata – her bleeding being, upon at least one occasion, noticed by the pupils in her classroom.[11]

In July 1882 Mrs Nicholson died and, at the invitation of three of her fellow teachers, Minnie and Kate Catterall, who were sisters, and Miss Elizabeth Roberts, Teresa went to lodge in the house of a Mrs Joanna Flynn at 15 Ariel Street, Bootle. It was while living here that the most extreme demonic persecutions yet began to occur. A letter of testimony from Kate Catterall describing the events of one week in August 1883 provides a good indication of the pandemonium that was occurring in Teresa's presence in the Ariel Street lodging house, and is worth quoting from at length.

On the evening of Sunday 19 August, says Kate, she was disturbed by a knocking, which she initially thought was coming from the house next door. However, this was then followed by the window in her room rattling and a loud noise coming from the landing, succeeded by a rustling that passed through her room towards the window, which was then 'shaken so violently that I felt it would either fall out or be shaken to pieces' – all on a night when there was 'no wind' says Kate.

On Tuesday 21 August, Kate heard a 'terrible' noise coming from inside Teresa's room, 'which sounded like a loud clap of thunder and seemed as if it would shake the room down', followed by 'a loud knocking as of furniture being broken to pieces in one corner'. The girls asked Teresa to come in and sleep with them for safety, but she refused. The night after, Satan could apparently be heard assaulting Teresa in her room. Kate heard 'blows given with great force', followed by the sound of her head being bashed down against the floor several times. The force of these knocks was so loud that Kate thought that the floor might

Minnie Caterall is tormented by the Devil in her own bed. Or was it actually a poltergeist?

fall through. Satan's assault then culminated with the 'most terrible and piercing screams and sounds of someone being dragged across the room towards the door and struggling and pushing at it as if to get out' before coming to an end with a sudden 'fiendish yell', after which all was silence.

Two days later, the Devil followed Teresa to school, which must have livened up her lessons somewhat. According to Kate, that afternoon a noise as if the blackboards in the room above her were being 'continually dragged about' could be heard. Kate went to see what was going

on, but both teachers upstairs denied that they had been moving anything, and said that they had heard nothing. However, from downstairs the noise could still be perceived quite clearly, being so loud that it shook the classroom partitions. Kate's pupils could hear it too, and it continued when the school was empty of kids during playtime. Sometimes it sounded like 'the low growl of some wild animal', at others 'a rumbling of thunder' or, as one child put it, like 'they are rolling something on the floor upstairs'. That night, back at her lodgings, Miss Catterall was then assailed by a horrifying stench of sulphur and 'something else, I cannot describe what', which only made her day even worse. Just a typical week, it seems, when you're lodging in the same house as the Lord of Hell himself.[12]

Minnie Catterall backed her sister's testimony up in her own letters, even adding in further sensational details such as the time that she heard the Devil 'walking with a tremendous foot on the landing and wriggling the handle of the door most dreadfully; and again, as if someone suspended over the door of Teresa's room was laughing and screeching with the most hideous and fiendish laugh'. Perhaps most disturbingly, she said, she had just settled herself down into bed one particular night, when 'suddenly I felt the warm breath of a huge crawling beast coming stealthily towards my hand with its tongue and large teeth'.[13]

Elizabeth Roberts, too, agreed with the two sisters about what had gone on at the house in Ariel Street. Mrs Flynn, the landlady, even claimed to have been levitated and attacked by Satan one night while sharing a bed with Teresa; according to her, she 'felt [her]self raised up from the bed and almost suffocated' before being rescued by her lodger telling her to make the sign of the cross and say a Hail Mary. Mrs Flynn did, and all returned to normal.[14] Even Father Powell, Teresa's headmaster, experienced strange things in the lodging house. After being fetched out by the terrified women after they had heard 'a noise as if a person sawing' in their bedroom and then 'a long mocking laugh like [it was] descending the musical scale' coming from the top of the stairs, Powell stood there in fascination as he heard an exaggeratedly loud crash, 'as if a body had been dashed to the ground', which shook the ceilings and windows, followed by a sound indicating that Teresa was being dragged across the floor and her head being smashed down into it repeatedly again.[15]

Even though she was being followed around by Beelzebub, however, Teresa was still popular with her pupils as, when they were suffering with small ailments such as toothache and earache, Teresa reputedly only had to touch them lightly with a crucifix to cure them. Once, she is said to have caused the thick red weals that had been inflicted upon one child's back by a rather overenthusiastic caning to instantly disappear simply by touching them. Even more bizarrely, this strange woman was even able to open drawers by a kind of 'holy remote control'; supposedly, Teresa only had to make the sign of the cross over them to make them shoot open of their own accord. All the while her visits from Christ and other assorted holy figures, as well as her sufferings with the stigmata, continued unabated. Indeed, so frequent were her divine ecstasies that eventually Teresa's fellow lodgers began to pay them no notice, 'She's off again!' being their only comment about it all.[16]

So, given all of these miraculous events that occurred in her presence, no doubt Teresa Higginson is by now considered to be one of the major saints in the Catholic canon, right? Wrong. In fact, she is not even a saint at all. While Canon Alfred Snow, her spiritual director for over twenty years, felt compelled to say that he had a 'firm conviction that Teresa was not only a saint, but also one of the greatest saints',[17] it seems that the Catholic Church itself disagreed. Teresa's cause for canonisation was taken to Rome in 1937, more than

thirty years after her death in 1905, but it only reached the stage of her being declared 'Servant of God', which is some way short of full sainthood. On 21 February 1938, a letter was received by her supporters from the Vatican declaring that her case for sainthood had been declared '*non-expidere*' – meaning that, while it had not been rejected outright, it had not yet been totally accepted, either. Now, over seventy years later, this still remains the case. Apparently, in the eyes of the Catholic Church there still needs to be some kind of 'major miracle' that can definitively be attributed to the intervention of Teresa before full sainthood can be conferred.[18]

At first sight, this seems odd. Haven't we just read about miracles galore happening? Maybe so, but this doesn't necessarily mean that the Catholic Church totally accepts them all as being genuine events. But why not? Was there something suspicious about them? Sadly, yes. Let us look firstly at Teresa's wounds of the stigmata. How real were these? The main source for material about Teresa's life is a little vague on this particular point, but I am reasonably sure that nobody ever actually saw these wounds *forming* upon Teresa's body (although blood was seen to flow from them upon several occasions, once they were already there).[19] For example, according to Susan Ryland's written testimony about the initial attacks of this malady, the appearance of the wounds on Teresa's hands was only at first inferred by her due to the fact that, when Teresa handed her a towel in the morning after washing her hands, it was spattered with blood. Susan herself admits that she 'did not examine' Teresa's hands at this point though, being, as she put it, 'strangely wanting ... in curiosity about these things'. Additionally, during this early period Teresa was getting up of a morning with her hands closed and her thumbs packed tightly inside her fists, as if hiding something, perhaps. While there were certainly wounds on her palms, then, there seems to be no proof that she didn't just dig them in herself with her nails or some other sharp implement, unseen.[20]

Is this a fanciful supposition? Not necessarily. Numerous allegations have been made about stigmatics 'helping their wounds along' in the past. The idea of 'pious fraud', as it is known, taking place in the case of Teresa Higginson does not necessarily mean that she was *consciously* faking her wounds, however. In her insane desire to imitate Christ, she could well have done so entirely without knowing it; she probably won't have set out to intentionally deceive anybody other than herself. On the other hand, Teresa's wounds were not merely trifling ones. Could she really have inflicted them upon her own person without screaming out in pain? And, if so, then how would she have gone about it?

Well, we will recall that, even as a child, she used to lie under her bed and intentionally stick sharp objects into herself. Apparently, she carried this childhood habit on into adult life. In one letter to her spiritual director, for example, Teresa openly admits how she liked to badly mutilate herself in order to please Christ, something that she began to do aged twenty-one. The details are not for the squeamish:

> I at first wore a cloth (in which I put twisted wire and tacks) but it was continually breaking, and I began to use a pair of goffering irons made red hot to burn myself and which I found very effectual, for when they would not really burn they would sear, and this I used in every part of the body that was not actually exposed to view. When I had a very sore burn I used to put on some cobbler's wax on a piece of leather which I had for the purpose, and once I had two large holes in which I used to pour turpentine. Two or three times when I had

crushed toes and felt them sore, I pulled off the nails by wedging in small splinters and so dragged them out. Then another time I saw some of the small wire cloth that I told you of and I got a small piece and wore it round my arms, then I procured enough for the waist, but I think the heat and discharge from the sores rotted it, for it broke into small pieces.[21]

Teresa certainly had the capacity to withstand extreme pain, then – and, indeed, the ability to keep her activities secret from the people with whom she lived.

She was telling the truth about all this, too; according to Father Powell, his weird employee came to him one day and begged for permission to go and brand herself with a hot iron. After she had informed him about her self-mortifications, Powell was intrigued to see whether her claims were just exaggeration, and very kindly told her to go ahead. The next day, he would surprise her by asking to see the burn, perhaps half-expecting to find out that she was lying. However, she was not; she lifted up her arm to him and displayed a 'ghastly wound' just above the wrist. One time, she was forced to extract a wire belt from her stomach due to being ill, and it took her three months to eventually get it out – something that she did by the rather counterproductive method of boring great holes into her flesh and then filling the wounds with vinegar and salt. To make life even more unpleasant, at one point she took to only eating rotten eggs and putrid, decayed food, all washed down with some foul and dirty water that had previously been used for washing gutted herrings in.[22] Given these undeniable talents for senseless self-mutilation, it is not unfair to say that producing the wounds of the stigmata on her palms would have been a cinch for Teresa, by whatever means.

Indeed, it is also fair to say that many local people at the time did not believe a word that Teresa said, branding her a 'lying hypocrite'. Others attributed it all to mere 'hysteria', meanwhile, and some of her symptoms – such as the bouts of paralysis and unconsciousness – do indeed make this a plausible enough diagnosis for the time.[23] There can surely be little doubt that her visions were essentially delusional and self-created, too – after all, none of them were actually witnessed by anybody else who was present in the room with her. This just really leaves the visitations of the Devil as being evidence that anything genuinely paranormal was actually going on here at all, then.

Some of these are a little suspicious too, though. For one thing, many of the loud noises, as if Teresa was being beaten up and dragged around the place, occurred when she was in her room alone. Given what we have just seen she was capable of, perhaps she might simply have been play-acting – albeit sincerely – during these episodes, rather than genuinely being beaten up by Satan. Furthermore, some of the things that the Devil is meant to have done to Teresa occurred when people's backs were turned, or their attention otherwise occupied. Look, for instance, at the following piece of testimony from Susan Ryland: 'I found the holy water stoop and bottle broken in a strange manner. I did not see it done. I have never seen Miss Higginson thrown out of bed, I have found her almost out and unable to replace herself … I saw, though indistinctly, because of the dark, things thrown at her … I found water which I left by her for the purpose of washing her thrown over her. I did not see it done.'[24] Clearly, all these events *could* have been faked.

However, perhaps we should not be too hasty. After all, certain of the events, particularly the strange noises and rattling windows, were experienced by several other independent witnesses too. You cannot just dismiss their testimony outright. Furthermore, the fact

that objects generally are not seen at the start of their flight or actually being broken, is frustratingly typical of many genuine poltergeist hauntings, suspicious though this may seem. As mentioned earlier, Teresa's demonic torments do seem to have been very poltergeist-like in their nature; so maybe that is what we should put these particular elements of the case down to. But what would a poltergeist want with her?

Actually, there is a long history of Catholic saints and mystics being persecuted by invisible spirits – of the type that they once termed demons, but that we now call poltergeists. St Godric, to give but one example, was plagued in his hermitage by mysterious showers of stones and had objects thrown at him, as well as undergoing the indignity of having Mass wine poured over his head by invisible hands – at least according to his biographer.[25] There are numerous other instances that I could cite, but the question of why saints should find themselves being so bothered by spooks is at first sight quite a puzzling one. One possible answer, however, may come in the modern theory that poltergeists are not actually the spirits of the dead at all but, rather, the temporarily exteriorised forces of the human mind. This theory is often referred to in terms of being something called 'RSPK', or 'Recurrent Spontaneous Psycho-Kinesis', this latter phrase referring to the alleged ability of people at the centre of poltergeist disturbances (often termed the 'focus') to move objects around, etc., purely with the power of their minds. The classic profile of a focus-figure would generally be a teenage girl going through puberty, with all of its attendant personality issues. What is meant to happen, supposedly, is that these mental disturbances and imbalances become manifest outside the body somehow, in the figure of the 'poltergeist', as some kind of unconscious cry for help from the poor confused mite.

However, not every focus is a teenage girl. Many poltergeist victims are, shall we say, a little 'unbalanced' in their nature or, indeed, outright hysterics (although, equally, most are not). Given what we know of Teresa so far, it seems safe to say that she, too, could be classed as being a little disturbed, given that she deliberately poured turpentine into her wounds, enjoyed drinking fish guts and thought that she was married to Jesus. Many of these focus-figures, furthermore, seem to be subject to involuntary lapses into altered states of consciousness while they are being persecuted by their polts. Indeed, frequently, the very worst outbreaks of ghostly phenomena often coincide with the exact periods when they are in trances or suchlike. As a result, some theorisers have hypothesised that poltergeist hauntings are largely a result of these states of altered consciousness, providing a kind of spontaneous psychic outlet for a focus-person's inner psychological issues.

Perhaps the fitting so often experienced by focus-figures is the same basic kind of strange fit that has overcome many saints, visionaries and ecstatics, too – including Teresa Higginson. Maybe, if this kind of theory proves to be correct, Teresa's fits were responsible somehow for releasing 'the Devil' out onto the streets of Liverpool, then. Furthermore, there is the fact that many of Satan's visits were paid at night, while the people in the house were preparing to go to bed. Again, this is a classic poltergeist pattern of behaviour and is explained by some as being possibly related to the altered states of consciousness that we all undergo immediately prior to falling asleep. The fact that Teresa could apparently sometimes control Satan's visits – in one of her letters she speaks of having stopped the Devil's appearances temporarily so that her housemates could get some peace, for example[26] – is further tantalising evidence that she herself may well have been in some sense ultimately responsible for them.

But, if this interpretation is correct, then why did the ghost come disguised as the Devil? One obvious answer is just that this is the form that Teresa, being a religious hysteric, would naturally have expected any supernatural assailant to take against her. Another clue, however, can be found in the fact that she was reading a biography of the Curé d'Ars at some point while living in Mrs Nicholson's lodging-house – she must have been, as she lent it to her daughter Ellen.[27] This book was presumably Alfred Monnin's *Life of the Curé d'Ars*, first published in English in 1862. The text tells the quite remarkable tale of Jean Baptiste Vianney (1756–1859), a very bizarre French priest who shared many characteristics with Teresa. He, too, underwent various processes of religiously motivated self-denial and hardship, while working in his parish in the remote French countryside – and he, too, was constantly persecuted by the Devil.

The main way in which Satan manifested himself to the Curé d'Ars bore great resemblance to the way that he manifested himself to Teresa Higginson; namely, he would produce a series of loud sounds from nowhere, just like a poltergeist. Apparently, the Curé, who nicknamed his persecutor 'Grappin', would typically be 'awakened at midnight by three loud knocks which betokened the presence of his enemy' before a 'horrible noise' would be heard on the staircase, together with much else.[28] At other times, meanwhile, 'The presbytery is turned upside down, the doors slam, the windows rattle, the walls shake, and fearful cracks seem to betoken that they are about to fall prostrate.'[29] Sound familiar at all?

The fact that these noises persecuted the Curé most often around bedtime is another similarity between the two cases. Yet another parallel comes in the fact that Satan used to attack the Curé in the same fashion in which he allegedly assaulted Teresa; according to him, while he could not see the Devil, the demon several times tried to throw him out of his bed onto the floor and even attempted to kill him.[30] A further similarity comes in the Curé's apparent ability to magic up miraculous provisions from out of nowhere; supposedly, he could make wine and bread last long beyond the natural point at which they should have ran out, like Christ feeding the five thousand, and cause money to materialise in response to his own and others' needs.[31] Teresa, of course, is meant to have done this kind of thing with soap and wood, too.

There is even one strange series of events in Teresa's life that seem to have been directly modelled upon a particularly peculiar phenomenon that persecuted the Curé. Namely, accusations were made against Teresa that she was secretly eating meat when she was meant to be on a fast; once, some flesh was found floating in a cup that she had just been using to gargle her throat out with, and, on another occasion, some bread and meat was discovered in her provision box.[32] This whole episode bears startling resemblance to the fact that, supposedly, pieces of meat would keep on materialising inside the Curé d'Ars' saucepans on designated abstinence days, too.[33] He said it was the Devil who was responsible for this morally compromising fact.

Teresa was apparently highly suggestible in such things. For example, Louise Lateau, the Belgian stigmatic mentioned briefly earlier, was in the news around the same time that Teresa herself was undergoing her fits and visions. Louise too bore the wounds of Christ, went into trances and fugues, fasted constantly and was meant to have had the power of clairvoyance. As such, it seems likely that Teresa's knowledge of this case ultimately influenced the form that her own religious experiences ended up taking. Probably, it was the same with Monnin's book about the Curé d'Ars; if she had not read this, then would the Devil's torments have

taken the form that they eventually did for her? Possibly not. The fact that her headmaster, Father Powell, had actually met the Curé, having gone on pilgrimage to see him in France, must also have made a great impression upon Teresa. When Powell saw this magical man and told him how he had prayed and fasted for the good of his parishioners, then asked him why it had all done no good whatsoever, the Curé simply looked down at him and asked nonchalantly 'Have you tried blood?' (more Christopher Lee than Christian, perhaps …)34 When Powell died, he was found to have been wearing a hair shirt; so it seems that, throughout her life, Teresa was surrounded by highly religious types who would probably only have encouraged her extreme beliefs and mystical inclinations.

Maybe this is why, by her own admission, Teresa actively *wanted* to be tormented by demons; she prayed and 'besought my beloved Jesus and Mary to allow the Devil to torment me', apparently. Evidently these prayers worked as, she said, Satan and his imps then

> rushed upon me and said they would burn me with a fire, a liquid fire, a fire that would burn forever and never consume. Then I felt every part of my body cringe and curl as it were with a scalding burn which seemed to saturate through the bones to the very marrow; then grasping hold of the throat they nearly strangled me, and I perceived again the horrible stench of those sins the punishment of which … [I had been] given the leave to suffer.35

The Curé d'Ars, too, began to 'rejoice' in his persecution by demons, and to desire its continuance; he felt that, somehow, it all betokened 'an approaching harvest of souls' for God.36 By actively desiring Satanic persecution in this way, both strange mystics hoped ultimately to prove their love of Christ and to dispel their exaggerated and unnecessary sense of guilt about the way in which they had lived their supposedly 'sinful' lives. If both the Curé and Teresa wanted to be sinners so that they could then be punished for it, then maybe the poltergeist phenomena that followed them around was just another weird kind of self-torment by another means?

Certainly, the public mockery and spite aimed at both mystics as a result of their paranormal experiences was actively enjoyed by each of them, backing this view up further. 'Oh, how glad I was,' said the Curé one day, 'to see myself thus trampled underfoot by all men, like the mud in the streets! … I rejoice in the Lord at all that can be said against me, because the condemnations of the world are the benedictions of God.'37 Meanwhile, so many accusations of impiety were made by people against Teresa Higginson that she eventually concluded that the Devil must have been going around and deliberately impersonating her purely to blacken her name in the eyes of the public!38 Seemingly, Teresa just used to take all of these accusations quite meekly, and made no real attempt to defend herself against the tirade of abuse and calumny – it was just yet another painful cross for her to happily bear in the name of the Lord.

Eventually, though, the controversy surrounding her in Bootle grew so great that her headmaster, Father Powell, was removed from the parish of St Alexander's and Teresa herself dismissed from her job at the school. Unable to find further employment in Liverpool, she eventually left and spent the next twelve years of her life in retirement at St Catherine's Convent in Edinburgh.

There are other stories told about Teresa's miracles, but they are something of a mixed bag. Particularly laughable is the claim that she was able to attract herds of sheep to hear

her preach in the fields simply by saying 'Jesus!' out loud to them,[39] and tales of her alleged ability to engage in acts of bilocation (being in two places at once) seem a little suspect, too. According to her, she was able to send her soul out to act as a missionary in Africa while her physical body was safely at home in Bootle.[40] However, seeing as the only real evidence that this happened is that she said it did, we can probably discount this episode as being mere fantasy. The further fact that, once again, Teresa's accounts in this respect sound suspiciously similar to claims which had been previously made by another famous Catholic mystic – in this case Sor Mariá de Jesús de Ágreda, a seventeenth-century Spanish nun who is supposed to have bilocated herself to South America in order to convert the natives while actually being locked up inside a convent in the Old World – also suggests that, while not lying exactly, her subconscious mind was able to work out its fantasies based upon pre-existing life models from Catholic history, something in which she was no doubt steeped. Her famous account that, one day, while looking after a church in a priest's absence, she encountered a 'ghost-priest' who resupplied her with wicks and said a personal Mass for her, even going so far as to give her the Communion Host, likewise has no witnesses other than herself and can also probably be discounted.[41] Further claims that while living in Edinburgh in old age she predicted the First World War, simply because she spoke about her visions that in future conflicts people would fight in the air and under the sea, are similarly vague and hard to substantiate.[42]

As for the end of Teresa's long tale, she returned home from Edinburgh to Neston on the Wirral, where her family were by now living, in July 1899, when her sister became ill. After her sibling had recovered, Teresa went to live in the Mount Pleasant area before, remarkably, coming out of retirement and taking up one final teaching post in the Devon village of Chudleigh in 1903. Here she caught bronchitis and died, of the after-effects of a stroke, on 15 February 1905. Her family brought her body back up to Neston, where she now lies buried peacefully in the graveyard of St Winefride's church. She might not have been a saint, but Teresa Higginson is undoubtedly worth remembering nonetheless. After all, how many other people can claim that they once had the Devil for a housemate?

2

A Sight for Sore Eyes at Winwick's Holy Well

Winwick, a small village three miles north of Warrington, is well-known across Merseyside for one thing only – its Victorian mental asylum, which finally closed its doors for good in 1997. For years, anyone who did or said anything odd could be threatened with the phrase 'If you're not careful they'll take you away to Winwick', and what this meant was instantly understood. Perhaps the place should be known for something other than this, however – for, in a field on Hermitage Green, about a mile or less from the parish church of St Oswald's, lies a well, made holy by a saint, that is meant to have miraculous curative powers.

St Oswald (*c.* 604–642) was a Saxon king, the son of King Æthelfrith, who spent most of his youth in exile in the old Scottish-Irish kingdom of Dál Riata, after his father had been killed in battle in around AD 616. It was while in Scotland that he was converted to Christianity, a religion that, following the defeat of his rival ruler Cadwallon ap Cadfan, the King of Gwynedd, he did his best to spread throughout the reunited kingdom of Northumbria, which in those days extended right across the north and north-east of England. Apparently, prior to his defeat of Cadwallon at the battle of Heavenfield, near Hexham, Oswald had a vision of St Columba, who told him that he would be victorious. Telling his nobles of this experience, they are all said to have agreed to be baptised into the Christian faith if the prophecy should come true. It did, Cadwallon and his Britons being roundly defeated in spite of their superior numbers, and so it was that Christianity began to spread again in the north of England, where it had previously been in decline.

According to the Venerable Bede, the monkish forefather of all English historians, Oswald lived like a saint even in power, being generous in terms of doling out food and alms to the poor. Eventually, however, Oswald was killed in 642 while fighting Penda, the ruler of the pagan kingdom of Mercia, at the battle of Maserfield. Most people identify the site of this battle as being in Shropshire, somewhere near the appropriately named town of Oswestry, but an alternative location sometimes claimed for this event was Winwick. Frustratingly, Bede is vague about where exactly Maserfield – or *Maserfelth*, as he originally has it – was, giving legend-mongers much scope for speculation. Some say that it refers to the modern district of Makerfield, which is indeed rather closer to Winwick than it is to Oswestry.

Either way, Bede tells us that Oswald quickly came to be regarded as a saint, a view only enhanced by the fact that the spot where he died – wherever that may actually have been – soon became associated with miracles. People began to dig up the earth from the ground where he fell, it is said, eventually digging down a hole as deep as a man's height, which exposed an underground spring and lead to a well being formed there. Another legend, meanwhile, states that after his death a bird flew down from the sky and picked up Oswald's severed right arm, took it up into a tree and then dropped it to the ground, a spring suddenly forming from the spot where it landed. The name of Oswestry, indeed, is usually said to come from the words 'Oswald's Tree', perhaps backing up the location's claim to be the true site of Oswald's death, rather than Winwick. (Some say that the bird pecked out Oswald's eye and dropped that to create the spring, though, thereby accounting for the water's subsequent reputation for being miraculously able to cure eye diseases). These curative miracles, confusingly, were subsequently spoken of as occurring both at Winwick and at Oswestry.[43]

Whatever the truth of all this, there are certainly holy wells at both places, and the association of Oswald with each of them appears to be very old. St Oswald's church in Winwick, for instance, seems to date in places from the early thirteenth century, although additions and alterations have been made to it at innumerable points since.[44] While a date frequently given for the main building's completion is 1358, the Legh Chapel part of it is definitely older, and it appears that an earlier stone church once stood on the site – as, if rumour is to be believed, did some form of ancient pre-Christian structure. However, a church of some kind must have stood on the spot way prior to the 1350s, as its first recorded rector was the aptly named Hugh de Wynewhick, in 1192. This is still more than 500 years after St Oswald's death, though.

On the west face of the church stands a restored statue of St Oswald, and there is also an inscription set in the sandstone wall, which seems to refer specifically to the place as being the site of Oswald's demise. While the statue of St Oswald, together with that of St Anthony, alongside whom he stands, was erected as recently as 1973, both the originals were much older, having been destroyed by Oliver Cromwell's men during the Civil War (his troops being stationed in the building after the nearby Battle of Red Bank in 1648).[45] The Roundheads didn't seem to touch the inscription, however, which is of much more uncertain age. However old it is, though, translated from the Latin into cod-Middle English, it reads thus:

> This place, O Oswald, formerly pleased thee greatly;
> Thou wert King of the Northumbrians, and now thou holdest the Kingdom of the Poles, [?]
> Having been martyred in the place called Marcelde. [Maserfield][46]

As for the miracles of St Oswald themselves, wherever they were meant to have originally occurred, Bede had the following to say:

> How great his [St Oswald's] faith was towards God, and how remarkable his devotion, has been made evident by miracles since his death; for in the very place where he was killed by the pagans ... infirm men and cattle are healed to this day ... many took up the very dust of the place where his body fell, and putting it into water did much good with it to their friends who were sick ... Many miracles are said to have been wrought in that place.[47]

Apparently, these beliefs about the curative powers of the well lingered on around Winwick for many centuries afterwards, one late nineteenth-century visitor writing in *The Antiquary* about how 'at the present day there are people who use the water as a cure for sore eyes' and of how 'certainly within the last twenty years' this liquid was used as holy water in the nearby Catholic chapels (St Oswald's itself by this time being an Anglican establishment).[48] The fact that the well lies on a site called Hermitage Green also speaks of the possibility that a hermit, some seeker after spiritual truth, perhaps, once lived on or near the site, looking after the holy place.

However, much of this history is suspect, and some scholars have questioned whether the miraculous well of Winwick actually has Christian origins at all. This idea can be made clearer by a brief examination of some of the legends surrounding the other St Oswald's Well, at Oswestry. Here, the methods spoken of for actually effecting a cure using the well's magical water are very strange. As late as the 1880s, it was believed that, if the water was going to work, you had to go to the spring at midnight, scoop some of it up into your hand and drink a little while silently making a wish for your cure, before then throwing the rest against a particular stone at the back of the well, which supposedly marked out the burial place of St Oswald's head. Should your aim be bad, however, and even the tiniest splash of water fall elsewhere, then God and St Oswald would not grant your wish – which sounds a little unchristian of them, frankly. Other, equally weird, methods for gaining some relief from your ills included wishing into a hole in the archway of the well's wall, throwing a stone into the water and making a big enough splash with it so that it soaked your head up above, or finding a nut from a beech tree with markings that looked like a face on it before then dropping this down into the water so that it landed floating face up and then counting to twenty; if the nut sank before that time, then your desire for health would not come true.[49]

These practices sound to the modern ear more like magic than veneration of the saints, which has led some folklorists to make claims about all such holy wells in Britain actually being originally shrines for the worship of ancient pagan river goddesses and the like, the association with Christian saints being a later ploy by the church to facilitate the country folk's conversion to Christianity. There are problems with this argument in the eyes of many modern scholars, but let us run with it in the case of Winwick's holy well. Is there any evidence that the site was once associated with ancient pagan water spirit worship?

As mentioned earlier, on the west face of the church, together with the statue of St Oswald himself, is another carved figure of a saint, this time St Anthony of Egypt – who is standing next to, of all things, a pig. But why is this porker here? The most common folk explanation speaks of a magic pig that disrupted the building of the original church. Apparently, the structure was at first slated for construction upon another site but, in the middle of the night after the initial foundation stones had been laid, the mystical pig came running along from out of the darkness (squealing 'wee-ee-wick, wee-ee-wick, wee-ee-wick'), and picked up the stones in its mouth before then transporting them all to the site where the church *should* have been built, namely upon the hallowed soil where St Oswald had met his end fighting for Christendom. Upon seeing the result of the pig's work the next morning, the church's builder saw the wisdom of the porcine vandal's architectural criticism, and built the structure in its present spot instead. Furthermore, the pig's cries of 'wee-ee-wick' were then modified and taken as being the new name of the parish in the clever pig's honour.[50]

This seems an odd legend initially (especially as to Bede it was the *well* and not the *church* that occupied the spot where Oswald met his end), but it is in fact only a local variant of a well-known international folklore motif, in which the Devil is said to try and stop churches being built by moving their foundation stones away to more inaccessible places. The general explanation for the popularity of this type of tale is that it was invented in order to account for church buildings sometimes being erected in out-of-the-way locales. Indeed, there is a variant version of the pig tale from Winwick, in which the pig is not holy, but actually Satan in disguise. Another north-west church, St Peter's in Burnley, once had a similar tale associated with it, in which the location of the 1122 church was determined by goblins and demons in the shape of pigs who took to shifting away the building materials to a different place in the locality every night.[51]

Yet another local legend, however, recorded by the noted antiquary Edward Baines, says that the animal represented on the side of St Oswald's was actually some kind of giant monster-pig that roamed the vicinity assaulting men and livestock and could only be stopped by having a holy edifice like a church built nearby. For his own part, though, Baines asserts that the pig on the wall in fact represents a crude attempt at rendering an element of the heraldic shield of a local family of nobles, the Gerrards, who have a chapel named after them inside the church – although, seeing as the Gerrard family crest features a roaring lion as opposed to a pig

The demon pig interferes with important building work.

rampant, this seems unlikely to me. The resemblance of the little piggy on the wall to a lion is scant to say the least.[52] As for the name of Winwick being derived from the creature's squeals, this charming idea, sadly, is wholly false; more reliable scholars, who don't tend to believe in helpful pig-sprites, think that it actually comes from the conflation of the Anglo-Saxon words W*ineacas' wic*, meaning 'the farm or dwelling of Wineca'. Unless this Wineca should turn out to have actually *been* a property-owning pig, which would be most unusual, it appears that the whole story, in whatever form, is entirely without basis.[53]

However, there is yet another legend concerning the pig, which has been taken by some as providing possible evidence for the notion that the holy well associated with the church was originally devoted to some kind of ancient pagan river-goddess. Joseph Pearce, in a small booklet he published about the history and legends of St Oswald's church in the mid-1930s, said that he spoke to a local resident named Alice Bytheway, who told him that the pig up on the wall next to St Anthony was, in actual fact, nothing less than a 'fairy-pig' called 'Peg with Her Golden Bell'. The tale attached to this helpful little Peg was much the same as the one ascribed to the pig above. However, Pearce professed to see great significance in the fact that the pig's local folk name was Peg. He said that Puck, that arch-fairy of the woodland, best-known to modern readers through his depiction in Shakespeare's *A Midsummer Night's Dream*, was once known as Peg in various places in the north of England. Furthermore, this 'Peg' was said to act like a brownie did in traditional English folklore, performing chores around the household and farm for its masters – and even, according to him, acting sometimes as a magical 'goblin builder', just like the Winwick pig had done. Furthermore, he noted that two northern river fairies or goddesses – Peg O'Nel of the River Ribble, and Peg Powler of the River Tees (perhaps a variant form of Jenny Greenteeth) – had similar names.

Because of this, implied Pearce, what we know nowadays as the well of St Oswald must at one time have been a well sacred to the fairies or local water goddesses, a fact that the early missionaries in the area tried to turn to their advantage by transforming Peg into a more acceptable and helpful entity in their tale of the church-building pig, intending, as he put it, to 'make good Christians out of the fairy spirits'. In fact, he even goes so far as to say that there is a carving resembling a mermaid somewhere in the church. This he suggests represents a 'fond memory' upon behalf of its creators for 'the lingering legends of the pixy goddesses of Roman and British Verantinium [the Roman name for Warrington]'. Actually, though, the mermaid was frequently used in Christian art as a kind of warning against both vanity and the dangers of unfettered lust and female sexuality, so we need not necessarily speculate that this image is a kind of half-pagan shrine to Jenny Greenteeth lurking half-hidden within the House of God.

And as for Peg's association with bells? Picking up on the fact that the carving of the pig on Winwick church seems to have a bell placed around its neck, Pearce speculates the following: 'Even as they [the early Christian missionaries] used Christian bells to exorcise demons, so perhaps they chained the bell around the neck of "Peg the Good Helper", giving him a new name, and incorporating him in effigy into the very walls of the Holy church for a new period of useful service here.'[54] All this, of course, is quite ingenious – although I personally feel that a more likely explanation for the carving being given the nickname 'Peg' by the locals is simply because it half-rhymes and proves alliterative with the word 'pig'!

Furthermore, the fact that the pig appears next to a depiction of St Anthony admits of a somewhat different explanation to that provided by Pearce. St Anthony of Egypt

(251–356) was one of the most significant of all Christian saints. A desert hermit, and one of the founders of monasticism, many famous legends have sprung up around him over the years, several of them involving pigs. For example, in some accounts he is meant to have once been a swineherd himself, before getting his call from God. Other people say that his association with pigs comes from the fact that in the past people used to pray to St Anthony to intercede for them when they had skin diseases and rashes – a more earthly cure was to apply pork fat to the affected area, which brought swellings down and helped to reduce itching. Thus, when he was shown in various artworks as being accompanied by swine, it seems likely that many people, unaware of the precise nature of the symbolism that was being referred to here, just thought that Anthony liked to hang around with pigs for some reason, and so it was that people who worked with these beasts took him as their patron.[55] Other commentators simply came to the conclusion that the pig was just a symbol for the Devil, whose temptations St Anthony had once so famously conquered while living alone in the Egyptian desert.[56] Whatever the truth of the matter, he is certainly frequently depicted in devotional art accompanied by a pig, so it appears highly likely that this is the real reason for the animal's appearance upon the church wall.

Why the bell around its neck, though? The probable explanation for this fact also lies with St Anthony – or, rather, with an organisation that he inspired, the Order of the Hospitallers

The Winwick Pig as it appears today upon the side of St Oswald's church.

of St Anthony. This holy body of men, founded around the year 1100 or so, wore black robes with a blue 'T-shaped' cross upon them and used to go around ringing little bells to attract alms. It seems that they also placed bells around the necks of the animals – including pigs – that they took with them for fresh food on their travels, in order to ward off disease and the evil spirits that were once thought to cause it. Therefore, as a result of familiarity with this group and their habits, it appears that artists began incorporating the black robes, T-cross, bell and pig into their depictions of St Anthony.[57] Whatever the real truth of how St Anthony came to be associated with pigs, though – and the wildly differing accounts given above suggest that perhaps nobody really knows – it is indisputable that he *is* associated with them in Christian art. Therefore, it appears to me that Pearce's speculations, while certainly interesting, are ultimately without basis. There is a pig on the side of the church simply because St Anthony is there too, not because of pagan river goddesses.

Tellingly, it is a fact that the statue of St Anthony that stands there on the west wall of St Oswald's church today was only put in place in 1973. The niche which he now occupies seems to have been left empty since the Roundheads' initial act of vandalism upon it during the Civil War. As such, for many hundreds of years, the pig stood up there all alone, with no explanatory saint to accompany him. Local residents will have wanted an explanation for this beast's puzzling presence to themselves, of course, and it appears that the various legends surrounding the Winwick pig were the best they could come up with.

All this, of course, is not to say that St Oswald's Well and its nearby church *definitely* didn't originally have their ultimate origin in practices of pagan worship in the area at some uncertain date in pre-history; but, almost by definition, we can have little idea what went on in most places during pre-history, let alone in the little parish of Winwick. It is certainly possible, I suppose, but remains essentially beyond proof, in my view. As for the alleged miracle cures, well, it is a matter of simple historical fact that people used to believe in their reality. Bede's original accounts may just have been early church propaganda aimed at getting more people to believe in the Christian religion, perhaps, but if so then it was propaganda that worked. The well is still there though, so, should you ever find yourself suffering from eye trouble then you could probably do far worse than to take a trip down to Hermitage Green and throw a bit of holy water over your face while saying a prayer at midnight. It might not actually work, but at least it's cheaper than going to the opticians!

3

The Liverpool Shroud

Everyone knows about the famous Turin Shroud, the 14-foot by 3-foot length of linen cloth kept inside the Cathedral of St John the Baptist in Turin, which bears the likeness of a bearded man said to be Christ himself. The image is supposed to be a miraculous imprint made on the cloth once it had been wrapped around the dead body of Jesus after his death on the cross. Such was the spiritual power inherent within his frame, say believers, that the mere touch of his skin against the fibres was enough to create the outline of his bleeding and crippled body upon it. Others, however, say that it is a fake – another kind of 'pious fraud'. Arguments still rage about the shroud's authenticity; a recent news story, for instance, reported that researchers from an Italian institute had declared that the image could only have been made by something akin to ultraviolet lasers, which would obviously have been far beyond the capacity of man to create in the distant past. This has led some to speculate that it was in fact formed by some kind of flash of 'supernatural light' coming forth from Christ's body, perhaps at the very moment of his Resurrection itself.[58] Whatever the truth about the Turin shroud, though, that is not our main business here – for a little-known fact is that a very similar image was once actually kept inside the cupboard of the head of a Merseyside hospice!

In February 1981, Father Francis O'Leary, the director of St Joseph's Hospice (part of the Jospice International chain) in Thornton, north-east of Crosby, received a telephone call from Robin Downie, a consultant surgeon at Fazakerley Hospital. He had a forty-four-year-old West Indian man from Bootle named Les (his surname was never revealed) in his care, suffering from cancer of the pancreas. His condition was incurable, and he was given only about two weeks to live, at best. Dr Downie wanted to know if Father O'Leary had a bed spare at the Jospice for this man. It turned out that he did.

While he had not been an especially religious man previously, once he came to stay at the Jospice Les began showing interest in the Catholic faith, requesting a Bible to read and allowing prayers to be said for him. When asked by someone why he had been admitted, he answered simply 'I've come here to meet God'. Apparently, he even had a vision of Christ appearing to him while he was in his sickbed, suddenly sitting bolt upright and talking

to somebody that no other person in the room could see, saying something like 'Oh my Lord, you are here. You have come for me. But I, Les, have never done anything for you!' Then, examining his hands closely, Les added plaintively 'These hands have done nothing for you, and yet you have come to me.' Reportedly, he was 'enthralled' by the Mass held in the ward the day before he died, Father O'Leary saying that he had been 'overcome by the awesomeness of the Holy Sacrifice'. Due to events such as these, Les made quite an impression upon the nurses and staff at the Jospice, as descriptions made by them of him 'radiating an indefinable goodness' seemed to show.

However, as the doctors had foretold, Les was not much longer for this world, and he finally passed away at 5.55 a.m. on 9 March 1981. By 11.00 a.m. the undertakers had arrived to take away his corpse, and Patricia Oliver, one of the nurses, immediately set about the usual routine of stripping the dead man's bed and scrubbing down the mattress cover in preparation for the next terminal patient's admission, Les' bedsheet and pyjamas being permanently disposed of. However, there seemed to be some difficult stains on the nylon mattress cover that wouldn't come off. Nurse Oliver looked down to examine them more closely, and found that the stains had formed the perfect imprint of a hand upon the material. Other members of staff were called in to examine it, and it was found that there were other markings on the mattress cover as well, including stains that marked out a clear image of Les' lower torso, upper legs to just below the knees, shoulders, buttocks and the faintly visible image of his face. The left hand was by far the clearest part of this unusual phenomenon, which immediately brought to mind the superficially similar printings upon the Turin Shroud. Father O'Leary seemed particularly interested in the possible relic, and folded the mattress cover over and took it home with him, where he wrapped it up inside a plastic bag for safekeeping and put it inside a cupboard.

There the 'Liverpool Shroud', as the press would eventually come to dub it, remained for the next five years, while Father O'Leary's attention remained focused more firmly upon the rather more pressing concern of helping to care for the sick and dying. However, after he read an article upon the Turin Shroud in the *Catholic Herald* in March 1986, he finally resolved to submit the cover for scientific testing to see what 'learned men', as he called them, thought of his own strange artefact.

Apparently, Liverpool's forensic scientists could provide Father O'Leary with no explanation for what had happened. Undaunted, he took the relic to the London Hospital Medical School, where even the world-renowned specialist Professor James Cameron said that he could not give a definitive explanation for the image's appearance. However, he did put forward a fairly plausible hypothesis; noting that the outline of Les imprinted on the mattress cover corresponded with the areas where small hollows would have been temporarily created in the mattress beneath by the weight of Les' body, Cameron suggested that some kind of fluid related to the dying man's cancer might have oozed out of him, pooled itself in the hollows, and then stained the mattress cover after seeping through his pyjamas and the bedsheet immediately beneath him, via a process called 'enzymatic action'.

Dr Frederick T. Zugibe, a very eminent American pathologist to whom the mattress cover was loaned by Father O'Leary in August 1986, came to a similar conclusion. Zugibe is rather an expert upon the death of Christ and the Turin Shroud – he has made a close study of the latter, and in 2005 even write a book, *The Crucifixion of Jesus: A Forensic Inquiry*, in which he purported to prove that Christ died not of asphyxiation on the cross, as most crucifixion

victims do, but as a result of shock due to loss of blood he had sustained during the beatings he underwent prior to actually being crucified.[59] During his investigations, Zugibe found that Les' medical records indicated that during his time in the Jospice the dying man had become incontinent due to his illness, passing very dark, mahogany-coloured urine that

The Liverpool Shroud. Note the visible cross formed upon the allegedly miraculous artefact by the curious intersection of the bum-cheeks.

contained large amounts of a substance called bilirubin. Bilirubin is naturally present in the human body, and is largely derived from haemoglobin, the red pigment in a person's blood. When the liver is damaged or obstructed, however, as pancreatic cancer will tend to do, it can build up and then be expelled in large amounts in a person's bladder movements.

After examining the mattress cover in some detail, using techniques such as UV observation and light microscopy, Dr Zugibe did, as might have been predicted, discover traces of bilirubin there on it. There seems, then, to be an obvious conclusion to be drawn; namely, that Professor Cameron was right and that fluids released due to Les' cancer had been the ultimate cause of the appearance of the image. Furthermore, Zugibe reveals that, in his final few weeks of life, Les was being given various combinations of the following drugs in order to provide pain relief and other beneficial effects: diamorphine, Dorbanex, Mogadon, Largactil, chlorpromazine, Stemetil, Duphalac, Dulcolax, and large quantities of cocaine. Given this fact, it is perhaps not too much of a surprise that he claimed to have seen Jesus Christ standing there at the bottom of his bed one day. It might also account for his calmness and sense of acceptance in the face of death; after all, this is one reason why such drugs are given to dying people in the first place, is it not?

However, despite these facts, there is still much cause for questioning in Zugibe's report. For example, he admits that only small traces of bilirubin could be found, and that there was none at all on the parts of the mattress where there was no imprint of Les' body. As he says, this could have been due simply to the mattress cover having initially been washed down by Nurse Oliver (and the fact that it had been locked away in a cupboard for five years probably didn't help much, either!), but it is still something of an irregularity. Furthermore, there were several layers of material that the bilirubin would have had to have passed through in order for it to have stained the mattress cover; initially, Les' pyjamas, then through the bedsheet, and then finally through the polyurethane surface of the mattress cover down into the nylon itself. In the case of the vague imprint of the head, it would have had to have passed down through one or two pillows and pillowcases in addition to all this! While various experimenters did manage to replicate the basic outline of a body on a mattress cover via the enzymatic action of fluids, all proved utterly incapable of making any markings as clear as they had been on the original artefact through as many intermediary layers as that.

Dr Zugibe could only explain this curious anomaly by guessing that perhaps, seeing as clinical charts indicated that Les had wet the bed several times in the days leading up to his death, some of this urine would obviously have soaked through to the mattress cover beneath. When the bedsheets above were then subsequently changed, some residue of urine, containing traces of bilirubin pigment, would naturally have remained there on top of the mattress cover. This would then dry out – but, if Les had wet the bed again on top of his new dry sheets, some might seep through and cause the previously dried bilirubin traces to liquefy once more. In this case, the pressure of Les' body on top of this newly liquefied pigment might be enough to force some of the substance through the polyurethane surface of the mattress cover down into the nylon fibres beneath, causing the outline of his body to appear imprinted there more clearly. This, though, is purely a hypothesis; however likely the reader may find it as an explanation, it cannot actually be *proved* as such.

Zugibe's investigations, though, did produce one discovery that was truly bizarre. Part of his examination involved flipping videotaped images of the relic into negative mode, reversing what you see. Remarkably, as with the Turin Shroud, the details of the image

seemed much clearer and better defined when viewed in this way, in particular the previously vague outline of the body's face. Suggestions of a chin, mouth and eyes became visible when the mattress cover was viewed like this ... and yet, weirdly, they were not the chin, mouth and eyes of Les himself! Father O'Leary, when viewing the reversed mattress cover, said that that it looked nothing like the man, as a comparison of the face with photographs of Les clearly confirmed. This fact led Dr Zugibe therefore to conclude that the 'face' on the negative view was in fact nothing more than a random simulacrum that happened to have been there; a mere 'artefact', as he put it.

Father O'Leary, though, had a different view of the reason why the face on the mattress cover did not resemble Les – namely, that it was not actually an image of Les at all, but of Jesus Christ Himself! Perhaps remembering Les' alleged vision of Jesus before his death, Father O'Leary noted that, in the view of the Catholic Church, 'Christ is present, crucified again in every suffering person', and Les certainly was suffering, to be dying of cancer. His thoughts upon this matter are not quite clear, but it appears that Father O'Leary felt that Christ's body and Les' body merged somehow in a kind of mystical union immediately prior to death, leaving the image of Jesus/Les there on the mattress once their twin souls had departed. O'Leary then used this theory of his to come up with a novel hypothesis to account for the fact that scientific carbon dating of the Turin Shroud in the 1980s had placed it as having its origins somewhere between the 1260s and the 1390s, rather than at the actual time of Christ's death around 2,000 years ago – namely, that it wasn't actually the death shroud of Jesus at all, but an imprint of Jesus as temporarily incarnated in the body of an unknown and dying medieval man! O'Leary admitted that this idea was 'farfetched and stretching the bounds of reason to the ultimate,' but said that it at least 'had to be worth a thought'.

And is it? Certainly, there was one other strange coincidence about the whole affair, which might indeed give you pause for thought. The left hand of Les/Christ, it will be remembered, was the clearest and most striking feature of the mattress cover imprint. The then-logo of Jospice International, meanwhile, (selected in 1970, more than ten years before Les died) featured an open-palmed left hand with its thumb touching a cross. Les' hand on the relic is also open-palmed, and its thumb, too, is touching a cross on the mattress cover – well, sort of, anyway. It is actually touching the part on Les' dead body where the bum-cheeks intersect with the vertical line going downwards that marks out the border between his two legs, but it could easily be taken for a cross if you look at it from a certain angle. In the old Jospice logo, meanwhile, the crumpled and suffering body of Christ is being cradled within the palm of the hand touching the cross – which presumably belongs either to God or to Mankind as a whole, which seems somehow symbolically apt. We will recall that, when the suffering Les had his vision of Jesus, he specifically looked down at his own hands and said 'These hands have done nothing for you, and yet you have come to me.'

Perhaps, however, if the imprint of Les' hand after death helped people to find some faith and consolation in the face of their own suffering by virtue of its apparently miraculous nature, then those hands of his actually did do some good after all, in spite of his own protestations to the contrary. As Father O'Leary himself once wrote, 'we may have been sent, through the Jospice Imprint, a supernatural phenomenon, which may be an aid in highlighting the veracity of the Holy Shroud [of Turin] and all that is implied in it, for the benefit of a very materialistic, unbelieving and cynical world.'[60] What you make of this idea, of course, is entirely a matter of your own faith.

4

Spontaneous Human Combustion in Widnes?

Widnes, a relatively small town just south of Liverpool, has a few vague claims to fame – its once all-conquering Rugby League team and its status as the one-time centre of the British chemical industry, for instance. In the annals of fortean research, however, it is well-known for one thing above all others, and that is the strange and seemingly inexplicable death of Jacqueline Fitzsimon, a seventeen-year-old cookery student at Halton College, who suddenly burst into flames for no apparent reason one day in January 1985.

Initial reports of the case in the national press suggested that Spontaneous Human Combustion (SHC) was a viable cause for Jacqueline's tragic demise. Official investigators of the case were quoted as saying of the SHC hypothesis that 'It's a real possibility at the moment. We cannot find any other reason, but the investigation is still going on' and her parents were meant to have said: 'Our daughter's death is a complete mystery. No one seems to know what happened.' Furthermore, at the initial (adjourned) inquest into the death, held in Whiston on 22 February, Bert Gillies, a Cheshire Fire Prevention Officer, went on the record as saying 'So far there is no clear explanation of the fire ... Spontaneous Combustion is a theory most of us have treated highly sceptically, but it should be examined.' But what, exactly, had happened to the poor girl in order to make the professionals say things like this?

It seems that Jacqueline had been attending a cookery class at Halton College in Widnes on 28 January, where she had just taken part in a practical exam. Coming down the stairs after exiting the classroom and chatting to her friends, she abruptly burst into flames, becoming what was described by some as being a 'human torch'. The flames were beaten out by pupils and staff, and she was taken to nearby Whiston Hospital, where she eventually died at 5.34 a.m. on 12 February, after fifteen days spent in intensive care. She had suffered 13 per cent skin loss, and is presumed to have ultimately died not of her burns *per se*, but of something called 'shock-lung', which was dependent upon them. While lying there in hospital, however, Jacqueline was quite conscious, and, in an interview with a Detective Sergeant Geoffrey Able, provided an apparently rational reason for her catching on fire: 'I must have been standing too near the cooker. I was right next to it. I may have been leaning

on it. We had left the gas rings on to warm the classroom.' Had her cookery smock, then, simply caught fire somehow on the cooker's naked flame?

It sounds, on the surface of things, a reasonable enough idea. Indeed, at the second inquest into Jacqueline's death, held four months later on 28 June after full investigations had been made by the police, fire service and Health and Safety Executive, an ultimate verdict of 'misadventure', backing up the gas-cooker theory, was reached. Perhaps this is not too surprising, however, as at the very beginning of the hearing the coroner overseeing proceedings, Gordon Glasgow, specifically warned the jury to ignore any media speculation they had heard, and to disregard SHC as being a possible cause of death. Furthermore, the Home Office chemist, Philip Jones, gave his opinion that SHC could not have been the cause of death in this case because, apparently, 'the necessary chemical reactions required were not evident' – which was a slightly odd statement to make because a) if SHC is real, then nobody yet knows what 'chemical reactions' exactly are required, and b) it implies that the Home Office believed that there were *real* cases of SHC wherein these chemical reactions were present, despite the fact that they clearly believed no such thing. This attitude on behalf of the presiding officials involved, in addition to the fact that the Fitzsimon family themselves were reportedly very upset about all of the public speculation concerning SHC, brought a curtain down across the whole affair for most.

However, not everybody was satisfied by the verdict – and indeed, there were numerous odd irregularities about the case. While two of Jacqueline's classmates confirmed that they had indeed been leaning against the cooker for about fifteen minutes prior to leaving the lesson, they also said that she must have been at least 8 inches away from the nearest open jet of flame from the gas ring. However, in their eagerness to leave the classroom for breaktime, Jacqueline and her friends had been hanging around just next to the door, well away from any cookers, for at least five minutes before leaving the room. This means, if the cooker was responsible, that her white cookery smock must either have been on fire or smouldering for several minutes before she actually caught light, without anybody noticing the fact – which seems unlikely, to say the least. Furthermore, it appears that it was not actually her smock that ignited first, but the clothing that was *underneath* this, namely her jumper! We know this because, after she had begun to yell that she was on fire, her friends had pulled off her smock and found her knitted jumper aflame beneath it. Indeed, Jacqueline's actual flesh appears to have been entirely unburned everywhere except where it was in direct or very close contact with her jumper. Quite how a flame from a gas cooker could have ignited a layer of clothing *beneath* another one was, of course, a real mystery to many at the time.

In addition, the Home Office chemist, Philip Jones – he who said that the correct 'chemical reactions' were not present for SHC to occur – carried out experiments with some of Halton College's catering smocks, and found that, by holding one up a few millimetres away from the gas-ring flame, it took only about thirty seconds at most for the smouldering and heat from the affected material to become noticeable to anyone, let alone to someone who was actually wearing it. Seeing as there were a good five minutes between Jacqueline moving away from leaning on the cooker and then going on fire, the idea that she had set herself aflame like this could therefore be discounted.

Furthermore, Jones found that, despite his best efforts, he could not get the catering smock to actually burst into flames at all during his experiments; it had just smouldered. When you then take into account that Jacqueline was apparently at least 8 inches away

from the flames on the gas ring when she was leaning on the cooker, rather than only a few millimetres, the assertion that it was the oven that was responsible thus seems to collapse. Indeed, under cross-examination, Jones is said to have admitted that none of his evidence actually supported the conclusion that this is what had happened. A thirty-page joint report from Cheshire Fire Brigade and the Shirley Institute (a prestigious scientific establishment in Manchester) agreed that this could not possibly have been the answer, but the coroner simply decided not to use this document as admissible evidence at the inquest, for whatever reason.

Furthermore, there seems to be some question as to whether Jacqueline and her friends had actually been leaning against lit ovens that day at all. Robert Carson, the cookery lecturer, vehemently denied this assertion, saying that the rings on the gas fires had been switched off for an hour prior to the end of class. The police were not informed about the incident until two days after it had occurred, and by the time that Detective Sergeant Geoffrey Abel had gone to visit Jacqueline in hospital on the evening of 30 January – where, he said, she had been sitting up in bed and talking, not looking as if she was close to death at all – she had been visited by numerous family and friends. She had discussed her experience with them and it seemed that, as such, had by this stage already made her mind up about

Halton College (now renamed), where an alleged case of SHC took place during a cookery class in the early 1980s.

what exactly had happened. Indeed, look at the statement she gave to the officer from her sickbed again more closely: '*I must have been* standing too near the cooker. I was right next to it. *I may have been* leaning on it.' Maybe this was just supposition on her part; according to Abel, Jacqueline actually admitted that she could not specifically remember having leaned upon the oven at all. By the time that the final inquest into her death had come around several months afterwards, however, it seems that most of the witnesses had decided that she definitely *had*.

By far the oddest evidence to emerge from the inquest, though, was that presented by two hairdressing students, who said that they had seen a 'strange glowing light' appear in mid-air above Jacqueline's right shoulder before falling down her back. Allegedly, she then screamed out 'It's gone down my back – get it out!' (something that is not backed up by any other witness statements, it has to be said) before bursting into flames. Other witnesses said that there was no smoke or smell of burning, only naked flames, and the fact that Jacqueline wasn't initially in all that much pain after the bizarre conflagration is also a bit weird. However, witness contradictions abounded. Some students said that they had witnessed Jacqueline on fire in the toilets, when most said that she had not been anywhere near them, for instance, a major inconsistency that was never actually cleared up. Even more sensational, one of the hairdressing students claimed that the girl she had passed on the stairs with the strange light hovering over her was not even Jacqueline Fitzsimon at all, but another person entirely! Given these incredible and frankly ridiculous discrepancies, it is probably no surprise that the coroner and expert witnesses seemed to lean very heavily towards the seemingly 'common sense' notion that Jacqueline had just been standing too near to the open flames on the cooker that day, an opinion apparently endorsed by the jury's ultimate verdict of misadventure.[61]

Nonetheless, unreliable witnesses or not, it seems to me that the whole affair raises enough questions for people to legitimately query whether or not the poor girl actually combusted from unknown means that sad day in 1985. If it was a case of SHC, though, then there are irregularities about this idea, too. For one thing, while Jacqueline's burns were obviously severe, they were nothing like as bad as in the usual pattern of SHC, wherein the vast majority of the body is incinerated down into nothing, not even bones, with the frequent exception of a few extremities such as charred hands and feet. Indeed, according to Dr Cradwell, a pathologist called to give evidence, the burns on the girl's back and buttocks were actually classed as being 'superficial', her later demise having more to do with the subsequent septicaemia and inflamed bronchia in her lungs, rather than the initial burns, as stated earlier. Furthermore, Jacqueline did not die instantly, hanging on for over two weeks, whereas most SHC victims die more-or-less straight away.

But perhaps we are getting a little ahead of ourselves here. What, after all, *is* SHC? Is it really a paranormal phenomenon? Some people think so, pointing to the inexplicable fires that sometimes take place during poltergeist hauntings and drawing parallels between these and SHC. Accounts of poltergeists actually burning *people* are extremely rare, however. There is one significant exception to this rule, which perhaps deserves to be examined here given its apparent surface similarity to what happened in Widnes in 1985.

At Binbrook Farm near Grimsby between December 1904 and January 1905, it seems that a poltergeist was active; objects were moving around by themselves and some spontaneously bursting into flames. In the *Liverpool Echo* for 25 January 1905, for example, is printed a

letter from a schoolteacher living in the area, testifying to the fact that a blanket had been found ablaze in an empty room, in which there was not even a fireplace.[62] By far the most significant thing that caught fire during the haunting, however, was the farm's unfortunate maidservant. This young girl – sadly unnamed in newspaper reports – ended up in hospital, 'in a critical condition', with extensive burns on her back, supposedly inflicted by the ghost. The owner of Binbrook Farm, a Mr White, described how her injuries came about thus, in an interview with a local newspaper: 'Our servant girl, whom we had taken from the Workhouse ... was sweeping ... [the] kitchen. There was a very small fire in the grate, there was a guard there, so that no one can come within two feet or more of the fire, and she was at the other end of the room, and had not been near. I suddenly came into the kitchen, and there she was sweeping away, while the back of her dress was on fire. She looked around as I shouted and, seeing the flames, rushed out through the door. She tripped, and I smothered the fire out with wet sacks. But she has been badly burned, poor girl, and she is at the Louth Hospital now, in terrible pain.'[63] Surely the several parallels between this ghastly event and the Widnes case hardly need to be pointed out? The writer Charles Fort, who first brought the Binbrook case to prominence, specifically tried to link it with contemporary instances of SHC, and you can certainly see why.[64] When the girl (who survived) was interviewed in hospital by an investigator, she even demonstrated similar thought-processes to those Jacqueline Fitzsimon did, saying that 'a spark from the fire, I suppose' must have started off the incident.[65]

However, while what happened to the maidservant at Binbrook Farm back in 1905 initially sounds fairly similar to what happened to Jacqueline Fitzsimon in 1985, looked at more closely, there are no real grounds for linking the two. After all, there is no indication whatsoever that either Jacqueline or Halton College had ever been associated with, or persecuted by, poltergeist phenomena. In fact, while SHC is undoubtedly a currently unexplained phenomenon, its association with poltergeist hauntings is exceedingly rare, and, if it does ever prove to actually exist, it is probably best thought of as being some kind of entirely natural (albeit highly unusual) phenomenon, rather than a paranormal one *per se*.

As such, there have been numerous 'natural' theories about SHC put forward over the years. A once popular nineteenth-century idea, for instance, held that its victims were simply drunkards whose bodies had become saturated with flammable alcohol and spirits, leading to a fiery death. Others have sought to draw similarities between the natural combustion of things like peat and certain members of the vegetable kingdom, saying that SHC is just a human version of that.

A more plausible explanation for the Widnes case, however, might be that it was an example of a so-called 'static flash fire'. In the course of performing everyday activities – walking across a carpet, for instance – it is a fact that a static electrical discharge can build up in a person's body or clothes. You only have to rub a balloon against your jumper to see this. Therefore, some people contend that abnormally large amounts of static electricity can occasionally build up in the human body for whatever reason, and then release sparks that ignite clothes. The first person to propose this as a possible explanation for SHC was Professor Robin Beach, of the Brooklyn Polytechnic Institute – although, it must be said, even he had his doubts about whether it was really possible.

If there is such a thing as a static flash fire, however, then its proponents say that one of the key signs of such an event would be the appearance of bright flashes or shimmering

flame-like effects either in the air or on the body of the person affected, as the electric sparks are discharged – and a 'strange glowing light', it will be remembered, is indeed supposed to have been sighted going down Jacqueline Fitsimon's back just before she caught fire during the Widnes case. There are some accounts in existence of people who appear to have survived static flash fire incidents, too, and they also are in many ways curiously similar to what happened in Widnes in 1985. In the winter of 1980, for example, a Cheshire woman, Susan Motteshead, was standing in her kitchen in her pyjamas when a sudden and short-lived yellow and blue fire sprang up on her clothing for no apparent reason and then burned itself out almost immediately, leaving her entirely unharmed. When the fire brigade arrived, in an attempt to discover what precisely had happened, they attempted to set fire to Mrs Motteshead's pyjamas themselves, but were unable to do so; they were actually fire-resistant! Apparently, it was only the layer of fluff on top of them that had managed to burn itself off due to her bizarre bodily emissions.

Another apparent case of a static flash fire that didn't quite manage to burst out happened in September 1985, not too long after Jacqueline Fitzsimon herself had exploded into flames. A young girl named Debbie Clark was walking home one night when she realised that she was being followed by sudden flashes of blue flame that were fizzing out from her person. She thought this was funny and began walking around her garden in circles, shouting 'Look at this, mum, look!' Her mother did look, and began screaming, as did her brother, who began wailing something about SHC. They got her inside and threw her into the bath, which was deemed by them to be non-conductive in nature. The flames eventually went, and Debbie just sat there laughing about it all.[66]

Perhaps Debbie would not have been so amused, though, had she undergone the horrible fiery persecution experienced by Paul Hayes, a nineteen-year-old computer programmer from London, on the night of 25 May 1985 (that same year again!). He was walking down a road in Stepney Green when, suddenly, he was engulfed in flames from thin air. Initially, he thought that some thugs must have doused him in petrol and thrown on a match, but there was nobody around who could have done such a thing. His description of the event makes horrible reading: 'It was like being plunged into the heat of a furnace ... from my shoulders to my wrists my arms felt like they were being prodded by red-hot pokers ... my chest felt like boiling water had been poured on it. I thought I could hear my brains bubbling.' He fell to the floor screaming, closed his eyes and crawled up into a ball, waiting to die. And then – suddenly – nothing. He opened his eyes, and there were no flames, not even any smoke. He made his way to the nearby London Hospital, where he received treatment for burns to his face, neck and ears. Nobody there had a clue what could have happened to him.[67]

Several commentators – notably the former coal miner and CID officer John E. Heymer, in his 1996 book *The Entrancing Flame* – have looked at cases such as these and concluded that Jacqueline Fitzsimon's was of essentially the same type, and that all were the victims not of ghosts, but of anomalously excessive amounts of electrical discharge. But, if so, then why was it that these charges built up in the first place? We can only speculate, but it is fascinating to note that both Debbie Clark and Susan Motteshead had suffered with having excess amounts of static electricity in their bodies from when they were young; Clark said that she used to cause electrical appliances to break down or explode in her presence, and Motteshead claimed to have been well-used to getting shocks from touching metal objects like fridges. It would be interesting to know if the same had been true of Jacqueline

Fitzsimons, too; there was no evidence given to suggest that it was at the inquest, of course, but perhaps nobody had ever thought to ask. Maybe there was something slightly unusual about the chemical biology of all these people that made them susceptible to undergoing such disturbing experiences, then? Who knows?

Overall, I think that the individual reader just has to make their own mind up about what really happened that fateful day at Halton College back in early 1985. Certainly, the coroner's inquest seems to have been something of a whitewash, but that doesn't, in my view, mean that we necessarily have to invoke paranormal phenomena in order to be able to account for poor Jacqueline Fitzsimon's tragic death – simply highly unusual yet actually entirely natural ones.

5

The Blind Girl Who Could See

When you hear about a blind person who can still see things, the human mind tends to jump to one natural conclusion; that they aren't actually blind! Apparently, this is the majority opinion relating towards Margaret M'Avoy, a young and sickly girl from Liverpool, who caused a sensation during the years 1816 and 1817 by claiming to have lost her sight before then astounding visitors by demonstrating her ability to read pages from books, to tell different colours of silk and glass, and to describe the appearance of strangers who walked through her door. Supposedly, she could perform these miracles simply by running the ends of her fingertips either over or in front of these objects and people, using them as her 'eyes' rather than her real ones. The prestigious *Dictionary of National Biography*, after listing Margaret's name and the dates of her short life (1800–20), when giving her reason for inclusion – where other people might have 'artist', 'poet' or 'statesman' after their name – prints only one word: 'imposter'.[68] Is this a fair assessment of her case though, or not?

It seems that, for around a year prior to the initial onset of her alleged blindness in June of 1816, Margaret had been complaining of a severe pain in her head, something that was only aggravated, on 4 June, by the firing of some guns from a nearby fort, which sound made her head throb and beat. She began staggering around, being affected by giddiness and dizziness, and her eyes, in which she had already been suffering blurred and double vision, became bloodshot. On 5 June, she received her first visit from the man who was to become her greatest champion, a Liverpool doctor by the name of Thomas Renwick, later the author of a book about her case. When he visited her at the home in which she lived with her mother in St Paul's Square, near to the old waterfront, he diagnosed her as suffering from something that, in the inexact medical terminology of the day, he termed 'oppression of the brain'. Another medical man in attendance, a Dr Thomas, prescribed a course of leeches to purge her of 'bad blood', which only caused her to faint.

The next day, 6 June, Dr Thomas pronounced Margaret to be completely blind. Calling upon her again, Dr Renwick found her pupils utterly insensitive to light, and had cause to suspect that water on the brain, or hydrocephalus, was the ultimate cause of her problems. She now progressed on to displaying even more alarming symptoms, such as convulsions

and temporary paralysis down her right side. Masses of fluid were vomited up by her, and she was not expected to survive for long. However, after she had expelled this fluid her condition began to pick up a little – but the blindness still remained.[69]

In early September 1816, Margaret's stepfather, a Mr Hughes, was sat reading a book about St Thomas à Becket, and happened to pass some comment about it. By way of reply, Margaret said that, before she had lost her sight, she had read an account of his life too, in a book called *Lives of the Saints*. She then made the rather bizarre comment, in the circumstances, that if she was given this book, she could point out where it was written. Mr Hughes accordingly placed this tome into her hands, and Margaret pointed out, somehow, where the part in question was, and began passing her fingers over it and reading out a few words. Impressed by this, Hughes gave her a Bible, opened at random, to run her digits across and read, as a test. It seemed that she could do so perfectly.

After hearing of this phenomenon, Doctors Renwick and Thomas called upon Margaret again, and found that these claims were quite accurate. They tested her eyes by exposing them to candle flames, and saw no reaction to them. Seemingly, she was still blind – and yet, she could read. They blindfolded her, and still she could do it. Her method initially was to place her fingers across the first letter of a word, run them across from left to right up to the word's end, then go back again, and name it. Using this technique, she could read just under one word per second.

Initial experiments found out more; she could tell when a sheet of paper was blank when she touched it, and also feel a person's name that had been scratched out from a book with a pen as being mere scribble. Then, however, she began performing even more remarkable feats, such as telling accurately the colour of the print. She was also able to correctly state the colour of people's clothing, to tell which playing cards had been placed under a small table before her, and to distinguish between different hues of glass just by touching them. Soon, she was able to tell the difference between differently coloured cloths, wools and silks, saying that the brighter and more colourful the piece of material she was handed, the more pleasure it gave her to touch. She even knew the colours of liquids contained within sealed glass bottles just by running her fingers across them, apparently.[70]

As word of her miraculous abilities spread, large numbers of curious visitors, many of them medical and professional men, came to visit the sick girl in her home – although she and her family studiously avoided accepting any money or other kind of hospitality from them that might have compromised their claims. The opinions of those who attended the house in St Paul's Square to see the Wonder Girl, however, were decidedly mixed. Some went away satisfied that her abilities were real, others that she was a complete fraud.

One of the most obvious objections to make about Margaret's claims, naturally, was simply to say that she wasn't blind at all, and just a fake. In order to test out the genuineness or otherwise of her blindness, then, several rather extreme and comic experiments were devised. One common trick was to suddenly pull out a pistol and aim it right in the poor girl's face to see if she should then start with shock. After Dr Renwick had tried this idea out to his own satisfaction with his unwitting victim, he began lending his gun out to other people and encouraging them to have a go, too. Several did; and, it appears, she did not even flinch. In order to test out the effects of such a prank being played upon a sighted person – purely for comparative purposes, you understand – Dr Renwick then pointed his weapon at a random stranger in order to see how *he* reacted, after first asking him if he would like

to take part in an experiment. Apparently, he nearly fell from out of his chair![71] Dr Renwick also varied his tactics at times by, variously, dashing the point of a penknife right up to his patient's eye, as well as making to punch her in the face, burn her with a candle and poke her eye out with his fingers, always pulling up, however, just at the final moment possible.[72] All of these trials, of course, were kept as a strict secret from Margaret and her family. Such, it seems, were the ethics of medical science in the early nineteenth century.

For every result of an experiment, however, it seems that there must be an equal and opposite result, and opponents of Miss M'Avoy's claims supposedly tried to catch her out in a similar manner. Allegedly, for instance, a certain Sir George B. Collier called at the house one day and exposed Margaret by standing in front of her face and making 'such whimsical grimaces and distortions of countenance' that she had no option but to burst into laughter when she saw the funny faces being pulled before her.[73] One almost dreads to think what other kinds of things more unscrupulous visitors to the M'Avoy household might have done in front of the poor girl thinking that she couldn't see them ...

However, there is some dispute about whether or not this last incident actually took place at all, seeing as several witnesses who were present at the time that Sir George was meant to have done it denied that he ever did so. Nevertheless, such claims got much local publicity in the pages of the *Liverpool Mercury*, whose then editor, a Mr Egerton Smith, was eager to present himself as being Margaret's nemesis. He turned up at her house one day with a specially constructed eye-mask that he desired Margaret to wear, betting 20 guineas that she would be unable to read even a single line of print with it on. A bystander at the scene offered to double this prize. Apparently, Margaret became agitated at this prospect, and turned the offer down flat.

The issue of this mask was an important one to Smith, as he was firmly of the opinion that the blindfolds that Margaret usually now wore while giving her public demonstrations were somehow faulty, and allowed partial admission of light through apertures around the nose, enabling her to see, albeit faintly, what colours of cloth and so forth were being handed to her. This theory may have had some merit, as one other prominent opponent of Margaret's, Joseph Sandars, had put her usual mask on and manipulated the muscles of his face so that he could just about see down through it around the nose area. However, Dr Renwick seemed quite happy to explain away this feat of Sandars' simply by pointing out that he had a very big nose! Margaret M'Avoy, he implied, being much more petite of snout, would have been utterly unable to do any such thing.[74]

Egerton Smith's device was not so vulnerable to nasal tampering, however. So pleased was the editor of the *Mercury* with its supposedly foolproof design that he placed a print of it in his newspaper for all to see, and repeated his offer of 20 guineas if Miss M'Avoy would take up his challenge. According to Dr Renwick, though, Margaret would have been unable to accept this offer, as the mask, due to its design, would obstruct her breathing and thus exacerbate her poor physical condition even further (even a hand being placed before her mouth would now cause her immense breathing difficulties, it seemed, so delicate had her health become).[75]

Clearly Egerton Smith did not believe this excuse, however, as he subsequently printed allegations that an unknown man had called around at the *Mercury*'s offices after the picture of the mask had been published, claiming to have been a representative of Miss M'Avoy, and saying that she would be very happy to accept the challenge, if only he could be allowed to

take the mask back to her house and have it examined by her there for a few days prior to the trial. Suspicious of tampering, permission was of course refused by the editor – although the fact that nobody had actually been sent out from the M'Avoy household for this purpose led Dr Renwick to conclude that Smith was simply making this smear up in order to blacken her name in his columns.

Certainly, there does seem to be little doubt that the editor of the *Mercury* was not above printing baseless rumours about the case in his pages, purely in order to back his opinions about it all up. For example, he wrote that 'we have also heard from a very respectable and not very circuitous quarter, that our heroine has been seen repeatedly dressing her hair, and adjusting her dress in the manner of a young lady at her looking glass.' As Dr Renwick points out in his own dismissal of these rumours, however, this simply cannot have been the case, as at the period concerned she had no hair to comb, due to her head having been entirely shaved in order to facilitate the application of medical blisters.[76]

This is, of course, not to say that there was nothing suspicious about Miss M'Avoy's allegedly miraculous abilities, which Renwick himself felt compelled to call a 'new and supernatural faculty', so incredible did they seem. After all, some of the claims she made were exceedingly bizarre, none more so than the fact that she came to insist that she could read books more easily when a kind of magnifying glass was placed between the page and her fingers! She said that 'the letters appear larger, and as if they were printed on the glass' when she did this. Strangely, moreover, according to a Revd E. Glover, who subjected Margaret to various tests, 'she does not hold the glass within the focus of the eye, but as it were within the focus of the point of the finger, which would appear in this case to serve the purpose of the eye.'[77] Perhaps this was because, as she put it, 'the letters seemed to rise ... up to the fingers' when she was using it.[78]

Yet more strange was the way that Margaret was supposedly able to 'feel' people's reflections through glass and mirrors. She could run her hands across a mirror placed before her and then say out loud the names of persons who entered the room through the door behind her.[79] Most remarkably, she could apparently see out of the front window of her house, with her back turned to it, simply by placing a hand upon the inside of the pane and 'feeling' what was out there. One time, for instance, on 4 August 1817, she was able by this method to correctly describe the appearance and clothing of the people who passed by, as well as outlining accurately the positions and activities of four different workmen in a churchyard across the road.[80] She was able to do this kind of thing even while sight-impeding goggles were placed upon her, it is said.[81]

During experiments with the Revd E. Glover, meanwhile, Margaret was able to describe in detail the activities of a man who was sent outside and told to perform various activities in order to test her out. Apparently, he played the clown, making a spectacle of himself by climbing up railings and throwing himself off them, bizarre behaviour which she could not have been expected to have simply guessed about. Strangely, she said that while 'feeling' things through the window like this, everyone she saw became midgets, the clowning rail-jumper appearing to be only about two feet tall, and added that the scene outside seemed 'as if painted on the glass'.[82]

Furthermore, it was sometimes possible for Margaret to see and read things in the dark, as even Egerton Smith had to admit to having observed upon one of his first visits to her household.[83] Even when books were placed beneath bedclothes, where she could not

possibly see them, and then opened at random, she proved able to read them, according to the evidence of William Evans, a prominent Liverpool surgeon of the time.[84] Another odd feat of hers was the ability to tell the shade of different colours of the spectrum when they were thrown upon the back of her hand through a prism. Seemingly, she was able to detect minute variations between the heat of the different wavelengths of coloured light – or, at least, that is what her experimenters concluded.[85] Margaret's extreme sensitivity to colour was certainly remarkable; on one occasion she correctly stated that a stained glass was deep crimson, when everyone else in the room (including Egerton Smith) thought that it was black. Then, however, as some sunlight passed through the window behind the

Margaret M'Avoy demonstrates her ability to 'read' using only her fingertips and a magnifying glass.

glass, illuminating it more fully, it became apparent that she was in fact correct. Smith's only explanation for this event (which occurred while she was blindfolded) was that it must have been 'a bold guess upon her part'.[86] At another time, however, her powers failed her in exactly the reverse fashion, and she declared a piece of paper to be black when it was actually a very deep shade of crimson.[87]

Contradictory evidence such as this seems to run through Miss M'Avoy's history, leaving it very easy for both supporters and opponents alike to build a case either for or against her. For instance, it seems that Margaret 'mysteriously' lost her abilities temporarily whenever sceptical visitors were present. She would become highly agitated, the temperature of her hands dropping pronouncedly, and masses of sweat appearing upon her top lip, and then declare herself unable to tell the colours of things or to perform any of her other usual tricks.[88] Because of this fact, obvious inferences were drawn about the true nature of her abilities by some.

Worse than this, however, were those occasions when she appears to have been caught engaging in direct fakery of her powers. For example, Joseph Sandars, author of a hostile pamphlet entitled *Hints to Credulity*, published a letter that had been sent to him by a certain Mr Jones, one of a number of interested parties who had examined Margaret at the house of John Latham, a Wavertree surgeon, in October 1816. He said that, upon being given a handkerchief to handle, M'Avoy had been unable at first to tell its colour, and became embarrassed. She requested more time to handle the item, which was granted, and then after about ten minutes of being closely watched, loudly exclaimed 'I cannot find it out!' and threw it down petulantly onto Mr Jones' knee. Taking advantage of this sudden commotion, she then, according to Jones, took a quick darting look at the handkerchief (her eyes were not actually covered at this point, she was simply meant to look away from the things she was given to touch) and then grabbed it back quickly, placing it behind her back and feeling it in her hands once again. Damningly, it was only after she had performed this highly suspicious action that Margaret was able correctly to say what colour the thing was.[89]

One particularly ingenious experiment – or baited trap, if you prefer – was detailed for posterity by a Thomas Lutwyche, who took part in it. After being told that Margaret could tell what time a watch was showing simply by running her fingers across its glass covering, Lutwyche and two visitors decided to test this out. Initially, they held a conversation with her, which was conducted with a gold watch hanging, apparently carelessly, from one of the men's hands in front of M'Avoy's face, so that she could see it (if see she actually could). Then, they proposed openly to test her watch-related abilities out. Unbeknown to her, however, one of the persons present had another gold watch with them, which was of remarkably similar design to the first. By an act of sleight-of-hand, Lutwyche managed to slip Margaret this second watch which he had, surreptitiously, wound on one hour forwards. She felt across this watch's face without looking at it, and confidently pronounced the correct time … but the correct time that the *other* watch that had been displayed to her showed, not the one that she was *meant* to be 'reading'![90] Given such testimonies, it does seem obvious that Margaret M'Avoy was, at least sometimes, an absolute fraud.

But fraudulent *all* of the time? For every apparent act of fakery, as mentioned earlier, it really was possible to discover another apparently genuine feat performed by the girl. Furthermore, there is no doubt that Margaret was genuinely very seriously ill. She was

frequently prostrate and in great pain, and seemed to be suffering from several tumours in the side of her body. She regularly expelled green slime from her mouth as well, and her eyes were often bloodshot and full of discharge.[91] As such, you do have to ask why it would be that a seriously ill girl in her painful condition would bother wasting what remained of her life performing fake magic shows for the benefit of strangers, when neither she nor her family ever profited in any way from the whole affair. On the one occasion upon which some money was left behind for the M'Avoy family – by a kindly Lord, who left them a few pieces of silver so that they could buy some fruit – it was sent back to him with a polite note explaining that they could not possibly accept such a thing.[92]

Whether a fake or not, however, it was obvious that Margaret's life would be short, and on 9 August 1820 she finally died, having written out her will four days earlier (it is a remarkable fact, incidentally, that she only actually learned to write *after* going blind!).[93] The dissection of her body – performed by Robert Harrison, the Liverpool surgeon, twelve hours after her demise – only deepened the mystery surrounding her, though. Upon finishing, Harrison declared that he could not even determine what the cause of death had been. Despite her apparent tumours and the frequent expulsions of green slime from Margaret's body, it seemed that, once he had opened her up, Harrison could find nothing wrong with her. In his own words, 'I must say that I did not notice any organic disease sufficient to destroy life. I feel more inclined to attribute her disease to excessive and long continued debility, the primary cause of which I cannot attempt to explain.'[94]

Her brain, too, seemed perfectly normal, even though this was where you might have thought that the true secret of her powers lay. All the fluid that had previously been lying upon it had drained away, and the only irregularity that could be found there was 'a small fungus-like excrescence' that 'might be compared to a small portion of fur' in a ventricle leading up to it.[95] As for her eyes, the muscles inside them did seem to have atrophied somewhat, something which Dr Renwick attributed to their withering due to lack of use in her final years because of blindness.[96] Certainly, an experiment made upon her eyes in 1819, when blunt-pointed probes were stuck into both of her corneas, producing no sensation of pain or awareness upon her behalf whatsoever, suggests that the nerve endings in them had gone completely sometime beforehand, too.[97]

These findings of her autopsy are indeed curious, although perhaps they need not puzzle us too unduly. Medical science in the pre-Victorian age was nowhere near as advanced as it is now, and it wasn't too much more advanced in certain respects as the era drew to a close, either. The fact that Dr Harrison didn't really know what killed Margaret M'Avoy isn't *that* strange, then – but the utter absence of any tumours in her side seems bizarre in the extreme, as both Dr Renwick and other medical men had diagnosed them, felt them, and even made incisions to partially expose them.

What could have caused her alleged powers, then? One possible explanation might be that Margaret was suffering from something called 'hysterical blindness', a strange mental condition wherein, while there is nothing physically wrong with a person's eyes as such, they still somehow manage to convince themselves that they are completely blind. Hysteria is a controversial and much-misunderstood condition that can manifest itself in many forms – Dr Renwick himself termed it 'one of the most Proteus-like diseases we are acquainted with' – but it does appear, from Renwick's own account, that Margaret occasionally exhibited signs of suffering from it. Indeed, certain contemporary observers appear to have held the

view that her convulsions and illness as a whole were essentially hysterical in their nature, and possibly they were partially correct.[98]

And yet, this can hardly be the whole story. It's easy enough to see how, without even being a conscious fraud, Margaret could profess herself unable to see and still manage to read out passages from books when they were placed before her, but hysteria cannot cause a person suddenly to develop the faculty to read in the dark, beneath bedclothes, or when securely blindfolded. Hysteria could be a part of the answer, but not the whole one. What other explanations might there be, then? One potential solution might well lie in that odd condition known as synaesthesia, wherein a person's senses somehow become combined neurologically, allowing them to 'taste' music, or 'smell' sounds. Maybe Miss M'Avoy could somehow 'taste' or 'feel' colours? According to one experiment tried upon her, by closing between her lips a series of differently coloured flower petals, Margaret could distinguish their hues quite accurately.[99] Strangely, it furthermore seems that, if any obstacle, such as a hand or piece of paper, were placed between her mouth and the object she was trying to tell the colour of, her powers usually instantly vanished – so maybe she could 'taste' the visible world to some extent somehow?[100] But, then again, this theory would not be able to account for *all* of her miraculous powers, either.

Maybe, then, once her sight had apparently vanished, M'Avoy's other senses began to over-compensate for her loss of faculty in the most remarkable manner. Certainly, Margaret does seem to have been hypersensitive to things in some way; she could accurately foretell when a thunderstorm was approaching before it arrived, being able to feel the slight vibrations its noise was causing in the air, for instance, and via a like method could feel when the cannon on ships some miles distant were being fired prior to the sound waves actually reaching her ears. This might be taken to imply that it was the case that her sense of feeling had become almost like some kind of over-sensitive superpower – and yet, really, however sensitive your fingers become, do you honestly think that it would enable you to feel colours, or to tell the appearance of people running around outside simply by touching the glass in front of them? It seems unlikely, at best.

Maybe, then, she was just psychic? This could be maintained, I suppose, but I hardly think it can be proven. Probably, you will just read the evidence provided about Margaret according to your own pre-existing ideas about the matter, whether you think she was genuine, fraudulent, or a bit of both. I cannot tell you the answer to this conundrum for certain myself, and I hope you do not expect me to; that, after all, would simply be a case of the blind leading the blind.

6

Trips Down Memory Lane in Bold Street

It has often been said that Liverpool is a city stuck in the past, its people perhaps pining for those long-vanished days at the height of the Victorian era when it was known as the 'second city of Empire', renowned as being one of the busiest ports in the world, and one of the richest cities in the land. Walking around the centre of Liverpool is indeed, in some ways, like taking a walk into the past; it is a well-known fact that the city has more listed buildings than any place in England other than London, and its greatest architectural gems are now more than a hundred years old. In the main shopping area of town, meanwhile, modern shops and chain stores still occupy grand old stone structures, lending a certain air of dignity even to the most brash of contemporary window displays or crude, brightly-coloured signage. There is one part of the heart of Liverpool that seems to have a window onto the past of a more literal kind than even close study of the city's architectural heritage can give you, however – for Bold Street, just off Clayton Square in the main retail part of the city, is famous in popular legend as the site of several alleged time-slips.

Bold Street certainly does have a long history. Originally, it was laid out as something called a 'ropewalk' – that is to say, it was deliberately made to be of such an extent that the distance from one end to the other was exactly the same as the standard length of rope used in sailing ships. Individual strands of the rope could thus be stretched out from one end of the street to the other, and then entwined together, thereby making it the perfect size. In other words, then, Bold Street was originally just a gigantic ruler or tape measure. It was first decided to erect some buildings there in around 1780, and the street was named after Jonas Bold, a prominent slave merchant, banker and sugar trader from the area (he became Mayor of Liverpool in 1802). Homes were built, largely to house the rich merchants that the city and its port were then creating in large numbers, and shops soon sprang up there too, often of an exclusive nature, leading to the place becoming known as the 'Bond Street of the North', after the famous upper-class London shopping district.[101]

Stories about time-slips in the Bold Street area (time-slips being those strange occasions when people from the present seem somehow temporarily to travel through time, usually to the past, before then returning back to the modern day) have years become classic

and well-known legends in Liverpool over the past fifteen or so. You can pick up local newspapers and come across an account of at least one such alleged experience most years nowadays, it appears. But how did such extraordinary tales get started? And can they really be true?

The most famous such Bold Street story concerns an off-duty policeman from Melling (a village near Sefton) named only as Frank who, together with his wife Carol, was spending one Saturday afternoon shopping in Liverpool city centre. Carol went to Dillons bookshop to buy a copy of *Trainspotting* by Irvine Welsh while her husband took a stroll up to a record store in Ranelagh Street to get himself a CD. About twenty minutes or so later, Frank returned to meet his wife at the bookshop but, as he came up to Bold Street, the area seemed to have become strangely quiet. He was then nearly knocked down by a 1950s-style box van, which beeped its horn at him as he tried to cross the road. This vehicle had the word 'Caplan's' written across its side. The presence of the traffic in this area rather surprised Frank, as Bold Street has, in recent years, been essentially pedestrianised. Going up to the bookstore, Frank was surprised to find that it was no longer there; instead, its front window showed a display of handbags and ladies' shoes, and the name 'Cripps' was written on the signs over its two entrances. At this point, Frank noticed that all of the people around him were dressed in old-fashioned clothes from the 1940s or '50s, which really disturbed him.

Then, suddenly, Frank noticed a young girl, aged around twenty or so, wearing modern clothing (hipsters, whatever they might be, and a lime-green coloured top) walking into the Cripps store holding a Miss Selfridges bag. He followed her in, relieved to encounter somebody else from his own timeframe, and the interior of the Cripps store changed 'in a flash' to the inside of Dillons bookstore, just like it should have been. Frank went up to the girl, grabbed her by the arm, and asked her if she too had seen what he had. Apparently, she had; she said that she had thought that it was a new clothes shop that had just opened, and had gone inside to have a look, when she then realised to her intense disappointment, philistine that she was, that it was now just a bookshop. She laughed, shook her head, and walked away. Frank then found his wife and, as far as we know, spent the rest of his life living happily in modernity.[102]

This story has become fairly celebrated since its publication in a 1997 book about Liverpool mysteries by a well-known local author and media personality, later being given further outings in the press, online and on regional radio shows, too. It has been retold many times. For instance, an article about time-slips in the *Liverpool Daily Post* of 30 October 2003 recounts what is essentially the same story, but with numerous minor alterations. For one thing, it now appears that the experience actually occurred in 2002, and that Frank had travelled back in time not in Dillons bookshop, but in Waterstones, which took over the premises in 1998. For another, Frank apparently no longer wanted a CD from a shop in Ranelagh Street, but instead became momentarily separated from his wife on account of bumping into a friend and stopping to chat to him for a few minutes. The girl with the Miss Selfridge bag whom he met also acted slightly differently in this account, not actually going into the shop, but standing outside it looking bemused and saying 'I thought they sold books here', which is actually a reversal of her motives for approaching the store in the original version – perhaps the young girl had simply decided to study harder and waste less time on fashion by the time this tale was being told? Furthermore, while the old-fashioned shop still had the name Cripps hanging over its doorway, the van that nearly ran Frank over had

The Waterstones bookstore in modern-day Bold Street. Is this unlucky individual about to step through a time portal into another dimension? Probably not, but I had my camera ready just in case.

Cardin's, not Caplan's, painted across its side. A few other details have also been added to the story in this recounting, including that most of the 1950s men Frank saw were wearing mackintoshes and hats, and the women full-length skirts and headscarves.[103]

This alteration of the tale in its telling, of course, is a classic pattern of what happens with urban legends as they are spread orally from person to person. Perhaps, before the narrative was originally recorded in print, there were other subtly differing versions of it going around Merseyside, too? In the tale's defence, however, there are certain historical details about the narrative that do add up; for instance, Cripps really was a ladies' outfitters that occupied what is now the Waterstones building in the 1950s, and there was also a Liverpool family firm named Cardin's, which operated a fleet of vans at the time. As for the original Caplan's name, there was a man named Louis Caplan, Lord Mayor of Liverpool in the 1960s, who operated a wholesale business on Soho Street, not too far away, so perhaps the name on the vehicle in the first version of the story was related to him somehow?[104] Then again, it is fairly easy to give a story a bit of historical credibility by throwing in a few references to old local firms, should you wish to do so.

Either way, the evident popularity of the original Bold Street yarn has led to several other accounts of time-slips on Merseyside being published, many of which are sensational and unbelievable in the extreme, such as the story of the shoplifter being chased by the police down Hanover Street before escaping through a time-portal back to the 1960s (18 May 1967, to be exact, as the young criminal thoughtfully looked it up for us on the front page of a newspaper)[105], and, from a little further afield, that of a man who claims to have seen through a kind of 'hole in the sky' into the future while driving across the Runcorn–Widnes Bridge, supposedly witnessing some kind of space-port filled with gigantic lenticular-shaped craft with red and blue lights on them flying around the place.[106] I could easily mention some other such unlikely-sounding tales if I wished.

Should we be *entirely* sceptical about accounts of Liverpudlian time-slips, however? Not necessarily, as there are some apparent first-hand accounts of such miracles to be found if you dig around a little. For instance, while online message boards might not necessarily be the most reliable sources of information, they do sometimes hold odd little nuggets such as the purported experience of a 'Bernadette G.', who said that, one day after walking out of Central Station, which leads directly on to Bold Street, she 'thought [she]'d walked into a film set!' as she was confronted by a scene in which cobbled streets, horse-drawn carriages and people dressed 'like the people on the Quality Street tin' were all around her. Then, says Bernadette, just as quickly as the scene appeared, it had vanished.

This posting then drew other responses from web users, such as that of a man from Runcorn who swears that, not far from Waterstones, he once saw a group of men and women 'dressed in Edwardian clothes and hats' who looked at the inadvertent time-traveller 'with slight contempt as though there was something wrong with [him]'.[107] The surroundings in Bold Street themselves did not alter to suit the Edwardian people's timeframe in this instance, however, so perhaps *they* were actually the time travellers here?

This account features an interesting postscript, though. Apparently, the witness concerned initially thought that it was most likely that the figures he had passed were simply modern people dressed up in costumes, perhaps for purposes associated with tourism or advertising. As such, he thought no more about it all, until he later encountered one of the famous Liverpool time-slip stories in a book. It could be said, therefore, that some people who have

had unusual experiences in Bold Street are simply now looking back and then reinterpreting them in order to fit in with the basic template of these newly popular narratives about local time travellers.

However, to be fair, there is some evidence that *something* odd is going on in and around Bold Street, at least if the claims made by Para.Science, an organisation dedicated to the scientific investigation of the paranormal, are true. In a 2003 interview with the *Daily Post*, Steve Parsons, a member of the society, said that he and his colleagues had received about a hundred accounts of alleged time-anomalies in the Liverpool area in the space of two years.[108] Some of these experiences dated back to the 1950s, and the vast majority of them centred upon Bold Street. Seeing as these reports came, for the most part, from first-hand witnesses, these at least could hardly just be passed off as being mere urban legends or the inventions of journalists.

Some of these accounts have been written up and placed – in anonymised form – on the organisation's website. One of them sounds similar in many respects to what is supposed to have happened to Frank that famous day outside Waterstones. According to a certain 'Mr X', he was walking down Bold Street when he noticed that the Collinsons clothing store seemed to have reopened, as its window was full of shoes and hats, as it had been prior to closing down. He also noticed that the Catchpoles model-toy shop had moved back to the other side of the street where it had been originally before moving its location a few years beforehand. Mr X then began to suspect that something was seriously wrong when he noticed that all of the noises around him were strangely muted somehow, and that everyone was wearing clothes that seemed at least ten years out of date. As he entered a bank on Hanover Street, where he had arranged to meet his wife, however, it seemed that everything returned back to normal.

Another story on the website, meanwhile, tells of the friend of a 'Mrs B.' who, one day in the 1980s, sat down on a bench that was opposite Waterstones (by which is meant what is *now* Waterstones, presumably) to eat some sandwiches, when she suddenly noticed that the sun began to dim itself strangely; she later likened this effect to a partial solar eclipse that she had once witnessed. The street, she then noticed, seemed to be unnaturally quiet, although there was another man sitting there on the bench too, very smartly dressed, as though in the fashions of the 1950s. The woman was actually able to interact with this fellow, as the two of them sat there chatting politely about inconsequential matters, as strangers sometimes do. As she took her eyes off him for a moment to put her sandwich wrapper into the bin, however, the man seemed to simply disappear. She looked around her and could see no trace of him – and, as she did so, the normally busy street filled with people again and the sun regained its ordinary brightness once more.[109]

Confusion arises in the data, however, when we consider that several accounts of supposed Bold Street time-slips seem, in fact, not really to be about time-slips at all, but simply about ghosts. For instance, it appears that a few ghostly occurrences have from time to time been reported from inside what is now the Liverpool branch of Waterstones, which is perhaps the very epicentre of the modern Bold Street time-slip stories. Apparently, one of the former staff members there once heard some unexplained footsteps in the building late at night[110] and, back when the place was still occupied by Cripps, a window-dresser in the store heard the distinctive cough of her friend the commissionaire while occupied down in the basement, at the very moment at which he died in hospital several miles away.[111]

Further tales from the Bold Street area that seem to be about 'mere' ghosts include that of the man who saw his dead grandmother making her way out of Central Station one day,[112] and the one about a group of around a dozen people who claimed to have witnessed a hansom cab pull up in the street, only for two smartly-dressed Victorian men to then get out of it and walk into a branch of Comet before simply disappearing (perhaps in response to the annoying shop assistants coming up and asking if there was anything they could help them with). Another story, about a Jack Russell terrier leaping up into the air and then vanishing instantly, 'like trick photography', would also surely have been classified as concerning a phantom rather than a time-slip had it occurred elsewhere than in Bold Street.[113] There is even one, extremely unlikely, yarn told of a child being kidnapped by a spirit and taken away into St Luke's church – a ruined structure at the top of Bold Street – which is obviously less time-slip and more ghost story in its nature.[114]Other odd Bold Street accounts, however, of people seemingly witnessing doppelgangers (ghostly doubles), either of themselves or of other people, probably deserve to be taken a little more seriously, being somewhat less sensationalist in tone than anecdotes about kidnapped children being dragged into abandoned churches. So, if something odd really is going on in Bold Street, what could it possibly be? According to Steve Parsons, of Para.Science, it could well be something to do with the fact that the nearby Central Station is part of an electrified underground railway line which loops right the way beneath the city centre; this, in combination with

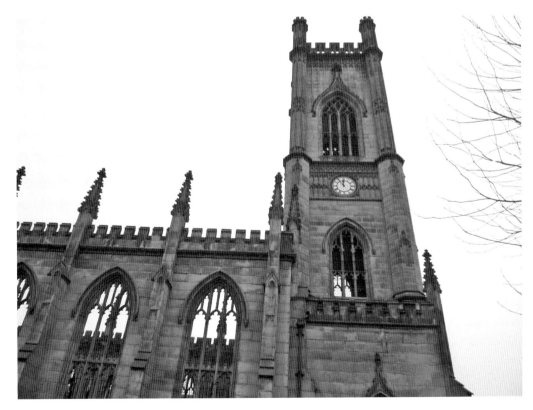

The ruined St Luke's church at the top of Bold Street, the setting for an allegedly ghostly kidnapping.

Merseyside's underlying sandstone bedrock can, he says, create something termed a piezo-magnetic effect. According to Parsons, such strong magnetic fields 'can affect the human mind and can affect time itself'.[115]

I'm not sure about the second part of that statement, to be honest, but there is much evidence that Parsons might be correct about the first assertion that he makes. What he terms piezo-magnetism is generally called piezo-electricity, and it is a genuine natural phenomenon in which electrical charge builds itself up in the crystals contained within certain substances such as rock – particularly sandstone, which contains quartz crystals – as the result of pressure and friction. If this charge builds up to a certain extent, the underground rock can actually then begin giving off detectable electromagnetic fields. In their classic 1977 book *Space-Time Transients and Unusual Events*, the Canadian scientists Michael Persinger and Gyslaine Lafrenière suggested pretty convincingly that there was a close connection between reported paranormal experiences and the underlying geology of an area, and the amount of electromagnetic influences to which it might thus be subject. Their core theory was that the build up of such forces below the earth or in the atmosphere might be the main factor behind encounters with ghosts, UFOs and so forth. But why? Well, for one thing, it seems pretty much proven by now that tectonic stresses in an area's underlying geology can produce things called 'earthlights', odd luminescent balls of energy that could easily be taken for alien spacecraft by ill-informed observers, but, just as significantly, it seems that electromagnetic fields can affect the human mind in certain strange ways, too.[116]

Persinger spent a large part of his career inducing bizarre visionary experiences within people in his laboratory, attempting to prove that the stimulation of the human brain by such fields could account for encounters with ghosts, alien abduction experiences and so forth. The results he has produced are actually pretty convincing (though are not enough by themselves to account for *all* such phenomena). Particularly interesting is the fact that he seems to have shown that the amounts of electromagnetic force needed to induce such experiences in a human subject are not necessarily as large as you might expect them to be.

It has further been suggested, of course, that the precise things a person might see when their temporal lobes or whatever are stimulated in this way would be culturally conditioned; i.e. a person would be highly likely to see the paranormal phenomena that he or she *expected* to see. Due to the new-found popularity of time-slip stories in Liverpool these days, then, perhaps the thing that people who are subjected to electromagnetic fields in the city centre are now subconsciously 'primed' to see would be time-slips or visions of people in Victorian and Edwardian dress.

Supporting this idea, perhaps, could be the frequent assertion made by witnesses in the Bold Street area that the world around them seemed at first to become 'strange' or 'uncanny' in some way in terms of its atmosphere just before their time travel began; time slows down, for instance, the level of noise in the street becomes lower or more muted than might be expected, and the light starts to acquire an odd, unnatural quality. These details could be taken as being indicative of persons entering temporarily into altered states of consciousness, prior to actually having their visions. Indeed, such a curious mental state has often been reported from persons who have encountered a variety of paranormal phenomena worldwide – it even has its own name, the 'Oz Factor', a term invented by the well-known local ufologist Jenny Randles in 1983.

An account of a man who experienced a sensation 'like stepping through a glass plate' in Bold Street before then suddenly seeing men wearing top hats saying 'Good morning' to him (a cod-Victorian image if ever there was one) sounds particularly suggestive in this respect. Another account, meanwhile, from an odd-job man who felt 'very sick and disoriented' after leaving the cafe in Central Station because 'everything around him was spinning in slow motion' before a 'popping' sound occurred and everything returned back to normal, sounds like little more than a minor medical issue – until you consider that numerous other people, presumably with no common underlying medical complaint, have also reported experiencing the exact same feeling nearby.[117] Could these have been some kind of electromagnetically induced interferences with the brain, with no attendant ghostly visions then following upon them? It might sound farfetched, but surely no less so than the notion that there is an invisible time portal nestling in the centre of Liverpool's main shopping district (although if there is, it should do wonders for tourism).

There are problems with this theory, though. For instance, I am not sure that the presence of an electrified underground railway system would definitely be adding to any potential piezo-electric effect in the area, as Steve Parsons suggested, and I don't think that any electromagnetic fields have ever actually been measured in the town centre, either. On the other hand, Liverpool's geology, being sandstone dominated, is promising, and the area is actually seismologically active. Surprisingly, earthquakes have been felt in Liverpool. In February of 2008, for example, a quake measuring 5.2 on the Richter scale hit Lincolnshire, the resultant tremor being felt all across the country, including on Merseyside, where buildings trembled and people were woken in their beds.[118] Further tremors were felt in the region in 2003, when a one-inch crack appeared in the car park of a pub in Knotty Ash, and in 2002, when a quake having its epicentre near Dudley in the Midlands was felt here too.[119]

There is a misperception that England is not a country that is bothered by earthquakes; in fact minor disturbances are not uncommon, as bodies of rock shift themselves around lightly and squeeze against one another, producing the occasional rumble in the English earth. There are numerous minor faultlines in the British Isles, including around Merseyside, just not any huge ones. While all that might be seen above ground when stresses occur at these faults would be furniture vibrating and the occasional chimney tumbling down, the amount of sub-surface energy required to produce such effects on top of the earth is still staggeringly large by human standards. Certainly, sub-surface stresses of this kind would most likely be enough to build up some level of piezo-electric charge in sandstone below the ground, and there have indeed been occasional reports of odd electricity-related phenomena from Merseyside over the years. For instance, there is an account in the Victorian journal *Annals of Electricity* of an event that occurred on a common in Liverpool on 11 May 1842, when several lines full of washing suddenly shot up into the air and then floated away across the sky, travelling *against* the wind. It has been suggested that abnormal electromagnetic currents present in the air might have been responsible.[120]

Maybe, then, there is some truth to Steve Parsons' interesting theory after all; certainly, it would be fascinating to know if there was any corresponding rise in the number of time anomalies or ghost sightings in Bold Street at times when tectonic and electromagnetic stresses could be shown to have been accumulating locally. It's an amazing thought that the very geology of Merseyside itself could somehow be implicated in the production of

the paranormal. Perhaps, then, if you are ever wandering down Bold Street and happen to encounter some smartly dressed Victorian gentleman doffing his top-hat towards you, or a fair maiden in petticoats casting you a suggestive glance, you should not get too scared, but instead simply stop and savour the moment; after all, it's not too often that a person feels the earth move for them while they're walking down a busy public street!

PART THREE

Scouse Spooks
Merseyside Ghosts, Animal Spirits, Poltergeists and Demons

It is almost obligatory in a book like this to claim that the region the author is writing about is 'perhaps the most haunted in Britain'. However, I shall refrain from doing so at this juncture. If you pick up a book about the supernatural history of Cornwall, say, and compare it to a book detailing the paranormal background of the Lake District, and then one about the ghosts and ghouls of London, and find that all three are claiming their own neck of the woods as being the undisputed 'ghost-capital of England', then it must be self-evident to even the most casual of readers that a certain amount of hyperbole is inevitably contained within such claims. Therefore, I shall be making no such remarks about Merseyside. As an area, it is in my view no more (nor less) haunted than are most others. However, this hardly means that there are no ghost stories to be told from within the region. Far from it! If Merseyside is no more nor less infested with spooks than any other given place within the British Isles, then that is surely only because there is no place in the whole country that doesn't have its fair share of poltergeists and spectres roaming abroad within it. These things occur almost everywhere, and there cannot be many communities throughout our land where at least a few such stories are not told. What follows are just a few of Merseyside's very best.

1

The Pig-Killing Poltergeist of Runcorn

Probably the best-attested and most remarkable Merseyside haunting of all time comes not from Liverpool itself, but from the smallish town of Runcorn, on the south banks of the River Mersey, just below Widnes. Here, on Sunday 17 August 1952, something remarkable wormed its way into this world and became a brief, five-minute wonder right across the globe.

This incredible entity was a poltergeist, that same kind of invisible spirit that had apparently bothered Teresa Higginson in Bootle a century beforehand. The spook's main victim in this case, however, was a seventeen-year-old lad named John Glynn, employed as an apprentice draughtsman by ICI (the old Imperial Chemical Industries) at their Weston Point establishment. He lived with his grandfather Sam Jones, sixty-eight, a widower; Sam's widowed daughter-in-law Lucy Jones; his own little sister; and Miss Ellen Whittle, an elderly lodger, in a place called Byron Street. Their house, a small corner terrace, is still in existence today, and is unremarkable in every respect – apart, perhaps, from the fact that it stands directly opposite Runcorn Cemetery. Those who feel that poltergeists are the invisible spirits of the dead may find some significance in this circumstance. Either way, Sam Jones himself had occupied the house quite happily for the past thirty-three years with no sign of ghosts ever being loose there, nearby graveyard or not. That fateful Sunday night in August 1952, however, was to change everything.

The house, evidently, was rather crowded – so much so, in fact, that John Glynn had to share a double bed each night with his grandfather; hardly ideal sleeping arrangements for a seventeen-year-old boy. Lucy Jones slept in another (single) bed in the same room, too, usually with John's little sister. This cramped arrangement was presumably made in order to allow the lodger, Miss Whittle, to have her own room, seeing as she was paying for it. The phenomena began, apparently, when the family were making their way to bed. Hardly had they settled down to sleep than they were disturbed by a scratching noise coming from inside the dressing table next to Sam and John's bed. They thought it might be a mouse, so put the light on and investigated. Finding nothing, they turned out the light and got back under the sheets again.

As soon as they had done so, though, the racket started up again. Over subsequent evenings, the noises turned into other characteristic poltergeist sounds, such as knockings

and rappings. Then, items of furniture began to rock back and forth and move around by themselves. Thinking a ghost was on the loose, Jones called the police. They could do nothing; three constables sat down on a chest on the landing, and were then promptly thrown off it by the spook. It being found impossible to handcuff a ghost, a local medium, Philip France of the Runcorn National Spiritualist church, was called in to help out instead. France went into the bedroom, claimed to communicate with a spirit, and then passed on some kind of message from it to the family. Although objects flew about while France's séance was going on, after this all seemed to calm down, and the poltergeist apparently left the house. As such, despite Sam Jones' attempts to stop the story getting out, an article appeared in the *Widnes Weekly News* for 29 August 1952, treating the whole thing as having been an odd but by now complete story.[1]

Within three weeks of the haunting initially having ceased, however, the spook was back again, and causing more trouble. It always seemed to manifest at bedtime, when the lights were switched out. Curiously, the polt had a favourite object that it liked to manipulate, too; namely that same bedside dressing table in which the mysterious scratchings had first appeared. This was rocking around from side to side, making odd noises, and its drawers flying out and across the room. By 20 September, John Glynn had persuaded an eighteen-year-old friend, Johnny Berry, to share his bed with him in order to give him courage (presumably his grandfather was sleeping downstairs now, then?). At this point the phenomena were at their height, and crowds – of more than a hundred persons – were congregating outside the Byron Street home. The great unwashed soon came up with a nickname for the ghost – namely 'Jooker', seemingly implying that the whole thing was just a fake.[2] Sam Jones, eager to show that it was not, repeatedly invited the crowd to come inside and stare at his grandson lying in bed in the dark while objects flew around him. Some of the more reliable and professional people on the scene were even allowed to stay late into the night.

The most notable such observer, it seems, was the Revd W. H. Stevens, then the Superintendent Methodist Minister of Widnes, who first visited Byron Street on the evening of Monday 22 September. He was a member of the SPR (Society for Psychical Research) and a man, initially, of a somewhat sceptical frame of mind. He was soon to become a believer in the reality of the case, however.

At around 11.30 p.m., it was decided that John Glynn and Johnny Berry should retire to bed and put out the lights. At first, all was quiet. Then, as soon as the light had been extinguished, the dressing table began to creak loudly and to shake and rock itself around. When the light was put back on it stopped immediately, and the table was found to have walked itself out from against the wall by a few feet. There were several witnesses to what happened next, as a crowd of people were gathered around by the bedroom door and extended right down the stairs. Once more, the lights went out – and once more the table moved itself forward, by about 6 feet. After putting it back in its place, Revd Stevens decided to see if the poltergeist was intelligent. 'If you can hear my voice, knock three times,' he said. The spook did not knock, but rocked the dresser from side to side violently. Immediately as the third such rock occurred, Stevens switched on his torch, expecting to find one of the boys in the act of cheating, but both lads were lying in bed with their arms tucked safely beneath the covers. The dressing table, meanwhile, was still rocking itself around, and continued to do so for a few seconds more. Going up to it, Stevens tried to make it sway himself. He found that it stood firm on the floor, and certainly would not budge of its own accord.

Soon after this event had occurred, books and a small alarm clock that had sat on top of the dressing table were flung across the room, a dictionary even hitting Stevens on the head. After this, a drawer was pulled out of the table and its contents emptied out on top of the bed. A thin cotton table runner was then ripped from top to bottom in a single tear, and a large, heavy box began turning itself over of its own accord. Worse, the boys themselves were assaulted; they had their pillows torn out from beneath their heads, and were lifted out of bed and then deposited down onto the floor – being, they said, dragged out by a force that they could not resist. Whenever the lights came on, all activity instantly ceased.[3]

Obviously, this initially sounds quite suspicious. However, the preference for operating in the dark, and especially at bedtime, is an established pattern in some – but by no means the majority – of poltergeist cases, so is not *necessarily* a sign of foul play going on. Furthermore, there is the fact that, on a few rare occasions, the Runcorn poltergeist actually did deign to play its tricks under good lighting conditions. For instance, one visitor to Byron Street, a local businessman called J. C. Davies, said that he had seen the dressing table beating itself against the wall of its own volition, very violently, while illuminated by a 100-watt lamp and three torches, albeit only for a few seconds.[4]

Generally, though, the spook did prefer to operate in the dark. So what evidence is there that the boys weren't just playing tricks? Well, for one thing, several observers said that they had witnessed unexplained pinpoints of glowing light inside the haunted bedroom while the phenomena were occurring – which is most odd, if accurately observed.[5] Unusual lights, of course, are commonly seen during poltergeist hauntings, this fact lending some credibility to the case.

In terms of the objects being thrown around, it is notable that they were hurled with such force that some of the plaster on the walls was knocked off. Furthermore, the alarm clock that was so treated eventually disintegrated under the force of the blows to which it was repeatedly being subjected.[6] In addition, the rocking around of the dressing table was so violent that it caused the plaster to fall down from the ceiling of the room below it, exposing the wooden laths.[7] However, while objects were thrown with enough power to smash through plaster and create dints in doors, whenever they hit people they did so extremely lightly, and caused no harm at all.[8] Again, this is a long-established pattern in poltergeist cases from right throughout history.

Another odd thing about the objects' flight was their frequently unusual trajectory. Upon one occasion when the lights were suddenly switched on, for instance, J. C. Davies, the visiting businessman, saw a cardboard box in suspension above the bed. Its movement was, he said, 'not that of an ordinary trajectory, but almost as if it were being carried with directional intent.'[9] Another time, a jigsaw was seen, by sudden application of torchlight, to be floating through the air at a height of seven feet while both John Glynn and Johnny Berry visibly had their hands beneath the covers.[10] This detail was frequently noticed; the boys had their arms tightly tucked inside the bed – which creaked badly as soon as there was any movement inside it anyway – and, upon one occasion, were being physically held down by other persons inside the room when the objects were flying and the dresser rocking in the dark, so it seems most unlikely that they could have been doing it all.[11]

Against this mass of accumulated testimony, however, there are some things that might lead us to make alternative conclusions about the haunting. For one, there is the account of the well-known local historian and mystery-hunter Richard Whittington-Egan, who

went to Byron Street to investigate the uproar for himself, around eight weeks after the affair had begun. In his view, 'not one' of the phenomena that he witnessed there, which included knockings, objects being thrown about and the famous rocking dresser, 'was of such a nature that it could not have been perpetrated by human agency from the bed'. Even worse, Whittington-Egan testifies that 'a sudden sharp stabbing ray' from his torch upon one occasion illuminated the extended arm of John Glynn 'being swiftly withdrawn' from the direction whence a 'spirit rap' had just rang out. Once he had observed this incriminating sight, says Whittington-Egan, the poltergeist 'appeared to be somewhat uncertain of itself' and the phenomena began to tail off.[12] This, apparently, is damning evidence.

Whittington-Egan was not the only visitor to Byron Street who witnessed an apparent act of fakery there, though. On 26 November 1952, W. H. Stevens, J. C. Davies, three journalists and a local pub owner turned up at the house and were let inside. While they were outside the bedroom, a noise was heard. The publican and one of the reporters crept up silently to the door and, in the light of their torch, saw Sam Jones banging a book on the wall three times before then throwing it away. When caught out like this, he simply replied that he had just found the book deposited down on his bed from who knows where, and had responded to this fact by tossing it across the room in anger. Clearly, however, this was definite evidence of skulduggery having taken place.[13]

However, how much do these events, taken in themselves, invalidate the rest of what is supposed to have happened in the haunted house? After all, the pattern of genuine phenomena gradually petering out and then being replaced with fraudulent events is a commonly noted one within poltergeist studies. If people turn up expecting to see something and then see nothing, then it often makes poltergeist victims feel like fools or liars. They don't wish to disappoint visitors, and so produce false book-throwings where once there were genuine ones – or so the theory goes. At Byron Street, the ghostly occurrences had begun to fade away sometime in October – way before 22 November, when Sam Jones threw the book, and probably before Whittington-Egan had made his visit to the house, too. Maybe the family just didn't want to let down their guests?

In any case, not every opportunity for fraud was taken up by the Byron Street residents. On 23 October, for example, the BBC paid the family a visit, and set up cameras in the bedroom. They rigged up an unsteady table from the remains of the dresser, which by this stage had been entirely demolished by the spook, and put various items up on top of it for the ghost to throw. Berry and Glynn were then placed behind this table, the adults stood some way away and the lights were put out, creating perfect conditions for fraud, the BBC, presumably, wishing to make absolutely certain of getting their film footage. Nothing, however, happened. This was perhaps a shame, as the lodger, Miss Whittle, had fallen down a nearby quarry and died the previous night, providing an ideal opportunity for her disembodied spirit to return to the house. And yet, embarrassingly, it didn't.[14]

Was Sam Jones just sick of being made a fool of in front of outside observers in this way when he threw his book across the room that night one month later, by which time all the genuine phenomena had entirely ceased? It must remain a possibility, surely. Jones had made efforts to prevent the media from getting involved initially and, once he had failed in this task, perhaps he felt obliged simply to go along with it all. It appears, indeed, that the local press actually *wanted* him to act in this way somehow. It is notable, after all, that the journalist who saw him throw the book made no attempt to quiz him about the matter,

having no desire to bring an interesting story to its end, or to antagonise one of its main players.[15] Even by the time that Whittington-Egan had paid his visit, perhaps around the week of 10 October, the poltergeist had largely wound itself down; despite the fact that, as the investigator left the house in the small hours, there were still some sightseers huddled outside in the rain directly beneath Glynn's bedroom window, and a pair of tired police officers pleading with them all to just go home to bed.[16] Furthermore, the story had spread abroad, and created international interest. The family even received a letter from as far afield as Germany, enclosing a helpful formula for exorcism. Sadly, however, the envelope had been tampered with in the post, and one of the pieces of paper containing part of the formula was missing, rendering it useless.[17] People all across the world, then, were eager to hear more news of the now famous Runcorn poltergeist. Having to live and sleep under such conditions of pressurised expectation, perhaps it is no surprise that John Glynn and his granddad eventually felt the need to try and resort to fraud after the poltergeist had actually gone away, then?

However, there ar some further sensational events associated with the case, which we have not so far mentioned, that only make the true story even harder to fathom. Sam Jones was a farm labourer working for a certain Harold Crowther of Pool Farm, on nearby Heath Road. This farm, too, was haunted, just like the house in Byron Street was – and the events there had broken out at almost exactly the same time, namely on 10 August, when Crowther saw a ghostly figure resembling his wife's dead father wandering around the place. Not long afterwards, he found that three of his pedigree pigs, for no apparent reason, had simply lain down and died.[18]

Within a fortnight, all of Harold Crowther's pigs were dead – fifty-three of them in total. Five vets examined the bodies, and could discern no plausible cause of death. Had a ghost killed them? Crowther soon saw something that led him to believe that this was indeed the case. It was, he says, 'a large black cloud about seven feet in height, shapeless except for two prongs sticking out at the back', which he saw floating around outside by the pigsties. Three days later, Crowther's wife witnessed the same thing. A few weeks afterwards, Harold Crowther saw it again; this time in his kitchen. He claims that he rushed past it heading for the light switch, when he felt its two prongs, which were 'solid, like blunt sticks', going for his throat. As soon as he switched the light on, however, the thing disappeared – just as the spook at Byron Street did whenever the lights went on. Indeed, remarkably, according to Crowther, this black cloud then showed up at Byron Street itself, where it was seen (by Crowther) hovering above John Glynn's bed. Crowther said that he had seen the thing for the last time on 13 December 1952, when he let his two farm dogs loose on it. They jumped up, snapping and snarling, as it rose into the air and simply disintegrated. This time, it was lighter in colour and much smaller than it had been upon the previous times he had observed it. Apparently, this sighting of the cloud coincided with the concluding trick of the poltergeist at Byron Street, which, we are told, announced its final departure by folding up the carpet in the bedroom.[19]

Can we believe all this? Well, remarkably, livestock have allegedly been killed by poltergeists before, most notably at Binbrook Farm near Grimsby in 1904/05, a haunting that we looked at briefly earlier. Here, as well as the servant girl bursting into flames, a ghost also seemingly caused a number of the farm's chickens to be killed in a bizarre fashion. Apparently, out of some 250 fowl, only twenty-four were ultimately left alive. All the others

Harold Crowther is confronted by the Runcorn poltergeist and its deadly, pig-killing prongs.

had been slaughtered in the same weird way, the skin on their necks having been pulled off and their windpipes snapped. No natural predator, of course, kills its victims in this fashion and then leaves them uneaten, and furthermore many of the deaths occurred when the chicken coop in which they took place had been placed under strict surveillance.[20] If a polt can kill chickens, it might be said, then there's surely no reason why one could not slaughter pigs as well.

Even the appearance of poltergeists in the form of black clouds and mists is not unique, although it is exceedingly rare. There was a case from Scotland in 1695, for instance, wherein, among other phenomena, a spectre resembling a big black cloud manifested in a barn while some farm workers were saying prayers and began to hurl barley chaff and mud into their faces. It gripped some of them so hard around their arms with its own smoky appendages that, apparently, for five days afterwards their limbs remained very sore.[21]

Furthermore, there is the added detail that the cost of the damage that was ultimately caused by the Runcorn poltergeist was estimated at £20,000, a very large sum for the day, most of which must, presumably, have been accounted for by the killing of Mr Crowther's prize pigs rather than the ultimately petty damage done at Byron Street.[22] It is extremely unlikely that the farmer would have half-bankrupted himself only in order to add some weight to his ghost story and it does appear that the pigs really did die, so this too must be considered a detail in favour of his claims.

However, it does seem slightly suspicious that seemingly all of the most remarkable incidents in the Runcorn case were witnessed only by Crowther. As you might expect, for instance, he was a regular visitor to his employee Sam Jones' home once he had heard what was going on there. While in the haunted bedroom, Crowther says, he was the only visitor who had been able successfully to communicate with the ghost (if you exclude the medium Philip France who had turned up at the outset and claimed to have had a nice chat with it, that is). Apparently, Crowther went into the room, placed his overcoat on the dressing table and told the poltergeist 'If you don't want it, give it back to me.' It immediately did so, and he replaced it back on the dresser, the coat being hurled back at him three times in succession. Then, after he had seen a drawer thrown out from the dresser, as usually happened, he sarcastically shouted out 'Why not put them back for a change?' Flashing on his torch, he claimed to have seen the drawer wriggling its way back towards the dressing table, as if it were alive.[23] If he was telling the truth about these matters, then we might almost be justified in suspecting that Crowther was the poltergeist focus in this case as opposed to young John Glynn, as most commentators have traditionally supposed.

A 'poltergeist focus', we will remember, is the technical name given to the person around whom the ghost's activities most frequently occur. As we saw earlier with Teresa Higginson, some people have proposed that something known as RSPK, a kind of psychic force emanating from within the mind of the focus, actually causes all of the polt's tricks, without the victim's conscious knowledge of the fact. It has been theorised that the focus, placed in some kind of intolerable position at home, work or school, bottles up their frustrations and then gives vent to them unconsciously by unleashing the poltergeist upon the world in order to lash out at it. I don't think that this theory fits all the cases on record, myself, but it certainly seems relevant to some. The case of the Runcorn poltergeist surely fits into this latter category.

Most persons who have written about the case have agreed that John Glynn was the most likely candidate for being the focus at Byron Street. This seems plausible, as his tense

mental state was commented upon by several contemporary witnesses at the time. For instance, a police constable called out to the haunted house by Sam Jones right at the start of the outbreak was of the opinion that Glynn was 'in a state of nervous collapse' when the whole thing began.[24] You could say, of course, that this is quite a natural reaction for a seventeen-year-old boy to have when he finds out that there is a poltergeist in his home, but it appears that there were certain mental irregularities about the boy even after the haunting had come to an end. In January 1953, only a few months after the ghost had disappeared for good, Glynn left Runcorn to complete his National Service. However, while away with the Army, it appears that he had some kind of nervous breakdown, and military physicians recommended his discharge.[25] Furthermore, while the haunting was still ongoing, friends and family began to take note of the evident strain and stress that was being placed upon the lad, and became worried for his welfare. Accordingly, distractions and treats were organised for him, which did not always pan out too well, sadly. Upon one occasion, for instance, some family friends invited John to a garden party at their home in nearby Frodsham, which he gladly attended. The hostess was pouring him out a nice, cool glass of lemonade when, for no apparent reason, the glass simply shattered in her hand. Bizarrely, not a single drop of the lemonade fell onto the floor; instead, it all jumped out of the glass and landed over John himself, drenching the poor boy and, presumably, only heightening his own self-consciousness about the matter even further.[26]

It seems safe enough to say, then, that John Glynn was not his usual self at this time. But why? Possible reasons for his mental stress are not too hard to find. For one thing, as already alluded to, he had his National Service coming up. It seems that Glynn was a serious, quiet and studious young boy, exactly the type of kid who would not exactly have relished being taken away from home to be shot at by foreign insurgents in Cyprus, Kenya or Malaya.

We can also presume that there were some underlying stresses present in his usual homelife, too. We will remember, for instance, how crowded the bedroom at Byron Street was at the time, and that Glynn had to share a double bed with his elderly grandfather. This kind of situation is hardly healthy, and perhaps some significance can be found in the fact that the phenomena initially began to manifest themselves when the two men were in bed with one another. Could it all have been a form of unconscious psychic protest by the boy against his sleeping conditions? It is noticeable that, as the case went on, Sam Jones seemed to have stopped sleeping in the same bed as his grandson, his place being taken instead by the boy's good friend, Johnny Berry. In addition, Glynn's little sister was farmed out to stay with others during the haunting, freeing up a little more sleeping space in the room, too. When the lodger Miss Whittle died by falling down the quarry, I suppose that another bed must then have been freed up temporarily, as well. Perhaps it is significant that, as more and more sleeping space was freed up in the house, the phenomena began steadily to decline. Possibly the fact that the poltergeist's final action was to roll up the carpet had a kind of symbolic significance to it, too; expressing, perhaps, some kind of conflicting feelings Glynn had about leaving his cramped home for a while, but only in order to then have to complete his dangerous National Service.

No doubt to some readers this proposed explanation for affairs will seem somewhat unlikely and overly elaborate. Maybe it is. Also, it doesn't really explain what went on with the pigs on Harold Crowther's farm. But, then again, something strange certainly happened in a small house in Runcorn in 1952, and there has to be some explanation for it all ... doesn't there?

2

Poltergeists Over Merseyside

Over the years, dozens of reports of poltergeist activity from right the way across Merseyside have made the news headlines too, however, and not just the 1952 Runcorn case. For instance, in Penny Lane, as all Beatles fans know, there is a banker with a motorcar and so on – at least according to the famous song lyrics – but how many people realise that there was once also a poltergeist lurking there, too? Number 44 was the epicentre of the haunting, which took place in 1971 when the building was being used by a printing firm called Xerolith, owned by two local businessmen named Ken Shackman and John Hampton. When they left the shop empty overnight, loud sounds were heard coming from inside – footsteps, bangings and so forth – which eventually became so bad that the neighbours complained. One weekend, the noises were of such a volume that locals called in the police, thinking that vandals were destroying the shop. Upon gaining entrance, however, the plods found that the building was in fact empty.

An explanation was needed. As such, floorboards were ripped up, and walls and furniture checked for rats and mice – but none were found, so Shackman and Hampton sat up all night with a tape recorder in the house next door, to try and hear the disturbances for themselves. They succeeded in doing so; banging and shuffling sounds were heard, and the walls were hammered upon so loudly that they actually began to vibrate. Upon checking the recorder after the noises had ceased, the two men found that they had succeeded in capturing the polt's rampage on tape; meaning that they were definitely real sounds, rather than simply psychological in origin. Eventually, though, as so often happens in such cases, the noises began to reduce in volume and eventually ended up fading away into nothing.[27]

Penny Lane is not the only poltergeist-haunted street in Liverpool that has Beatles connections, however. Not too far from Princes Park lie rows of old Victorian terraces known collectively as the 'Welsh Streets', on account of the fact that, not long after they were built in the 1880s, an influx of Welshmen came and settled there in order to take up work at the then-thriving docks. One of these is called Madryn Street, and it was here, at No. 9, that Ringo Starr (then still just plain old Richard Starkey, of course) came into the world on 7 July 1940, continuing to live there until the age of four.

More significantly for our present purposes though, in late 1992 Madryn Street was also revealed to be the home of a somewhat malicious sounding poltergeist. The terrace in question was owned by the Liverpool Housing Trust, and its tenants at the time were Anthony and Alison Santos and their children Tracey, three, and baby Tony, aged sixteen months. For more than a year, they said, following on from the birth of Tony in September 1991, they had been plagued by ghostly activity at the address. The washing machine was bounced across the kitchen, cash was stolen and hidden away, objects were smashed, and cupboard doors opened of their own accord. Much more sinisterly, perhaps, the poltergeist also made an attempt to smother Anthony while he was lying in bed, and baby Tony was thrown out from his cot by unseen forces.

Scared, the Santos family called in Father Tony Wright, of the nearby Our Lady of Mount Carmel church. Visiting the Toxteth terrace, Father Wright witnessed a large glass ashtray sliding across a table and then shattering on the floor, seemingly all by itself. He was quoted in the *Liverpool Echo* as feeling that 'there is a physical presence in the house'. Backed up by this testimony, Anthony and Alison approached Liverpool Housing Trust and asked to be temporarily rehoused for a week while an exorcism took place in their Madryn Street home. Despite the fact that exorcisms do not generally last for a whole week, the Council agreed, spending £700 of taxpayers' money putting the family up at the Jamaica House hotel on Dale Street in the city centre. In their absence, Father Wright blessed the house, and a spokesman for the Council defended their actions, saying that the family were genuinely terrified, and needed help. However, when the Santos clan returned from their subsidised sojourn at the hotel, they said that the ghost was still present, Alison Santos claiming to have felt it touching her. Another appeal was made to the Council, and the family were offered different accommodation nearby, new tenants being lined up to move into the Madryn Street home instead. However, Liverpool Housing Trust, eager not to be seen to be providing their tenants with an easy excuse to request to be rehoused, now denied that their actions had anything to do with poltergeists, in which they seemingly did not believe. 'There is nothing wrong with it – it is just an ordinary terraced house,' Andy Barrett, a Trust spokesman, was quoted as saying. He claimed instead that the family were simply being moved on the advice of Social Services (who did apparently officially believe in poltergeists, then!).[28]

The (mildly) violent and threatening nature of the Toxteth poltergeist, however, is not entirely without parallel in Merseyside history. Nor, indeed, is it the only Liverpool spook to have chased people from out of their homes. For example, there was once a case that came to be known as the 'Stoneycroft Horror', after the suburb in the east of the city where this particular haunted house was located. Apparently, a widow named Mrs Birrell owned the home and rented it out to lodgers, some of whom were bothered by the sound of phantom footsteps, creaks and groans coming from out of thin air itself. On one occasion, Mrs Birrell was caused to faint by the appearance of a glowing yet transparent apparition that manifested before her on the stairs before then disappearing through a wall. As this event occurred, apparently, all of the lights in the house flickered spookily. In all, as many as ten tenants were caused to leave Mrs Birrell's lodging house by the activities of the spook, which can hardly have been terribly good for business, all things considered.[29] A more modern polt that wanted to turf residents out of their home, meanwhile, was reported on in 1996, when it emerged that a house in Hunts Cross near Woolton was allegedly being haunted by the ghost of a former railway worker, who supposedly pushed

Poor baby Tony is hurled out of his cot by the Toxteth poltergeist.

the mother of the household down the stairs and also scrawled 'I want you out!' on a blackboard there.[30]

Sometimes, though, it is not poltergeists *per se* that have forced Liverpudlians out of their homes, but, rather, the senseless actions of those idiotic human beings who torment people who happen to find themselves being haunted by one. In Speke in June 1986, for instance, a mother and daughter, Shirley and Elizabeth Kane, began experiencing poltergeist phenomena in their council house. Furniture and various other items, including a television set, started picking themselves up and then smashing against walls. At one point, a hammer flew across the room and narrowly missed hitting a neighbour in the head. Another time, a priest called in to perform a blessing, Father Paul Montgomery, was so scared by what he saw there that he ran away down the stairs, handed over a bottle of holy water and escaped, declaring 'I'm off, it's beyond me!' After the story hit the press, astonishingly, several local residents decided that the Kanes must have been 'evil' or 'witches', and mobs congregated outside, throwing stones at their house. Several windows were smashed, and the family had to be given police protection – and all this, shockingly, in the late twentieth century.[31]

The most recent instance of people being forced out of a home on Merseyside by a poltergeist occurred in 2011, when French musician Jean-Marc Mariole and his wife Charlotte revealed to the world that the flat that they had bought above a butcher's shop in Frodsham was haunted. Events began just four weeks after they had moved in during April 2010, when stamping noises were heard and 'flying blobs' seen around the place. Apparently, bedsheets were even witnessed levitating, and 'orbs' captured on video. (Orbs are 'mysterious' spheres that often show up on cameras at supposedly haunted locations. Some people think they are spirits, but they are actually merely dust and pollen particles reflecting light back into the camera lens) More convincingly, upon one occasion, Charlotte says that she was in the bathroom when the door suddenly slammed shut behind her. Then, the shower curtain began sliding back and forth along its rail by itself. The door remained fast-shut, no matter how hard Charlotte pushed on it, and she resorted to trying to soap up the lock to get out. When this did not work either, she had to call for help from neighbours. Furthermore, black silhouettes appeared on the walls and screaming sounds were heard at night. The most characteristic type of disturbance, however, came in the form of loud and incessant banging noises that broke out when the couple went to bed, forcing them to evacuate their home and seek refuge in a nearby Holiday Inn, where they ended up racking up a bill of £3,000. Their savings running out, the Marioles eventually resorted to sleeping outside in their car. Worse, said Jean-Marc, the poltergeist was ruining their sex life with its constant disturbances![32]

It is not only private residences on Merseyside that have been troubled by poltergeists, though. Public buildings and workplaces, too, have seen their fair share of weird goings-on over the years. For example, there used to be a building in Quarry Street in Woolton that was used as a training centre for ambulance workers. Prior to 1967, however, this training centre was owned by the police, and was long-reputed to have been haunted by a former copper nicknamed 'the Sarge', who had supposedly been killed many years beforehand when the wheel of his wagon had struck some kind of bollard, hurling him down to the ground.

Whatever the truth of this tale, there were genuinely poltergeist phenomena present on the site. Phantom footsteps, doors opening and closing by themselves, and windows shattering of their own accord were all reported by trainees using the building. However, perhaps the

most notable poltergeist occurrence from the place happened years beforehand, and was told to the press by a seventy-five-year-old retired policeman, Jack Elsworth, whose father had been station sergeant there during the later years of the nineteenth century. Jack, it seemed, knew all about the old Woolton Police Station – indeed, he claimed to have actually been born there! In any case, the strangest tale that Jack's father had passed down to him about the building concerned a corpse that had been laid out beneath some tarpaulin and placed under lock and key overnight in a back room. The next morning, when the room was unlocked, the dead body was found somehow to have moved itself down from its slab and onto the floor, still covered up in its protective sheet. Other unusual happenings in and around the building included a horse being uncoupled from the shafts of its cart outside when nobody was near it, and a Union Jack vanishing from its usual place high atop the station flagpole, only to later reappear in St Helens, several miles away.[33]

St Luke's church at Sankey Bridges, Warrington, (now a furniture warehouse, sadly) was also once allegedly haunted by an invisible ghost. Here, around 1908, some unseen entity apparently began displaying that characteristic sense of humour so often found with poltergeists, by bursting out laughing during services and interrupting the vicar in full flow. In particular, this ghost – christened 'Shaver Jivvens' by the locals, after a jovial local barber whose constant laughter had only been put an end to by his death in 1905 – had a particular thing against weddings, saving his loudest guffaws for such events. Upon one occasion in 1916, so it is said, a soldier was marrying a girl from Widnes there and, when the vicar asked the usual 'do you take this woman to be your lawful wedded wife?', Jivvens burst out with an especially loud peal of mirth, leading to the vicar threatening to bring a halt to proceedings if the joker did not surrender himself. After it was all over with, it seems, the two annoyed families of the happy couple then engaged one another in a mass brawl outside, thereby ruining the day for all.[34] I don't know if this story is actually true or just local folklore, but it's certainly a funny little story either way.

Another public building supposedly haunted by a poltergeist is the Boat Museum in Ellesmere Port, on the south bank of the Mersey. Opened in 1976, the museum is located on the site of the old Shropshire Union Canal, which once took goods up to the Mersey to be transported across to the Liverpool docks, and is well worth a visit if you're at all interested in boats (but probably not if you aren't). The docks, buildings, locks and other facilities of this now-disused waterway, which finally closed in 1968, have all been adapted into a place of displays and exhibitions by the museum's staff. It is a place, then, where the past is still alive – especially, it seems, in terms of its ghosts. Rumour has it that the spirit of a former night watchman at the canal in the 1950s, called Arthur Jones, haunts the site still. Maybe he does. Certainly, there appears to be *something* odd present on the site. During an all-night vigil held at the place by some ghost-hunters on 14 October 1995, for instance, it seems that the sound of doors slamming and phantom smells of old industrial products like soap, sulphur and creosote were experienced. Far more dramatically, though, one of the ghost-hunters was picked up by an invisible poltergeist-like force and hurled some 6 feet across an old converted warehouse into a plate-glass panel, leaving him so shaken that he never went on another ghost-hunt again in his life.[35]

No doubt the most notorious public building on Merseyside to have found itself being bothered by poltergeists, though, was the old Palace Hotel in Birkdale, now a suburb in the southern part of Southport. This place was built in 1866, and finally demolished over

100 years later, in 1969 – which was when the most interesting phenomena were recorded, as we shall see presently. The hotel, it seems, had a particularly tragic history down the years. For one thing, the hotel's architect, William Mangnall, allegedly committed suicide by jumping from the structure's roof after he had accidentally caused it to be constructed facing the wrong way round. Perhaps unsurprisingly, however, this particular tale is wholly untrue, Mangnall actually having died of natural causes around 1868. Some horrible things really have happened at the Palace, though. In 1961, for example, the body of a six-year-old Southport girl, Amanda Jane Graham, was found hidden beneath a bed in one of the rooms. It turned out that she had been murdered by one of the hotel porters, who must have been some kind of sex offender. During the Second World War, meanwhile, the place was commandeered by the authorities and used as a rehabilitation centre for injured US airmen. Worse, after a nearby shipping disaster on 9 December 1886, thirteen local lifeboatmen from the area had drowned trying to rescue the crew of a stricken vessel, the *Mexico*, which had been driven onto the beach at Ainsdale and was thus in danger of being wrecked. The lifeboatmen were sent out but their boat, the *Eliza Fernley*, was capsized by a sudden wave, with only three survivors making it back to shore, one of whom, John Ball, died later in an infirmary. Taking into account the lives of the crew lost from the *Mexico*, twenty-eight people died off the Southport shore that day. The dead, water-filled bodies of the lifeboat crew were recovered and brought back to dry land, being laid to rest temporarily in the pub that at that point adjoined the Palace Hotel, in later years known as the Fishermen's Rest in recognition of those who lost their lives at sea that day. The hurried coroner's inquest into the affair, meanwhile, took place in one of the rooms of the hotel itself. Calamity has been a major component of the Birkdale Palace Hotel's history, then.

By 1969, however, it was slated for demolition. A foreman named Joe Smith won the contract to pull down the building, and he arrived there in April with his ten-man team of wreckers. They intended to take advantage of the fact that the building was a hotel and still partially furnished by sleeping out there overnight until the job was done. However, it was not long before the men began being disturbed by spooky phenomena. First of all, they started hearing footsteps, some of them apparently coming from high heels, and voices being raised in argument from within the empty bedrooms upstairs. However, it later turned out that this disturbance was not being caused by ghosts at all, but rather by some adventurous local couples who had decided to sneak into the building after dark and have sex with one another.

Then the hotel's lift began malfunctioning, starting up all by itself – which was nothing too unusual, perhaps, just faulty electrics. Thinking along these lines, Joe Smith cut the hotel's electricity off, seeing as the lift's activities were making his men a little nervous. No good, however. Still the lift kept on working, going from floor to floor with its lights flashing and doors opening. A man from the electricity board was called in and confirmed that there was no power in the building; it should have been impossible, then, for the lift to be going anywhere at all. Next of all, Smith and his men tried putting a kind of brake on the lift, and removed the emergency winding-handle from it as well, so that it couldn't be used at all. Still, though, the elevator worked. When it had gone up to a higher floor one day, the workers decided to fix the thing once and for all by cutting its cables. This having been done, the lift should, quite naturally, have fallen down to the bottom of the shaft as there was no longer anything there to be holding it up. However, it did not. It simply sat there, suspended in mid-air inside the lift shaft, in seeming defiance of the laws of physics. After

twenty-five minutes of the men banging on top of it with sledgehammers and producing not the slightest effect, suddenly the spell was broken and the lift hurtled down to the bottom of the shaft with such speed that it crashed through and buried itself 4 feet deep in the cellar floor. Eventually, the workmen became so scared of the things going on in the hotel (they kept on waking up in the morning only to find that they had been locked inside their rooms overnight, for example) that they elected to stop sleeping out there and started working during daylight hours only.

This, it seemed, was a mistake, as various acts of vandalism then began to take place inside the property at night. Windows were broken, fires started up and iron balustrades and other items destroyed. This was bad for business, as the demolition men had been intending to sell on much of the furniture and ornamentation. In May, 200 removed doors, stacked very neatly and awaiting sale, were hurled over a balcony one evening after everyone had gone home, costing Smith and his pals hundreds of pounds in potential profit. Human vandals?

The infamous haunted lift at the Palace Hotel in Birkdale, which worked of its own accord.

Very probably, but given poltergeists' well-known penchant for smashing things up and creating chaos themselves, we might be led to wonder.

Supposedly, other phenomena occurred at the place too. For example, one source claims that Southport Police received a phone call coming from inside the hotel one night after the workmen had left, in which a female voice pleaded for help as she had been trapped inside there after dark. Upon arrival, though, the police found that the phone lines had all long been cut, rendering this feat impossible. Other people, meanwhile, speak of the phantom of a little girl (perhaps the murdered Amanda Jane Graham?) being seen around the building before any demolition work had even begun, while the hotel was still in business.

Today, the only part of the old Palace Hotel that remains is The Fishermen's Rest, now an independent pub on Weld Road. This too, it seems, is haunted. Shadowy forms have been seen walking about there by the bar staff and, apparently, the apparition of a little girl has been witnessed, too – maybe the young murder victim again? The usual highly subjective phenomena – cold spots being sensed, people feeling that they are 'being watched' – are spoken of as having occurred inside The Fishermen's Rest as well, though these, of course, are proof of precisely nothing. However, while it is undoubtedly the fact that some embroidering of the tale of the haunted hotel has taken place over the years (after the affair with the lift had occurred, the local myth about the death of the hotel architect shifted in order to fit in with it by claiming that he had jumped down the lift shaft instead of from the building's roof, for instance), it does seem that there really was a poltergeist present on the spot back in 1969 while demolition work was taking place.[36]

Probably the most nationally well-known Merseyside location to be allegedly haunted by poltergeists, though, is Brookside Close, the *cul-de-sac* made famous by the former long-running Channel 4 soap opera *Brookside*. This is a real place, and was until recently still rented out as a film set for *Hollyoaks*, *Grange Hill* and various other programmes that I am pleased to say I have never watched, although today it consists purely of private residences. In 2008, though, filming was taking place there of a low-budget horror movie called *Salvage* (no, me neither), when the actors, director and other people on set claimed to be being bothered by ghosts. Supposedly, they dubbed the place 'Spookside', and alleged that lights were flickering out for no reason and objects such as photographs were going missing off set, being pinched by polts. Apparently, every time that the actors and cameramen went into some nearby woods to shoot the final scene they were scared off by sudden winds and dark clouds. Somehow, the media implied at the time, the deaths of seventy-two of *Brookside*'s entirely fictional characters during its twenty-one-year run (an unrealistically high mortality rate even for inner-city Liverpool) were responsible for the 'haunting'. Obviously, there has to be a very strong suspicion that this particular poltergeist was invented by the film-makers purely for publicity purposes, in order to promote their obscure little film. Clearly, it didn't work.[37]

Perhaps partially because of rubbish like this, official attitudes towards the existence of poltergeists are generally somewhat sceptical in their nature. For instance, in March 2010 a man from Skelmersdale who was babysitting for a friend called the police asking for help as, he said, a poltergeist was 'trying to kill' him. He described objects in the house flying around, walls moving, smoke and condensation filling the room, and water falling from out of a ceiling. Upon investigation, though, police officers decided that there was no polt on the

premises after all but, rather, that the man was either mentally disturbed or had taken some drugs earlier that evening – a highly suitable person to let babysit for you, clearly.[38] Maybe this assessment was indeed correct; but can poltergeist cases as a whole be dismissed quite so glibly? I think not. In my view poltergeists are real, and they have been encountered on Merseyside just as much as they have anywhere else

3

The Lady Vanishes

Poltergeists are not the full story as regards Merseyside's ghosts, however. Those weird spectres commonly known as White Ladies (although other colours of Lady are available, as we shall soon see) are also regularly encountered in the region, too. Speke Hall, a well-known Tudor mansion located in the south-east of Liverpool, is the home of perhaps the most famous of these female wraiths, the notorious Grey Lady. This place is very old; construction of the current hall began in 1530, although there were other buildings on the site previously, some of which have been incorporated into the manor house that stands there now. With the white and black oak frames and decorations so typical of the period, the place is now owned by the National Trust and as such is open to visitors. There is much to see there. The hall was, in the past, the seat of the Norris family, Roman Catholics who allowed priests to secretly hold masses there under the Protestant rule of Elizabeth I, when such practices were liable to get you burned at the stake. The hall has features such as a 'priest's hole', where the cleric could hide in order to evade detection, a secret observation post built into a chimney so that people could keep watch for potentially dangerous visitors, and an eavesdropping hole that was intended to allow the conversations of persons approaching the front door and awaiting admission to be overheard from inside. Within the grounds, meanwhile, are two yew trees, known as 'Adam and Eve', believed to be somewhere between 500 and 1,000 years old.39

In addition to these particular tourist attractions, however, there is another – the resident ghost, generally known as the Grey Lady, though sometimes her colour is said to be White. The most famous appearance of this phantom was supposed to have occurred during a dinner party being given by a Miss Adelaide Watt, the hall's final private owner, who inherited it in 1878 aged twenty-one. The precise date that the Grey Lady was apparently sighted is unknown, but, supposedly, it was observed by Miss Watt and all of her guests, who tried (unsuccessfully) to speak with it before it simply floated away and disappeared through a wall. More recent sightings of the fabled Grey Lady seem to be scarce indeed, however. Instead, rumours about cold spots and the sound of unseen children crying are about as elaborate as modern tales from Speke Hall get. References to a ghost being present there

– particularly within the hall's Tapestry Room – do go back a century or more, however, with the account of a Miss Adelaide MacGregor, who claimed to have seen a translucent figure walk across the room before passing straight through a wall next to a window, being perhaps the most significant. Apparently, subsequent investigation of the spot where the lady vanished revealed that there was a secret passage leading out through the wall and into the grounds.[40]

Those, at least, are some of the stories about the place; whether they are actually true or not, I have no idea. But if there is a ghost wandering around Speke Hall, who is she? Stories differ. The most commonly cited identity, however, is that of Lady Mary Beauclerk, the daughter of the Norris family, who held the hereditary rights to the hall. Lady Mary married a man named Lord Sidney Beauclerk, the son of the Duke of St Albans, in December 1736. Due to this event, ownership of the hall ultimately passed down to the Beauclerk family, presumably after the death of Mary's parents. Lord Sidney, however, is said to have had a fatal flaw in his character – he was a gambling addict. Gradually, the Norris family's fortune was eaten away by his ruinous obsession and eventually there was nothing left. When he broke this news to his wife, Lady Mary is meant to have gone temporarily insane with rage and despair, rushing up into the Tapestry Room, picking her baby son up out of its cradle and hurling it down to die in the moat below before then committing suicide herself with a knife. Ever since, Lady Mary's despairing phantom – the Grey Lady – is said to have walked around the building bemoaning her actions, invisibly rocking the cradle in the Tapestry Room and crying with regret for the senseless murder of her son.

However, sadly this story cannot be true. Records appear to show that Lady Mary and Lord Sidney had only the one son, Topham Beauclerk, who lived to the age of forty-one – quite old for a baby – and who became a celebrated wit and friend of Samuel Johnson, the compiler of the first English dictionary. Furthermore, the old oak cradle that is said to rock around of its own accord within the Tapestry Room is Victorian, not Georgian, so didn't even exist during Lady Mary's lifetime.[41] In addition, there are numerous other versions of the legend, which damages its credibility even further. One variant, for example, has it that Lady Mary actually killed her infant by flushing it down a toilet, whereas another retelling has it that Lord Sidney's character flaw was that he had constant affairs, not that he was a gambler. Yet another, meanwhile, says that it was a servant girl who killed her son after being impregnated by Lord Sidney, and not Lady Mary at all. A further version alters the story completely, saying that the baby-killing took place during the Civil War, when the female occupant of the hall at the time (not Lady Mary then) threw her child out of the window in a bid to escape with it from Cromwell's forces, who were then bearing down upon the building – a rather foolhardy plan that predictably went wrong.[42] All of these stories about the ghost's origins are most likely little more than invented yarns.

But invented why? I doubt that the Grey Lady really is Mary Beauclerk. But does that mean that the ghost herself does not exist? Not necessarily. There is a process known among folklorists as 'back-formation', wherein people come across something that they cannot explain and then simply make up a kind of 'origin myth' for it. Thus, a church sited in an out-of-the-way spot might have been placed there by a demon pig, as we saw earlier at Winwick, and a Grey Lady floating through the rooms of an old Elizabethan manor house might have some kind of tragic story created for her in order to account for her presence. Perhaps, then, the Grey Lady is real, and the tale of infanticide is simply a myth used to explain why she haunts the hall?

The Grey Lady of Speke Hall looks into the cradle of her murdered child.

Then again, you might want to claim that the alleged sightings of the spectre are purely imaginary in themselves, too. After all, I can find no *modern* accounts of anybody having seen it. Furthermore, many other old manor houses have had White and Grey Ladies attached to them, and not just Speke Hall – so perhaps local rumour-mongers were just keeping up with fashion? For example, another such building on Merseyside, Brimstage Hall on the Wirral, just next to Higher Bebington, is also meant to have its own White Lady that wanders through its rooms. For good measure, it is said to have a Black Lady flittering around there, too.

Brimstage Hall is certainly old enough to have its own ghosts. It seems to have been constructed sometime between 1175 and 1350, therefore making it much older than Speke Hall. For a long time it was the ancestral home of such aristocratic families as the Hulses, the Domvilles and the Troutbecks, its original architecture being medieval in date, with further wings being added to it in both Elizabethan and Victorian times. It is perhaps most notable for its private chapel, in which there is a small carving depicting a smiling cat – believed to be the inspiration for the famously grinning Cheshire Cat that Lewis Carroll, who visited the hall, included in his 'Alice' books. As for the ghosts themselves, they both have their similarities to the Grey Lady of Speke Hall. The White Lady of Brimstage is supposed to be Margaret, the youngest daughter of the Earl of Shrewsbury, who is meant to have killed herself at the hall in 1807 by throwing herself off the medieval tower there. The Black Lady, meanwhile, is even more interesting. She is said to have appeared in the Victorian wing, cloaked and only visible from the waist or knees upwards, due to the floor there being raised after she had died. And how, pray tell, did the Black Lady die? Why, by throwing herself off that same tower, of course – a major Health and Safety hazard, clearly![43]

However, this is all, once again, just folklore. The suicides are, I think, fictional; and the proposed date of death for the Black Lady (the eighteenth century, supposedly) does not even fit with there being a wing there for her to have roamed, of whatever height, in any case.

Probably the weirdest tale of a spectral Lady from Merseyside, though, is that of the Grey Lady of Thurstaston Hall. Thurstaston Hall on the Wirral, which dates back to 1350 at least, and may well be even older, was during the nineteenth century the seat of the Cobb family, who at some point invited the Victorian portrait-painter, Reginald Easton, to stay there in order to have him paint some miniatures of their children. However, upon arrival, Easton found the house to be full of guests, and there was only the one spare bedroom left to put him up in. This, the Cobbs knew, was haunted by the Grey Lady. They didn't tell Easton this fact, but upon the very first night he spent there he was to find out all about the spirit for himself, as he woke up suddenly in the early hours and saw her standing there at the bottom of his bed! She was elderly, looking down fixedly at the floor, and appeared to be wringing her hands in distress. At first, Easton did not realise that she was a ghost and attempted to speak to her. Not gaining any response, he rang the bell for assistance, thinking perhaps that a confused old woman had simply gained access to his room – whereupon the entity immediately vanished.

The next day, Easton told his hosts about what he had seen, and Mr Cobb came clean to him about that particular bedroom being haunted by the Grey Lady. Easton was then told her sad story, which was of the usual melodramatic nature. She was, it turns out, a murderess. One of the Whitmore family, who had owned Thurstaston Hall before the Cobbs, the Grey Lady had been, in life, the last of her line. There had been a male heir to the family

fortune, but she had strangled him while he was still a little boy so that she could claim his inheritance herself. Supposedly, she had confessed to this crime while on her deathbed, and was now returning to haunt the scene of the outrage, as ghosts so often do.

However, Reginald Easton, it seems, was not particularly scared of ghosts. In fact, making use of his training, he set out to draw this one's portrait! He asked Mr Cobb if the Grey Lady would appear again, and was informed that she would turn up there every night he slept in the room, at approximately the same time. Forearmed with this knowledge, Easton prepared himself fully for her next appearance, leaving his lamp on to provide some light and setting up sketching materials next to his bed that night. When she came for a second time, the artist acted with typical Victorian courtesy towards the fairer sex, and enquired politely if he might possibly have her permission to make a sketch of her. Apparently, the answer was no, because she immediately vanished into thin air. Undaunted, he continued with his plan anyway, and built up a portrait of her throughout his stay, adding to it with each night's brief manifestation. When he had finished, the picture was shown around and apparently caused much astonishment on account of the fact that it did indeed bear remarkable similarity to the dead woman herself, as depicted in a painting that had since been taken down from the walls (and that Easton had therefore himself not seen).[44]

Was this all just an elaborate joke on Easton's behalf? At first, you might think so, but in 2006 some remarkable corroborative evidence of his tale came to light. An old drawing with an accompanying hand-written letter appeared for sale on eBay. The drawing was a *carte de visite* (a small mounted photograph or image used as a collectable visiting card in the past) and showed a hideous old hag dressed in a white gown, stretching her hands out at the bottom of a bed. Underneath it was a handwritten note, reading 'Photo of a ghost seen by 23 people at Thurstaston Hall, Cheshire [as the Wirral then was] and painted by W [sic] Easton RA in the haunted room.' Amazingly, a copy of Reginald Easton's portrait of the Grey Lady had showed up at last!

Included with it was a letter from a William Hope, then the owner of Thurstaston Hall, to his aunt, a certain 'Hon C. Denman', and dated 13 June 1882. Such is its interest that it is worth reproducing here (almost) in full:

> My dear Aunt Charlotte,
>
> We were much interested in the picture of our ghost. I am bound to say we have never seen her, nor have any of our friends for the simple reason that we never use the room for sleeping purposes, but from time to time we have been much alarmed by the violent ringing of the bell, rung so loudly and persistently that it could not be the work of rats.
>
> Mr Easton stayed here about a year before we came to the place. I never met him ... The lady who haunted the arch room [the bedroom] ... was one of the Whitmore family who lived here for 600 years or more. Nothing more of her is known other than that she was a Miss Whitmore and murdered her child. The family died out entirely at the early part of the century [i.e. the 1800s]. There were 12 daughters and no sons and none left any issue.
> ... Your affectionate Nephew,
> William Hope[45]

This letter is doubly fascinating, because it seems to confirm the truth of Easton staying at Thurstaston Hall and painting the Grey Lady's portrait there, and also gives us some clues

as to the truth behind the phantom's back story. Here, for instance, we have a variant tale, in which the Whitmore woman murders not just the heir, but *her own child* who is the heir. Further elaboration of this notion, meanwhile, has occurred in yet another version available, which says that Miss Whitmore stabbed her child and then dropped the knife, losing it. When it was later found by one of the servants, she was tried and executed for her crime, this being considered to be evidence against her, and thus it is this murder weapon for which the Grey Lady is frantically scanning the floor whenever she is now sighted.[46] The presence of such alternative versions, of course, seems possible evidence that the whole story is just made up.

Looking at the origin-myths of these phantoms, then, I think it is probably safe to say that most of them are either entirely fictional or, at best, highly distorted. But are the Ladies themselves just made up, too? Well, much like the ghost at Speke Hall, the spirits don't seem to have been seen much at either Thurstaston or Brimstage in recent decades; the nervous behaviour of dogs around the suicide tower is about the best we can do as regards signs of ghostly activity at this latter place, and a single alleged sighting of the Grey Lady at a window by a team of archaeologists from Liverpool University in 1980 was the last time that anything was seen at Thurstaston, as far as I am aware. Are White Ladies, perhaps, on the verge of extinction in the modern age, then?

Maybe not in St Helens, where sightings of a Grey Lady were reported on in the local press even as late as the 1980s. Taylor Park was the site where this bizarre apparition was witnessed – and not just by one person, but by several. The first report came in to the *St Helens Star* from a retired teacher (unnamed, due to fear of ridicule) who wished to tell journalists of something odd that had been experienced by her daughter and her friend in broad daylight in the park in February 1986. Apparently, the two girls (both adults) were sitting on a bench near to a long walk filled with rhododendrons when the family dog jumped up onto one of the girls' knees. Then, from amidst the bushes came a young girl with pale, shoulder-length hair and an old-fashioned sky-blue dress (why not the Blue Lady, then?) of a type last worn during the Victorian age. The letter-writer, evidently subscribing to the popular view of ghosts being the returning spirits of the dead, wished to know if readers were aware of any tragedies or crimes that had occurred in the park in the past. Another St Helens resident then wrote in to tell the newspaper that, when she was a young girl, she had been passing by the same area when a tall man, with his face partially covered by the peak of his cap, jumped out from the foliage and grabbed her by the dress before then fleeing, and wondered if her assailant had pounced upon another young girl and perhaps killed her, many years beforehand. This was, however, entirely speculation upon her behalf.

Other recent sightings of the Grey Lady in Taylor Park were not speculation, however. Four years earlier in 1982, for example, a courting couple had been out sitting on the bench near the rhododendrons at around 11.30 p.m. when they heard a 'swishing or whipping noise' coming from within the bushes. The male half of the pair went in to investigate, but could find nothing. Then, however, as the lovers walked out into a clearing, they both saw a spectral woman floating towards a structure within the park known locally as the 'old man's hut'. She was semi-transparent, glowing, was dressed in a long and pale Victorian-style gown, and gazed directly at the couple for as long as twenty seconds before then gliding away back into the bushes where, apparently, she disappeared in a kind of mist.[47]

Another female ghost that is still seen in the present day on Merseyside is the White Lady of Willow Park, who is said to haunt the area surrounding Castle Hill, on the outer edges

of Newton-le-Willows near Golborne. There are many tales told of encounters with this particular phantom, whose legend dates back at least 150 years. Like all such Ladies, she has her accompanying legend. According to a poem published locally in 1914, the White Lady was, in life, named Lizzie, being employed as a maid by a 'kind widower/And maiden relative' locally. While in service, she is supposed to have fallen in love with a local boy, who seemed equally keen, before disaster struck; the lad was going with other girls behind her back. Distraught, Lizzie penned a suicide note to her mistress and in the middle of the night, went out to the nearby Newton Lake and plunged into it, drowning herself in despair. Because of this supposed history of hers, the Newton-le-Willows White Lady is meant to act in a particularly hostile fashion whenever the person who witnesses her happens to be a man, going out of her way to deliberately try and harm or frighten him somehow.[48]

This is, of course, a highly romantic story, and presumably quite false. Indeed, true to form, there are numerous local variants of it. Some say that Lizzie was drowned in the lake by her husband on their wedding night, others that she hanged herself in a kitchen and did not drown at all, and yet others aver instead that she was killed by being bricked up inside a local cave, which she also supposedly haunts. Other accounts, meanwhile, say that her actual name was Victoria Hood, and her husband was called Robin! The first mention I can find of this particular White Lady dates from 1834, when an Edmund Sibson, the then-vicar of Winwick, attended an archaeological dig upon Castle Hill (which is actually an ancient burial barrow), and was told the legend, recording it in his account of the event. Presumably, the tales were current even before this date, so there has certainly been enough time for locals to make up as many origin-myths for their own White Lady as they pleased.[49]

Whatever her genesis, though, 'Lizzie' is definitely still seen in the vicinity. Admittedly, the Willow Park area is a kind of natural 'bowl' or valley, in which white mists accumulate, which could perhaps account for certain sightings, but not others. For example, in the 1960s a young male cyclist was confronted by a huge female form while cycling past Castle Hill, which caused him to pedal away at top speed in fright. In August 1972, more sensationally, a motorcyclist going by the lake was astonished to see a white figure drift out in front of him on the road. He then felt an arm grabbing him around the neck, and throwing him from his bike. Lying distraught on the ground, he looked up and saw the White Lady floating there above him, looking down. Too scared to even pause to get back on his motorbike, he ran all the way to the nearest police station and would only return to pick up his machine the next day, when accompanied by a police escort. In November 1989, meanwhile, it was reported that several motorists going by Newton Lake had witnessed the White Lady hovering over the road, floating into the path of car headlights, and causing people to swerve to try and miss her. One man even crashed his car after such an encounter, or so he says![50]

These accounts are particularly interesting, as they demonstrate what is apparently increasingly happening to the traditional figure of the White/Grey Lady in the modern era – namely, they seem to be transforming themselves, whether literally or simply within the popular mind, into road ghosts. For example, at Brimstage it turns out that the White Lady has occasionally wandered free from her usual haunts, and begun manifesting instead as a phantom hitchhiker; that class of young female apparition that appears by the roadside, solicits a lift from a passing motorist (generally male) and then simply disappears from the back passenger seat when the driver isn't looking. In the 1970s and 1980s particularly, such an apparition was encountered in Brimstage. Other phantom hitchhiker tales from

the Wirral include the ghost that appeared to a woman walking home from Clatterbridge Hospital in 1970. The female spirit just stood there, seemingly waiting for a lift, before vanishing away instantly as soon as the other pedestrian approached her. This same ghost was witnessed several times in the area by other persons, too.

Perhaps these particular phantoms do not sound too much like White Ladies to the reader. However, the next account of a Wirral road ghost seems definitely to suggest that the two classes of being are somehow linked. This sighting occurred in either July or August 1970 (accounts differ). A motorist was driving along Poulton Road from Higher Bebington when he saw a girl with long hair and a dark coat standing by the side of the road, seemingly waiting for a lift. He stopped to offer her one, but, as soon as he had done so, the young lady slowly melted away into nothing before his very eyes. What does this tale have to do with White Ladies, though? Simple. Poulton Road runs along right next to another supposedly haunted old manor house, Poulton Hall, which is also reputedly bothered by a female ghost, that of a local novice nun, who either died the victim of a broken heart nearby, or who was killed somehow after leaving Poulton Hall on her way back to her nunnery. Local legend now has it that this phantom hitchhiker is just the ghost of the nun, re-enacting her fatal last journey in an alternative form.

In many ways, this story appears to be a modified adaptation of another tale about a Wirral road ghost, that of the White Lady of Dibbinsdale Bridge in Bromborough. Her legend has it that in life this spectre too was a nun, who was walking from Birkenhead Priory to St Werburghs Abbey in Chester (now Chester Cathedral) when she stopped and asked for a night's shelter at Poulton Hall, which does sit quite near to this bridge. The hall's owner, it seems, imprisoned her and then starved her to death, possibly for refusing to have sex with him, or perhaps simply because he hated nuns. Either way, the ghost of this alleged dead nun is now said to haunt the area around Poulton Road and Dibbinsdale Bridge, either in the form of a White Lady without a head, or of a Red Lady with a rusty-coloured dress and swinging a lantern. Apparently, numerous persons have encountered both of these figures near the bridge, and sometimes cars have driven right through them, a stereotypical motif of road-ghost stories.

A pattern, then, is becoming clear here. There are several locations on Merseyside where White Ladies have previously been associated with either manor houses or lakes and parklands, but where, in later years, they have begun popping up on roads and bridges instead. This has happened at Brimstage, Poulton, Dibbinsdale Bridge and Newton-le-Willows. As sightings of White Ladies in and around manor houses themselves have declined, then, sightings of female ghosts, of all varieties, on or near roads close to the White Ladies' former haunts appear to have risen. There are a few accounts of male road ghosts from Merseyside – a man in a green jacket who goes up to cars passing by Brimstage Hall holding a petrol can before then disappearing, and an old man dressed in a tweed jacket and cloth cap who has likewise been observed to vanish into the ether while pedalling over Dibbinsdale Bridge – but these are rare.[51] Instead, the ghosts seen on Merseyside's roads are predominantly female, a pattern that is repeated elsewhere in the world. But why on earth should this be? And why are they linked so frequently with White and Grey Ladies?

In order to arrive at a possible answer, we have first of all to abandon any crude notions we may have about ghosts being, in each and every case, the spirits of the dead. They might not be. It is a certain fact that people *see* ghosts, but not necessarily that these are the returning

The phantom hitchhiker of Bebington would disappear before motorists' very eyes.

departed. For instance, when it comes to White Ladies, many people – mostly Jungians – have theorised that they are spirits not as such, but that they are archetypal manifestations of some aspect of mankind's collective unconscious. Rather than encountering the souls of the dead *per se*, people might well be experiencing instead some kind of essentially impersonal manifestation of femininity itself; seeing the embodiment of the female principle of the collective human soul, perhaps. If this idea is true, then all attempts made by local tale-tellers to link these apparitions with specific people and tragedies are ultimately doomed to failure – and indeed, we have already noted how many such legends are doubtful or even demonstrably untrue.

However, these invented origin myths for the White Ladies, while literally false, might perhaps contain an element of a deeper truth somewhere down within them. For instance, they all seem to speak of White Ladies haunting halls and manor houses either because of their mistreatment at the hands of males, or because they have betrayed, somehow, their own female roles during life. In terms of the wronged White Ladies, for example, we can encounter tales of suicidal and betrayed lovers, or people whose lives have otherwise been ruined by their husband's character failings – which are, inevitably, characteristically male ones such as gambling-addiction or infidelity. In appearance, these Ladies are generally young, beautiful and somehow mournful and melancholy in aspect. Where the Lady has betrayed her own stereotypical female role in life herself – like the Grey Lady of Thurstaston Hall, who murdered her own child for personal gain – they appear instead as hideous old hags, being punished eternally for betrayal of their own gender roles as devoted mothers or wives. These ghosts, then, apparently have a certain social message coded away inside them.

It is notable, in light of this finding, that Merseyside's female road ghosts follow this general pattern, too. They generally seem young and vulnerable in appearance, which is rather fitting with the more modern opportunities for male maltreatment of females which have sprung up during the motor age. Some women, of course, really do end up disappearing after accepting lifts from strange men on lonely roads at night, and there's nothing much supernatural about it all. Maybe the phantom hitchhiker motif is somehow symbolic of this fact? Possibly apparitional symbols of wronged femininity no longer tend to be seen in manor houses because these are now no longer the homes of people who were once in such a good position to mistreat women; instead, reflecting more modern anxieties and concerns, these walking symbols appear upon our roads instead.

Another option, however, is to consider the modern White Ladies of the road and their ilk as being personifications, somehow, of Nature herself, another archetypal female figure that has been metaphorically raped by mankind – by, for instance, building roads that run right through her most cherished beauty spots. It is perhaps notable, for example, that the White Lady of Willow Park only began bothering motorists instead of walkers once the smaller local lanes and byways had been replaced by the laying down of the M6 motorway straight through the area – a development that has, it must be said, rather compromised the beauty of the place. The White Lady here is now no longer generally seen mourning by the lake as she once was but, rather, assaulting men on noisy motorbikes who speed through the place, helping to ruin the environment.

If ghosts really are 'encounters with ourselves', or our own subconscious minds, rather than with the departed dead, as some theorisers have plausibly suggested, then what does

the preponderance of White Ladies and female road ghosts on Merseyside say that we have done to our area? I am well aware that some readers might find this particular notion somewhat far-fetched. Possibly it is. But, surely, it is no more far-fetched than the idea that Merseyside's female spectres are all just murdered nuns, child-killers, car-crash victims and disappointed lovers?

4

A Liverpool Ghost Tour

Like many big cities across the UK, modern-day Liverpool now has its own ghost tours available for tourists and spook-seekers alike. What is there, though, on such tours to see? Well, wherever the guides decide to lead their customers, they have a lot of allegedly haunted Merseyside places to choose from. Let us embark upon our own such road trip now, then.

We shall begin with some good old-fashioned phantom monks, who have been witnessed wandering around a haunted monastery. That's just the kind of thing that tourists like to hear about, and Merseyside has a prime example. Norton Priory, located on the south bank of the River Mersey just east of Runcorn, dates from the twelfth century, having been closed down in 1536 as part of Henry VIII's famous dissolution of the monasteries. In the 1970s, the remains of the abbey and its grounds were opened to the public, and remain a popular destination for sightseers – and one sight that can supposedly be seen there are its famous ghostly monks.

Perhaps the most notable encounter with these apparitions occurred in 1972, when a poacher from Runcorn claimed to have seen two shrouded monks while he was out in the woods near Norton Priory, hunting illegal game. According to him, they were singing the popular hymn 'Oh Come All Ye Faithful', albeit with all the words in Latin. They were quite close to the man, who says that he stuck out his hand to see if they were real, but it just went right through them and began to sting with cold. Then, the monks appeared to perform some kind of blessing upon the poacher, turned around and floated away back in the direction of the old priory.[52] However, seeing as 'Oh Come All Ye Faithful' dates back only to the eighteenth century – although some scholars do dispute this, saying that it may have originated in the 1200s – and the abbey had been destroyed partway through the sixteenth century, as we just said, certain elements of this story appear to be a little dubious. Nonetheless, it is a curious fact that the hymn originally did have its words in Latin, and used to be known as 'Adeste Fideles'; words that the poacher, who claimed to have no prior knowledge of the language, distinctly said he heard.[53]

Another tale about the ghost monks, meanwhile, comes from a woman who purports to once have lived around ten minutes' walk away from Norton Priory. She claims her little brother, when aged four, had begun seeing figures flitting around the family home – figures

that nobody else could see. In his words, they had 'brown robes, bald heads, and lots of funny jugs of beer.' Seemingly, they were having drunken parties, complete with music, in the middle of his room at night. Then, odd poltergeist-like phenomena started to occur around the home too. Upon one occasion, for instance, phantom footsteps were heard running up the stairs – and when the household's two children went to check what was going on, they found that morning's post all stacked up there on the landing in a neat little pile. Things came to a climax, however, when a drunken monk appeared to the little boy in his room, began dancing, and started to strip off.[54] If this is true, then perhaps Henry VIII was right about what went on inside England's monasteries after all!

Another ghostly monk once seen on Merseyside was even more bawdy in its nature, though. Indeed, if we are to believe the account given of its activities by a certain Gill Philipson, an ex-nurse from Liverpool, this particular ghost monk was actually a habitual rapist. She said that, for a period of ten years, between 1984 and 1994, she would wake up paralysed in her bed only to find a hooded figure, whose skin was grey and wrinkled, pressing down on her chest and subjecting her to sexual molestation. While this was going on, Gill said, she was unable even to scream out to her husband, who lay fast asleep in the bed right beside her. It must be said, though, that this sounds like a classic case of the disturbing hallucinations that often accompany a perfectly natural medical condition known as 'sleep paralysis', in which a person awakes in the night unable to move, and often witnesses frightening entities that are not really there, such as old, witch-like hags and frightening demons. Frequently, these hallucinations seem to press down upon the woken sleeper's chest, as in Gill Philipson's case. This interpretation of matters can perhaps be backed up further by the fact that a gang of paranormal investigators whom Gill asked for help merely recommended that she attend relaxation classes, which remedy appears to have worked.[55]

Ghostly monks, of course, are a very traditional form of apparition. Another traditional form of ghost is the phantom horseman – and, lo and behold, Merseyside allegedly has one of those to its name, too. What is more, just like the dead Hessian warrior in Washington Irving's classic story *Sleepy Hollow*, it is meant to be headless! Yet again, this particular ghost comes from Runcorn, which would appear to be a very haunted place indeed, at least in legend. The place where the ghost allegedly wanders is the Stockham Lane area, a largely disused path that cuts through Runcorn's Town Park, near the centre of the settlement – and the story surrounding this particular steed and rider is stereotypical to the point of parody. Supposedly, the rider is a headless Cavalier, his ghost horse pale white, and both only ever come out on the night of a full moon, when they gallop at top speed along the lane, causing anyone who sets eyes upon them to instantly go insane.

Obviously, this melodramatic tale must be pure folklore – mustn't it? Maybe not entirely, as in 1982 Runcorn's newspaper ran a story headlined 'I saw the ghost of a headless horseman', in which a local man, named only as Chris, related how he had taken a short cut home down Stockham Lane on the night of a full moon and had indeed heard the unmistakable sound of horse's hooves coming from the distance. Turning around, he says, he saw the headless horseman himself, galloping out of a fog-bank upon his luminous steed. Perhaps unsurprisingly, Chris then fled.

I cannot find any other first-hand accounts of anybody having witnessed Runcorn's ghostly Cavalier, sadly, but there is one very curious coda to the tale. Apparently, a local paranormal investigator, Mark Rosney, was walking down Stockham Lane himself late one

The drunken, stripping ghost monk of Norton Priory.

foggy night in February 1982 while still a teenager. He had read the report of the recent sighting in the newspaper, and was therefore a little nervous at the prospect of walking alone down the lane. Sure enough, as he did so, he heard the sound of hooves trotting towards him. He ran, and, looking over his shoulder, saw a white horse coming out of the mist. Eventually, the beast caught up with him, and ... it was just a horse. It had no rider, and God only knows where it had come from, but it was no ghost at all. It was, however, very friendly – so friendly, in fact, that it began to follow Mark home. His parents' bungalow being too small to accommodate the animal, Mark took it to the nearest police station and handed it in as lost property, no doubt to puzzled faces all round![56]

This is all very odd. A real white horse being seen in the very same spot where, not long since, a ghostly white one had also been witnessed, just seems weird. Was it merely a coincidence? If so, then perhaps it was just the kind of thing that Jung was talking about when he used terms such as 'meaningful coincidence' and 'synchronicity'. On the other hand, maybe it could be hypothesised that Chris, the original witness of the phantom, had simply seen this same loose white horse in the park coming at him from out of the mist himself, and then misinterpreted matters somewhat. Given his knowledge of the pre-existing legend about the headless horseman in the area, did he simply see what he expected to see at the time, somehow, rather than what was actually there? It seems a plausible enough theory, though we can never be *entirely* sure.

Other spectral Cavaliers are said to have popped up on Merseyside with disarming frequency too, however – although none of them have been seen riding horses. Several skirmishes between Roundhead and Royalist troops did take place on Merseyside during the Civil War of 1642–51, which perhaps accounts for this fact. Ever since it had refused to pay King Charles the incredible sum of £15 in taxation, Liverpool had been at loggerheads with England's monarch. Hence, when the Civil War eventually broke out, the city sided with the Roundhead rebels. Prince Rupert of the Rhine, King Charles' nephew, led the Royalist assault on Liverpool, and anticipated an easy victory over the Roundheads. Reportedly, he referred to Liverpool contemptuously as being 'a mere crow's nest which a parcel of boys could take', and in 1644 the siege of the city began. Prince Rupert's Cavalier troops found it harder going than expected, however, and in one assault alone they ended up losing 1,500 men. Eventually Rupert was forced to carry out a sneaky night attack. This worked, and the Cavaliers, victorious, plundered Liverpool and exacted their revenge in blood.[57] Given this bloody history, then, it is probably no surprise that there have been numerous sightings of ghostly Roundheads and Cavaliers across Merseyside. For instance, a phantom Cavalier used to haunt the branch of Waterfields bakery in Woolton Village back in the 1960s when the premises were occupied by the Winnicott poodle salon. Here, the spectral soldier was frequently seen in the basement, staring through a hatch with a big grin on his face before disappearing. Apparently, the staff members got so used to him showing up there that they gave him his own nickname – 'Charlie', also the name of the king for whom he had once fought.[58]

The epicentre of local sightings of Civil War ghosts, though, is Warrington and its surrounding environs. Here, spectral echoes of the past still linger on quite loudly, or so it seems. For example, in 1949 a car full of Widnes Rugby League Club supporters were travelling home from Wigan when their car got a puncture near Winwick, where Oliver Cromwell himself had led his troops into battle against an army of Scottish Royalists in 1648. They got out to perform repairs, but were most surprised to see three Roundhead soldiers

in the field next to them. Allegedly, these figures remained visible for half an hour, before the rugby fans managed to get their car fixed and then drive away in terror. Another mass sighting of the New Model Army apparently took place at Winwick in 1925, meanwhile, when a coach on its way back from Blackpool stopped by a field to allow several daytrippers to get out and empty their bladders. While doing so, they were astonished to see a dozen or so Roundheads milling around in the field there before them. Furthermore, during the nineteenth century, it is said that the residents of Winwick were sometimes awoken by the sound of phantom armies crossing swords outside in the night.[59]

Another Warrington ghost story concerns a spirit popularly known as the 'Cavalier of Wilderspool', who was frequently seen, across at least a sixty-year period, sitting on the banks of the Mersey in the Stockton Heath, Grappenhall, Bridge Foot and Appleton areas in the east of Warrington. Some people even said that they had seen him looking in through their windows at them. Wally Barnes, the local ghost expert, said that he once met an ex-policeman who claimed to have encountered the Cavalier himself. The sighting took place in 1934 around the Blue Bell Dingle area, while the constable was out looking for a woman's missing dog. The spirit was just standing there, and at first the PC thought that it was a man in fancy dress. He drew his truncheon but then realised that he could see through the figure, which then promptly disappeared. Again, the sighting of this ghost did correspond with an old Civil War battle site in the area.[60]

In addition to all this, Warrington can also make a fairly plausible claim for containing Merseyside's most haunted spot, namely the old Burtonwood Air Base just outside town. The base was opened in 1940 for use by the RAF, but in June 1942 its facilities were transferred over to the USAF after America had entered the war. During this time, it became the largest air base in Europe, with as many as 18,000 personnel being stationed there. After the Second World War, US troops continued to occupy the base, but by 1965 it had been returned to the British MoD. US forces did return in 1966, though, and began transforming much of the site into a gigantic storage depot, this function being retained until 1994. In recent years, though, the old base has fallen into disuse and disrepair, and most of the hangars and bunkers have now been demolished. Nowadays, much of the land where the place once stood has been earmarked for commercial and residential development, driving away most traces of what once used to be there.[61]

As you might expect, given all this history, most of the ghost stories from the place centre on the idea of phantom Second World War airmen, both American and British. Probably the first such encounter came from 1946 when two American troops, still billeted in the area, were walking back to base when they saw a puff of smoke coming towards them on their path. As it got closer, this strange mist resolved itself into the shape of a human being, wearing an airman's uniform. This was no ordinary airman, however – for, in addition to appearing out of some smoke, the unfortunate spectre also had no head! The ghostly airman walked past the two Yanks, and then disappeared into a hangar on the airbase. Various other people apparently saw the same spook during the post-war period, and it appears that the local folk explanation for its headless nature was that, in 1944, a bomber had made a crash landing at Burtonwood due to bad weather. However, during this awkward landing, the pilot accidentally pressed his ejector button, and ended up getting his head sliced off on something as he sprang out.[62] I suspect that this is just a local tall tale, of course, but that doesn't mean that the headless airman himself was not real. Indeed, a headless figure

has been sighted around the Burtonwood area in more recent years, so it is not just a mere post-war legend. For example, Burtonwood Services now lies on part of the site of the old air base and, not long after it was opened in 1974, it seems that one of the cleaning staff was disturbed in her duties at night by the sound of some pots and pans falling down in the kitchen. She went inside to investigate, and saw an ethereal figure with no head, quickly making its exit from the room through a solid wall.[63] The headless airman of Burtonwood lived on for far longer than the mid-1940s, then, it seems.

Not all of the base's ghosts are dead airmen, though. For example, there is one old hangar, known as 'Hangar K', which is still standing on the site, and this is used as a small local museum. A popular exhibit there is an old bus, one of the first ones to enter service in Warrington. One day in 1978, a volunteer staff member who had been repairing an aircraft in the hangar looked up to see an old man with a beard sitting in the vehicle, by the steering wheel. The museum was closed, so the staff member asked one of his colleagues who the fellow was – only to be told that nobody else, other than the two of them, was in there, as far as he knew. Going up to the bus to examine it more closely, they found it was empty. Puzzled, they traced back the vehicle's history. It turned out that it had been salvaged from among the trees in a local wood, where it had once been lived in by a reclusive old man. Upon tracing this man's sister, she had produced a photograph of him; and the reader will surely have already guessed by now that the man in the picture was the very same old-timer who had been spotted sitting there behind the wheel of the bus in the museum.[64]

Poltergeist phenomena have been reported from the base, too. Security guards on the site, for instance, have reported encountering a 'phantom whistler' – the distinct sound of someone putting their lips together and blowing has been heard by several staff there, without anyone ever being found to account for it all. Another, rather more violent, phenomenon reported from the base occurred in 1980, when a Squadron Leader and one of his men drove up to an abandoned hangar in order to have a look at some kestrels that had made their nest there. The Squadron Leader started speaking about how the base was in a state of disrepair and how the hangar they were standing in was going to be demolished soon when, suddenly, a loud crack was heard coming from the direction of his car. Turning around, they saw the windscreen, which was made from safety glass, shattering for no apparent reason, 'as if somebody had pushed it out from inside and at the same time hit it with a heavy hammer', in the words of one of the witnesses. Apparently, it transpired that the spot where the car was parked had once been used by the USAF to store the coffins of dead airmen before burial.[65] Was there a connection here, or was it just coincidence?

Interestingly, several UFO sightings have been made near the base as well as ghosts being encountered there. On 13 May 1978, for example, two local men witnessed 'a large orange ball' hovering directly over the place in the middle of the night.[66] Perhaps because of stories such as these, a rather unlikely rumour once built itself up locally that RAF Burtonwood was being used as a secret underground storage depot for captured alien craft. It isn't true, of course, but some apparent credence was added to the rumour by whispers that the dip that occurs in the road when you pass by the base on the M62 is not actually caused by former mine workings underground, as is generally accepted, but by some kind of hidden subterranean UFO compound. Tales about red beams from the sky hitting locals out walking dogs near to the base's perimeter fence, and of a crop circle being found just outside it in 1990, only fuelled speculation about the true nature of the area even further.[67] Undoubtedly,

then, it appears that Burtonwood Air Base is something of a major hotspot for paranormal activity – at least according to some of the locals.

If one of Merseyside's airfields is supposed to be haunted, though, then so are its main docks. Here, stories are told of a ghostly liner pulling up and then vanishing, and of a phantom jaywalker, an old man who is knocked down by motorists before then disappearing. In the mid-1980s, meanwhile, a tale was current among construction workers busy renovating the Albert Dock that, during blasting work, a ghostly arm had come from out of a wall and approached one of the workers.[68] Supposedly, this phantom arm was connected in some way to the discovery of chains that had been used to tether slaves awaiting transportation to America, but this seems very unlikely. Liverpool was indeed at the centre of the slave trade during the 1700s – some may say that its wealth was largely built upon it – but, of course, ships simply set out from Liverpool, picked up their human cargo in West Africa, and then took them away across the Atlantic over to the plantations in America and the West Indies. It would have been an illogical waste of time for seafarers to bring their slaves back to Merseyside first, so such supposition about the origin of this alleged disembodied arm is probably just nonsense.

Another bizarre ghost sighting is supposed to have occurred at the Albert Dock and involved the well known husband-and-wife presenting team Richard Madeley and Judy

The Albert Dock, where viewers of an episode of ITVs *This Morning* programme claimed to have witnessed a ghostly pirate bothering Richard and Judy.

Finnegan, who used to anchor the ITV daytime programme *This Morning* live from the area every weekday. During the broadcast of the 19 April 1993 edition, the duo were interviewing an exorcist named Graham Wyley as part of a segment about ghosts. Just as the psychic exorcist said 'I don't sense anything here', it appears that viewers at home witnessed a ghostly pirate gliding across the Albert Dock studio and then sitting down on top of the coffee table between Richard and Judy. Shocked viewers jammed the show's phonelines in order to report the phantom, indicating that many of the housewives, pensioners and long-term unemployed who made up the *This Morning* audience at the time actually believed that the ghost-pirate was real. Spokesmen from the show denied that any technical trickery had taken place on their part, but it would surely appear blatantly obvious that this is what actually must have occurred.[69]

Liverpool, as already mentioned, has more listed buildings than any place in England other than London, the legacy of the city's former riches. Many of these, it seems, have their attendant ghosts. Not far from the city centre, for example, is St George's Hall, a beautiful piece of neo-classical architecture. The building these days contains concert halls and a law court, and in the past even used to hold prisoners in the basements down below. Prior to its public opening in 1854, it was the site of the first Liverpool Infirmary, from 1749 to 1824, but is probably best known to citizens of Liverpool today as being a grand public space where schoolchildren are often forced to go and sit through tedious awards ceremonies. Something else available there, though, is a ghost tour, as the place is supposed to have several spirits resident within it. The most commonly cited experiences alleged to have occurred within the building include the sighting of a man in the concert room sitting with his head in his hands, who simply disappears when approached, ghostly hands being felt touching people on the steps in the Great Hall, and disembodied voices being heard in the basement. Supposedly, these are the souls of condemned prisoners who were once held in the cells below floor level, though this is of course just supposition.[70]

Probably Liverpool's most haunted buildings, however, are its theatres. If you believe everything you are told about these places, then there must be at least a dozen different phantoms walking their halls. Perhaps most famously, in 1999 repair work at the Liverpool Playhouse was disrupted after several workmen downed their tools, claiming that poltergeist phenomena – including slamming doors, taps that turned themselves on and off of their own accord, and a mysterious 'dark presence' appearing around the place – had scared them so much that they no longer wanted to set foot there. Ghosts, however, seem to have no such qualms. Another Playhouse ghost, for instance, is known as 'Elizabeth', and is supposed to be the phantom of a former cleaning lady who had her neck broken by a falling fire curtain while she was mopping down the stage in 1897, when the place was still a Music Hall. Some say that this 'accident' was actually murder.

A first-hand account of a ghostly encounter in the Liverpool Playhouse came from the Birkenhead-born actress Pauline Daniels, who was sitting in her dressing room in 1986 when her door opened and a lady's voice was heard complimenting Pauline upon her costume; 'That looks fantastic', she is supposed to have said. However, when Pauline turned around, there was nobody there, and she was later told that she had just encountered the spirit of a former wardrobe mistress at the place. Daniels even claims to have had a further sighting of a ghost at the Playhouse, spotting 'a gent in cape and top hat' sitting in one of the theatre's boxes while she was onstage in a production of *Shirley Valentine*. Perhaps this was the same

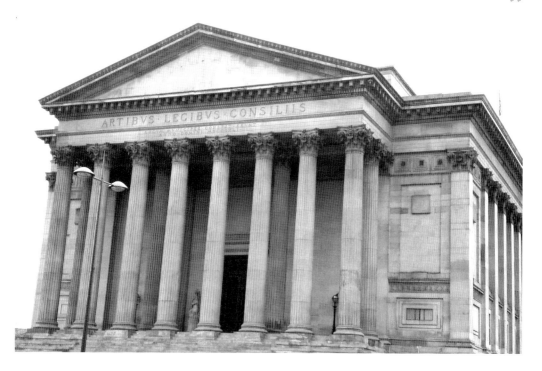

Two views of St George's Hall, a reputedly haunted spot in central Liverpool.

Victorian/Edwardian gent who is meant to wander the theatre's coffee bar in top hat and frock coat, searching endlessly for his daughter who supposedly ran away from home to be an actress sometime in the early 1900s. In 1996, it appears that Pauline recorded a hat-trick of ghost sightings in the Playhouse; she saw Elizabeth, the dead cleaner, sitting in seat A5 in the galleries, which is supposed to be one of her traditional haunts.

Another haunted local theatre is the Liverpool Empire, where the ghosts of three former music-hall comedians – Jimmy Clitheroe, Wee Georgie Woods and Arthur Lucan – are all supposed to roam, the first of them dressed up in his trademark comedy schoolboy outfit. More disturbing by far, however, is the little Victorian girl who is said to be seen crying in the theatre's bar late at night before being approached by the ghost of a man with no eyes (or dark eyes, in some accounts) who then leads (or drags) her away. Apparently, she has been appearing there for forty years or more, and instantly disappears if anyone tries to approach and comfort her. A 'phantom whistler' was also supposed to have haunted the place back in the 1950s, whose activities are said to have once ruined a rehearsal of *Swan Lake*. Outside the Empire, meanwhile, is meant to walk another ghost, the 1950s Liverpudlian crooner Michael Holiday, who committed suicide in October 1963. He is allegedly seen, wearing his trademark silver suit and with a large quiff, walking from the nearby taxi rank and up to a stage door. Furthermore, in the 1960s a group of staff at the theatre noticed several Victorian actors and actresses milling about onstage, before then suddenly disappearing. Examination of old programme notes allegedly revealed that one

The Liverpool Empire, allegedly the city's most haunted building, despite stiff competition.

of the figures sighted was a certain Mary Anderson, who had appeared in a version of *A Winter's Tale* there back in October 1888. One of the Empire's old dressing rooms, Dressing Room S, was also notoriously haunted for many years by an amorphous black shape that would show up in the mirror, although there was nothing ever actually visible there in the room to be causing the reflection. The oddest ghost story from the Empire, though, concerns a spectre sighted by the actor Stanley Lupino in 1926, while he was performing in a play called *Better Days*. He was wearing white make-up with black circles around his eyes, and waved his fist towards two stagehands. One of the pair, named George Friday, is said to have died in the theatre three days later, after letting out a terrified scream.

Yet another haunted Liverpool theatre is the Royal Court, where 'Old Les', a dead former janitor, can allegedly be encountered by ghost-seekers almost to order. It is said that he will open and close the door of his old office upon request. If you say 'Les, please open the door,' he will. And, if you then say 'Les, please close the door,' he'll oblige you by doing that too. So well known is the legend of Les in the Royal Court that if any small accident occurs there, such as an object being knocked over, someone half-jokingly says 'It must have been Les.' Purportedly, Les haunts the building because he died up on its roof, slipping and breaking a leg while clearing out the gutters on an icy day. He then died of exposure supposedly, a story that I sincerely doubt is true.

The weirdest of Liverpool's theatreland ghosts, however, is surely the smelly phantom that haunts the toilets of the Everyman Theatre on Hope Street. In the cubicles, strange things are said to happen. Footsteps are heard and shadows sighted, and hand dryers and lights turn themselves on and off, even when the building's electricity is turned off from the mains every night before locking-up time. Worst of all, though, is the ghost's stench; it smells, apparently, quite strongly of wee. You might think a toilet that whiffs of urine is not inherently paranormal in its nature, of course, but members of staff have tried fumigating the place and all to no avail; still the phantom smell can be discerned lingering around the stairwell outside the haunted urinals. Wherever the ghost goes, apparently, it leaves its musky scent trailing along unpleasantly after it.[71]

Can we really believe all this, though? After all, actors are, stereotypically, a suspicious lot, and it does seem rather obvious that most of this is just entertaining legend. There is one final case from within a Liverpool theatre, however, which is altogether more sinister and convincing.

Many readers of this book will no doubt be aware of Dennis Wheatley's classic horror novel *The Devil Rides Out*, either by virtue of having read the original 1934 tome, or having seen the classic 1967 Hammer Horror film version of it, starring Christopher Lee and Charles Gray. Essentially, it is a tale of Devil worship, in which an evil Satanist, Mocatta, tries to perform a human sacrifice in order to allow Satan to pass into our world. In February 1993, a stage version of this tale was being put on at the Neptune Theatre, in Hanover Street. However, it seems that all was not well with the production. The story is too elaborate to detail in full here, but the poltergeist-like events that ended up plaguing the play appeared to have their origin in some of the stagehands making a mess of drawing a pentagram – a well-known occult symbol, in the form of a five-pointed star – on the stage floor. Sadly, they painted it in upside-down, which, as any aficionados of this kind of thing will know, is supposed to be a big mistake.

This does sound highly melodramatic, of course, and subsequent tales of smoke machines going off by themselves and lighting and sound equipment malfunctioning could obviously

be pure coincidence. However, as the performances continued, cast and crew members began experiencing disturbed sleep and nightmares, and heavy fire doors in the theatre started opening and closing of their own volition. Worse, a lighting engineer named Jackie Saunders experienced poltergeist phenomena in her flat after going home. On the night of the second performance, she and her boyfriend were approaching their front door when they heard a huge bang coming from inside. Then, a loud scratching sound appeared, as if something was running itself along the inside of the door. The boyfriend announced loudly that any burglars in there had better watch out, flung the door open and put the lights on – but there was nobody inside to be seen. The next morning, Jackie awoke with a very sore throat. Looking in the bathroom mirror, she found that her neck was covered with dark bruises all around it, as if something had tried to strangle her in the night.

Eventually, a white witch named Analesha Casells who worked at the theatre was allowed to bless the pentagram prior to the show starting up every night, and things calmed down. However, on the last night, Analesha did not get a chance to bless the inverted pentagram – and, once more, poltergeist phenomena broke out. The lights and sound effects began to work of their own accord, and the Stage Manager was grabbed by an invisible force and pulled backstage. Most bizarrely, while the actors were onstage, they looked up into the lighting box and saw a third figure besides the two engineers who were supposed to be in there, which promptly 'fizzled out' as they watched. So disturbed were they by this appearance that they actually began forgetting their lines. Right at the end, meanwhile, the final scene was ruined as the smoke machine – which was turned off and unplugged – started spewing out fog, having to be dragged offstage, where it filled the wings with dry ice. As soon as the show was over, the pentagram was destroyed and the stage floor hastily painted over; and that, it seems, was the end of that.[72]

One final notable Liverpool location that must surely be mentioned here, of course, is the world-famous Cavern Club, where the Beatles played many of their first gigs. This establishment first opened on 16 January 1957, and was owned initially by an entrepreneur called Alan Sytner, who had a taste for all things jazz. Before the Beatles came along, though, Sytner needed a way to get the punters in – and he soon found one. He simply announced to the press that the ladies' toilets were haunted. Somehow, Sytner actually managed to get this made-up story printed in *The Daily Herald* (now *The Sun*), resulting in much publicity for his latest nightspot venture.[73] Thanks to the efforts of one of the club's former owners, ex-Liverpool defender Tommy Smith, The Cavern is still open today (albeit in a slightly different location) and is obviously a good place to visit – but you won't be able to see any ghosts in the ladies' toilets there, sadly.

There are some other ghost stories concerning the Beatles, however. For example, according to Paul McCartney, when in 1995 the three surviving Beatles (George Harrison not having yet died) got together to record a version of John Lennon's unreleased song 'Free as a Bird' as part of a brief reunion, Lennon's ghost was there in the recording studio with them. Odd noises were heard and electrical equipment malfunctioned, apparently – and, most bizarrely of all, one of their session-tapes contained the following noise at the end of it: 'zzzwrk ngggggwaaaahh jooohn lennnnnon qwwwrk'. This sounds rather like the kind of thing that some paranormal investigators claim to pick up on tape recorders that they leave running at certain supposedly haunted sites, and then try to pass off as being the voices of the dead. Known as EVP (Electronic Voice Phenomenon) recording, it is quite a craze at

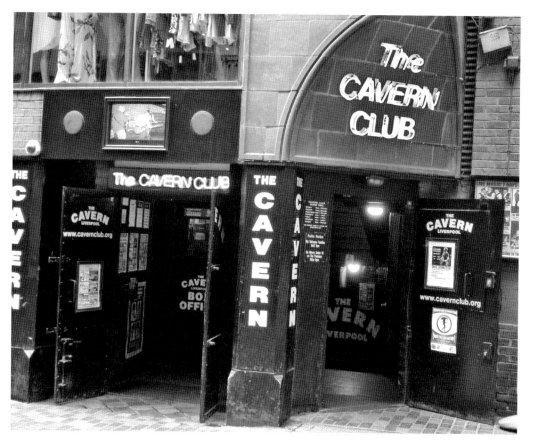

Liverpool's world-famous Cavern Club, where the music is great and the toilets are haunted – allegedly.

present, although usually it seems that people just read whatever they want to hear into what are, in actuality, just random sounds. Probably, that is what happened here, too.74

Another musician who claimed to have encountered John Lennon's ghost, meanwhile, was the Oasis frontman Liam Gallagher, a big Beatles fan. According to him, he was staying at a friend's house in Manchester when he had an out-of-body experience that culminated in him sensing the presence of Lennon lurking around nearby. Purportedly, John's widow Yoko Ono has seen his ghost too, sitting at his famous white piano, and several people claim to have seen his spectre wandering around in the Dakota Building in New York, the scene of his assassination by the crazed gunman Mark Chapman in 1980.75

Surely the most remarkable alleged series of encounters with the spirit of John Lennon, however, began on the evening of 15 November 1992, when a retired printer from North Wales, Mike Powell, claimed that the dead Beatle had appeared at the bottom of his bed. Despite Mike having no pre-existing musical ability, he says that Lennon chose him, for some reason, to be a conduit through which new Beatles songs, written by John in the afterlife, could be transmitted to the world. This kind of claim is not unknown in paranormal circles – some people purport to have 'channelled' whole symphonies from dead composers, for

instance – but it is generally accepted, I think, that such compositions actually come only from within the medium's own subconscious mind.

Apparently, Mike was going through a tough period when his first sighting of John occurred – his parents had just died and he was being divorced – and it seemed that John felt some sympathy for him. In any case, Lennon looked Mike hard in the eye and began psychically transmitting a song to him; it came to him fully formed, complete with lyrics, and, when he picked up a guitar, he just seemed to 'know' how to play it properly. Since this first meeting, says Mike, Lennon has appeared to him more than fifty times, and passed on over 350 new tunes to him. Furthermore, Mike now has late-night 'inspirations' from John, who instructs him to paint pictures of things such as smoking guns and an image of the Queen sitting at a funny angle. In May 2011, it was revealed that Mike had recorded fifty of these uncanny compositions onto CD and was planning to send them off to Yoko Ono so that she could confirm, somehow, that the tracks – with titles such as 'Yoko, I Love You' and 'It Was You' – were actually the work of the real John and not just of a delusional person, as might otherwise have been thought. Thus far, her response to this request is not yet known.[76]

And there we must leave our short Liverpudlian ghost tour – not due to lack of material, but more due to simple lack of space. No doubt the reader will have their own tales to tell about the region, which could have lengthened this particular section out indefinitely. If you do, then don't keep quiet about them; people like to hear them, and it helps make Merseyside a more interesting place in which to live.

5

Demon Dogs and Curious Cats
Mystery Animals Across Merseyside

There is a fascinating branch of study known as 'cryptozoology'. Essentially having its origins in the work of the now legendary Belgian writer and zoologist Bernard Heuvelmans, the word basically means 'the study of unknown animals'. It is often assumed that these creatures – termed 'cryptids' – are real, physical, flesh-and-blood specimens that are simply as yet unknown to science.

However, there is another type of cryptid, whose existence is rather more controversial. These are known nowadays as 'zooform phenomena', a term coined by the cryptozoologist Jonathan Downes. 'Zooforms' are the strangest type of cryptid of all for, while they might look and sometimes act like animals, they probably are not actual animals at all! Instead, they seem to be something more like ghosts or elementals. Supposedly, these bizarre beings have physical characteristics or abilities not possessed by any known creatures in nature; they have glowing red eyes, for instance, can change shape and size, perform impossible leaps, or simply disappear into thin air before a witness' eyes. They are undoubtedly elusive and yet, at other times, appear able to produce physical effects upon the environment around them, such as leaving paw prints or scratches behind.

Perhaps the most famous such phantom cryptid from Merseyside is the 'Hell-Hound' of Formby shore, known generally as either 'Old Trash' or 'Skriker'. Allegedly, this ghostly dog, said to be of gigantic size, jet black in colour and with large glowing eyes, roams the shoreline between Formby and Ainsdale, two coastal towns to the immediate north of Liverpool, just below Southport. Legend has it that the hound's cries are an infallible omen of death to whoever hears them; a common element of demon dog tales from elsewhere in the country, too. Folk narratives of other kinds have attached themselves to Old Trash as well, however, such as in an old local yarn about a notorious Formby drunkard who encountered the dog one night on his way home from the inn and lashed out at it with his walking stick. This stick passed right through Skriker, and the dipsomaniac fainted away when the beast crouched down in front of him as though ready to spring up and strike. Waking up some time later, the man found Trash still sitting there staring portentously at him, something that made him get up, run away as fast as he could, and vow to give up drink forever. The moral being

enforced at the end of this narrative, of course, reveals it quite clearly as being one of fiction rather than fact.[77]

Are there, though, any grounds for supposing Old Trash to be a creature of fact rather than folklore? Apparently, there are. In the early 1960s, a group of reporters from a local rag went up to the beach at Formby one Hallowe'en night, in search of the monster. They wanted, it seems, an appropriately spooky story for their next edition. Remarkably, they got it; a 'huge dark shape' was seen by them moving around on top of a nearby sand dune, in silhouette. As they approached it, they could see it circling around and moving in the characteristic manner of a dog. When the newspaper men reached the top of the dune, however, they could see no sign of Old Trash – or, indeed, of any of the paw prints he should have left behind him. The journalist who wrote up the story for his paper said that he and his colleagues were 'sincerely convinced that what we saw and heard was not of this world'. However, it does have to be said that a newspaper headline along the lines of 'Local Men Don't See Phantom Dog' wouldn't exactly have made for very good copy.[78]

'Old Trash' of Formby Sands; don't go near him if you're drunk.

Other alleged first-hand sightings of Skriker at Formby are, it has to be said, very hard to come by. The only one I could actually find came from Steve Howe, a local photographer. He claims that, when out camping with his friends near the beach at Formby one night in the 1970s, he decided to go and have a dip in the sea. As he approached the water, however, he heard an odd noise, 'which sounded for all the world like a steam-train,' coming towards him at great speed from the other side of the dune he was walking past. All of a sudden, a gigantic black dog appeared up there on top of the 10-foot-high sandbank, before then bounding down the beach and away past Steve at great speed. As he turned around to see where the dog was headed, he found that it had simply disappeared into nothing – even its loud panting had stopped suddenly, and it was nowhere to be seen. According to Steve, this beast actually had red eyes. This is certainly a remarkable sighting, but I can't find any similar first-hand ones like it on record anywhere.[79]

In fact, probably the best evidence for Old Trash really haunting Formby comes not from the scattered fragments of the tradition found on Merseyside today, but from the wider picture of phantom dog sightings in the British Isles. Trash, you see, belongs to a very distinct order of spirits, generally known as 'Black Dogs'. Beasts fitting the description of Old Trash have been seen right across the country for hundreds of years, and have been given a variety of local names, from Black Shuck in Norfolk to Moddey Dhoo in the Isle of Man to Shag-Dog in Leicestershire. The names Trash or Guytrash are specific to the old Lancashire region, while Skriker is known from both Lancashire and Yorkshire. Supposedly, the name 'Trash' is onomatopoeic, being a reference to the sound the creature's paws make as it splashes along down muddy lanes (or, in Formby's case, along the wet sands).[80]

None of the motifs mentioned in the tales of Trash from Formby are in any way unique. The sound of its wailing is known as a death portent in many places in Britain, for example, and the detail of the glowing red eyes, likewise, is most common in these tales. Great size, unnatural speed, eerie blackness, sudden disappearance, and the lack of any footprints left behind it are other features of the Formby legends that pop up time and time again in accounts of the Black Dog from elsewhere, too. Even the unlikely sounding tale of the drunkard putting his walking stick through the beast, revealing it as being incorporeal in nature, has its parallels; exactly the same thing is once supposed to have happened to a man walking along the road between Cromer and Overstrand in Norfolk.[81] All these similarities speak quite strongly of Formby's Black Dog being a genuine local tradition, and not mere recent invention.

However, there has been an apparent decline in the number of sightings of such cryptids in recent decades. It seems that fewer and fewer people have been seeing things like Skriker with each passing generation since the Second World War. Why could this be? One possible answer that has occasionally been put forward is to say that Black Dogs *are* still with us – it's just that, nowadays, they have employed yet another one of their supernatural abilities, and changed their shape … into that of phantom cats.

Since the 1960s, the most famous type of cryptid to have been repeatedly sighted within the British Isles is surely the Alien Big Cat, or 'ABC'. ABCs are well known to us all. Sightings of big cats such as panthers, pumas, lynxes, cheetahs and even lions have been reported on in the British press for decades now, the most famous of which is probably the Beast of Bodmin. Generally, mainstream commentators have viewed these reports as being down either to misperceptions or to colonies of big cats having established themselves within

the British countryside after escaping from zoos, circuses or private collections. There is, however, certain evidence indicating that ABCs might actually be rather more zooform than they are genuinely feline in nature.

Indeed, ABCs appear to have many things in common with Black Dogs such as Old Trash. For one thing, they seem predominantly to be jet-black in colour. This might not initially sound quite so remarkable if they are things like panthers – everyone has heard of a 'black panther', after all – and yet, actually, this detail is in fact very odd. Black panthers are not, as most people think, a distinct species of big cat at all. They are actually melanistic leopards; that is to say, completely ordinary leopards that happen, through mere genetic chance, to have been born with entirely black fur instead of spots. Panthers, then, are extremely rare. They only pop up with such regularity in zoos precisely *because* of this rareness; if any hunter should get hold of one, then they can easily make a fortune from selling it on to a zoo, due to their novelty value.[82] Given this fact, then, why are so many British ABCs apparently jet-black? It should be impossible.

Further impossibilities about ABCs include their ability to avoid capture and to change appearance and size, and their frequently bizarre, un-big-cat-like behaviour. To give but one example, we could examine the famous case of the Surrey Puma, which began appearing on farmland in that county in 1962. This 'puma' appeared sometimes *as* a puma, sometimes as a kind of leopard, and sometimes as a bizarre amalgamation of various types of big cat all rolled into one. It was unable to leave any footprints behind it in the snow, and yet did so in mud. Weirdest of all was the fact that during the height of the puma scare strange lights, seemingly from nowhere, began shining upon farm buildings after dark. After the lights had appeared, so did the animal; it seemed to be connected with them somehow.[83] This, apparently, was no ordinary cat.

ABCs then, it seems, fulfil the same imaginative function for the modern mind as Black Dogs once did. But what of Old Trash of Formby? Has he, too, turned feline? You could argue, perhaps, that he has. In January 1997, it was reported that a 'black panther' had been seen wandering around near Ainsdale and Southport. Local newspapers were inundated with letters from readers claiming to have seen the beast prowling around in Formby Woods. Such was the volume of panther reports in the area, in fact, that the police felt obliged to send out a helicopter in order to look for the ABC from above. Perhaps unsurprisingly, given that it was meant to have lived in a wood, they didn't find it.[84] Was this uncatchable phantom perhaps the modern form of Skriker himself? I don't know, but it's certainly an appealing idea.

Probably the most significant spate of ABC sightings from Merseyside, however, centred around what was dubbed by the local press as being either the 'Widnes Panther' or 'The Beast of St Michaels Golf Course'. Sightings of a mystery creature on the loose in the town seemed to begin during 2000, but in May 2001 the first report of it being encountered on the aforementioned golf course came in. There were two witnesses to the ABC there, a certain Paul Burns and his son, who had reached the sixteenth hole when they stopped dead in their tracks as they saw the animal standing merely yards away from them, seemingly in a stalking position. Apparently, the cat was 'bigger than an Alsatian' with a 'long tail' and 'was very sleek'. Perhaps bravely, the two golfers moved towards the cryptid intending to try and get a closer look at it, whereupon its ears pricked up and it sprang away quickly into the nearby trees and woodland.[85]

The now disused St Michael's Golf Course in Widnes. If there is a big cat living there, it would have to be chemical-resistant.

Once the ABC had first been spotted on the course, it kept on turning up there on various subsequent occasions, too, particularly throughout 2003. Strangely, the appearance of ABCs upon golf courses is a commonly reported feature of British big cat sightings. It has been speculated that this could be because of a combination of rabbits being easily exposed as prey on the greens and fairways and the rough areas of courses providing good cover for the cats to hide in, but it does have to be questioned whether or not golf courses really provide a plausible habitat in which ABCs could flourish and yet remain largely unseen or uncaptured by man. After all, the rough on any municipal golf course is hardly likely to be *that* great in extent and the main part of the courses are pretty much guaranteed to have large numbers of people wandering across them each day. In addition, with St Michaels Golf Course it also has to be considered that it was closed down by the Health Protection Agency in 2004, after the soil in the area was discovered to be riddled with such levels of arsenic that it was deemed to be a risk to human health.[86] Hardly the kind of place where a panther would be likely to have thrived, you have to admit.

Perhaps, however, big cats don't actually *live* in such places, but simply pass through them occasionally upon their wanderings through a larger habitat. Maybe this could be why sightings of ABCs in the area are not limited merely to Widnes golf courses. For instance, big cats have been encountered just over the River Mersey, too, particularly by anglers out fishing in the area around Norton priory, home of the phantom monks, just east of Runcorn. One such report hit the papers in June 2007, when an angler named Steven Crabb came forward to tell the world what he had seen while out fishing with his ten-year-old son at around 3.00 a.m. one night some months previously. Hearing a rustling coming from within some bushes 12 feet away from his tent, Steven saw something large and dark jump out from them and onto the path. He shone his torch onto it, and saw that it was, in his words, a 'black panther'. It looked right at him, and Steven turned his torch off in fear. Fortunately, however, it then took little notice of him, walked down to the edge of the water, had a drink and then wandered away calmly along the edge of the water-reeds. The next day, Steven returned to the spot with his wife and they both said that they had seen large paw prints in the mud by the edge of the river. If only he had taken some photographs of them![87]

A more recent sighting of an ABC near Norton Priory was reported on in February 2010, after a Will Hayes, of Runcorn, claimed that he and his friends had been camping out on a fishing trip in the area when they heard some rustling coming from within nearby bushes in the early hours. Will used his torch to investigate, and saw its yellow glow being reflected back at him from two eyes, which he said were 'similar to a cat's, but much larger'. Bravely, he went out and followed the creature to the water's edge, finding that it had no interest in him. Instead, the black-bodied beast walked over to the net that he and his friends had left out in the water by the riverbank overnight. Deciding that he had best just leave the animal alone, Will returned to his tent. The next morning, the boys examined their net and found that it had been ripped open at the side, and all the fish it had previously contained had now gone. On top of the net there were bloodstains, and large paw prints could be seen in the mud next to it.[88]

Surely the most sensational reports of ABC activity in the region, however, occurred in July 2007, when sightings of a panther came in from the village of Frodsham, just south-east of Runcorn. Here, the police felt the need to make a public statement about the affair, seeing as it was ultimately quite serious in its nature. According to Inspector Phil Hodgson, of

Frodsham Police, he and his colleagues had first received a report from a man who claimed to have seen a black panther, around 10 feet long (leopards/panthers reach a maximum of around 5 feet in size) and moving at a rate of 40 mph, running around close to the reservoir which sits near Mersey View and Crowmere Lake just outside the village – and, curiously, just across the road from Frodsham Golf Club. Apparently, the police treated this report with a fair degree of scepticism. Then, however, they received a call from a farmer in the vicinity, who said that some of her cattle had been attacked in their field by an unknown animal. A vet called out to examine the livestock confirmed that it was certainly not any dog that had caused their injuries. Furthermore, one of the woman's lambs was found dead nearby, having been stripped of its carcass and its bones licked clean in the classic manner of a big cat. Inspector Hodgson reassured the public that there was probably nothing to be afraid of, though, as he had ordered a police aeroplane to sweep the area looking for signs of any beast from above, and had informed firearms officers about the situation as well. No ABC was ever found, of course; but, if there was not one at large in the region, then what exactly had killed the farmer's lamb and wounded her cows?[89]

Well, first of all, I think we have to say that it is most unlikely that the Widnes Panther and the Norton Priory and Frodsham ABC were simply the same animal on the walkabout, as the local media seem to have suggested. While these places are all very close to one another in terms of human geography, in order for a big cat to get from St Michaels Golf Course to Norton Priory, it would have to pass through several built-up areas, across a fair few main roads, and then either swim across the River Mersey, or wander across the Runcorn–Widnes Bridge. This doesn't seem terribly likely. So, if there are mystery feline cryptids in and around Runcorn and Widnes, then they cannot simply be the same one; there would have to be at least two of them in order to account for the numerous reports from across both sides of the Mersey. But how likely is it that two panthers could have escaped into the wild and then taken up home so close to one another in human terms? Not terribly likely, I would suggest. Perhaps, then, the beasts are not actually big cats at all?

This was the explanation preferred by a group of paranormal investigators known as UPIA (Unknown Phenomena Investigation Association) who came to the area in 2010 after reading reports of Will Hayes' encounter with the panther that ripped open his fishing net. They said that they had found some very interesting footprints on a derelict sports pitch at Haddocks Wood near to where many of the recent sightings had taken place. These marks belonged not to a big cat but rather to a pine marten, a rare type of large weasel that is usually found only in Scotland.[90] If so, then the animal's out-of-place nature would still be of interest to cryptozoologists, but does this theory entirely stack up?

Some parts of it do. Pine martens do indeed sometimes eat fish, are good swimmers, so can hunt near water, and do have a vicious bite and claws on them. They also tend to come out at dusk or night, like the ABCs at Norton Priory did. Also, a few are known to live in North Wales, which is not too far away for an isolated example of the species to have travelled from. But there are also several problems with this idea, too. For one thing, pine martens don't really look that cat-like; their tails, for instance, and the shape of their heads and small rounded ears, are nothing like a big cat's. They are also not jet-black, being usually light to dark brown in colour, sometimes with a cream or yellow 'bib' on their chests. Neither are they ten foot long or larger than an Alsatian, as several witnesses stated that the ABC was; they usually grow no longer than 21 inches. Most seriously, of course, pine martens are not

known to attack full-grown cattle or strip clean the carcasses of young lambs (although they will eat dead animals if they come across them).

Ultimately, I don't think that the cryptid was a pine marten. However, I'm not sure that a big cat could really be on the loose in the area, either. Granted, there is a lot of countryside around Runcorn and Frodsham, but enough to support an ABC – or even a whole colony of them, perhaps – for so many years, uncaptured? A lack of reliable food sources and heavy traffic and noise in the locality (the M56 passes right through it) make this idea seem quite implausible. One other possible answer to this whole conundrum, though, can be found in events from November 1981, when a gamekeeper, Reg Bryant, was shooting pheasants near the River Weaver, about 5 miles south-east of Frodsham, when his spaniel was attacked by a large spotted cat. After shooting it dead, Reg took the cat's corpse to be examined by experts from Liverpool University, who said – wrongly – that it was an ocelot. However, subsequent examination of a photograph of the animal's body by noted cryptozoologist Dr Karl Shuker later proved that the dead felid was in fact a large leopard cat; that's *leopard cat*, note, *not* an actual leopard.[91]

Leopard cats (*felis bengalensis*) are slightly larger than an ordinary domestic cat, and adorned with a coat featuring typical leopard-like black splotches on golden brown fur. They can be vicious, and can potentially grow up to 3 feet long. Seeing as there definitely was at least one of these beasts on the loose near Frodsham in the 1980s, could it be that there are still more of them out there in the local countryside, accounting for the contemporary ABC sightings? Well, obviously it is possible; but, once again, we come up against the problems of colour and size. Leopard cats are not naturally black, nor are they bigger than Alsatians. Also, they are native only to South-East Asia, not Europe; it is possible to keep one as a pet, but you would need a licence. While leopard cats can breed with feral cats and domestic moggies, creating hybrids, there are no known colonies of these beasts in Britain. Furthermore, their natural prey is limited to the same small animals that normal cats eat – rodents, birds and fish, etc. They certainly don't attack cows!

And, in any case, we cannot just automatically jump to the conclusion that there is definitely a colony of wild animals of a certain species living somewhere, just because a single such corpse has been found. After all, if this were true, then St Helens might be the home to an entire pride of lions, seeing as, on the night of 20 May 1980 a dead lioness was dragged out of a lake near a disused brick quarry known as 'the Clegg' and caused much puzzlement locally.[92] Speculation as to its origin centred around the rumour that it was dumped there by a travelling circus after it had died while visiting the town, but for a while it was not known whether this was an urban myth or not. However, if we can believe the online testimony of one local man, this theory actually was the true one. According to him, he was working for his father's skip-hire business at the time, when the circus hired them to take away a load of waste from their operation and then just dump it somewhere. Included within this detritus, it seems, was the corpse of the lioness. The man simply took it along to the Clegg, dumped it all on the floor, and then bulldozed it into the lake. Seeing as photographs of the dead lion being retrieved from out of the Clegg accompany this man's testimony, this story does actually seem to be true.[93] Sadly, then, wild lions do not live loose in St Helens.

However, it seems equally likely, in all honesty, that wild leopards and panthers do not live in Frodsham, Runcorn and Widnes, either. Maybe the beast really is a zooform and

not any kind of real flesh and blood creature after all, then. Curiously, some reports of the animal from the area do actually have certain ghost-like elements to them, which could be used to back this theory up. For instance, in November 2010 a jogger in Runcorn's Sutton Park saw what he described as being a 'large, shadowy thing', which was lying down in the distance, suddenly spring to life and then run away into the trees nearby. It was, the man said, huge – and very, very fast. It moved, apparently, at 'lightning pace', and was travelling so fast that 'it seemed to glide across the grass'.94 Just an expression? Perhaps, but there are numerous accounts on record of ABCs being able to move at an unnaturally fast pace, or in a fashion that seems more paranormal than it does natural. Maybe, then, these things are somehow more like visions than they are anything actually solid? You can look for hard and conclusive evidence of ABCs being at large in the Merseyside region all you like, but it seems most unlikely that it will ever be found. This is just one reason why many people seem to believe that they are, essentially, little more than ghosts.

Some mysterious phantom animals reported from Merseyside, of course, were *never* conceived of as being flesh-and-blood. For example, there are an awful lot of stories from the area concerning ghostly rabbits! One such tale comes from Warrington where, throughout much of the nineteenth century, a spectral white rabbit was allegedly seen by many persons in the Bank Quay area, its appearance being considered, just like that of many Black Dogs, an infallible portent of death or disaster for some relative of the person who saw it.95

A more celebrated white rabbit from the Warrington area, however, is the pale and ghostly one that could formerly be seen, so legend has it, being chased through the grounds of Bewsey Old Hall – former seat of the Boteler family, Warrington's founders – by a pack of hell hounds. This legend was well-known to a famous local resident, Lewis Carroll, who is thought to have based the famous White Rabbit character from his 'Alice' books upon the spook.96 Whatever the truth of this legend, there does seem to have been some genuine association between the residents of the hall and rabbits, as during archaeological excavations of the site in the 1980s a fourteenth-century seal die carrying the impression of just such an animal was found among other interesting items.97

Surely the best tale of a ghost-rabbit from the region, however, concerns the infamous 'Crank Rabbit', which is supposed to have haunted the small village of Crank, just north of St Helens, during the first half of the 1800s. Here, rather like at Bank Quay, locals feared the spirit of a large white rabbit with lop ears that used to jump out at people walking the roads between Crank and Rainford at night and then follow them home. To have the ghost-rabbit hop along after you in this way was dreaded, just like it was in Warrington, as it meant that doom or death was headed towards your household. The evil bunny eventually stopped being seen quite so often – though not entirely – after the railway junction was built at Rainford in 1858. Curiously, there is a railway station at Bank Quay, too. Is the latter story just a local adaptation of the original Crank one, perhaps, or does it speak of an old and now long-forgotten Merseyside tradition of rabbits being death omens?

A funny little folk story sprang up in order to explain the existence of the Crank Rabbit locally, however, concerning an old wise woman who had great knowledge of the healing powers of herbs. This woman had a granddaughter named Jennie, who had a pet white rabbit. However, a local man named Pullen who had come to the old woman for a cure had a grudge against her. Her magic medicine had not worked for him, and he had become convinced instead that she was actually a witch who had cast a harmful spell against him.

Accordingly, together with an accomplice named Dick Piers, he broke into her cottage one night hoping to prick her arm and draw out some blood to break the power of her magic. The old woman, however, awoke, and began screaming at their faces, which they had blacked up for disguise, and Jennie, with her rabbit in her arms, ran in to help. Seeing the intruders, she fled from the house pursued by Pullen and Piers, who wanted to stop her raising the alarm. Jennie managed to escape, however, and all the miscreants had to take out their anger upon was the poor little pet rabbit, which Jennie had dropped during her flight. This brave creature rushed out from a bush at them, but they simply kicked it to death in their fury. The next morning, Jennie was found dead at the bottom of a hill; she had fallen and injured her head in her panic. Her grandmother recovered, but was unable to say who the intruders had been, due to their blackened faces. She left the village in despair, and it seemed that Piers and Pullen had got away with it. They had not reckoned, though, upon the revenge of the rabbit.

According to the folktale, it began appearing to the two men at night, again and again, its mournful pink eyes accusing them and reminding them both of their hideous crime. Dick Piers was the first one to give in. He wrote out a confession and then killed himself by

The fearsome phantom white rabbit of Crank.

hurling himself down a nearby quarry pit. Pullen was the next to die. He was walking past the grandmother's old house one night when the ghost-rabbit came out and began to attack him. Every move he made was copied, mirror-fashion, by his little furry adversary. He ran away, but it sped after him, chasing him around the fields all night long until, eventually, he went insane and died of exhaustion.[98]

Far stranger even than tales of ghost rabbits, however, is the story of the giant talking cat that supposedly appeared in Speke during November 1953. Allegedly, a twelve-year-old boy from Rycot Road was playing Cowboys and Indians with his eleven-year-old friend Alan, who lived on Hale Road, one evening just before Bonfire Night. As darkness fell, the kids lit a small fire in Little Woods, the area where they were playing (now long-since claimed by housing developments), and Alan dipped his arrow into the flames before firing it up into the air. As soon as he did so, a very bizarre animal appeared in front of the lads 20 feet away; it was a gigantic tabby cat, 4 feet in height and, scarily, with human eyes, which were blue in colour. 'Hello children,' it said, and the boys panicked and fled out onto Western Avenue, where the 82E bus nearly knocked them both over. Back home, the boys told their parents what had just happened, but unsurprisingly they were not believed. The next day, the boys returned to the wood and lit a fire once more, hoping to see the cat again, having gathered together a bit more courage in the interim. Sure enough, the giant feline reappeared, came out from the trees, and sat itself down in front of them on the other side of the fire. It said that its name was Semeel, and that it was something called a 'Guardian'. It warned the boys to stay away from the wood, as there was a paedophile hanging out there who wanted to kill them. The boys returned home with this information and passed it on to their parents who, once more, failed to believe them. They knew this alleged pederast, and told the boys that he wasn't even in Liverpool at the moment, having gone away on holiday to Wales. A week later, however, this was found not to be true; the man had secretly returned to Speke and had built himself a den in the woods, where he was lying in wait. The police arrested him, and he confessed. It later turned out that this man had made an attempt to abduct and abuse a boy in Widnes five years beforehand. Semeel, it seemed, had saved the boys from a terrible fate![99]

Obviously, we are now deep within the realm of folklore and legend with such tales, rather than of actual experience, and there are various other such narratives involving purely legendary cryptids from Merseyside in existence, too. For instance, the area is even said once to have had its own dragon! Supposedly, way back when, the villages and farms that lay between Farnworth and Bold Heath (now both parts of Widnes) were being repeatedly bothered by a dragon that lived deep within the Runcorn forests around Halton Castle and continually flew out from its lair, eating the cattle in the fields and ruining people's livelihoods. A brave blacksmith named Robert Byrch, who lived at Cuerdley Marsh (nowadays a tiny area lying just at the borderline between Widnes and Warrington), decided to use his metalworking skills in order to kill it.

Accordingly, inside his workshop, he constructed a solid metal cage, almost like a suit of armour, large enough for him to hide inside, and with four jointed legs coming down from the bottom of it. Over this, he stretched the hide of a cow, with its head still attached, so that, from a distance, the contraption would look just like a real cow. Robert then took the disguise down to the fields, got inside it, and started mooing, pretending to be just such a ruminant quadruped himself. When the dragon spied him from above, it swooped down and grabbed the fake cow in its claws; whereupon Robert thrust out his sword and stabbed

the reptile fatally in its belly. He had to staunch the creature's wounds by shoving his fist inside the hole he had made until the dragon landed, however, for fear that it would just fall down into the Mersey and drown him with it, seeing as he was currently encased within heavy metal. When the dragon finally landed on solid ground, Robert jumped out, chopped the weakened lizard's head off, and went away to tell the King.

The King (the tale never says *which* king) rewarded the blacksmith by knighting him and giving him the new name of Sir Robert Bold, in recognition of his courage. He then awarded the new knight as much land as the dragon's hide would contain. Therefore, cunning Sir Robert quickly sliced up the dead dragon into tiny pieces and then laid them all out in a big circle, claiming the land now known as Bold Heath, together with the whole of Cuerdley to the south of it. The cow hide that Robert had used to disguise himself with, meanwhile, scored across with the dragon's claw marks, still hung up above the Bold family pew inside

A cunning plan was eventually concocted to slay the Cuerdley dragon.

nearby Farnworth church as late as the 1870s – or, at least, some old piece of leather or other certainly did. Nowadays, however, the only smoke belched out into the air near Cuerdley comes not from a fire-breathing dragon, but from the large cooling towers of the massive power station at Fiddlers Ferry.[100]

There is one final cryptid from the Merseyside region which remains for us to examine here, however, and that is surely the most significant one of all – the famous Liver Bird itself. What, exactly, was a Liver Bird? Was it a real creature? Debate over this issue has raged for years, and no *definite* answer has ever been arrived at by historians. However, the most widely accepted explanation for the animal's position as the official symbol of Liverpool itself is that, when King John granted his charter for the place to exist as one of his ports in 1207, he included a stamp of his seal at the bottom of the document as proof of its authenticity. John's seal, it seems, featured an eagle with a sprig of broom in its mouth (the eagle being a symbol of his namesake St John, and the broom being a traditional piece of heraldry associated with the Plantagenet kings); an eagle that, as it was copied down by hand upon subsequent documents by scribes, began to look less and less like an eagle, and more and more like an imaginary bird of no known species. The general opinion, then, is that the Liver Bird is the result of nothing more than medieval copyists' utter cack-handedness when it came to copying out other people's drawings.[101] Suggestions that the animal was actually a duck[102] or even a dodo[103] are, needless to say, entirely without foundation.

The Liver Bird, then, was probably originally nothing more than an eagle representing King John, but by the 1350s the town of Liverpool (as it then still was) had decided to adopt the malformed bird as the main symbol on its own corporate seal, the stamp it used to give authenticity to official documents. Was it then known as a Liver Bird or as an eagle, however? Nobody knows, as the first specific reference to a Liver Bird (spelled 'leaver bird') that we know of dates from as late as 1668, in a description of a ceremonial mace that had been donated to the settlement as a gift by the Earl of Derby. In 1797, though, the College of Arms granted Liverpool its own official coat of arms, which depicted what was by now, very definitely, no longer an eagle. The College of Arms described it as being a cormorant, a type of wading seabird that can be found in and around the Mersey mudflats, and said that it was seaweed inside the thing's mouth, not broom. The word 'laver', it seems, describes a type of seaweed found locally, and so some people have presumed that this was where the creature's name came from, something backed up by the fact that cormorants do indeed partially feed upon this substance. In any case, the opening of the Liver Building on the city's waterfront in 1911 paved the way for the symbol's modern popularity as being perhaps the ultimate emblem of Liverpool, seeing as the structure contains two towers, each of which is topped by one of the famous Liver Birds, looking out across the Mersey, the river that had once made the city rich.[104]

These two particular depictions of the Liver Bird are – other than the one found upon the crest of Liverpool Football Club, perhaps – the most famous versions of the creatures in existence. As such, numerous myths have sprung up about them over the years, such as the odd idea that they do not in fact represent either eagles or cormorants, but instead two gigantic survivals from Liverpool's prehistoric past, something akin to feathered pterodactyls, maybe, which had once lived in the Mersey and had had to be slaughtered before the city could be founded. Other versions of this story say that the prehistoric survivors were not killed, however, and willingly agreed to become the city's spiritual guardians, instead.[105]

Certainly, the idea that the statues are supernatural guardians of the city seems to be a relatively widespread local fairytale told to children. It is said that if they were ever to flap their wings and fly away the banks of the Mersey would flood, destroying Liverpool. Other people, however, say that one Liver Bird faces out to sea in order to act as a guardian and protector of those sons of Liverpool who have had to set sail for foreign climes on the ocean waves, while the other one looks inland towards the city itself, caring for these men's families. Yet others, meanwhile, aver that the birds face away from one another so that the male, looking inland, does not become attracted to the female one, looking out to sea, and unceremoniously jump on top of her. If the Liver Birds were to mate, it seems, disaster would somehow befall the city.[106]

Further tale-spinners, though, say that the statues regularly come to life at night, upon evenings when the moon is red. The most scurrilous myth about the Liver Bird statues, however, is that they flap their wings whenever a female Liverpudlian virgin walks past them in the street beneath. Seeing as nobody has ever seen them do this, it seems that the tale is an intended slight upon the chastity of the female inhabitants of the city, and one no doubt invented by Mancunians. In actual fact, however, the story is a probable reference to the fact that Liverpool's dock area used to be full of street-prostitutes seeking custom from the newly landed sailors.[107]

Nonetheless, entertaining though these local myths may be, it seems that there is no evidence whatsoever for saying that the various statues and pictures of the Liver Birds represent any kind of genuine cryptid; or is there? A very strange item appeared in the 2 July 1824 edition of the *Liverpool Mercury*. In this, the editors announced that a mystery man had just that very day walked into their offices and presented the astonished staff with a real, stuffed Liver Bird – or, at least, that is what the visitor *said* that it was. The *Mercury* staff, as the original report put it, had 'been taught to regard our corporation bird as the creature of fiction, like the renowned phoenix' but added that 'we must be permitted to observe, that if there be such a bird as the liver, this must be one of the species, as the resemblance it bears to our best representation of that bird [upon the College of Arms' crest, presumably] is most remarkable'. This avian creature was, it seems, about 2 feet tall and 'of a most elegant and symmetrical form'. The stuffed bird was placed on display in the *Mercury's* offices for anyone who had an interest to come along and have a look, in the hopes that some ornithologically-minded reader would be able to definitively identify it.

At first, this identification might seem to have been rather simple to perform. Seeing as the Liver Bird depicted upon the official insignia of the city was deemed, by the College of Arms, to have been a cormorant, then the 'Liver Bird' must obviously just have been one of these creatures that had been stuffed, surely? If the animal handed in to the *Mercury* looked exactly like the 'best representation of that bird' upon the city's seal, then this seems like the safest conclusion to draw.

The staff of the newspaper, however, seemingly did not agree with this idea. After a certain Mr Riddiough of Ormskirk, an expert ornithologist – 'who has stuffed hundreds of birds in his time', as the *Mercury* put it – had voiced his opinion that the specimen was indeed just a dead cormorant, the journalists laid out the reasons why, in their view, it couldn't be. Many other 'very experienced persons' had called at the offices since the bird had been handed in to them, and had proclaimed that the specimen on display 'differs from any bird they ever saw in their lives'. They were no ornithologists themselves, the newspapermen said, but

The famous Liver Building and the equally famous Liver Bird perched on top of it. But was the Liver Bird real?

even they knew that cormorants were web-footed; yet the bird in the office had 'fine long slender toes, without the slightest web', apparently. Their final description of it was this: 'Its height is about two feet, beak and legs dark iron grey, neck, breast, belly, and thighs, reddish brown, back and wings, bronze colour, beautifully variegated in the light with shades of green, purple and reddish hues.' They had an exact drawing made of it before its owner returned to reclaim the thing, just in case anybody should prove able properly to identify it in the future. As far I can tell, nobody ever was, and the whole matter was just forgotten about.[108]

So, what was it? Well, like the staff at the *Mercury*, I am not an ornithologist either, so I don't know. Given the other tales of incredible cryptids and zooform phenomena that have been supposed to haunt the Mersey's shores over the years, however, perhaps it should not surprise us too much that even the famously fictional Liver Bird might end up having at least a tiny grain of truth lying there behind it.

6

The Devil and All His Works

Some of the creatures discussed above sound as if they were positively devilish or demonic in their nature, particularly Old Trash of Formby Sands. Traditionally, of course, demons and the Devil himself have been associated with certain human agents here on earth, namely witches and warlocks. This is a somewhat unfair association, though, because witches in the form of 'wise women' and 'cunning folk' were once an accepted part of the countryside landscape right the way across Europe, and thought of as able to perform beneficial white magic, not just cast evil spells, being considered 'healers' more than wicked sorcerers by many. However, Christianity, sensing a rival in its midst, set out literally to 'demonise' these persons, attempting to blacken their name by connecting them in the popular mind with Satan and his imps. In this aim, it has to be said, the Church was most successful, and modern people still tend to conflate witches and so-called Satanists together as being one single class of people, no matter how inaccurate this idea may actually be. As such, few places in Europe are entirely free of folktales about sinners' and witches' commerce with demons, ghosts and devils – and Merseyside is no exception.

Indeed, two of the most famous names of modern witchcraft come from the area. Perhaps most significantly, Gerald Gardner himself, founder of what we now call the Wicca movement, was born at Blundellsands near Crosby, just north of Liverpool, in 1884. Without Gardner, contemporary Paganism would look rather different in its nature. While living on the edge of the New Forest just before the Second World War, Gardner claimed to have been introduced to a coven of witches who said they were among the last-surviving modern practitioners of an ancient system of magical beliefs that had its roots in pagan antiquity. In his later books, such as 1954s important *Witchcraft Today*, Gardner fused these alleged ancient practices together with certain esoteric elements either of his own invention or borrowed from notorious occultists like Aleister Crowley, and revealed details of what came to be known as 'The Craft' or 'Wicca'. While these developments did not take place in Merseyside as such (which is why we are not dwelling upon them at any length here) it does nonetheless remain a fact that much of the ritual and belief of the modern witch religion derives ultimately from the work and writings of a local man.[109]

Another significant twentieth-century occultist from Merseyside was Orrel Alexander Sanders (better known simply as Alex Sanders, although his real surname at birth was Carter) who was born in Birkenhead on 6 June 1926 in a place called, appropriately enough for someone of his leanings, Moon Street. During the 1960s, Sanders became well known to tabloid readers, after he declared himself to be 'King of the Witches', and began promoting himself by regaling reporters with all kinds of outrageous tales about the kind of things he had allegedly been getting up to. According to him, he was initiated into the world of witchcraft when, while still only seven, he was sent away from Birkenhead to visit his grandmother Mrs Bibby in the Welsh countryside for a while, to recover from TB in the fresh air. One evening in 1933, he made his way back to her house for his tea, but neglected to knock on the door first before going inside. This proved to be a big mistake as, he said, he was confronted with the disturbing sight of her standing naked in the middle of a magic circle she had drawn on the kitchen floor. His grandmother, it seemed, was a witch!

Seeing that her secret was now revealed, Mrs Bibby ordered Alex to strip off and join her inside the circle. Then, the boy was told to bend his head down into his own groin. While he was doing this, his grandmother produced a sharp sickle and cut one of his testicles, telling him that 'You are one of us now' as she did so. Supposedly, Mrs Bibby then began instructing her young charge in the art of witchcraft, telling him that she was a hereditary witch, having been a direct descendent of the well-known Welsh rebel Owain Glyndwr, who (according to Sanders, at least) was once the King of the Witches himself. Applying the law of succession to this claim, it therefore followed that Sanders was now the new Witch-King, and had to be instructed in the black arts. His seventy-four-year-old grandmother did this by engaging in ritual sex with him and then letting him copy out her Book of Shadows (a kind of 'witches' manual' in modern Wiccan lore). It later turned out, however, that this rather sick story of Sanders' was essentially false; he had actually been initiated into witchcraft by a woman from Nottingham during the 1960s. Both Mrs Bibby and Alex's mother were interested in the occult, but the above tale was just exaggeration.

While living among the working classes in Birkenhead as a young man, though, it seems that Sanders was genuinely immersed in matters esoteric, this false origin-myth notwithstanding. For instance, he appears to have found work at some point as a spiritualist medium in the area, working under the name of Paul Dallas and performing healing rituals upon the sick. It has been claimed in addition that he and his two brothers were extremely psychic, and that they carried out séances at their home in Moon Street in which full-bodied apparitions would materialise from out of the ether. Alex's mother, by now entirely used to such occurrences, would busily run around doing the washing, ironing and cleaning while they went on raising the dead, totally unconcerned by it all. This, however, sounds like a rather romanticised image of domestic necromancy to me.

The Sanders family eventually moved away from Birkenhead to the home of all darkness and evil, Manchester, where Alex says that he first became involved in 'black magic' proper, manipulating a middle-aged couple who said that he resembled their dead son, getting them to buy him his own house and give him an allowance so that he could live a life of debauchery for free. This fortune, he said, he had engineered through sorcery. However, by the early 1960s, stung by a series of personal tragedies, Sanders had turned away from this pursuit, and discovered instead the writings of his fellow Merseysider, Gerald Gardner. In 1962, he somehow managed to persuade the *Manchester Evening News* to run a full-page

story on him and Wicca, and his fame began to grow. By 1965, he was claiming to have over 1,600 followers in 100 covens (groups of witches) across the country, all of whom recognised him as being their king – an assertion that outraged those other modern witches who were not his disciples.

After this, Sanders' media activities became ever more outrageous. Upon one occasion he offered to resurrect a man from the dead for the local press. Accordingly, one night at a supposed 'magical site' in the Cheshire village of Alderley Edge, in front of a reporter and a photographer, he stood over a dead body swathed in bandages, and asked a GP to perform a medical examination upon it. The doctor pronounced it to be dead, and Sanders then began reciting a magical formula over the corpse. Unable to resist the power of the spell, the body started to move, and the newspaper men fled the scene with a great story to print. Sadly, however, the 'corpse' was just a live man wrapped up like a mummy as a stunt, the 'GP' actually being one of Sanders' friends in disguise, and the 'magic spell' simply a Swiss roll recipe that he read out backwards in a funny voice.

Eventually, Sanders resorted to using sex to get publicity. He kept on appearing in photographs naked except for a loincloth, and surrounded by nude witches – their lack of clothes during rituals, he said, being an inviolable 'witch law' under his kingship. On another occasion, he claimed that he gave birth to a 'spirit baby' called Michael (which used to possess him at parties, causing him to act wildly and insult people, so he said) by convincing a fellow disciple to engage in an act of mutual 'magical masturbation' with him. At one point in his life, Sanders claimed to have been following a route of magic he called the 'left-hand path'; perhaps this was because he was too busy using his right hand on his mate?

However, many people assert that Sanders did actually have certain psychic powers alongside all the mumbo jumbo being performed for the benefit of the media. By the laying on of hands, he was meant to have cured people of cystitis, heroin addiction and even cancer. He even said that he was able to perform instant abortions simply by pointing at a pregnant woman's stomach and 'willing' the foetus to die. Obviously, such cures are more than a little ambiguous in their nature, but there are some people who believe that they were genuinely magical.

In later life, it seems that Sanders – by now living in Sussex – regretted his earlier courting of the press, and he appears to have devoted the rest of his life to more serious magical practices than reading out Swiss roll recipes in front of journalists in the middle of the night. He spent his time from now on channelling spirits, initiating others and trying to do good. All things considered, Alex Sanders was one of Britain's most significant occultists of the twentieth century, a sub-class of Wicca known as Alexandrian Wicca being named after him and still followed around the world today.[110]

Long before the days of the modern Wicca movement, though, it seems that there was already witchcraft abroad in Liverpool, as in 1667 the city had its very own witch-trial. Apparently, a woman named Margaret Loy, who lived in Castle Street near to what is now the modern town hall, was arraigned for being a witch, and eventually confessed herself guilty (no doubt after being put under much pressure and torture), accusing her sister, a certain 'widow Bridge', of being one too. According to Loy's confession, she and her sister had become witches after their mother had died, leaving them nothing in her will, due to poverty, except for two 'familiar spirits' (demons, generally in the shape of animals such as black cats or toads, which Satan was meant to hand over to his witches to act as their

servants). With these inherited devils, it seems, Margaret Loy said that she and her sister had worked much magic. What happened to Loy and the widow Bridge after this unlikely confession had been forced from them, however, I do not know.[111]

Witch trials on Merseyside are a thing of the distant past, however, of the Middle Ages and early Renaissance ... aren't they? Apparently not. Amazingly, as late as 1876, there was a trial involving witchcraft held at Warrington. In September of that year a Mr and Mrs Jackson, of Dial Court, were summoned before magistrates and charged with beating up an eighty-four-year-old woman named Maria Platt, in a dispute about the hanging of a clothes line. Living in close quarters amid narrow streets in what seems essentially to have been a slum area, space was at a premium, accounting for tempers being raised over what now sounds to us like a very trivial issue. The couple certainly were angry, though, the two defendants allegedly whipping Mrs Platt with the washing line, knocking her to the ground and raining down blows before then threatening to kill her. Several people apparently saw this whole unedifying spectacle happen.

However, the only witnesses who subsequently turned up in court were for the prosecution, and they all testified that Mrs Platt was entirely the victim in the matter. It seems that the Jacksons' defence witnesses did not appear as they had been told to, their solicitor informing the court that they were all afraid to do so on account of Mrs Platt being, in their view, a notorious witch and fortune-teller, who would curse them if they should happen to cross her. It was denied in court that Mrs Platt had made her living like this, though, and argued instead that it was Mrs Jackson who had in her possession various cups, glasses and tarot cards for use in fortune-telling, which she had offered to sell Mrs Platt some time earlier. Either way, the bench decided that the Jacksons were obviously guilty of abusing an old woman, bound them over to keep the peace for six months, and fined each of the defendants £1 – a much more appreciable sum of money in 1876 than it is now.[112]

Stories involving witchcraft on Merseyside still appear in the press, even today. In 2010, for instance, it was reported in the *Liverpool Echo*, seemingly in all seriousness, that a local pub had been burned down by a witch's curse. The blaze at the establishment in question, the Magazine Hotel in Wallasey, was put down by the fire services to a power surge which blew up a fuse box, leading to £200,000 worth of damage being done. According to the pub's owners, Linda and Les Baxendale, though, the fire was actually caused by witchcraft.

It seems that the establishment is 250 or so years old, and had, at some point at least a century ago, acquired some strange decorations hanging above the bar. These were two little figurines of witches, and one of the Devil, fashioned from out of brown felt, which local tradition said were cursed. Should you touch them, it seemed, dreadful misfortune would follow. Linda Baxendale, who had begun running the pub in 1980, said that she had received an anonymous phone call when she and her then husband Phil had first moved into the place, telling them never to move the figures. The caller claimed that a painter and decorator had taken them down temporarily while doing the place up in the 1970s, and had then promptly been involved in a serious car accident at the top of the road. Further accidents followed. Phil, after accidentally touching one of the witches, fell down through a trapdoor into the cellar and broke his collarbone the next day, and another unfortunate ended up smashing both his knees. Deciding to take the curse seriously after this, Linda left the figures well alone and over the years they were not even dusted down, coming to acquire cobwebs and other detritus all over them.

One Friday night, however, a mystery man ran into the pub, so Linda said, and stole one of the witches. By Sunday morning, 18 April, the pub was aflame. The remaining two figures, it seemed, survived the blaze, despite the bar around them having been scorched, but then mysteriously disappeared. When the Magazine reopened in September 2010, though, a brand new witch was hanging above the bar, having been bought specially from a shop in Pendle. A new brew was also put on sale in the pub in order to celebrate its reopening, called 'Witches' Revenge'.[113] No doubt this story appearing in the local press got the Magazine's reopening some good publicity.

Another related myth which still has some popularity on Merseyside is that old yarn about somebody selling his soul to the Devil. This, of course, was what witches were sometimes supposed to have done in the past (according to church propaganda, at least), but, as time passes and fewer and fewer people believe in the reality of witchery, the motif has been modernised and readapted to fit other characters, more suitable to be discussed in the twentieth and twenty-first centuries. For instance, there are persistent Liverpudlian myths concerning the idea that John Lennon sold his soul to Satan in return for musical success. While this story is current across Merseyside, though, I don't think that anyone literally believes in it ... well, except for a man named Joseph Niezgoda, that is.

Niezgoda, an American (naturally) published a book in 2008 entitled *The Lennon Prophecy*, which claimed that the youthful Lennon, disillusioned by the death of his mother in a traffic accident in July 1958 and his abandonment by his father while still a small child, entered into a deal with Beelzebub to achieve fame and fortune through his music. Supposedly, various references are made to Lennon's devilish deal throughout some of the Beatles' best-known songs – at least, according to Niezgoda, who also pulls certain of the singer's public pronouncements (such as his notorious claim that the Beatles were 'bigger than Jesus') into the mix as 'evidence' of his theory, too.[114] Another version of this tale that is popular on Merseyside, meanwhile, adds the detail that the site of Lennon's pact with the Devil was at Mossley Hill crossroads in the south of Liverpool.[115] However, this notion is clearly just an adaptation of an older and much more famous legend of an exactly similar type, that of the black American blues singer and musician Robert Johnson, who is supposed to have sold his soul to the Devil in return for being given musical ability at a crossroads near Dockery Plantation in Mississippi.[116] In much folklore, the image of a crossroads stands in for a kind of 'crossroads between two worlds', where a person was once considered more likely to encounter the supernatural, which perhaps accounts for the popularity of this specific motif being spoken of so often in soul-selling myths of this type.

Another Merseyside legend concerning a Faustian pact centres around a bizarre 'tomb' (actually just an elaborate gravestone) which sits in the graveyard of the derelict St Andrew's church on Rodney Street near the city centre. Shaped like a small, black, stylised pyramid, it is the final resting place of one William McKenzie, supposedly a compulsive gambling-addict who lost his soul to Satan. There are two variant versions of how precisely this event came about; one says that he deliberately sold his soul in return for being guaranteed success in a high-stakes game of poker. Another, however, has him gambling with a certain Mr Madison, and losing all his money. At this point, Madison was supposed to have proposed gambling for the one thing McKenzie had left, namely his immortal soul, which the foolish fellow agreed to do – not knowing that 'Mr Madison' was actually Satan. Whichever version is being told, however, it is said that the Devil then informed his victim that he would claim

his soul as soon as he was laid to rest in his grave. Therefore, in order to cheat his way out of going to Hell, McKenzie interpreted these words of Lucifer's in a strictly literal sense, and insisted that, when dead, he should not be buried in a grave at all but, rather, stored away above ground in his pyramid, sitting upright at a table and clutching a winning hand of cards, symbolising his ultimate triumph over evil. This arrangement had its price for McKenzie, however, and his unquiet ghost is supposed to wander through the graveyard of St Andrew's still.

It's a good story, although obviously untrue. William McKenzie himself, however, was real enough, and it really is his body which is stored away beneath the pyramid. A successful railway contractor and engineer of Scottish origins, he died in 1851, leaving behind him an estate worth £383,500 – millions in today's money.[117] If McKenzie really was a gambler, then, he must have been quite a successful one, with little need of demonic aid to help him cover his losses.

A possible, though unlikely, internal view of McKenzie's tomb.

But what about the idea that McKenzie is buried sitting up inside his pyramid at a table playing cards, though? Is there any truth to this rumour? Sadly not. Unusual burials in order to cheat the Devil are a common motif of English folklore. For instance, there is a whole sub-genre of folk stories in which the Devil threatens a man who has annoyed him by saying that, when he is dead, he will steal his soul 'whether buried in church or without'. As such, the cunning opponent of the Devil arranges for his corpse to be laid to rest in a most unusual fashion either inside the wall-cavities of the church, or half-beneath the church walls and half-outside them, thereby managing to turn Satan's own words against him, just like William McKenzie is said to have once done. There are numerous variants of this basic tale, and it seems quite clear that the story surrounding the pyramid in St Andrew's churchyard is simply yet another one of them.[118]

Actually, of course, stories about half-in, half-out churchburials are a kind of folk-explanation for how certain people came to be buried in niches within church walls. Likewise, the story of McKenzie and the Devil is clearly just a Liverpool legend that has arisen to help people try and explain through myth the appearance of the weird pyramid in Rodney Street. However, where did McKenzie get his idea for the pyramid from in the first place? Probably, he copied it from someone else. John 'Mad Jack' Fuller, once the Squire of the hamlet of Brightling in East Sussex, a former MP and noted drunk, was laid to rest

Mckenzie's tomb on Rodney Street; building-work prevents you from getting up close to it at the moment, hence the railings and security fence. Or is that just MckKenzie trying to keep the Devil out.

in his own pyramid tomb in 1834 in the grounds of the church of St Thomas à Becket, in Brightling. For years afterwards it was said by locals that he was entombed inside the place, in full dress and top hat, and sitting at a table with an entire roast chicken and a bottle of wine ready before him. Sadly, this proved to be untrue during renovations that took place there in 1982.[119]

Given the similarities between the way that both McKenzie and Fuller are meant to have been buried inside their respective pyramids, then, it seems likely that one story has been based upon the other. Seeing as Fuller died nearly twenty years before McKenzie, however, his was surely the original legend. It does appear that there was a certain vogue at the time for tombs being created in such a shape, perhaps due to the craze for all things Egyptian that was then prevailing in England. The pyramid in Rodney Street is not actually a sign of anything occult, then – merely a monument built in stone to the fads of early Victorian burial fashion. And as for its future? Well, if McKenzie's ghost really does wander through the graveyard, it won't be able to rest in peace any time soon, seeing as Liverpool City Council recently approved plans to renovate the ruined St Andrew's church and transform it into student flats.[120] Perhaps one of the place's new young residents will one day break inside McKenzie's pyramid during rag week, then, and find out once and for all whether he is sat there at his table still, clutching a winning hand full of aces held triumphantly between skeletal, cobweb-strewn fingers. Somehow, I doubt that he is.

The Albert Space Dock
Merseyside UFOs and Aliens

In August 2011, some shocking negligence on the behalf of Liverpool City Council came to light. As a result of a Freedom of Information request made by an unnamed member of the public, the world was informed that Merseyside's emergency services had not made even the most basic preparations for the catastrophic fallout that would inevitably occur should Liverpool ever suffer a full-blown alien invasion. The request ran as follows: 'Can you please furnish me with any and all information held by yourselves relating to plans to deal with an alien invasion? By alien, I mean a life-form that evolved on a planet other than Earth, and travelled here by any means possible.' Thanks to a quirk of the law, the emergency services had to take this enquiry seriously, and provide an appropriate response. Merseyside Police said that they currently had no specific plans for dealing with an alien attack, but did point out, in an attempt to reassure the public, that if such an extraterrestrial outrage did occur they would simply treat it as a generic 'national emergency', and follow the usual guidelines laid down for such situations. The local health authorities made a similar response. Merseyside Fire & Rescue Service had a different attitude to the query, however; they dismissed it as being 'vexatious' with 'no serious purpose or value' and got on with doing something important like putting out fires, instead.[1] However, perhaps we should not be *quite* so dismissive of this man's question, even if it was probably intended as a joke; after all, Merseyside has played a surprisingly significant role in ufology over the years. For example, the journal *Magonia*, the main outlet for what might be termed 'alternative' perspectives and viewpoints upon ufology, was based in Liverpool under the auspices of its Liverpudlian editor, John Rimmer, for a long period, which is surely worth celebrating. Perhaps even more significantly, numerous UFO sightings and close-encounter cases have supposedly taken place on Merseyside over the years too – some of which are among the most bizarre ever recorded, as we shall now see.

1

Runcorn's First Space-Traveller

Runcorn is not a famous place, the amazing Byron Street poltergeist notwithstanding. However, it is at least vaguely notable for having a couple of firsts to its name – the first major dedicated bus lanes in the country were built in Runcorn, for instance, as was the UK's first indoor, 'American-style' shopping city, Halton Lea, which, perhaps surprisingly from today's perspective, was considered to be astounding and important enough to merit being opened by Queen Elizabeth II herself back in 1972. Far, far more interesting than these dull facts, however, is the idea that it was from this obscure town by the banks of the River Mersey that the first trip by a British citizen beyond the limits of our earth's atmosphere supposedly took place – an event which was formally announced in the unlikely place of the front page of the *Runcorn Weekly News* of 10 October 1957.[2] Beneath the bizarre headline 'Spiritualist insists he was first in outer space', reporters told of a local man, James Cooke, of Westfield Road, who in the early hours of 7 September 1957 had apparently made first contact with a group of alien beings from the planet Zomdic at the top of a local sandstone prominence called Runcorn Hill, just south of Cooke's home.

Cooke, it seems, had known that he was a 'chosen one' from an early age – he had to be, his mother had told him so. Perhaps because of this fact, Cooke informed interviewers from the local newspaper that he had always been sure that the space-people would contact him one day. While a member of a local Spiritualist church, he had already been communing with the dead; now, he was ready to use his psychic abilities to contact aliens, too. Accordingly, when he began receiving telepathic messages from a flying saucer telling him that the ETs would meet him in the early hours of Saturday 7 September 1957, he was already mentally well-prepared for such a thing. He had been seeing saucers buzzing through the skies of Runcorn for quite some time now, and had even witnessed an entire formation of them earlier that day, he said. At around 2.00 a.m. the final confirmation message came through into his head, and Cooke went out to Runcorn Hill, where, at 2.15 a.m., the spaceship at last arrived.

It was a classic saucer-type craft, apparently, 120 feet in diameter and 'as brilliant as lightning' to look upon, and it kept on changing its colour, from blue to white to red. It

stopped around 20 yards away from him, and hovered slightly above the ground, the grass at the top of the hill waving to and fro gently beneath it. Then, a gangway was let down from the ship, which did not quite touch the floor. Following this, a telepathic voice in Cooke's head gave him the following message: 'Jump, do not step. Jump on to the stair. The ground is damp. Jump. Don't have one foot on the ground or you will be hurt.' It seems that this was because it had not long been raining and the grass was wet, which would have given Cooke some kind of electrical shock if he had touched the stairs at the same time as one of his feet was in direct contact with the ground.

Once inside the craft, Cooke found that it was not the real 'mother ship'. That was hovering somewhere up above, waiting. Inside this smaller ship, however, was a bright light that seemed to come from everywhere and nowhere at once, casting no shadows. The telepathic voice reappeared, and told Cooke to take off all his clothes. He did so, and a strange suit appeared next to him. He was instructed to put it on. However, the suit, which was made from some kind of plastic-like material, was all in one piece, and Cooke found it difficult to get into. There was even a mask-like covering for Cooke's head and face, which sealed over his lips, physical speech now being considered unnecessary on account of the telepathic powers of everyone involved. Once he had finished, the suit sealed itself together at the point where it was meant to fasten, in an airtight manner. Then, Cooke was transferred safely into the mother ship.

Here he was greeted by the aliens, who were basically human in form, and appeared to be Scandinavian, as was fashionable at the time. They seemed friendly, and greeted him with a bizarre salute, placing their left hands over their eyes and their right ones over their hearts. Telepathically, they informed him that they were going to take him on a trip to their homeland, the Planet Zomdic, whose existence, conveniently enough, was unknown to the earth's scientists as it was in another solar system. The Zomdicians also informed Cooke that they could read his mind and he theirs, and that, therefore, it was impossible for either him or for them to lie to one another. As such, he felt that he could trust them, and they set off together on their journey beyond the stars.

As an engineer by trade, Cooke was well-placed to understand the workings of the Zomdicians' ship. It operated, he said, upon a 'harmonic principle' – i.e. it was controlled by music! The ship's pilot sat down upon what looked suspiciously like a bucket in front of a table on which was a small hammer-like object. Picking this up, the pilot began to tap it upon some metallic strips, arranged in the form of organ stops. A beautiful 'ping' was heard, which then began to grow louder and higher, and the craft took off. Once in flight, the space pilot was able to control its movements simply by placing his left hand upon a kind of small ball and moving it about accordingly. When the time came for the saucer to land on Zomdic, the pilot took up his tiny hammer once more and struck some more of the metal strips with it, causing the musical humming to cease, and the ship touched down safely upon the ground.

Outside, Cooke was surprised to find that the planet's vegetation was all yellow, not green, and that the Zomdician equivalent of grass was a kind of small herb with beautiful blue-tipped flowers. Zomdic had roads, but these were preserved purely for historical purposes, as everybody had their own mini-ship in which they could fly around at a height of about 20–30 feet off the ground. He was taken in one of these flying musical cars to meet one of Zomdic's 'Wise Ones'. This chap seemed graver than his fellow beings, and had a disturbing warning for James Cooke to heed.

The Zomdician craft operated upon strict harmonic musical principles.

'Listen,' he announced, no doubt in portentous tones, 'The inhabitants of your planet will upset the balance, if they persist in force instead of harmony. Warn them of the danger.' This, seemingly, was a reference to the Cold War between Russia and the West and the various atom-bomb tests that were then going on. Cooke, however, was understandably puzzled when he heard this statement. 'But they won't listen to me,' he said, quite reasonably. 'Or anyone else either,' sighed the Wise One wearily, and Cooke was then given a crash course in interplanetary physics. Harmony, it seemed, was indeed the key, in space travel as in life.

After this interstellar summit had ended, Cooke was taken back down to Planet Runcorn, went back into the smaller ship and tried to get changed again. He had immense trouble getting himself out of his plastic suit, however, and eventually resorted to retrieving a razor

A bisexual Zomdician Wise One gives James Cooke a most stern warning.

blade from inside the coat pocket of his own ordinary clothes, and then slitting the garment open with it. Climbing down from out of the ship onto the damp grass, Cooke then forgot about the Zomdicians' previous instructions and neglected to let go of the stair rail when he placed his feet on the ground. As a result, his hand suffered an electrical burn – the only piece of evidence he was able to show to anybody by way of proof that his whole extraordinary encounter had really happened.

It was 10.50 p.m. on Sunday 8 September when Cooke walked back into his house on Westfield Road. In earth-terms he had been missing from home for quite some while, and he was greeted by his mother and four of her friends, to whom he told his extraordinary tale.[2] Perhaps feeling a sense of responsibility to warn the planet of the errors of its ways, Cooke then wasted little time in spreading the word, presumably at some of Runcorn's Spiritualist

meetings, and it was not long before the local press got hold of the story. No doubt due to the innate comic potential of Cooke's sensational claims, word soon began to spread across the rest of the country about the Runcorn man's strange meeting with spacemen, and he was even interviewed by TV crews. The British media, it seemed, had found its first real 'contactee' – the name then given to persons who claimed to have been in contact with friendly aliens, and whisked off by them to their homeworlds.

Flying Saucer Review, the leading British UFO periodical of the day, sent out an investigator, Thelma Roberts, to interview Cooke after the story broke, and thereby gained yet more details about Zomdic and its inhabitants to pass on to an ever-grateful world. Roberts found Cooke to be 'a sincere and kindly person with an open and receptive mind, devoid of vanity and with a keen sense of humour', and he gladly answered all of her questions 'without wavering'. He informed her that the people he met on Zomdic were very curious of appearance, being 'baby-faced' and attractive, with good, smooth complexions. He said that he could 'only call them beautiful'. Moreover, the inhabitants of the planet had no distinct genders, being, as he put it rather amusingly, 'bisexual'. However, seeing as he also said that some of the Zomdicians had beards, perhaps he was a little inconsistent upon this point!

They did not have money, Cooke said, as, so advanced was their science, that every person on the planet was able simply to instantly transform pure energy into any kind of physical form they wanted. This gave the Zomdicians immediate access to any food or object they desired, thus putting an end to any need for cash or coins. 'What they need they have', was how *FSR* put it at the time.[3]

The national media is hardly likely to give space to such a man in the long-term, however, and while he was becoming ever more well-known – or perhaps notorious – locally, on a national level Cooke soon began to drop out of view. Harold MacMillan, Prime Minister at the time, just wasn't ready to listen to his calls for world peace and, as such, Cooke focused instead upon holding meetings with a small group of like-minded souls, who met in a converted shop in Runcorn to try and contact the men from Zomdic once more. Later calling themselves the Church of Aquarius, they would all sit around a luminous plate in a darkened room attempting to 'tune in' to telepathic messages from the stars, until eventually Cooke would begin to have some kind of visions of spacemen. This method of talking to aliens, quite clearly, had much in common with Cooke's earlier religion of Spiritualism – but with discarnate 'aliens' standing in very capably for discarnate 'ghosts' in order to better reflect the more technological and space-age concerns of the times.[4]

Runcorn's first contactee didn't give up on the notion of physical interplanetary travel entirely, however, and in November 1959 Cooke was at it again. This time, he was psychically summoned up to Helsby Hill, in nearby Frodsham, where yet another flying saucer stopped to pick him up. However, he did not go to the planet Zomdic on this occasion, but instead to a place called Shebic. This planet, he said, was much larger than the earth, and had very different atmospheric conditions, the days being longer and the nights 'exceedingly cold'. All of its people were humanoid in appearance, being around 5 feet 2 inches tall, and having lovely golden-brown skin, perhaps as a result of their long hours of daylight. Certainly, it seemed as if the people of Shebic would have had plenty of time to spend lounging around sunbathing; just like on Zomdic, there was no industry, and nobody had to have any kind of job. Not everything was better up there in space, however; sadly, there were no birds or

birdsong on the planet, so Bill Oddie wouldn't have liked it much.[5] This, though, was to prove to be Cooke's final holiday from the surface of our earth up to a daftly named planet in space, and he had to settle for channelling through more messages from beyond for the next few years, instead.

In the 1960s Cooke's beliefs changed somewhat, and from June 1961 he began styling himself not as plain old James Cooke, but as 'The Most Illustrious Brother, the Reverend James Cooke, APh', and declared himself to be the head of the Aquarius Church, and no longer simply its chief medium. In other words, then, he had essentially appointed himself as being the Space Pope! In July 1966, however, it seems that the Reverend Cooke had his downfall, when two popular Sunday scandal sheets, The *News of the World* and the *Sunday People*, carried an exposé of his latest antics.

It transpired that, short of money, Cooke and his followers had taken a cheap boating holiday in the Norfolk Broads and begun wandering around the area selling brooches shaped like discs, which, they said, would bestow 'mystical powers' upon their wearers, as well as handing out religious tracts in an attempt to gain more converts and turning up at pubs rattling collection tins. The *Sunday People*'s headline at the time – 'Crackpots in Dog Collars' – was an apt summary of what most people must have thought of Cooke and his crew after reading these accounts. After this exposure of his dubious moneymaking activities, Cooke seemed to fade from view and eventually ended up dying in obscurity. The Church of Aquarius, then, is no more – it closed its doors to messages from the 'space brothers' for good in 1969, the year that mankind finally landed on another world for real.[6]

However, while it is easy to laugh, it is important to realise that James Cooke did not undergo his weird experiences within a cultural vacuum. Although, obviously, it is most unlikely that Cooke really did go on short vacations to outer space, I don't think it is enough to say that he was simply lying about it all, either. Rather, he appeared to be sincere in his beliefs – a fact that perhaps might make us inclined to laugh at him even more. But should we? After all, there were plenty of other people like him at the time, going around and befriending pro-CND aliens.

Probably the first saucer contactee, for example, was a certain Daniel Fry, who on Independence Day of 1949 claimed to have seen a semi-spherical UFO in the New Mexico desert, from which a disembodied voice calling itself 'A-lan' emerged, telling him that the sphere was just a remote-controlled probe that had been sent out from an alien mother-ship and asking him if he'd like a ride inside. He said he would, and was then rushed across the night sky to New York and back again in less than half an hour – or so he said. Once aboard the craft, A-lan informed Fry that his people's ancestors used to live on earth themselves tens of thousands of years ago, on two rival continents called Lemuria and Atlantis. However, they both developed atom bombs and then succumbed to the temptation to wage nuclear war against each other, irradiating the surface of the planet and making it uninhabitable for generations, and causing both Lemuria and Atlantis to collapse together beneath the waves. Witnessing the rapidly unfolding 1940s Cold War tensions on earth, A-lan had a simple message for mankind, in light of his own species' sad military history: 'an ounce of understanding is worth a megaton of deterrent'. As a result of his experience, Fry eventually set up an organisation called Understanding, Inc., which was devoted towards spreading the message of peace and love espoused by what he termed the 'space brothers'.[7]

The basic form of this experience is hardly a million miles away from what James Cooke claimed to have undergone with the Zomdicians. Indeed, Fry's encounter seemed to set a pattern for other contactees to start following, whether consciously or not. For example, as well as the anti-nuclear stance of the various races of Space-Brother that began to be encountered as the 1950s progressed, another curious common pattern of these supposed encounters was that so many of the aliens claimed to come from Venus – the so-called 'planet of love'.

For instance, the second significant contact made between mankind and the Space-Brothers occurred on 1 April 1950, when a certain Samuel Eaton Thompson said that he had seen a landed saucer containing forty-five naked men, women and children – all of whom were beautiful and suntanned – in a small wood by the town of Centralia in Washington State. Two of the nude children were playing with one another outside the craft, and when he came across them he was invited onboard. There, the aliens told Thompson that Russia and America were tearing each other apart because all men on earth had been born under different star signs; they, however, being Venusians, had all been born under Venus, the 'sign of love', and so lived with one another in perfect harmony. However, all was not lost, because the Venusians were here to spread a message of peace so that Jesus Christ could return down to earth and love then reign supreme.

The message from space to humanity, it seemed, was obvious; get naked and love one another, throw away your weapons and make peace, not war ... man. The impeccable proto-hippie credentials of Thompson's Space-Brothers were even backed up by the fact that they were all strict vegetarians.[8] Another, later American contactee, meanwhile, Woodrow Derenberger, claimed to have been taken up in a rocket to a planet called Lanulos, which was nothing more than a giant Edenic nudist colony in space.[9]

All of this is highly relevant to Cooke's case, as he too was clearly undergoing psychologically similar experiences to Fry, Derenberger and Thompson. Like their own personal Space-Brothers, Cooke's Zomdicians were beautiful and Scandinavian in appearance, and warned against the dangers of nuclear war, promoting instead the fine qualities of 'harmony', which could cause even such wonders as interplanetary space-flight to take place, if only we would give it a chance. Harmony, it seemed, caused beautiful music to be made, and rockets to take off. To get all Freudian for a moment, the Zomdicians' 'bisexual' (i.e. hermaphroditic) nature could also be read as being a kind of symbol of humanity coming together and resolving its essential differences in a state of unity or oneness – only here, this unity seems to have been figured forth as being sexual rather than pacifistic in its nature. The tall, healthy, Nordic physique of the Zomdicians, meanwhile, could also be emblematic of a kind of 'evolved man', as could their telepathic powers – they represented, maybe, what we could perhaps become, if only we would put our differences behind us for a moment and focus instead upon 'growing' together as a species.

Cooke, meanwhile, might not have openly stated that his Zomdicians were communists, but a close look at the way in which they ordered their society makes it quite clear that they actually were. Most obviously, they appeared to have abolished all forms of money and currency, one of Marxism's ultimate goals. Furthermore, seeing as the Zomdicians were able to transform energy instantly into any object they liked, they had essentially banished the notion of private property and inequality as well; because, if every person had effectively 'seized the means of production' for themselves in this way, each and every individual could have whatever object they so desired every day until the end of their lives.

Thereby, the people of Zomdic seemed able to combine both the panacea of universal brotherhood as espoused by communism, and the material wealth of 1950s America, the most prosperous society the world had ever seen. In short, then, on Zomdic the nastier elements of Soviet communism had been tamed and made almost child-friendly and they were combined with the best elements of the then-booming capitalist America too. It was all a kind of unconscious wish fulfilment on Cooke's behalf, a sort of projection of earth's current dire Cold War stand-off out into the depths of interstellar space, where East and West's differences all magically and instantly became resolved amidst an atmosphere of bisexual love and harmonic principles.

But why did these extraordinary alleged trips into outer space take place for Cooke precisely when they did, namely on 7 September 1957? A possible clue comes in the fact that, on 4 October, the Russians launched *Sputnik*, the first man-made satellite, up into the earth's orbit. When this happened the space age had truly begun, causing widespread hysteria across the Western world. People became highly nervous about this amazing occurrence, fearing that the Russians may be spying on them from up above, or speculating that the Cold War might shortly begin to move into space, with nukes raining down onto earth from the stars. It seemed, in short, as if Russia was currently winning the war for world domination and that nuclear holocaust lay ahead for the capitalist atomic powers of America, Britain and France.

It was against this generally prevailing atmosphere of pre-*Sputnik* space-based paranoia, then, that James Cooke had his first encounter with the Zomdicians. It was only a mere matter of days after *Sputnik*'s launch itself, meanwhile, that the man from Runcorn chose to actually announce his meeting with the friendly communists from beyond the stars to the press. It seemed that, in such an environment, both the newspapers and the public were desperate for some fantasy, some good space-related news for a change, in order to divert their attention temporarily away from the possible forthcoming Soviet apocalypse. The idea that, elsewhere in the universe, highly evolved, psychic communists had already won their own Cold Wars by using the powers of peace, love and musical harmony instead of neutron bombs seemed to be a piece of fantastical wish fulfilment to which the public at the time proved highly receptive.

In short, then, while it is not my view that James Cooke was an outright liar or even a madman, he must certainly have been a highly fantasy-prone individual. It would not be right to claim that he was a fraud, as he appeared to believe entirely in the tales he was spinning, all of which had clearly been influenced by the Cold War world around him. Probably, he really did undergo some kind of bizarre visionary experience up there on the slopes of Runcorn Hill that night in 1957. He did not, however, actually fly up into the night sky to Zomdic. One question does remain to be answered about the whole affair, however; where on earth did he get that mysterious burn on his hand from?

2

That's Why Aliens Go to Tesco

James Cooke's claims were strange enough; but even more bizarre – far, *far* more bizarre, in fact – were those made by a Wirral man to both the well regarded local ufologist Jenny Randles and the British Government during the mid-1980s. He said, in all seriousness, that he was at the centre of an intergalactic war that was then taking place between several rival gangs of aliens, who were entering into our world through some kind of mysterious portal at the top of Bidston Hill, just outside Birkenhead.

Randles at the time had a programme about UFOs on Radio City, the well-known Liverpool-based station. On 6 January 1983, following one of her shows, she received a letter, with no forwarding address and signed only 'B.I.R.', which made the astonishing claim that a family living on the Wirral, who wished to remain anonymous, were currently undergoing repeated alien contact in the area. Intrigued, Jenny made an on-air appeal for this mystery letter-writer to contact her at his convenience. On 12 January, he did so – by turning up on her front doorstep!

She invited him in, as ufologists do, and sat down to have what was probably the strangest chat of her life with him. This 'B.I.R.' (henceforth 'Bob') proved to be thirty-two-year-old man living with his 'wife' – they were not actually married, he explained, he had simply run off with her after being forced out of the army due to his frequent psychic experiences while in uniform – in the town of Rock Ferry, on the Wirral. He had two children, was currently unemployed, and said that it was in fact his own family who were suffering from the frequent attentions of alien beings. Jenny asked him what exactly was happening to him. It was a long story.

Bob, it seemed, was one of life's stranger souls, and had been almost since birth. In 1959, at the tender age of eight, he claimed to have begun receiving repeated bedroom visits from a spectral gnome he called 'Green Eyes', who would appear to him from out of a green mist in bed at night. The gnome told him (arguably quite accurately) 'you do not belong here – you belong somewhere else'. His parents, naturally, did not believe him, and nor did they do so when, one day, he told them that he had seen a pixie with a flute in the family toilet. As proof of his reality, this pixie had told the young Bob that, if he would care to climb up onto a chair, he would find that there was a bottle of whiskey sitting on top of his cupboard.

Bob did so, and found that there was indeed a bottle of whisky stored away unseen up there – although it was empty, sadly. Bob's father's reaction to this information, however, was most unsympathetic. He simply threw Bob against a wall and told him to stop lying.

Still the strange happenings kept on coming, though. In his youth, Bob had several encounters with various aliens while in bed, and once, after he was ran over by a truck and told by doctors that he would never walk again, a 'being' appeared to him and said that it would heal him. Apparently this entity kept his word as, the very next day, he was up and walking around again, amazing the staff at the hospital.

His actual UFO encounters, however, did not begin until he moved to the Wirral in 1975. Here, he rapidly became aware that there was an inter-dimensional warp hole for alien spacecraft on top of Bidston Hill, through which various UFOs and aliens (which all actually came from Spain, he said) were constantly passing. But why were they coming here? It transpired that the earth was currently at the centre of what might be termed an 'intergalactic property dispute', with a race of space-scientists warring with a race of space-soldiers to see who got to keep it, on account of its usefulness as a transport hub. After all, these portals – or 'window areas', in ufological terms – cut down drastically on travelling time when flying through space, and there were several most convenient ones here on earth, including the one on Merseyside. Several other races of aliens had subsequently become involved in this battle too, and Bob, with his superior psychic abilities, was deemed by them to know too much about it all. Therefore, it was decided that he had to die.

Several times he was tricked by being given an uncontrollable 'psychic impulse' to go up to Bidston Hill, where evil beings lay in wait to try and trap him. One time, he was zapped with lasers when strange streaks of light came down from the sky and immobilised him, before then thankfully being rescued and carried off down the hill to safety by a race of giant see-through birds with funny beaks. At other times, however, he saw other breeds of translucent aliens he called 'The Hairy Balloons' and 'The Hairy Pillar Boxes', who seemed hostile. Fortunately, he managed to kill off one of this latter species in a psychic duel, when it attempted to kill him. He was not naive enough, though, to think that he would manage to keep on evading their clutches for long.

One positive development, however, was that some of the aliens popping through to Bidston Hill from Spain were apparently quite sociable, most notably one calling himself Algar. Algar would fly past Bob sitting on his flying saucer and wave to show that he was his friend. One time, he even used special rays from his spacecraft in order to clean Bob's carpet for him. After being telepathically called out of his house and told to go and look out over the Mersey Estuary, Bob was lucky enough to witness an entire fleet of UFOs, one of which swooped down over an old man who was passing by and knocked his hat off into the sea. It then hovered over Bob's house, and beamed its light rays down. The UFOs all then flew away back to Bidston Hill and returned through the portal to Spain, their mission complete. Going inside his house, Bob found two white spots on the carpet where the saucer's rays had hit it. Over the next few hours, these then spread themselves out wider and wider, making the carpet positively sparkle as they did so – and thereby conveniently obliterating all evidence of their ever actually having been there in the first place, of course.

However, perhaps we should not mock Bob's claims too much, for there is one very curious fact about them – namely, that Bob's wife Bess claimed to have witnessed these things going on too! She had been with him when he saw the UFO fleet, apparently, and had even met

Bob succesfully killed a Hairy Piller Box with his psychic powers on top of Bidston Hill before it had a chance to 'dominate' him.

Algar (who was sadly assassinated by the evil group of aliens on 4 October 1981, thereby leaving the earth in great peril). She also claimed to have been abducted by extraterrestrials with her husband one night and then placed inside a secret alien storage depot in Bolton.

Surely the most remarkable encounter Bess had with enemy aliens, though, was when she and Bob saw two of them doing their shopping one day at the Tesco store in Birkenhead! Here, they were buying dog food, tin after tin of it, which they were sweeping into their trolleys; they were literally clearing the shelves of the stuff. They must have been humanoid in appearance, however, as it seems that nobody noticed that they were ETs – except for Bob and Bess, naturally. Telepathically, Bob tried to find out what they were doing. They were having their own psychic conversation, in which they called each other XY_4 and XY_5, and he managed to gather that they had been sent out on a scientific mission to study what food humans ate, but had evidently got it all wrong. Then they realised that someone was listening in to their thoughts, and began looking out for a spy, so Bob and Bess left. Upon being told this, Randles asked Bob why he hadn't alerted anybody to the fact that there were aliens in the supermarket. He replied, quite seriously, that he didn't want any ufologists pouring into the place bothering the aliens or the shop staff while they were clearly all so busy!

Much more weird information was passed on to Randles by Bob over several more visits, and he even gave her the chance of becoming his 'psychic apprentice', an offer that she turned down as, in her words, 'the side-effects seemed unacceptable'. Bob eventually stopped calling upon Randles, however, when he knocked on her door while she was out and was greeted by her husband Paul who threatened to punch him if he didn't clear off and stop looking up at the sky saying that he wanted to take Jenny off up there to meet 'them' at last.[10] And there, it seemed, the long story of Bob, Bess, Algar and the interstellar war on Bidston Hill was to end. Or so we thought ...

Remarkably, in 2008, after the long efforts of Dr David Clarke of Sheffield Hallam University to get the UK Government to declassify and release its once top-secret UFO files had come to fruition, a new tranche of military documents was made available to be viewed

XY4 and XY5 on a secret mission to infiltrate the Birkenhead branch of Tesco and investigate earth food.

by the public. Among these was a three-page letter from Bob that he had sent to the Ministry of Defence in 1985, warning them about the likely terrible consequences of Algar's death for UK national security. This handwritten note was so inexpressibly insane that it was widely reported on in the British press. At last, it seemed, Algar the alien had hit the big time!

In his letter to the MOD, Bob told them about several of the bizarre alien species he had encountered in the Wirral, including one that was 'green and very large, that had eyes all over it' and another female alien with 'fat worms sticking out of her head', like a low-budget Medusa. Also in the letter, Bob claimed that the space-war was hotting up; so much so, in fact, that he had witnessed a dogfight taking place between spaceships over Wallasey Town Hall, in which six saucers had ganged up on another one and then shot it down out of the sky. It crashed straight into the River Mersey, but became invisible as it did so, meaning that there would be no visible wreckage there for people to see. It did, however, create a huge splash in the water, 'as if done by an invisible entity'.

Bob's main topic in his missive, however, was the astonishing information that, in 1981, Algar had professed himself willing to speak to the UK Government and offer them his help against the invaders from Spain. Bob, it seems, was entrusted with the role of being the medium through which this epochal event of inter-species communication was to be set up and arranged; something which, he said, left him feeling 'over the moon with pride' about his pivotal role in galactic history. However, as already mentioned, Algar was assassinated later that year, before contact could be established, together with his team of space-scientists. The aliens then tried to 'dominate' Bob, it appears (perhaps mercifully, he doesn't quite explain what is meant by this term), but he proved too strong for them and they just died. Bob was still writing off to the MOD anyway, though, just in order to keep them fully informed about what was going on in Britain's skies, and to ask them if they were aware that there were several secret alien bases currently hidden across both Merseyside and Cheshire. Apparently they didn't know about this fact, and nor did they much care about it either – the Ministry simply stamped a terse 'NO REPLY' notice at the bottom of Bob's letter, stuck it away in a file and then promptly forgot all about it.[11]

But should they have done? Well yes, obviously. The things that he was talking about didn't literally happen. But did Bob *experience* them happening to him, perhaps in some kind of strange, altered state of consciousness? In my view, quite probably, yes. In the past, anybody reporting Bob's life history to the wider world would most likely have been acclaimed as being a shaman. Now, though, we would be more likely to try and pathologise him as being a madman. Is this fair? Well, up to a point. Anybody who sees aliens in Tesco cannot be entirely normal, clearly. But perhaps we should not be wholly dismissive of his mental state. Being 'different' does not necessarily equate to being *completely* insane. If we modern people have no comprehensible framework available to us through which to interpret people's visionary experiences, then that is probably as much the fault of wider society as it is of the people who undergo them, after all.

Furthermore, there is the awkward fact that there are some other Merseysiders who claim to have had similar experiences to Bob, too! For example, numerous people other than him purport to have seen UFOs hovering around Bidston Hill. If Bob was indeed mad, as many would no doubt assume, then are all these people insane also? It seems unlikely. Perhaps, then, we should take a closer look at that weird local landmark, and see what else we can find out about the place.

Algar would often fly past Bob on his saucer and give him a quick wave.

Bidston Hill is not the largest such prominence in the world but, seeing as the Wirral, where it sits, is predominantly a flat landscape, it does stand out rather. Surrounded by about 100 acres of wood and heathland, a kind of 'green oasis' separating Birkenhead to the south, Wallasey to the north and Moreton to the west, it stands 70 metres high, and contains a few buildings and various other curious features, such as an observatory and meteorological research station, built in 1866, a windmill, and even a lighthouse. Opposite to it is a sewage works, which was perhaps erected there as a necessary counterbalance to the spot's otherwise beauty. More interestingly for us here, however, it is also (in rumour, at least) a kind of 'hotspot' for various strange phenomena and experiences. First of all, we can look at something that is entirely factual, namely the presence of some interesting carvings made in the rock near to the observatory. One is a 4½-foot-tall carving of a sun goddess, dating from around AD 1000, which is supposed to face in the direction of the rising sun on Midsummer's Day. Another ancient carving, of a horse, can also be found in the area. This isn't exactly paranormal, of course, but it does indicate that the hill was used as a centre of worship or ritual at some time in the

distant past; and, perhaps in part because of such associations, the place definitely has what might be termed 'atmosphere'.

A lot of what follows is undoubtedly just myth and legend, rather than reality, but there are several rumours about the spot that have led to it gaining a certain uncanny reputation locally. For instance, there is another carving near to the observatory, this time depicting the rather more unsavoury sight of man being hanged in a noose and having a dagger pointed at his throat. This has led some to make utterly unfounded claims that the hill used to be used as a spot for human sacrifice. If this is so, however, then the carving itself seems likely to have little to do with it; it appears not to date back to prehistoric times but only to the eighteenth century, by which time this particular pastime had fallen out of fashion in England somewhat.

The fact that the stone steps that lead up from the nearby wood to the summit of Bidston Hill are known locally as 'The Witches' Steps' also speaks quite clearly of Birkenhead and Wallasey folklore having populated the place with supernatural beings. Legends about secret tunnels running beneath the hill, and being used by sorceresses to travel between one another's lairs are, however, entirely without basis. There *are* tunnels and artificial caves in the area, but they were built during the Second World War in order to store ammunition and act as air-raid shelters. Now long-since abandoned by the MOD, their dilapidated state was bound, I suppose, to lead to the springing-up of certain occult rumours about them eventually. Common sense, meanwhile, dictates that claims that the Holy Grail is buried beneath Bidston Hill are also most unlikely to be true.[12]

Bidston Hall (sometimes called Bidston Lodge), which sits nearby, is also reputed to be haunted by a ghost that bothers women in their beds at night. Apparently, female sleepers have reported waking up and being unable to move due to some invisible force on their chest holding them down – which sounds like a textbook example of sleep paralysis to me. This fact, however, has not stopped some commentators from making links between this 'ghost' and the unquiet spirit of Frederick Bailey Deeming, a notorious Birkenhead-born murderer from the Victorian age.[13] No doubt largely because of all these pre-existing associations between the place and the paranormal, then, Bidston Hill has, in recent years, become a popular site for ghost-hunters and UFO-spotters looking to spend a night out in the dark seeking the unknown.

This is not to say, however, that actual UFOs are not sometimes genuinely seen in the area. It didn't take long searching online, for instance, to come across the account of a girl calling herself 'Natalie', who claimed to have witnessed a 'spaceship-shaped object' hovering over Bidston Hill when she was putting something in her bin outside one night in September 2011. She assures us that she managed to capture this sight on film, but, sadly, didn't know how to put the resultant footage online. This testimony, of course, is quite worthless, but it was then followed up on the relevant site by a posting from a certain Steve Richards, a retired police officer who, he says, has been an amateur astronomer for over forty years. As such, you would think that he would know what he was talking about. He described seeing a 'very bright orange light', which remained stationary in the sky near Bidston Hill on the evening of 28 September 2011. The object was described as being 'like a star, but many, many times bigger'. It stayed absolutely still for a period of five minutes, and was witnessed by Steve's wife and son as well, before it then began to move off towards the hill where it faded out into nothing, leaving behind it no smoke or vapour trail. He did manage to examine the object through binoculars, but could discern no further detail beyond its being

'star-like'. The only rational explanation he could come up with was to say that it might have been a Chinese lantern – but those, I think, tend not to remain stationary in the sky for five minutes at a time.[14]

This is an interesting enough sighting, of course, but not too spectacular or amazing, and I don't propose here to collate all the dozens of similar ones I can come across from Bidston Hill for the reader's edification. Instead, it would be more useful to examine perhaps the strangest UFO encounter from the vicinity outside of Bob and Bess' own claimed close encounters.

This occurred on the night of 15 May 1980 (back when Algar was still alive – so maybe it was him?) at around 12.40 a.m., and involved a young teacher, Gareth Hughes, who was driving back to his home on the Wirral along the M53, which runs alongside Bidston Hill at one point in its course. As Gareth drove on towards Junction 2, which leads off to Arrowe Park, he passed by Bidston Hill on his right, a sight with which he was, of course, familiar. What he was not familiar with, however, was a very bright light, low down and close to the ground, over the railway station in front of the hill. He was puzzled; no such light had ever been there before. Was it some kind of mast or tower? As he drove closer to the thing, he could see that it was not. It was simply a light, disembodied, and hanging in mid-air with no visible means of support. As he drove beneath a cross-over bridge, Gareth decided to wind down his window and reduce his speed to 20 mph in order to get a closer look at whatever it was. Perhaps he need not have bothered; as soon as he passed out from under the bridge, the thing was right next to him, no more than 300 yards away from his car. This close up, he could see that it was not merely a disembodied light at all.

It was hovering at about the height of a block of flats, Gareth said – and it was quite, quite massive, blocking out a large proportion of the sky and Bidston Hill behind it. The top of the UFO was curved in two parts, resembling a pair of artillery shells in shape, angled downwards at 45 degrees and seemingly joined together by another part of the object further down. Two strong and clearly defined light beams were being projected down out of the bottom of these structures, but they did not actually reach the ground, cutting themselves off suddenly after a few yards. Behind each shell, meanwhile, was a reddish-pink jet of flame as if from retro-thrusters.

Gareth did not stop and take a closer look at the object – for one thing, it is illegal (and dangerous!) to stop on a motorway and, for another, he was understandably disturbed by what he was seeing. Turning off the M53, he could still see the pinkish jets of flame in the sky, even though the rest of the UFO was not visible to his view. Back home, he told his mother about what he had just seen, and they drove back out together to see if it was still there. It wasn't. Nobody else, it appears, reported observing it, despite the fact that Wallasey and Birkenhead were nearby and the motorway, even in the middle of the night, was hardly a remote or unused one – although it did seem unusually quiet on the night in question, Gareth not seeing a single car travelling along it in either direction throughout the duration of his journey. Even Jenny Randles, who was living within one mile of Bidston Hill at the time, and had passed by this same spot herself less than two hours earlier, didn't see it.[15]

What on earth was this thing? Was it really there? Well, it seems bizarre that no other people reported seeing the strange craft hovering there in front of Bidston Hill that night and, in the absence of any other witnesses, it does remain essentially unproven that the weird object was present anywhere other than within Gareth Hughes' mind. Many UFO encounters seem to occur while people are driving at night, and it has been hypothesised

that performing such a monotonous and half-unconscious activity along lonely and empty stretches of dark road can cause people to enter into mild trance states. Is that what happened here? Or are there other explanations?

One possible alternative answer might well lie in the geology of Bidston Hill – which, curiously, is best defined as being a sandstone outcrop. Indeed, the observatory up on Bidston Hill is made of sandstone that was quarried from the site in 1866.[16] Could the UFO, then, actually have been some kind of earthlight caused by the emission of piezo-electrical build-up from inside the sandstone, a phenomenon which we discussed briefly earlier? Initially, we will recall, Gareth simply saw a bright ball of light hanging there in the sky before Bidston Hill. Could this luminescent body have then interfered with his mind, somehow, a combination of its electromagnetic properties and the unconscious knowledge that the young teacher must naturally have imbibed about UFOs from the media over the years acting in combination to 'fill in the gaps' for Gareth mentally, causing him to witness what he simply *thought* was an alien spacecraft?

Maybe; for this theory to be more plausible, however, we perhaps need to find some evidence of there actually being some kind of luminous or geomagnetic anomalies present in the Bidston Hill area. Fortunately, such evidence comes easily to hand. For one thing, there are some large (by British standards) underlying geological faults in the Wirral,[17] and furthermore, according to the researches of a writer named J. R. Kaighin, in his 1925 book *Bygone Birkenhead*, weird aerial light phenomena are a natural feature of Bidston Hill itself. While conducting observations at the observatory on the hill around a hundred years ago now, Kaighin tells us, a certain astronomer was surprised to come across phenomena other than shooting stars and supernovas visible in the night sky. While working up there, he witnessed slivers of bright silver light, from an unknown source, which lit up the darkness above and even the trees and landscape around the building. These flashes of light also caused the instruments in the observatory to vibrate noticeably.

At other times, this scientist spoke of hearing strange murmurs, hums and buzzes in the air, and described the entire atmosphere of Bidston Hill as being 'as though some electric current, throbbing, palpitating, were at play', a theory which was backed up for him by the fact that he sometimes noticed weird electrical-like mirages which could be seen filling the air, superimposing ghostly shapes onto the hill's slopes, and looking as if 'thousands of glow-worms … a mighty host' were marching up the outcrop towards its summit.[18] This was in the early years of the twentieth century; if even a trained astronomer thought such things were uncanny and mysterious looking, imagine what earlier peoples must have thought of Bidston Hill when they saw similar odd lights flitting around the place. It is perhaps no wonder that tales of witches grew up around the place, or that people once chose to worship the sun goddess there.

Nowadays, however, people don't tend to see witches and sun goddesses when they encounter strange lights in the sky, but claim to have encountered alien spacecraft instead. Certainly, Gareth Hughes was not the only person to have witnessed such a thing on the M53 just off Bidston Hill – because there was another sighting, seemingly of the same craft, in the same place, which occurred five years after his own encounter, on 27 December 1985. If this was some kind of earthlight-induced hallucination, however, then it was a more remarkable one than even Gareth Hughes underwent; as, this time, the strange craft was seen by several persons at once!

Five people, Nicola and Jack Limb, their young son, their teenage daughter and their daughter's boyfriend, were all driving back to Wallasey late that evening from North Wales. As they passed by Bidston Hill, they came to the exact same point where Gareth Hughes had had his close encounter and saw, once more, something strange hovering over the railway station. It was, they said, 'a triangle of lights', with two bright white ones at the front (the beams of light which Gareth had previously witnessed, perhaps?) and a red one at the back. Despite slowing down to take a closer look, they could not really see what form the presumed craft behind these lights took due to their glare, but said that it wobbled and rocked around from side to side as they passed by it. Curiously, just as had happened the previous time this thing had been seen, there was no other traffic at all on the M53 to witness it, other than this one single car. The Limbs managed to keep the triangular object in view until, just like with Gareth, they lost sight of it due to the presence of intervening objects when they reached the turn-off at Junction 2.[19]

What can this have been? A kind of shared hallucination? There is a phenomenon called *folie à deux*, wherein two people can somehow manage to share in the same delusion, possibly hallucinatory in character, but it seems stretching it a bit to apply this notion to five persons, all of whom say they saw the same thing. I believe that the Limb family really did see something on the M53 near Bidston Hill that night; but what? Well, in this instance, we will notice how they only really saw some lights hovering in the sky there. The presence of the 'craft' behind it was just implied. Perhaps they were influenced in their interpretation of what they saw by their pre-existing knowledge of UFOs, the so-called 'black triangle' type of which was becoming more and more frequently reported on in the media as the 1980s progressed. Once again, they could have seen something genuinely strange and unexplained, perhaps an earthlight, and then their brains or unconscious expectations simply filled in the gaps. But, all the same, is it really plausible that earthlights could fly around in formation like that? Maybe, maybe not. And, if the thing wasn't objectively real, then how come the Limb family said that it looked almost exactly like what Gareth Hughes said he had seen there several years beforehand? This aspect of the case is, for sure, something of a mystery.

Presuming that certain electromagnetic stress-related phenomena can have an impact upon the human mind, however, then we might, just *might*, be able to come up with some kind of hypothesis for explaining at least part of what happened to Bob as regards Algar and his chums. After all, if something like this can happen to an ordinary family of five, or a person holding down a responsible job such as being a schoolteacher, then what influence might such forces have upon the brain of a clearly unbalanced and highly fantasy-prone individual like Bob up there on Bidston Hill? The uncanny legends about the place could only heighten the mystique of it for such a person, creating a kind of 'mythic landscape' in which Bob could wander happily around with Algar, this fact maybe even heightening his mental receptivity towards entering into altered states of reality. And what of the strange flashes of nocturnal light the astronomer witnessed while he was working at Bidston's observatory? Could a reoccurrence of these have been 'seen' by Bob as being laser beams being fired at him by spacecraft somehow, on the night when he said that he had been rescued from certain death by giant winged birds from outer space? It is my own personal opinion that the answer to the UFO mystery is likely to lie more deep within the mysteries of the human consciousness than it does in outer space. Sometimes, perhaps, 'in here' is an even stranger world than it is 'out there'. It certainly was for Bob, at least!

3

Silver-Suited Strangeness and Encounters with Extraordinary Entities

So far we have looked largely at UFO cases that seem unlikely to have been genuinely real, at least in any literal, objective sense of the word. We can't judge all such experiences by the standards of Bob, Bess and James Cooke, however – and there are some sightings of UFOs and their occupants from Merseyside that cannot be dismissed purely as being all down to the imagination of modern day shamans. For instance, there was a truly odd UFO encounter that took place on the evening of 27 January 1978 on the banks of the River Weaver near the small town of Frodsham, just south of the Mersey Estuary (where James Cooke claimed to have been taken up to the planet Shebic, remember), which seems initially so silly in tone that you might simply laugh at it all. However, seeing as the UFO and its occupants in this case were witnessed by no fewer than four persons at the same time – one of whom suffered some physical after-effects from the experience – in actual fact it cannot simply be dismissed so easily.

The specific location where the event took place was a local beauty spot known by the evocative (and apparently appropriate) name of the Devil's Garden. The four young men involved were poachers – and, as such, frustratingly demanded to remain unnamed – and were loitering around in the undergrowth waiting to shoot themselves a bit of free food, when they noticed a purple-glowing object gliding towards them across the south-east portion of the Weaver, some way off the ground, at about what would have been rooftop level. It was moving slowly, with some kind of fiery 'retro-rockets' on the underside, and stopped next to some bushes around 100 feet in front of the poachers, landing gently down on the ground while making a humming noise coupled with a kind of screeching, like the wind might make in a gale.

This UFO, which was perhaps 15 feet in diameter, resembled a big silver-coloured sphere with a kind of metallic 'skirt' banded around its base, with flashing lights on its edge and a row of windows across its middle. These windows were what gave the object its purple glow; up close, the UFO was vivid and painful to the eyes, suggestive, perhaps, of UV light or radiation being emitted from it. Certainly, radiation is what the panicked lads thought that it was, as they initially presumed that it must have been part of a Soviet nuclear powered

satellite that had dropped back down to earth, being influenced in this assumption by a recent news story about parts of just such a device falling to ground over Canada.

This theory was soon to become untenable, however, when two humanoid figures emerged. They were wearing silver coveralls and things like miners' helmets, the lights of which were giving off the same purple glow as their craft was. They crossed the field towards some surprisingly placid cows, which seemed to have been paralysed or hypnotised somehow, bringing with them a strange device to use upon the beasts. This gadget was a large portable clothes-horse-like framework made from thin metal tubing, with sliding bars on it, which the beings placed around and above one of the cows like a sort of cage, as if to measure it. At this point, the four teenage poachers decided to burst from their cover and make a run for it, not stopping until they had reached the nearest bridge, which carries the A56 over the river. Looking back towards the field, they found that the UFO had vanished. What particularly scared them at the time, however, were not just the silver men, but also a fear that they might contract radiation sickness from the purple glow. Perhaps such fears were not without foundation as, when they fled, one of the boys began to feel pain and a pulling sensation in his testicles, almost as if some form of invisible suction device had been applied to them. Afterwards, he discovered that his testes were bright red with a kind of

They came to earth to measure cows – in Frodsham.

severe sunburn-type rash, as were his legs, and his groin remained sore and tender for the next few days.[20]

Once the national press got hold of the story, they decided to treat it with predictable levity (sample headline: 'Close Encounter of a Moo-ving Kind'), but, looked at properly, it does not deserve this fate. There were four independent witnesses, all of whom saw the same thing, and one of whom suffered from medical problems, apparently as a direct result of the incident. It cannot just be dismissed as 'misperception', and the fact that the witnesses had absolutely nothing to gain from reporting their story, and indeed were only traced by its investigators at the time by chance, speaks against it simply being invented. You could claim that it was all a shared hallucination, of course, but it's a pretty remarkable one that is so elaborate that it causes radiation-like burns to appear on a boy's testicles and even affects cows as well as human beings. The case, surely, is a mystery.

There have been a few other encounters with mysterious UFO entities (often termed 'ufonauts') on Merseyside, though, and we shall examine some of the most interesting ones here. The Frodsham sighting is my favourite, personally, but it does have another close rival in the strangeness stakes, from just outside Warrington in 1978 – a genuinely eerie tale, and one with apparently fatal consequences.

The (once) village of Risley, towards the east of Warrington, is now becoming, like so many places on the edges of the region's towns and cities, more of a built-up area than it was previously. The Birchwood housing estate, for instance, constructed just south of Risley in the late 1970s, is now home to more than 10,000 people, and the village itself is a village no more, having being entirely subsumed into modern Warrington proper. The spot was not always like this, however. During The Second World War, the land had been used to house an ammunition dump and factory, and in February 1947, the Ministry of Supply set up a complex of offices and labs on the site, with the intention of developing the UK's first atom bomb there. In 1954, the bomb having been successfully developed, the newly formed UKAEA (UK Atomic Energy Agency) took over and expanded the site in order to perform research into using nuclear energy as a power source. There was a building jointly owned by the Universities of Liverpool and Manchester nearby as well, which opened in 1962, and inside which various experiments into things like sensory deprivation took place. Within this building, apparently, was a small nuclear reactor – a fact indicated by the structure being named the Universities Research Reactor. I wonder how many people who currently live in Birchwood actually know about all these pleasant facts, though. Very few, I'd imagine. It's not the kind of thing that estate agents tend to mention to prospective buyers, really, is it?

The area around Risley, then, was once just the kind of place that cheap 1950s sci-fi B-movies, in which alien beings come down to earth to warn mankind of the perils of playing with atomic energy, tend frequently to be set – and, appropriately enough, on the night of 17 March 1978, at about 11.20 p.m., just such a bad 1950s-style monster appeared there and scared the hell out of an innocent motorist who was passing by. For Ken Edwards, a service engineer in his late thirties, the decision he made to take a shortcut down Daten Avenue (which is still there) on his way home from a trade union meeting in Sale that night was to prove to be the worst error of his life.

On either side of him down this dark, lonely and unfrequented road sat the scientific establishments already mentioned – on the left, behind a 10-foot chain-linked fence, lay the UKAEA complex, and to his right, behind a steep grassy embankment lined with

bushes, was the university building, with its mini-reactor. It was from this direction that the nightmare came.

Ken first noticed it because his van headlights hit it. It stood 7 feet tall, was broad-bodied and, like the uncanny cow-measurers in Frodsham, was covered nearly all-over in some kind of silver jumpsuit. Its head, however, was jet-black and shaped like a goldfish bowl. As of yet, Ken couldn't see its eyes. Its stance, however, was remarkable; even though the slope of the embankment was steep it was walking at right-angles to it, which should have been impossible, and with its arms held out in a rigid fashion straight in front of its body, like someone pretending to be a zombie. These arms, moreover, were very strange indeed; instead of being jointed like a human's, they simply grew either from out of the top of its shoulders, or directly out from the front of its chest itself (reports differ).

Initially wanting to take a closer look, Ken stopped his van by the side of the road but, when he realised that it was not simply an optical illusion or a man in a radiation suit, he began panicking and yet simultaneously became paralysed, being unable to release his grip from the steering wheel. He later told investigators Jenny Randles and her colleague Peter Hough that he felt 'a sensation like two enormous hands pressing down on me from the top. The pressure was tremendous. It seemed to paralyse me. I could only move my eyes. The rest of me was rigid.' All Ken could do was sit there and watch.

Ken Edwards comes face-to-face with the disturbing Risley Entity.

As he did so, the creature walked, very awkwardly, into the road, in such a way that it appeared that its legs, like its arms, had no joints to them. Then it stopped – and looked straight at Ken. It was now that, for the first time, the terrified man realised that the thing had eyes. They were two little dots of light and, from out of these, two 'pencil-slim beams of light' were suddenly projected, firing right in through Ken's windscreen and illuminating him for, it seemed, about a minute. Then, the entity appeared simply to lose any interest in the puny earthling, turned its head, and stiffly dragged itself across the road to the UKAEA complex on the other side; and then promptly walked right through its chain-linked fence as if it were not there, like a ghost. It just raised its arms up into the air and passed straight through it before then disappearing into the darkness of the night over the top of the embankment.

Now, finally, Ken found that he could move again. He was confused and disorientated, and it was something of a struggle, but he managed to start his van up and drive back home, where his wife Barbara noticed his state of considerable distress immediately. 'What's wrong?' she asked him. 'I've seen a silver man,' he replied. Barbara believed him. She had to; he was in a state of shock, had what looked like burn marks on his right hand where he had been gripping the steering wheel, and, furthermore, he was about forty-five minutes later home than he should have been. It was 11.30 p.m. when he had first set eyes on the spaceman, an encounter that he thought had lasted only a few moments, and he lived merely fifteen minutes' drive away from Daten Avenue. Now, however, it was 12.30 a.m.; and his watch had stopped itself at 11.45 p.m. As such, forty-five whole minutes of his life remained unaccounted for; he had experienced the classic 'missing-time' motif so beloved of ufologists! But what had happened to him during these missing minutes? Had he been taken inside a nearby waiting spacecraft and examined, as so many others just like him have claimed? Due to the ultimate consequences of his sighting that night, we shall probably never know.

Unable to get to sleep, Ken asked his wife to take him to the nearest police station at Padgate. The officers on duty, knowing that it was St Patrick's Day, thought that Ken was engaging in a drunken prank, and initially gave him short shrift. Eventually, though, they became convinced that his distress was genuine, and made a call to the security forces stationed over at the UKAEA. After escorting Barbara back home, the police took Ken back to Daten Avenue, where he found twenty-five armed men, with searchlights and batons, awaiting him. Seemingly, they took his story seriously, and made a thorough search of the area, finding nothing. After they had drawn a blank like this, Ken was driven back home and allowed to try and rebuild his life.

Sadly, however, this was not to prove possible. First of all, someone from the Warrington police force leaked the story to the press, and reporters, ufologists and flying saucer cultists from the Aetherius Society (a kind of 'UFO religion' that happened to be holding a conference in Warrington at the time) made a beeline for his door. Representatives of this latter body apparently told Ken that he had been 'chosen by God' to undergo the experience, and silly headlines in the press, such as the *News of the World*'s 'Ken and a Flasher from Outer Space', must have only added to his embarrassment and discomfort. Less than a year after his close encounter, Ken then began to suffer from stomach cramps, and had to undergo emergency surgery for kidney cancer. He survived this, only to then succumb to throat cancer in 1982, dying at the young age of forty-four.

This sad fact, of course, could have been entirely coincidental. And yet, the sunburn-like marks on the fingers of Ken's right hand looked suspiciously like radiation burns. Could

his cancer have been linked to his experience somehow? Certainly, the sighting, while it might at first glance seem purely like some kind of hallucination, did have genuine physical consequences for the objects that surrounded it. Most obviously, when Ken went in to work on Monday morning and tried to use the radio in his van, it failed to work. Subsequent examination showed that a large power surge had shot through the instrument, perhaps through its aerial, burning out the transmitter and its diode circuit inside. It was gutted so completely that repair was out of the question and an entirely new one had to be fitted instead. If Ken's insides had been ruined as thoroughly as those of his van radio had been by exposure to the entity and its light beams, then this is as tragic an encounter with the unknown as can ever be conceived of.[21]

Approaching the idea of radiation from a different perspective, however, you could perhaps argue that Ken Edwards came across some kind of radiation-field from the nuclear facilities nearby, which interfered with his brain and then caused him to start seeing things, while also taking out his radio at the same time. If it was all a hallucinatory episode of this kind, then you could claim that the sci-fi nature of the 'mythic landscape' around him might have influenced the precise nature of his vision, maybe, but it is hard to see how precisely such a process might have worked. Curiously, though, there is one little coda to the case that indicates that it must have had at least some kind of subjective element to it; because, amazingly, Ken claimed to have seen the being again on a subsequent occasion, too!

Apparently, on 23 March, after the case had broken in the media, a UFO investigator had driven all the way down from Leeds to speak to Ken, and asked him to revisit the location of his sighting with him. Kindly, he agreed to do so; but, once there, Ken began to feel dizzy. Then, from out of the corner of his eye he saw the same entity again. It was only there for a few fleeting moments, however, on top of the embankment and walking away from him, and the ufologist accompanying him did not see it.[22] Given this fact, we might begin to think once more that Ken's vision was somewhat less than objective and physically real in its nature.

Except that somebody else saw a silver-suited figure in the countryside near Warrington at around the same time. In fact, more than one person did. These events occurred right in the middle of a wave of UFO sightings in the village of Lymm, just next to Birchwood and Risley, around 3 miles east of Warrington. Just south of Lymm is the village of High Legh and it was here that, in either May 1976 or March 1978 (frustratingly, the relevant records are unclear on this point – although if it did indeed take place within the latter timeframe, then this was *exactly* when the Risley entity was also abroad), a certain 'Mrs S.' and her family had their own initiation into the world of the weird.

One night, it seemed, this woman and her family were in their house when they saw a figure standing next to a tree in the back garden. They lived in an isolated spot on the edge of the village itself, so were naturally wary of the threat of intruders and kept a close watch on the strange form. Seemingly, however, this thing was no ordinary trespasser; it appeared bright and silvery in colour and, bizarrely, cast no shadow. The usually fierce family guard dog also acted peculiarly when this thing appeared; while it would normally bark and growl viciously at the approach of anyone towards the home, it remained unusually quiet and did not utter a single woof in anger.

At a distance, you could say that this was merely misperception. However, what occurred the following night is not quite so easy to explain away. This time, scarily, the figure came

right up to the French windows at the back of the house and began staring in, terrifying the entire family. Now, the silver man was glowing brightly, with a very intense light, which was so strong that it lit up the entire living room. So vivid did this become that, eventually, the being's body was entirely obscured by its shining, apart from its two round eyes, which seemed to be the source of the illumination – another apparent similarity with the thing that Ken Edwards saw at Risley.

Mr S., thinking that it was a burglar, ran out of the house in order to confront him – only to find that, as soon as he did so, the 'man' just vanished. There was no way, Mr S. said, that any ordinary person would have been able to escape from the large back garden in the mere instant it took him to open the door and get outside. However, the family did hear a big 'plop' coming from the direction of the swimming pool which they had under construction. This pool was currently empty, though, and so deep that it would have been impossible for anyone who had fallen in to get out again without a ladder – and yet, when it was searched, presumably with torches, there was no-one there. And that, it seems, was the end of their visits from the big silver man.[23] This case, surely, is good evidence that Ken Edwards really did see something weird on the loose in Risley that night – at least at first glance. However, the situation is not *quite* so simple as it at first might appear.

Silver-suited aliens, it seems, were all the rage across Britain in 1977/78. It all started when, on 4 February 1977, a group of fifteen schoolchildren from Broad Haven Primary School in South Wales became the subject of intense media scrutiny after claiming to have seen a large, cigar-shaped UFO land on some fields behind their playground during their lunchbreak. From out of this silvery craft then came, appropriately enough, a silver man – this time, with pointed ears. This event really was a media sensation, being reported on right across the world. UFOs became a hot topic in the British press, and sighting reports of silver men – who often acted as much like ghosts as they did aliens – soon began to flood in. One hotelier in nearby Milford Haven even began advertising 'flying-saucer-spotting weekends', in which a local expert called R. J. Pugh acted as a tour guide, in order to try and cash in on the wave of public and media interest in the area.[24] There was a major scare surrounding the idea of silver aliens going on in the UK at this time, then, which, sadly, is far too convoluted for us to be able to go into properly here. Significantly, however, it did involve tales of tall silvery glowing figures being seen looking in through people's windows – just like happened with the 'S.' family.

Furthermore, there is the complicating factor that February 1978, the month immediately prior to the Warrington sightings, saw the release in Britain of Steven Spielberg's new blockbuster film *Close Encounters of the Third Kind*. Sensing the opportunity to piggy-back on the likely popularity of this movie, newspapers in Britain began falling over themselves to print stories about UFO and alien sightings in their pages at this time. It seemed as if Columbia Pictures, who had invested a then-massive $19 million in the film, were collaborating with the press like mad in order to try and recoup their costs. In the early months of 1978, then, you simply couldn't escape hearing about space aliens in Britain even if you tried. Obviously, it is deeply facile to claim that Ken Edwards, the 'S.' family and the four teenage poachers in Frodsham only saw what they saw because of media coverage surrounding silver Welsh aliens and the release of a fictional movie at around the same time, but we shouldn't rule out the possibility of people's visions (if that's what they were) being influenced by the prevailing media culture then surrounding them.

I have a few firm viewpoints about the matter: firstly, that the witnesses, I think, were *not* just making things up and, secondly, that they probably didn't encounter any *literal* extraterrestrial beings, either. These people's experiences were real – they had to be, there were physical effects to them – but I don't think that you necessarily have to believe that the 'aliens' involved in them actually hailed from other planets. Such encounters seem to involve a complex interplay between the human mind, the cultural expectations that surround a person, and certain other, as yet utterly unknown, factors. In other words, then, these things are quite simply ultimately a mystery to us.

As such, rather than simply looking at the phenomena themselves, perhaps we should examine the people who witness them rather more closely, too. For example, beginning in August 1977, another Merseyside resident (named only as 'Daisy J.' by the person who discovered her – which was, once again, Jenny Randles) started seeing a silver-suited being wandering around in her garden in Wallasey, on the Wirral. According to Daisy, she saw a moving light in her garden one night, but took little notice of it. It came back, however, and upon the third evening she went up to the window, looked out and saw that the light was actually perched up on top of the head of a 6-foot-tall figure dressed in silver, which was floating a few inches off the ground at the other end of the garden by the wall. It had two further lights upon the end of each of its arms, too, apparently. According to Daisy, she simply concluded that this being was a ghost rather than a spaceman, paid it little heed, and then calmly went upstairs to bed!

This reaction may at first seem to be bizarrely sanguine upon Daisy's behalf, but it turned out that, to her, the paranormal was nothing much unusual. She had, it seems, visions of the future on a regular basis (including one correctly predicting the disastrous fire which broke out at the Tower Ballroom in New Brighton in 1969), and claimed to have encountered phantom footsteps and ghosts upon several occasions, including the spirit of her deceased ex-lodger. In 1978, when the spaceman started coming to visit, Daisy had suddenly acquired a poltergeist in her home, too; it stole money from her and then hid it in bizarre and unusual places, sprinkled piles of broken glass down over her carpet and left pools of water around after itself, as well. Her first-ever encounter with the supernatural, she said, had occurred in 1903 when she was only eight (she was eighty-four when interviewed by Randles) and was bouncing a ball against a wall. It rebounded into her hands and then instantly dematerialised into nothing, according to her.

Given this alleged history of weirdness upon Daisy's behalf, then, perhaps she was correct in calling her own silver-suited visitor a 'ghost' rather than an 'alien'? Certainly, the lady's experiences with this odd being do not seem to have been literally physical in their nature; according to her, the thing had paid her garden a visit every night for the past two years, and had even started looking in through the window at her. Sometimes, she said, she had seen the man and his lights flying in to land from over the top of a tall tree at the other end of her property. If this were objectively true, then surely we could expect somebody else to have seen all this going on too, though? You would have thought so – but nobody ever did. And yet, upon one occasion, a UFO seems to have left some physical traces there behind it in her back garden; in November 1979, Daisy said, she had seen a big oval red light come down and land there. The next morning, she went out to investigate the area where the thing had landed, and found that the weeds had been crushed down by 18 inches and were now covered in a grey, furry substance. This flattened oval did prove, upon subsequent inspection,

really to have been there, although the grey furry stuff was actually just a common garden fungus.[25]

Can we really separate the sightings of Daisy's odd being from her previous experiences of the unknown in this case, then? Possibly not. She herself thought she was 'attracting them [the UFOs and silver men], perhaps because I'm psychic'. The fact that many of her 'visions' (this is what she herself chose to call them) of supernatural entities in her Wallasey home occurred most frequently at around 5.00 a.m. when, again in her own words, she was 'in the deepest stages of sleep', also sounds most suggestive. This might all sound a bit dismissive, but this need not necessarily be so. Daisy's poltergeist phenomena and her predictive visions seem, after all, to have been real enough – at least presuming that she had been telling the truth about them, that is. Perhaps the silver-suited men and UFOs in her garden, then, might not have been *attracted* to Daisy, as she put it, but were actually *produced* by her somehow, instead. Maybe they were not real to others, but they were real to her. That is not to say that they were simply hallucinations, though; after all, if the red UFO was a hallucination, then how on earth did it manage to leave physical traces behind after it in the garden? Or was this 'landing-mark' simply a misinterpretation on Daisy's behalf of a pre-existing feature among the weeds?

It is, of course, hard to say. But, if we are to dismiss all these things as being mere hallucinations, then there are, as already implied, numerous elements to them, which are hard to explain away. Quite apart from the physical traces left behind them by these 'visions', there is also the fact that they appear to be able to be experienced by more than one person at once, and sometimes last for quite some time. In 1978, for instance, it was reported that a middle-aged woman had sighted yet another silver man at work in her garden in a Liverpool suburb. It behaved just like the one which Daisy had been seeing in Wallasey since the previous year. This time, however, it allegedly appeared not merely fleetingly, but for *five hours straight*, and was witnessed by multiple persons, including two police officers. When they went out to confront it, though, the 'spaceman' simply vanished into thin air.[26] These things are not aliens. They are not exactly ghosts either, though. Nor are they, precisely, physically real – but nor are they wholly imaginary. They are, instead, one of the oddest mysteries mankind has yet to untangle.

4

Paranormal Power Stations

There is another strange encounter with an apparent ufonaut from the Merseyside area that must be discussed here, however, as it seems to have occurred in conjunction with a number of supposed UFO landings in the region, including one that was allegedly witnessed, as above, by a group of serving police officers! Let us begin our account of this tale first of all with the actual sighting of the 'alien', though, if such a being it really was.

This occurred on an isolated and lonely road just outside the small settlement of Rainford, a few miles north of St Helens, at around 11.15 p.m. on the evening of 2 January 1978 – so, at around the same time as UFO entities were being seen in Frodsham, Wallasey and Risley as well, then! (1978 was a peak year for encounters with ufonauts worldwide, which has led to it being dubbed the 'Year of the Humanoid' in some circles) It seems that four men in their early twenties, named Geoff Hales, Stephen Simpson, Glynn Mathews and Keith Thomas, were driving back to Liverpool after a night out, when Geoff, who was driving, accidentally took a wrong turning near the A580 just outside Rainford. This, apparently, was easily done, the road not having any street lighting at the time, and the surrounding countryside being somewhat desolate and featureless.

In any case, Geoff soon realised his mistake and braked sharply, which led to the car skidding off the wet road and into a muddy ditch. The vehicle didn't seem to be particularly damaged, but it was stopped momentarily. The headlights, however, were still on; and lit up by them, around 25 feet away and standing in the middle of the road, was a weird looking figure.

It was perhaps 7 feet tall, dressed in a fluorescent white one-piece suit that glowed, and was much broader in terms of its chest and torso than an ordinary man would be. It seemed to be wearing a white helmet and short white boots, and there was a strange rectangular box on the entity's chest, with two red lights on it, each of which flashed on and then off again in quick alternation. At no point on the being's suit were any joins visible; not even between the top of its body and the bottom of its helmet. The oddest thing about it, though, was the size of its arms; these were tiny, only about 8 inches long by some of the men's estimates, and perhaps as out of proportion to its body as a T-Rex's are. Its hands were darker than

the rest of it, and some of the witnesses thought it might have been wearing gloves, although others said that they rather gave the impression of being claws. The four lads were certain that, whatever it was, it wasn't human. Geoff Hales began panicking and having an asthma attack, and there was a frantic race inside the car for someone else to get into position in the driver's seat and reverse away from the scene. This they eventually did, the duration of the sighting only being around twenty seconds or so in length.

Speeding away, the first building they came to was Brown Birch Farm, where they knocked up the owners and told them what they had seen. Seeing as it was evident that Geoff had medical issues, the farmer called up Kirkby police station, the nearest one available, who sent out three officers straight away. The PCs believed the boys' account, and went out to search the area. Nothing could be found, but the story soon reached the ears of the national press, who wrote it up in the usual fashion they employ with these things, implying that the witnesses had seen a Cyberman.[27]

This incident was particularly interesting not simply because of what actually went on during it, however, but also because of the specific UFO activity that had been reported from the area both prior to and just after the humanoid sighting itself had occurred. For instance, just a few years before the 1978 encounter at Rainford, a rare UFO landing report had come in from Rainhill, another village about 5 miles to the south. Here, on the evening of 18 May 1975, three people, including a Mr and Mrs Scothern, had observed a UFO, which consisted of three lights 'like tennis balls' arranged in a triangle, which came down at a steep angle, apparently to land within a little copse of trees. The witnesses went up to the site and saw an eerie glow emanating from out of the vegetation and, nervous, went away to get some other people to come and have a look. Upon returning, though, no trace of any light-source was now visible.

Going inside the copse to check up on matters further the next morning, however, they were surprised at what they saw. At the centre of the trees was a small pond, surrounded by thick mud. In the middle of this was a peculiar-looking metal coil which, upon later analysis, proved to be made of pure aluminium and, somewhat stranger, a series of unusual 'footprints'. These were rectangular in shape, not rounded, and had no instep, measuring 14 inches in length by 6 inches across. Due to their depth, they seemed to have been made by something very heavy. Weirdly, they simply started and then stopped right in the middle of the mud, almost as if something – or someone, perhaps – had been dropped down into it from above.[28]

Perhaps, however, this incident had occurred too long prior to the sighting in Rainford for it to be truly relevant. Another UFO event, though, had been reported to local police only the previous night, at 1.45 a.m. on 1 January, from a group of people in the village of Shevington, about 3 miles north-east of Rainford. They told police that they had seen a very large circular disc of light, bright red in colour, although with a certain bluish tinge to it, passing overhead at around rooftop height. It seemed to be lit from within, and illuminated the ground and surroundings beneath, a glow from it being evident even as it passed behind buildings. Moving slowly, it was entirely silent, and disappeared out of sight on a south-westerly course … or, in other words, in the direction of Rainford! Several more witnesses living in Orrell, also on the object's flight path, later came forward to report having seen a red cigar-shaped UFO moving in a south-westerly direction that night, too. This fact does, you have to say, add some credence to the four men's bizarre story.[29]

The Rainford humanoid. What did he want?

Further evidence of UFO activity in the Rainford area during that January came from a pair of police officers out on traffic patrol duties on the M62 near Rainhill at around 11.30 p.m. PCs Peter Lowe and Gareth Roberts saw a brilliant white-blue light shooting through the air at a fantastic rate before then coming to a sudden halt and hovering in the sky over Bold power station, just south of St Helens. Then, ten seconds later, it began to pulsate and sped off away to the south, where it hovered over the top of Fiddlers Ferry power station, on the outskirts of Widnes near to Cuerdley and Warrington. Again, the light started to pulsate and then resolved itself into a kind of inverted T-shape or three-pointed star, glowing very brightly for twenty seconds or so before then zooming away up into the sky vertically. Apparently, around thirty cars had parked up by the side of the road so that their occupants could get out and have a closer look at it.[30]

This event was surprisingly resurrected and brought back into the public eye recently, by virtue of a couple of reports that appeared in the *St Helens Star*. A CID officer named Gary Heseltine, founder of a UFO database called PRUFOS (Police Reporting UFO Sightings), a kind of log containing details of UFOs seen by serving police officers in the British Isles, contacted the newspaper in order to pass on details of how he had included the sighting of PCs Lowe and Roberts on his system. For Heseltine, the sightings above Bold and Fiddlers Ferry power stations in 1978 were of great defence significance because, in his view, they indicated that aliens were perhaps observing the UK's power infrastructure from above for reasons and purposes unknown.[31]

Whatever the merits of Mr Heseltine's theory may be, however, his call to the paper did result in some unexpected further developments in the story of the sighting, even after all these years. An amateur radio 'ham', named Robert Bennett, contacted the *Star* in order to tell them how he was messing about with his radio set on the evening in question back in January 1978, when a message came through on it from a Liverpool ufologist. He was busily watching the light, and asked Robert to tell the police what was happening, and quickly. Bennett did as he was told and called St Helens police who sent out three officers, one of whom was high ranking. They arrived, he claimed, at about 10.15 p.m. (which would put the beginning of this incident *before* PCs Lowe and Roberts' sighting, of course) and stayed there in front of his radio set until 3.00 a.m. relaying messages to those ufologists who were out there chasing the thing, as well as tuning in to police radios of the various officers who were joining them in their pursuit. According to Roberts, these broadcasts clearly indicated that the UFO at one point landed in a field in Rainhill, and that a PC and WPC were only around 20 yards away from it when it took off and flew away again.[32] That, at least, is Bennett's story, though it sounds somewhat implausible to me.

Nonetheless, the association of the UFO with the power stations in the area does seem to ring true – indeed, this is something of an established pattern in the region. In 1981, for instance, a blue oval object was seen by numerous witnesses hovering, once again, over the top of Bold power station. Ufologists arrived on the scene and actually managed to track the UFO south-westwards, where it seemed to be heading towards another power station at Connahs Quay in North Wales. Extraordinarily, the path traced by the object's flight appeared to correspond with a similar path laid out for it by overhead power lines![33]

This latter fact, perhaps, might provide some encouragement for those theorists who feel that UFOs are essentially electromagnetic in their nature. The detail that the original 1978 UFO over Bold power station then zoomed away to float about above Fiddlers Ferry power

station is also of particular interest, however, because that too, is supposed to be a UFO hotspot. There are numerous accounts on record of people allegedly seeing weird things hanging about in the sky above this structure – although we shall leave by far the oddest until the next section of this book.

For example, there is one account posted online from a marine engineer who claims to have witnessed a UFO 'of immense size' floating around above it at around 2.30 p.m. one day in November 2008. He said that it looked circular, with a 'tiny bite' taken out of its back, and was almost transparent. According to the witness, it dropped five orange lights from out of its main body, which then simply disappeared over the power station. Then, it accelerated away from the scene at such a speed that it just blurred itself out of sight. Incredibly, another large UFO then appeared above the station's cooling towers and performed exactly the same task before then vanishing itself, too. All of this happened within 4–5 seconds, apparently, giving some sense of the speed of the objects involved.[34] Obviously, you can just post whatever you like online and it probably won't end up being checked out properly by anyone, but this is an interesting story, if nothing else.

A more reliable account of a UFO above Fiddlers Ferry, perhaps, comes from 28 October 1978, when the Blackburn family of Warrington witnessed a bright light in the sky. Trying to

Fiddlers Ferry power station, an alleged hotspot for UFO sightings in Halton. I've never seen anything there, though, and I live right by it.

examine it more closely through a telescope, Mr Blackburn found that it was so bright that his eyes couldn't stand it. Then, slowly, the light moved towards him and went out; before then reappearing again, in the form of a white dome of light with three red ones set beneath it in a triangular formation. These lights and the dome all appeared to be attached to a classic 'disc' shape, and the whole thing began making a humming noise as it passed overhead in the direction of Fiddlers Ferry – over which location, it apparently disappeared.[35] More narratives could easily be given here if I chose to do so. However, it does have to be said that I can see Fiddlers Ferry power station from out of my own back window, and I've never seen anything strange buzzing about up there over it myself, sadly.

So, were boiler-suited humanoids with tiny shrivelled arms really out and about in the Rainford, Rainhill and Widnes areas scoping out the region's power-generating facilities throughout the early months of 1978, or are other explanations available? I'm sure that they are, because I find the idea of extraterrestrials coming down to earth and then spending all their time looking at cooling towers to be nigh-on incomprehensible, personally. But, nonetheless, UFOs do seem to have been sighted, with disarming frequency, within the close vicinity of Merseyside's power stations. Why? I have no idea – and nor, I would suggest, does anybody else, really.

5

A Window into Wonderland

These days, Merseyside is well known to British ufologists as allegedly being a so-called 'window area', or 'UFO hotspot'. But how did the region come to gain this reputation in the first place, and does it really deserve it? Well, I think that the influence of Jenny Randles, the area's most significant ufologist, has been key. Randles, a former secondary school Science teacher, has lived in and around Merseyside at various points in her life and has, as a committed and extremely able ufologist, investigated hundreds of alleged UFO and alien sightings in the district. While she has often been able to satisfactorily resolve many of them as being simply down to misperception, etc., she has also come across several others that she has been unable to explain. As a result, Randles appears to have come to the conclusion that certain places within Merseyside – and perhaps even the entire region as a whole – are some kind of major window area.

Jenny Randles' entertaining and informative books on UFOs and other mysteries, frequently co-written with her colleague Peter Hough, are extremely popular; she has sold over a million of them in total, across more than thirty years. As such, it is through reading of her work that other UFO enthusiasts often seem to have come across the concept of Merseyside being a UFO hotspot. In particular, Randles was primarily responsible for promoting the paranormal claims of a small area near the banks of the River Mersey which is sometimes now known as the 'Daresbury/Preston Brook Triangle', but which she prefers to call 'Wonderland', after *Alice's Adventures in Wonderland* by the Reverend Charles Dodgson (AKA Lewis Carroll) who was born in the village of Daresbury, just east of Runcorn, in 1832.

In the original book, of course, the young girl Alice slips through into another world by going down a rabbit hole. In the story's sequel, meanwhile, she passes into another reality through the titular Looking-Glass. In Randles' Wonderland, likewise, the possibility of stepping through some kind of portal into the world of the paranormal, particularly that aspect of it which is UFO-related, is seemingly ever-present. So, where is Wonderland, exactly? Essentially, it is a small strip of land bordering the Mersey Estuary at Runcorn, passing along down the M56 through Daresbury and Preston Brook, and then crossing over the River Weaver west through Frodsham as far as Helsby Hill, a sandstone outcrop which

seems to fulfil the same imaginative function locally as Bidston Hill does on the Wirral. In the book *Mysteries of the Mersey Valley*, co-authored by Randles and Peter Hough, the authors make no bones about it, saying that the places in this small stretch of land are 'doorways to more than just a spectacular view. They seem quite literally to show the way into a new reality. This one small, rural area, is probably England's centre point of high weirdness; a supernaturally rare spot where anything can happen and usually does.'[36]

Since this definition of Wonderland was first put forward by Randles, it has been taken up, and sometimes modified, by other enthusiasts. For instance, some people speak not of Wonderland or the Daresbury Triangle, but of the 'Halton Triangle', thereby incorporating the town of Widnes, just north of Runcorn, into the mix, too. Others have widened out this area again, and spoken of something larger called the 'Mersey Triangle' which incorporates all these places, plus the Wirral, the entire Mersey Estuary, and Liverpool itself, into the window area. The popularity of this 'Triangle' term, incidentally, presumably comes from a familiarity on behalf of its proponents with Charles Berlitz's bestselling 1974 book *The Bermuda Triangle*, a famous but unlikely piece of work that claimed a triangular area in the Atlantic ocean between Bermuda and Florida was a UFO hotspot, where large numbers of ships and planes went missing due to alien activity. Many critics, however, have called this supposed Bermuda Triangle of Berlitz's simply wishful thinking, and pointed out that the area of the Triangle itself was essentially arbitrary and completely made-up by him. Are the Mersey and Daresbury Triangles much the same kind of thing? Some critics, perhaps most notably the writer and publisher Peter Brookesmith, certainly think so. According to an article he once wrote, it was his view that that these so-called 'hotspots' on Merseyside were little more than an attempt by people like Randles to romanticise the general areas in which they lived.[37]

So, are those people who want to believe in the reality of Wonderland, like Dodgson's famous White Queen, simply guilty of wishing to believe in six impossible things before breakfast? Randles does not think so; according to a reply she once made to her critics, so many things had happened within the Wonderland area that 'chance seems very unlikely to apply'.[38]

But who is right in this argument? The only way to find out would be to perform a detailed examination of the issue. Let's look at the notion of a larger Mersey Triangle, first, and ignore the smaller Halton and Daresbury ones for the moment. Where on Merseyside, exactly, have UFOs been sighted? Apparently everywhere, as the following essentially random list of sightings will show:

The Wirral, September 1980: Gerry Marsden, of Gerry and the Pacemakers fame ('Ferry 'Cross the Mersey', 'You'll Never Walk Alone'), stopped his car while driving along the M53 in order to take a closer look at a bright white light in the sky, which was zigzagging around in a triangular pattern, before then zooming away off into the distance 'at a fantastic rate' and vanishing over the horizon. Curiously, of course, this was on the same basic stretch of road where teacher Gareth Hughes had seen his own triangular UFO near Bidston Hill a few months earlier.[39]

The Mersey Estuary, May 1988: Dave McCrimmon, together with his two sons and a group of other fishermen, saw a series of five 'dazzling orange crescent-shaped objects', a bit like giant glowing bananas, plunging down beneath the waters of the Mersey one after another, before then coming back out again in single fashion and flying away across the Irish

Sea. The sighting occurred after dark, and the UFOs were accompanied by a loud buzzing noise, like a swarm of droning bees.⁴⁰

St Helens, 10 May 1966: A policeman, Donald Cameron, looked out of his back window early this morning and saw six glowing white lights hovering above the houses at the end of the estate on which he lived. A reporter claimed in his newspaper that one of them was larger than the others and had a 'cup-shaped dome' on top of it, which had led Cameron to speculate that it was 'obviously the mothership', but this later proved to be a silly press invention. The five other lights were oval in shape and PC Cameron's wife saw them too. They were observed for thirty seconds before then flying away 'at great speed' towards Manchester.⁴¹

The Wirral, 12 July 1981: Crew members on a Dan-Air cargo flight from Belfast to Liverpool reported seeing a bright white 'lightbulb' in the sky as they came down to land over the Wirral peninsular. Two men out camping on Thurstaston Common north of Heswall independently reported seeing the same thing, hanging over a nearby factory. It then changed into a dazzling bluish light and zoomed away from the scene with incredible speed.⁴²

New Ferry, 24 November 1959: Mrs M. Sperring was hanging out her washing in her back garden, which overlooked the Mersey, when she saw a silver saucer with a yellow dome on top from which a light was flashing. It was spinning, and moved away in the direction of Liverpool proper.⁴³

Halewood, December 1979: 'Billy', a worker at the Ford factory (as it then was), was walking home from the night shift at 9.30 p.m., when he saw a sphere of bright white light, 7 feet in diameter, approach him across an open field. It was only about 5 feet off the ground and disappeared up into the sky as it drew level with him. Could it have been an example of that curious natural phenomenon known as ball lightning? Certainly, it does appear to have been electrical in nature, as it caused his hair to stick up on end from his head for two days straight afterwards!⁴⁴

Liverpool, Club Moor & New Brighton, January–February 1913: According to reports in *The Times* and *The Manchester Guardian*, mysterious airships and unknown aeroplanes were seen in the skies above these locations, carrying 'brilliant lights' and looking, at times, like 'exceptionally bright stars'. This was during a wave of scares about German zeppelins supposedly being sent over to England on military scouting expeditions at this time. However, none were actually dispatched to do any such thing, leaving the sightings unexplained except perhaps in terms of mass hysteria. The various 'scareship' panics of the late nineteenth and early twentieth centuries are an acknowledged precursor of modern UFO tales.⁴⁵ However, another 'scareship' panic did hit Liverpool on 3 July 2001. At around 8.00 a.m. a long, silver cigar-shape was spotted from dozens of homes and offices, drifting over the rooftops of the city. It then passed along the coast, and was last seen at around 8.00 p.m. near Blackpool. Witnesses said that it resembled a zeppelin, was 300 feet long, and was so low that they feared it might crash into a building. Speke Airport was swamped with calls reporting it, but nothing showed up on their radar. Someone from Hunts Cross, however, did claim to have picked up voices speaking gibberish coming from the craft as it passed overhead, using special equipment. Later analysis, though, suggested that the 'gibberish' was in fact Japanese! In reality, of course, the 'UFO' was simply a runaway advertising blimp that didn't show up on radar purely because of the low level at which it was drifting.⁴⁶

Lymm, 8 October 1968: Jenny Randles' colleague Peter Hough, as an eight-year-old boy, saw an 'impossible plane' in the sky during his early-morning paper round. It was in perfect silhouette, and was about the size of a normal passenger aeroplane, but it was blunt at each end, lacked any streamlining or tail fin, and had a pair of stubby rectangles for wings. Two rows of white lights shone above these latter protuberances. It began to rise upwards vertically, apparently in stops and starts, and then changed its direction – not by turning around in an arc in mid-air, but by rotating on its axis! It then drifted away silently in the direction of Manchester.[47]

West Kirby, April 1993: Mr G. was standing on the beach looking out over the Dee Estuary between the Wirral and Wales when his attention was caught by an elongated mystery object flying across the sky. Suddenly, it changed its flight path and plunged down into the waters of the estuary at a 40-degree angle, leaving no trail of smoke behind it. No crashes of aeroplanes or any such thing were reported as having occurred that day, however. There has been some speculation that this was a 'ghost plane' rather than a 'real' UFO as such.[48]

Skelmersdale, 12 August 1987: Three witnesses, a Mr and Mrs D. and their daughter, stopped their vehicle in order to look more closely at an object in the sky, which the little girl initially mistook for a 'flying car'. Indeed, viewed from side-on, the object did resemble a kind of bubble-car, with a flattened top to it. It had two oval red lights on its side and five brilliant bluish-white ones on the underside when it flew over the witnesses' heads, arranged in the shape of the five dots on one face of a die. Sightings of such an object in the sky over 'Skem' (as it is known locally) became so common that it eventually ended up being given the nickname 'The Skelmersdale Thing'.[49] For example, a fairly sensational subsequent encounter with the 'Thing' occurred on 17 March 1990 to a Mr H. who was walking back to a friend's house after a night out at 3.15 a.m. when suddenly he felt an uneasy sensation, as if something were watching him. Apparently it was; he turned around and saw two lights floating side by side over a school playing field. The 'Thing' was completely silent and looked, once again, like a strange kind of streamlined flying car, which this time had four white headlights and another four blue lights embedded in its base. At the rear were masses of white lights together with two large central red ones. Its bodywork was completely black in colour, and it appeared to have no windows. Scared, Mr H. stepped into a shaded area in order to escape being seen. The UFO was gliding slowly through the air but, as it passed by him, suddenly flipped over onto its side and shot off towards the Warrington area at a truly incredible speed. Some people have speculated that the UFO seen in Skelmersdale during this period was some kind of secret military project; but, if so, then why did it attract attention to itself by shining all those lights out?[50]

And that, I think, will do as regards random UFO encounters over the wider Merseyside area. Ten – chosen from among literally hundreds of others, and of deliberately varying quality – should be more than enough to demonstrate that strange things genuinely are seen in the skies right across the region. But does this really mean that the Mersey Triangle as a whole really exists as a UFO hotspot? It is debateable. Based upon recent figures, around 430,000 people live in Liverpool proper, and, in total, there are perhaps a further 1,000,000 living within the wider area which, for the purposes of this book, we are calling 'Merseyside'. Warrington alone has 200,000 residents, and St Helens 100,000. Over 300,000 people, meanwhile, live on the Wirral. Given this fact, it is hardly surprising that hundreds of people in the region have seen strange things in the skies. I doubt that, if I was to conduct a thorough

The Skelmersdale Thing: a UFO or a flying car?

survey of UFO sightings in and around, say, Newcastle or Greater Manchester, I would find substantially fewer accounts.

Furthermore, there is the fact that the exact geographical limits of what constitutes Merseyside are extremely vague. The time was that the Wirral was considered to be Cheshire, for example, and not Merseyside at all, but this definition has now changed. Therefore, where precisely you choose to draw the Mersey Triangle on a map is essentially down to you. In addition, you have to question why it would be that aliens would suddenly start respecting metropolitan borough and county boundaries.

However, maybe you would – sensibly – define UFOs as being something other than alien craft, and perhaps say instead that they are bizarre hallucinatory expressions of Merseyside's geology, relying upon a combination of the 'earthlights' theory and the piezo-electric effect hypothesis, which we examined earlier. This is fair enough; except that, of course, the underlying sandstone bedrock of the area – which is supposed to help to facilitate such phenomena, remember – does not exactly correspond with what we would call 'Merseyside',

and is definitely not triangular in shape. Indeed, there is a tourist attraction, a kind of countryside walking route, known as the 'Sandstone Trail', which runs from Frodsham on the south side of the Mersey Estuary, right the way down through Cheshire and thence into Shropshire. Should we extend the window area down here too, then? It is self-evidently the truth that people see UFOs in the skies over Merseyside. That is not, however, in my view necessarily enough to make it into one huge window area. Smaller locations *within* Merseyside, such as Bidston Hill, could justifiably be claimed as being so, but not, for me, necessarily the entire area as a whole.

What about the 'next triangle down', though, namely the so-called 'Halton Triangle'? Seeing as I live here I would desperately love this to be real; but is it? Widnes and Runcorn (the two main towns that constitute the modern borough of Halton) are both much smaller settlements than Merseyside as a whole is, and their borders far more clearly defined and obvious. So, what UFO experiences have been reported from this area, then?

Probably the first well publicised Halton UFO sighting – apart from those of James Cooke – occurred in November 1963 in Runcorn when Dick Newby, a RAF veteran, witnessed a 'huge blue star-like thing', which whizzed around just over the rooftops of Boston Avenue, before then shooting off towards Halton Castle. Because of his RAF background, Newby's sighting was taken seriously and reported with respect. Apparently, Dick had been sitting down to watch *Emergency Ward 10* with his wife and daughter when he saw 'a vivid bluish-coloured light' that appeared suddenly above the field in front of his house, before the giant blue star then went sailing across. Newby said that the sight had scared his daughter Ann so much that she refused to sleep on her own that night – even though she was fifteen years old at the time. The next day when she told her school friends about the UFO, two of them said that they had witnessed it as well. Whether they too needed to spend the night in the parental bed after this experience, however, remains unrecorded.[51]

Several years later, on 3 July 1967, a young man named Michael Baker, a twenty-year-old electrician's apprentice, was woken from his sleep at 2.00 a.m. at his house in Pine Road, not very far from Boston Avenue, by what he termed a loud 'whirring or burring' sound. He looked out of his window trying to work out was causing it for around fifteen minutes when, suddenly, he spotted an object hovering behind the rooftops of some newly built houses. Baker's seventeen-year-old wife, Janice, saw the weird thing, too. So did Janice's mother Betty Bennett and Janice's thirteen-year-old sister Geraldine, with whom the young couple were still living. It was a veritable family event, it seems.

The buzzing object was shaped like a glowing quarter-moon with the bottom cut off it, apparently, and the noise from it got louder as it approached and receded as it went further away. There was also a bright light 'like a moonbeam' being cast down from the night sky onto a path outside, which then disappeared along with the thing in the air. This latter object then reappeared, however, 'like a big bowl of fire'. A more elaborate description given of the object later, though, said that it shone with a golden glow, was spinning, and had ill-defined edges. It appeared able to shape-shift, as at one point the light folded itself up 'like an accordion' before then suddenly becoming a 'sharply-defined, spinning, metallic disc' and then turning back into something which looked more like a star again. At certain points, the noise it made was so loud that it seemed almost to be coming from the back garden. This same whirring noise had been being heard intermittently by local residents for the past three years by this point, having become well known in the area, and it seemed that other persons

in Runcorn had been seeing things in the skies at around the same time, too.[52] It is also worth noting that, in 1969, police apparently received a report of a UFO landing on the playing field behind Pine Road, but I have no more details of this alleged incident available to hand, sadly.[53] If this is all true, though, then it almost seems as if the Pine Road/Boston Avenue neighbourhood was essentially a window area *within* a window area!

Furthermore, on 5 October 1967, a mere matter of months after Michael Baker's UFO sighting, a similar noise was captured on a tape recorder at Hough Green, then a small village but now part of Widnes. Known as the 'Hough Green Hum', it resembled 'a weird combination of whirring, buzzing [and] grinding' emanating from some unknown point within the atmosphere, and was apparently so loud that it caused one man to jump into a hedge in order to escape the spaceship that he thought was coming for him![54]

However, does the similarity between the strange noises encountered in both Widnes and Runcorn here necessarily provide evidence that the two towns therefore make up some kind of unified window area for UFOs? Not really. For one thing, while the Hough Green Hum was undoubtedly real enough, it need not necessarily have had anything whatsoever to do with UFOs. It could well have been an entirely natural phenomenon. Furthermore, the buzzing noises were not localised purely across the Halton area at this time.

In the autumn of 1967, the entire country was undergoing a major 'UFO flap', as periods when large numbers of saucer reports come in are technically known. This UFO fever hit Merseyside as a whole, and not just Halton, and one of the main features of the wider Merseyside flap was the appearance of a weird noise in the sky. This sound was described in a letter from a Mr D. J. Furlong printed in the Liverpool *Daily Post* on 23 October 1967 as being 'a high-pitched whistling sound ... accompanied by a beeping noise in the nature of some kind of signal' passing overhead.[55] In the early hours of the day after this letter appeared, a Mrs Joyce Hennessey, of Huyton, then called the papers to say that she and her children had been awoken at around 3.00 a.m. by 'an intermittent whining sound' only to see an unexplained glow over the rooftops when they looked out of the window.[56] It appears that people on Merseyside soon started associating the mystery hum specifically with flying saucers, and more reports of the noise were then printed in the local press, coming largely from witnesses in the Wavertree area. On the night of 25 October, sightings of UFOs began flooding in from Mossley Hill, Fazakerley, Wallasey, Kirkby and Huyton. The RAF, however, said that they may have been responsible for these, due to night-flying exercises they were then carrying out. By this time, however, the UFO scare had even spread out to Warrington and Appleton Village, where 'a round ball' of light and a pair of red and white lights were observed by various persons.[57]

On 26 October, Merseyside police got involved, as they sent out special search parties to the Norris Green area after a motorist, Peter Murphy, claimed to have seen a black, shining object flash across his windscreen and hurtle into a field next to Croxteth Hall Lane, at around 11.25 p.m. Thinking that vandals had hurled a brick at his car, Murphy reported it to the police, and returned to the scene of the incident shortly afterwards with a PC David Jackson. They both searched the field, but could find nothing. They did, however, both witness a UFO hovering over the large Norris Green housing estate, which lay just to the east of the field, at a height of around 400 feet. It was the size of a dinner plate, they said, shaped like a star, and was bluish-white in colour. After remaining stationary for a few moments, it then appeared to fall down and vanish over the housing estate. Thinking that

things were dropping from the sky, it seems that PC Jackson took the situation seriously, as a search was then subsequently made of Norris Green, looking for ... well, for something, at least. Alien wreckage, perhaps? Then, later that night (i.e. the early hours of 27 October), a certain William Sharples, of Wavertree, managed at last to catch the mystery buzz on tape! He played it to reporters from the *Liverpool Echo*, who described it as being 'a high-pitched, continuous tone', just as had been reported to them by others.[58]

Therefore, it can be seen how, in spite of the apparent coincidence between mystery buzzes and hums being heard in both Runcorn and Widnes during 1967, this is not actually any real kind of evidence for there being a Halton Triangle at all. After all, the Hough Green recording was made right slap-bang in the middle of a much wider scare about mystery noises from above that was then going on across Merseyside as a whole. UFO events in the Halton Triangle, it seems, do not just simply occur in a vacuum.

Indeed, it seems highly likely that the whole notion of mystery sky-hums being associated with UFOs at all was picked up on by Merseyside residents from earlier events in the Wiltshire town of Warminster, which had been gaining great national media publicity since 1965. The UFO scare here had been started off by a letter in a local newspaper for 20 January 1965 from a man named David Holton, who claimed to have been encountering a baffling sky-hum in the town for several years, even saying that he had once witnessed this noise killing a flock of pigeons! It later transpired that Holton had made this entire story up in order to see if he could create his own artificial UFO flap in the town (he succeeded, evidently), but it doesn't seem unlikely that the 1967 Merseyside scare could have been ultimately influenced by serious media coverage of this prank (or 'psychological experiment' as he preferred to style it), too.[59] Certainly, the so-called 'Warminster Mystery' definitely did have an impact on some Merseyside residents, as a man called Geoffrey Mander, a cinema-manager from Anfield, once travelled down to Wiltshire in order to investigate matters for himself. Apparently, back in Anfield while he was away, two of the staff at his cinema received phone calls – on a *disconnected line*, no less – from anonymous persons, threatening him with dire consequences if he continued with his UFO-hunting activities. 'You must warn Mander that he must not move out of his proper station in life', the sinister voices told his staff.[60] You cannot ever hope to simply view the Merseyside 'UFO scene' in isolation, then.

After the sensational events of the late 1960s, throughout the 1970s and 1980s reports of UFOs over Halton still came in, but didn't appear in the local newspapers with as much regularity as they had before. Nonetheless, it was reported in 1972, that three locals saw an object resembling 'a flying teapot without a lid' over Halton Brow in Runcorn during daylight hours, and in 1979 several workers in a council building near to Runcorn Shopping City witnessed a 'huge orange sphere' moving over the sky towards the Palacefields area of town.[61]

There was at least one remarkably bizarre event from Halton during this period that deserves to be mentioned here, though. Late one night in 1977, it seems, a pair of security guards were on duty in their little hut protecting a building site near the small village of Moore on the south bank of the Mersey between Runcorn and Warrington. Not long after 1.00 a.m., however, a blinding white light filled the air, illuminating the security hut and causing the two men to hide beneath a table in fright. Nonetheless, despite the light's terrifying nature, it also seemed oddly beautiful and hypnotic to the guards, and they noted with surprise how they could stare right into it without even having to blink. This light was accompanied by a 'penetrating' buzzing/humming noise as well, apparently. The men

thought that this entire experience had lasted for around twenty minutes when the light eventually just simply vanished.

However, it transpired that, in fact, more than an hour had actually passed. The two men were under strict instructions to call back to the Warrington HQ of their security firm once every hour in order to reassure them that all was well, but they had missed their 2.00 a.m. call, so another guard had been sent out to see what had happened to them. He found them still cowering beneath the table, and could see no sign of the big white light. It turned out that the men's ordeal had actually lasted for over ninety minutes, meaning that more than an hour of their lives was missing. So where had it gone? We are almost taught these days by the popular media to expect that such people will have suffered an alien abduction, but this need not necessarily be so. The light, remember, was described by them as being somehow hypnotic in nature; perhaps exposure to it had simply temporarily entranced them and then altered their perception of time somehow?

This is not to say that the experience had been entirely subjective in nature, however; for the UFO left physical traces behind itself on the ground. A covering of white powder and mist which proved, upon closer examination, to have been dry ice and other kinds of ice crystals, was left on the floor where the light had had its epicentre, despite the fact that it had been far too warm a night for any frost or ice to have developed there naturally. Apparently, the heads of the security firm were delighted by this whole escapade and planned to tell the local papers, exploiting it all for advertising purposes using the tedious slogan 'our security is out of this world!', but their two unfortunate employees refused, shunning publicity and just wanting to forget about it all.[62]

After this lull, though, from 1994 to 1996 Halton suddenly began to undergo probably its most wide-ranging 'UFO flap' on record, when dozens of reports of weird things in the clouds started to pour in to the local newspapers. Perhaps not entirely coincidentally, this was the period when *The X-Files* TV show was going through its main wave of popularity. Inspired by this series, maybe, people in Halton – as elsewhere across the country – started 'watching the skies' with a new-found level of interest and enthusiasm. It was apparently during this period that the term 'Halton Triangle' was first used by enthusiasts, and Widnes and Runcorn's reputation as being a major window area for UFOs really dates back only to this relatively recent point in history.

Amid all of the usual relatively mundane accounts of strange lights being seen in the sky and so forth, though, there were at least two quite remarkable UFO encounters that took place during this period, both of which were widely reported. The first case involved multiple witnesses, and occurred on the night of 27 February 1995 when a thirty-one-year-old woman, Karen Conlon, was walking by the Mersey Estuary on Fair View Walk in the Castlefields area of Runcorn. While ambling along, she saw an orange glow in the distance, near to the Fiddlers Ferry power station on the Widnes side of the water, and which she initially took to be a street lamp. However, it was too high for a lamp, and was entirely still, so could not have been an aircraft either. A group of six youths then arrived and began staring at the object too. A sixteen-year-old lad among their number then pointed out that a 'dark tube' or 'black beam' seemed to be being let down from the UFO into the river, and was apparently sucking up a column of water from out of the Mersey!

After around ten minutes the UFO started moving upriver towards Warrington, when three of the teenage girls gathered around watching foolishly waved at it. At this point,

it turned around in an arc heading back towards the sightseers, some of whom became nervous. As it got closer, they could see that it initially appeared to be oval or 'bell-shaped' in nature before then transforming itself into a rectangle. Due to the angle at which it was flying, they could see its base, which had about six reddish lights arranged on it in formation. It was completely silent. It passed away overhead in the direction of Helsby Hill, where it disappeared. After this sighting had gained much publicity, two British Airways pilots eventually came forward to say that they had seen a similar orange-glowing UFO over Congleton when they were coming down to land their Boeing 737 at Manchester Airport some three weeks earlier, lending the story further credibility. Apparently, fiery orange glows have been reported along this stretch of the Mersey for hundreds of years, perhaps even giving rise to the legend of the fire-breathing Cuerdley dragon living in the woods nearby. Maybe the UFOs have been buzzing Runcorn for longer than we thought![63]

Following this now-famous water-sucking incident near Fiddlers Ferry that night, yet more UFOs were sighted over Halton over the next two years or so, including bright stars, black triangles and classic saucer-shaped discs. Descriptions even came in of huge UFOs, allegedly 'larger than two football pitches' in size, unlikely though this may seem.[64] The next truly classic Halton case, however, occurred on 15 July 1996, this time in Widnes.

In this instance, a young man was walking home at 2.30 a.m. past Widnes cemetery. Looking up, he saw a 'bright yellow light', spherical in shape, hovering about two houses high over the nearby footbridge on Avondale Drive. When he passed by it began following him and he broke into a run. As he made his escape, the UFO hovered over the cemetery and made a high pitched noise, described as being like 'a thousand wailing cats', before emitting beams of light and jets of flame from itself. These hit the railway tracks at Widnes Station, which sits right next to the cemetery itself. Returning home, the young man told his father about the incident, and they both went down to the tracks to investigate. Once there, they found that four of the railway sleepers were smouldering and that one of them had a 4-inch hole burnt through it. The two men called the police, and the officer who went to the scene discovered that the sleepers were still smoking five hours later. The PC also discovered that the two men were telling the truth about the hole as well, saying that it did 'look rather odd'. He could find no trace of accelerant having been used on the tracks in order to account for the damage, however. The officer later wrote up a report on the incident that was sent in to the MOD, who quietly filed it away and ignored it.[65]

Apart from a wave of 'black triangle' sightings in 1997, however, the biggest UFO flap in Halton's history was now over. That is not to say that sightings do not still go on in the vicinity, however, because they do. Probably the most widely reported Halton UFO incident after the 1994–96 flap, for instance, occurred just before 8.00 p.m. on 14 February 2001, when a large flying triangle, with red lights at its front and rear, was allegedly seen passing slowly through the air not far above the Runcorn–Widnes bridge. Apparently, several cars slowed down to take a closer look at the object, which supposedly brought traffic 'to a standstill' (traffic's usual state on the Runcorn–Widnes bridge in any case).[66]

The most contemporary Halton sightings, though, seem much less spectacular in nature. For example, on 4 May 2011 Laurence Baker, a seventeen-year-old student, saw a UFO flying low over his house in Millington Close in the Foxley Heath area of Widnes. He thought that it was not an alien spacecraft, as it was far too small, but instead must have been (in his view at least) some kind of secret military drone or piece of stealth-aircraft technology, as it

was only a few feet wide. It was oval or spherical in shape, covered all over in black cell-like panels that looked similar to scales, and had an antenna on the rear of it that was pointing in the direction it was travelling. Baker then made a sketch of the object and informed the press. According to him, several unmarked helicopters had been seen hovering over Foxley Heath prior to the sighting having been made, which he believed backed up his view that the MOD must have been involved somehow.[67] There are a number of other sightings from the Halton area that I could regale you with, but I think that's are more than enough now.

So, is there such a thing as the Halton Triangle, then? Once again, I think it is slightly debatable. There is no doubt that the area has had more than its fair share of UFO sightings over recent years, but this doesn't necessarily mean that it is definitely a window area. After all, prior to about 1994 the ufological history of the place wasn't *truly* special, James Cooke's escapades notwithstanding. Interesting things happened there, but not necessarily on a mass scale. Furthermore, while it is obviously true that the combined populations of Widnes and Runcorn are smaller than those of Liverpool or Merseyside as a whole, the number of reported sightings is not truly disproportionate to the population, which is still quite sizeable at around 120,000 persons in total, split more-or-less equally between the two towns.

Also, you do have to question why and where exactly this 'Triangle' would exist. After all, 'Halton', which effectively defines Widnes and Runcorn as one big place, is a very modern invention. The two towns were only designated a unitary authority as recently as 1998. Furthermore, Widnes sits right next to Warrington, another area which, together with its immediate surroundings, has seen plenty of UFOs (and silver men) over the years. Why not include this town in the Triangle, too? I am not necessarily suggesting that there is *definitely* no such thing as a window area here, but it does seem to me that both the Mersey and Halton Triangles have been somewhat randomly drawn.

What about Wonderland itself, though? Does that really exist as a window area, or is this a matter for debate, too? Surprisingly perhaps, given my slight scepticism about these matters so far, I think that the idea of Wonderland being a kind of paranormal hotspot does seem pretty plausible and capable of standing up to scrutiny. This is simply because the area of which it is supposed to consist is incredibly small, particularly if we leave Runcorn proper out of it, as I here intend to do.

Just to remind ourselves of where we're talking about, then, Wonderland is an obscure and fairly rural slice of land immediately south of the Mersey Estuary, stretching from the villages of Daresbury and Moore just east of Runcorn, extending down south past another village called Preston Brook and then south-west again up to the slightly larger, but still small, settlements of Frodsham and Helsby. If you don't include the town of Runcorn itself in this area, then none of these places are very large at all. In Frodsham, there are 9,000 people, and in Helsby 4,000. Preston Brook's population is only around 700, Moore's is about 800, and Daresbury contains just over 200 souls, according to recent figures. And yet, within this very small region, a very large number of apparently quite astonishing incidents have taken place – allegedly, at least.

Sightings of UFOs in Wonderland date back right to the 1950s. From the back bedroom window of their home in Stockton Heath (north of the river, and now part of Warrington) on 19 July 1956, for instance, a Mrs B. Shutt and her husband both witnessed a white-gold object hovering somewhere in the sky over Frodsham at around 12.30 a.m. According to

The bell-shaped UFO sucked up water from the River Mersey through a long, black tube.

Mrs Shutt, an architect: 'It was like looking at a disc edge-on, brilliantly lit from above but shaded underneath.' After about five minutes it faded out, but the Shutts kept on watching the skies and even woke up their neighbours, a Mr and Mrs Waterfield, to tell them about the spectacle. This was a good move, because it then reappeared, in more-or-less the same place. Now, according to Mrs Shutt, 'it was elliptical in shape, but changed to that of a sphere. At first there appeared to be two small objects in line astern with it, but these faded out. The sphere [then] faded out for a second time and did not reappear.'[68] However, while this is an interesting account, it is the more modern cases from within Wonderland that have really put it firmly upon the ufological map.

Take, for example, what occurred to an unnamed garage owner and his brother while they were driving along a stretch of the M56 between Daresbury and Frodsham on the night of 9 January 1998. Looking up, they saw a triangular black UFO with a red glow on its base hovering there right above their car, before then speeding away into the distance. They, at least, were in no doubt as to what they had seen, saying that it was 'so much like a spaceship, aerodynamic, sophisticated and tremendously fast'.[69]

Was it really a spaceship? I doubt it, although there is no question that bizarre science-fiction-type tales have been reported from within the area; there are numerous stories of cars suddenly packing up for no apparent reason on Wonderland's roads, and even some involving vehicles supposedly teleporting around the place, too. However, seeing as there are also local yarns about horses and carriages becoming immobile and then refusing to move on the roads that passed through Wonderland in centuries past, perhaps we could be justified more in speculating about ghostly forces haunting the spot rather than ones from outer space.[70]

Ghosts are sometimes sighted on the roads of Wonderland, after all. In the early morning hours of 29 August 2001, for instance, a woman named Ann Jones was driving back to her home in Frodsham when her car broke down about a mile outside Helsby. She got out, called the AA on her mobile, and then waited. As she did so, a strange figure appeared in the distance, walking towards her down the road. It was a man, dressed in an old-fashioned white working-smock – although at first Ann had taken it for a woman wearing a white dress. Feeling uneasy, Ann got back inside her car and locked the doors. The man had a beard, wore a hat, and was carrying a tool like a rake over his shoulder. He passed right by her car, looking straight ahead, as if he had not even noticed her. Apparently, the ghost – for that, she now realised, was what it was – was completely silent, and did not even make any sound of footsteps.[71] In light of what UFOs are popularly supposed to be able to do to cars on the road, it is perhaps worth noting that this glimpse of the supernatural, too, was accompanied by a vehicle breaking down. Could there be some connection between the two different types of phenomena here, which we can't quite make sense of as yet?

It may well be so, as there is a certain specific area within Wonderland, around half a square mile in extent, where ghostly forces do indeed seem to be in evidence, coexisting quite happily alongside numerous UFO reports. Near Preston Brook Marina, where diverse canal systems interweave themselves among the farmland, various bizarre happenings have been reported as occurring. And these are not just saucer sightings; for instance, late one night in September 1968, a certain Donald Smith was fishing at the marina with a friend of his when both men suddenly came face-to-face with a genuinely extraordinary manifestation of the unknown. As they sat there with rod and line, a giant bird, with

Widnes railway station, where one man professed to have seen a UFO firing jets of flame down into the tracks one night during the mid-1900s. A police investigation later seemingly backed this claim up.

a wingspan of at least 12 feet, swooped down onto one of the boats moored there in the marina. It pushed it down halfway into the water with its weight, and sent a small wave out across the previously still surface. It was a bizarre-looking thing; its beak was hooked, its neck long, yellow tufts of feathers hung over its three toes, and it gave off a foul, sulphurous odour. Most disturbing of all, said the two men, its eyes were bright red, which hardly seems natural. Fortunately, perhaps, Donald Smith's friend had brought a rifle with him intending to shoot rabbits. Now, however, it seemed as if he had a rather more valuable prize to bag; and yet, as soon as he took aim at the hideous bird, it simply vanished into thin air. It didn't *fly* away, please note; it just disappeared into nothing, quite instantly and inexplicably.[72] If true, this is a genuinely uncanny occurrence.

In the farmers' fields surrounding this spot, crop circles have been found, strange lights observed hovering around in the skies and poltergeists encountered on the canal system – including by no less a figure than Fred 'the weatherman' Talbot, Granada TV's well-loved and brightly-jumpered forecaster, who experienced a spook hurling around beer cans and growling at him while passing through a tunnel on the Trent & Mersey Canal in 1988 during filming of a documentary.[73] Wonderland, it seems, really does have everything, and all within such a small geographical space. There are dozens more Wonderland stories that

I could quote if I had the room; all those tales of panthers and ghost monks around Norton Priory we examined earlier on belong here too, properly speaking. Surely the Daresbury Triangle does indeed deserve to have window area status bestowed upon it, then, if anywhere in England does. English Heritage should really put a big blue plaque up somewhere nearby in order to commemorate all this weirdness.

But if Wonderland really is a window area, then why could this be? What is going on there? It is an interesting fact that, just like at Risley, there is a nuclear research institution in the vicinity, namely Daresbury Nuclear Physics Laboratory, officially opened in June 1967 by Harold Wilson, Prime Minister at the time. Here, various devices were built and used for experiments, including such things as electron accelerators, something called the Synchrotron Radiation Source, and energy ion scattering facilities. What precisely these devices do, I must confess I have absolutely no idea – and nor, I suspect, do most other of those commentators who have tried to claim that the lab's experiments have been somehow responsible for causing all the odd phenomena in the region. However, it is interesting to note that the sci-fi-style nature of the laboratory could be considered, once more, to be a contributory factor towards building up some kind of 'mythic landscape' in the Wonderland area, as perhaps had also happened at Risley. Most locals must have heard the stories about UFOs, car-stops and flying triangles, and everyone there is well-aware of the lab's presence, so perhaps these two facts combine somehow in certain people's minds in order to cause them to start seeing any bizarre phenomena they might encounter in a certain way; as top-secret stealth planes or futuristic alien spacecraft, for instance. I don't think that you can leave out an account of an area's local mythology when you are looking at the weird things that allegedly go on there.

An alternative, *apparently* more objective, way to explain the area's high weirdness-quotient, though, would be to look at its underlying geology, and then attempt to ascribe certain powers to it. This is, as with many areas of Merseyside, all too easy to do. Once again, sandstone predominates, although deposits of mudstone and other materials are present beneath Wonderland, too. The geology of Frodsham is particularly significant. Not only does the village sit on top of several layers of sandstone, a few faults also run beneath it, one of which, the 'Frodsham Fault', has its culmination at the mouth of the River Weaver. This, of course, is the very same riverside area where the silver-suited cow-measurers were seen in 1978.

However, we should not allow ourselves to get carried away too far by these facts. Simply saying that the 1978 humanoid encounter occurred because there was some sandstone faulting present in the area seems a bit simplistic. UFOs don't *automatically* appear just because of a particular bedrock being found in a place, especially not ones that apparently contain sentient occupants. Even if the presence of sandstone is a factor in such cases, there must also be other forces at work too, surely? There is in my view a sense in which the eagerness among some commentators to 'explain' an area's paranormal history purely in terms of its geology is in fact merely another way of creating a kind of 'mythic landscape', too. To discuss sandstone deposits and piezo-electricity may appear to be more scientific than talking about portals into an alien dimension or something, but actually it could sometimes be considered as being simply yet another means of re-enchanting the landscape, giving rise to a new kind of 'scientific mythology' about a place. The earthlights approach certainly has much validity to it, but it can probably end up being taken too far.

Furthermore, in addition to all this weirdness, the area in question also appears to have yet another one of those 'window areas within window areas' present within its midst, and that is Helsby Hill, right at the westernmost border of Wonderland. This hill, 370 feet high and the only one in the region of any real note, is quite odd just to look at; from a certain perspective at any rate. If you pass by it going along the M56 it actually looks like a simulacrum of a human face in profile! Once again, in light of what has been said above, it may or may not be considered significant by the reader that Helsby Hill is a sandstone outcrop and, indeed, has a disused quarry right next to it.

Perhaps the most notable UFO sighting that took place here occurred at about 5.05 p.m. on the evening of 2 December 1994, when a certain Mr T. (but not *that* one, sadly) was driving along the M56 on his way to Sale when he noticed a saucer-shaped object by Helsby Hill to his right, surrounded by a kind of thickish mist. As he got closer, he could see that it was stationary, and it had one big blue oblong window along its side and several others that were neon coloured. From beneath the UFO, light was streaming down and illuminating the ground below. Apparently, it was gigantic in size; and yet, nobody else on the motorway appeared to have even noticed it, apart from Mr T. Perhaps, then, the sighting was somehow subjective in its nature?[74]

The smaller Frodsham Hill, which is nearby, however, (yet another sandstone structure) was also the scene of a wave of alleged 'giant UFO' sightings in 1994 when, across the space of four evenings, more than thirty witnesses apparently saw a cigar-shaped object with shimmering coloured bands along its sides flying around near it.[75] Given this fact, perhaps we should not simply write off Mr T.'s testimony quite so easily, then.

Other UFO sightings in the direct vicinity of Helsby Hill include that made by a woman who, on 25 August 2000, witnessed a 'huge orange searchlight' with 'sprouting flames' coming off it passing by her in complete silence there,[76] and that of a man named Graham Clamp, who, together with his family and neighbours, witnessed a pink ball of light zigzagging its way across the sky past Helsby Hill on the evening of 20 May 1992, before then disappearing in the direction of Chester.[77] So, curiously, yet another Merseyside hill is proving to be a highly localised hotspot for UFOs. Whether this is because they provide access to concentrated lumps of sandstone or because, psychologically speaking, they are spiritually significant somehow as being 'closer to the sky-gods', is entirely up to you.

Wonderland is, however, in my view most likely a genuinely supernaturally-significant spot; if window areas do indeed exist, then this must be one of them. Too much has happened within such a small, sparsely populated district for it to be all purely coincidence, surely? While no doubt a certain amount of romanticising of Wonderland has been performed over the years by some, I have no hesitation in saying that Jenny Randles was probably right about the location being special somehow. We should feel lucky to have it here. I don't think that there actually are any aliens or spaceships buzzing around there, that top-secret government experiments are distorting time and space in the area, or even necessarily that the place's geology is the main factor in making weird stuff happen. But *something* strange is going on in Wonderland ... isn't it? Or do I just *want* it to be?

6

We All Live in a Yellow Space Machine

And now, to end this book, a very silly story indeed. It is well known that the Beatles, at the height of their incredible success, went through something of a 'strange' phase. Experimenting with eastern gurus and mind-altering substances, the Fab Four tried to escape the limits of their everyday earthly consciousnesses, and get high instead. Less well-known than all of this, however, is the fact that at this time John, Paul, George and Ringo commissioned a man to build them a flying saucer in order to enable them to escape the confines of this planet, which only hemmed them in.

This man was known as 'Magic Alex', and he was a clever little chap. According to him, if only Liverpool's most famous sons would give him enough money, then he could build them the following wonderful devices and inventions: an anti-gravity machine, invisibility paint, an electric spoon that would stir itself, coloured air, a giant artificial sun, an x-ray camera, electric paint, a force field to keep the pop stars' fans away from them and block out their screams, wallpaper that was also a wafer-thin stereo system ('loudpaper'), remote-controlled, colour-changing paint, and a floating house/recording studio contained within a giant bubble.

Apparently, the Beatles believed him. After he had invented something called a 'nothing box' (a plastic rectangle containing some Christmas tree lights that flashed on and off randomly until their batteries ran out) and showed it to John Lennon, Lennon adopted Magic Alex as being one of his many gurus. John – presumably stoned at the time – would apparently sit there in front of this box for hours mesmerised, looking at the pretty lights going on and then off again. Soon, the Beatles had given him a job in their new company, Apple Corp, where he had his own laboratory and freedom to work on any invention he liked. The best he could come up with, however, was an electric apple that lit itself up in the dark.

Despite this total lack of success, however, the mad professor somehow managed to convince at least two of the Beatles that he could build them their own flying saucer to take them into space. All he needed were the V12 engines from George Harrison and John Lennon's Ferraris, and he would be able to stick them together inside a big metal saucer

in order to make the Beatles their very own UFO. However, it seems that Paul McCartney heard about this madness and eventually managed to talk Lennon and Harrison out of it. It later transpired that 'Magic Alex', real name Alexis Mardas, was little more than a Greek TV repairman with a gift for talking up his own abilities – at least according to John Dunbar, a London gallery worker with whom he lived when he first came over to England. According to Mardas himself, however, he was 'a rock gardener, and now I'm doing electronics. Maybe next year I make films or poems. I have no formal training in any of these, but this is irrelevant.' Perhaps so; but he never did manage to make the Beatles that flying saucer ...[78]

The Beatles may come across as being somewhat gullible here, but perhaps this was only a consequence of their reputed prior interest in the world of ufology. This was not unusual for rock stars of the period; the Rolling Stones knew Desmond Leslie, the co-author of the famous book *Flying Saucers Have Landed*, for example, and even partied with him at his country house over in Ireland, as did Paul McCartney. The infamous 'UFO Club' in London, meanwhile, was one of the hippest nightclub venues of the time, and John Michell, author of books like *The Flying Saucer Vision*, was known to many musicians of the '60s. Dave Davies, of The Kinks, even eventually became a part-time UFO-hunter. David Bowie, likewise, was an amateur ufologist before he became famous in the guise of his Ziggy Stardust persona; he once stood up on top of a rooftop in Beckenham pointing a coathanger into the sky and seeing if he could pick up any alien messages from outer space. Apparently, he only gave up in this task when a passer-by asked him if he could get BBC Two![79]

Given this climate of UFO belief among the top pop stars of the time, then, perhaps it should come as little surprise that John Lennon himself – the most UFO-obsessed member of the band – claimed to have had his own saucer sightings, at least according to his one-time girlfriend May Pang. Supposedly, the two lovers were in their apartment in New York one night when they saw a spaceship flying by. It was shaped like 'a flattened cone' with a 'large, brilliant red light' on top and 'a row or circle of white lights' running around its rim. It was flying below roof level and giving off visible heat waves and yet, strangely enough, nobody else saw it, other than Lennon and Pang, standing there in wonder on the balcony. The aliens didn't land and take them away, however, perhaps being frightened off by the fact that they were both stark naked at the time. Pang later made the claim that Lennon had seen other UFOs before this night, and that he felt he might have been abducted by extraterrestrials while still a child living in Woolton.[80]

Certainly, Lennon did have a real interest in UFOs, mentioning them in his song 'Nobody Told Me' ('There's UFOs over New York, and I ain't too surprised') and even including the following note on the sleeve of his LP *Walls and Bridges*: 'On the 23rd August 1974 at 9 o'clock I saw a UFO.' This fact doesn't necessarily mean that he was really abducted, however – although Uri Geller, the well-known Israeli psychic spoon-bender and watch-mender, did claim during an interview that he had met John Lennon himself during the mid-1970s and been told of an abduction-like experience Lennon had undergone in his New York apartment. According to Geller, Lennon had been in bed one night when a bright light shone in through his bedroom door and four thin figures then appeared, guiding him into a tunnel of light and showing him a kind of replay of every moment of his life up to this point. At the end of this encounter, the aliens even left John a nice little present behind – a metal egg from outer space. Lennon then produced this space egg from his pocket and gave

it to Geller as a gift, apparently. That's what Uri says, anyway – although it must be said that, in the same interview, he also claimed to have foiled Noel Edmonds' plans to play a Gotcha Oscar hidden-camera trick upon him for an episode of *Noel's House Party* using his psychic powers. ('Noel was very impressed. It's the first time that this has ever been done.) So perhaps the reader should be left to make their own mind up about whether or not this whole yarn is in any way true.[81]

Surely the most bizarre UFO-related rumour about the Beatles, however, was that they were actually a bunch of aliens themselves. This strange idea has its origins in a weird piece of gossip that a Canadian prog-rock grouped called Klaatu, founded in 1973 by a pair of musicians called John Woloschuk and Dee Long, were in fact the re-formed Beatles in disguise. Named after the extraterrestrial from the 1950s US sci-fi film *The Day the Earth Stood Still*, Klaatu's biggest hit was 'Calling Occupants of Interplanetary Craft', later covered more famously by The Carpenters. Given these facts, and the allegations that Klaatu were in fact the Beatles, some people began to whisper conspiratorially that the Beatles were all secretly ETs themselves, and that Klaatu's work was just a way of preparing the world to be told of the fact. Needless to say, this was in no sense true.

Just as implausible, perhaps, are the persistent rumours that Paul McCartney died in a car crash in 1966 and was thereafter replaced by either an alien, a robot, an agent of the Illuminati, or a good old-fashioned lookalike called Billy Shears (he of *Sgt Pepper's Lonely Hearts Club Band* fame).[82] Footage is easily available online purporting to show Paul supposedly transforming himself into a reptoid alien during an old performance, thereby confirming David Icke to be correct in his increasingly mental assertions about the secret rulers of our world. Again, however, this seems most implausible. Unless something terrible has happened between this book being written and you sitting down and reading it, Paul McCartney is alive and well. So why make up all these daft tales about him and his bandmates?

The Beatles, needless to say, are true Liverpool legends. Probably this is why people insist upon creating so many *untrue* legends about them, then. In a way, all these insane rumours are a testament only to the band's own significance. No pop musicians have ever bettered them. In a very real sense, the Fab Four really were from another world – just not literally!

John Lennon tries out his own, personal UFO, courtesy of Magic Alex.

Conclusion
City of Dreams

And that, then, is the story of *Paranormal Merseyside* – except, of course, it really isn't, not by a long chalk. No book of this kind can ever hope to be completely comprehensive in its nature, and no doubt there are many more mysteries or strange tales from the region that I have been forced to leave out, either through personal ignorance or lack of space. I haven't even mentioned, for instance, the weird tale of Ethel Chapman, the local stigmatic who had visions of Jesus in her hospital bed, the strange story of John Middleton, the giant man who used to live in Hale Village, or the bizarre rumours which surround the legendary Purple Aki, a half-folkloric, half-real bogeyman character who will no doubt already be well known to many readers. Personally, I suspect that most of the weirdest things that go on – in Merseyside and elsewhere – never even end up being reported in any case, because the people who experience them are far too embarrassed or disturbed by what they have seen to go out and tell anyone. This is a shame because, as reading this book will hopefully have shown you, exposure to the strange things that have occurred over the years in the place where we live can act to enhance our enjoyment of it. If a place is worth living in, it is worth mythologising, whether with true tales or false, and clearly this book has been packed full with both.

By keeping alive the weirder parts of our history, we keep alive a kind of dream in which to live, and transform a world of dull industrial estates, commonplace housing, dirty alleyways and everyday shops into something full of awe and interest, where ambassadors from another world can, and frequently do, intrude upon our lives and spread around some welcome wonder in it. This can be seen most clearly, perhaps, if we think right back to the start of this book, and consider once more that small bust of C. G. Jung that stands in Liverpool city centre. Why is it there? Just in order to commemorate Jung's famous dream about the city being the 'pool of life'? Or is there a further reason?

The man responsible for its existence was Peter O'Halligan, a poet and self-styled 'dream merchant', who held a Jung Festival in the city in 1976 and convinced the council to allow him to erect the plaque and the bust in honour of his hero on the wall there in Mathew Street. This stone plaque, however, is not just any old lump of rock. It was sourced straight

from the quarry that stood across the lake from Jung's house on the shores of Lake Zurich, in Switzerland. Jung's house had been constructed to his own design, and one day, it seemed, the people who were building it brought him across a large rock from the quarry to act as a cornerstone for the tower of this new home. However, they had made a mistake, and the stone was completely the wrong size. They apologised and went to take it back, but Jung said no. He wanted to keep it. Looking into it, he thought he could see a kind of eye staring back at him from out of the rock, and into his very soul. He decided that he would retain it and install it in his garden as an aid to self-contemplation, equating it, somehow, with the famous 'philosopher's stone' of the old alchemists.[1]

This philosopher's stone (which, in legend, was of course not actually a stone at all) was a kind of mythical substance that was supposed to have the power to magically transmute base metals such as lead into pure gold. Jung saw through these old tales as being mere metaphor, and determined that the philosopher's stone was actually a symbolic representation of a kind of mystical journey that an individual could go on in order to try and transform himself into something better, turning the dross of his own everyday soul into one of pure, shining gold, perhaps. Very often, this 'journey of the soul' would take place at night, within an individual's dreams.

The rock that Peter O'Halligan transported over to Liverpool from Switzerland to make the plaque from came from the exact same spot in the quarry from whence Jung's original stone had been excavated. Indeed, it was essentially the 'back part' of the great Swiss mystic's own special stone. So, what we have, right in the centre of Liverpool – at the very heart of the city, the beating, bloody source of its life, Mathew Street, where the Beatles themselves once played their early gigs – is nothing less than a segment of the fabled philosopher's stone itself, at least in C. G. Jung's view.

Maybe, then, we should follow the lead of this magical item, and consider the stories contained within this book more closely. Jung was, in many ways, the foremost interpreter of dreams that mankind has ever produced, even outranking Freud. Contemplation of his beloved stone, meanwhile, was intended to turn the human soul into philosophical gold. Many of the tales told of poltergeists, ghosts, UFOs, miracles and other such unlikely but magical occurrences from Merseyside that we have just encountered are like dreams in their way, as well; dreams that, somehow, have escaped from their usual place within the human mind and begun manifesting themselves inexplicably – but wonderfully – outside of it instead. Perhaps a proper contemplation of these, too, can help transform the human soul into a form of philosophical 'gold'?

Tales of the supernatural should not simply be dismissed. Some of them might not be, in a narrowly literal sense, entirely true; but they are, surely, in some way beautiful in their nature nonetheless. At the very heart of Jung's original dream of a filthy, soot-clogged city, then, lies the radiant and shining pearl of myth. Why try and spoil it by going and attempting to take it all literally? Dream-logic is a powerful and marvellous thing; and the mythic, largely untold history of ghost-haunted Liverpool and its UFO-ridden surroundings, it seems, is absolutely full of it.

References

Note: Sometimes, due to pressures of time, etc., I have been unable to consult some of the primary sources made reference to within the book, and have relied instead upon quotes or partial reproductions of some newspaper articles, etc., contained within other secondary sources. Where this has taken place, primary sources are still referenced, however, for the aid of any readers who may wish to go back and look them up in their original form at their leisure. (All websites viewed between November 2011 and March 2012)

Introduction: The Pool of Life
1 C. G. Jung, *Memories, Dreams, Reflections* (HarperCollins, 1995), pp. 223–24.
2 Ibid., p. 224.
3 A. Tulloch, *The Story of Liverpool* (The History Press, 2008), pp. 1–2.
4 Ibid., p. 3.
5 *The Times*, 26 Nov 2011; J. P. Kerrigan, *A Bowl of Scouse: The Forgotten People and Hidden Events Beneath the Surface of Liverpool's History* (Countywise, 2009), p. 182.
6 http://en.wikipedia.org/wiki/James_Maybrick
7 *Fortean Times* 77, p.11.
8 http://www.guardian.co.uk/notesandqueries/query/0,5753,-1915,00.html
9 http://www.bbc.co.uk/news/uk-england-merseyside-12977162

Part One – 'My Mate Said...': Merseyside Panics And Rumours
1 The Great Leprechaun Invasion of 1964
1 *Liverpool Echo*, 2 Jul 1964.
2 *Daily Post*, 2 Jul 1964.
3 *Liverpool Echo*, 13 Jul 1964.
4 *Liverpool Echo*, 2 Jul 1964.
5 *Kirkby Reporter*, 17 Jul 1964.
6 *Journal* (Newcastle), 9 Jun 1964; *Flying Saucer Review*, vol. 10, no. 5; J. Clark & L. Coleman, *The Unidentified* (Anomalist Press, 2006), p. 24.

7 *Liverpool Echo*, 26 Jan 1982.
8 *Daily Post*, 25 Jan 1965.
9 Tulloch, *The Story of Liverpool*, pp. 84–85.
10 http://en.wikipedia.org/wiki/liverpool
11 http://magonia.haaan.com/2009/leprechauns/ – this online article by N. Watson is an excellent starting-point for research.
12 *Liverpool Echo*, 2 Jul 1964.
13 http://magonia.haaan.com/2009/leprechauns/
14 Ibid.
15 http://findarticles.com/p/articles/mi_qn4161/is_20070401/ai_n18784179/
16 http://news.bbc.co.uk/1/hi/scotland/8574484.stm
17 http://magonia.haaan.com/2009/leprechauns/
18 Ibid.

2 Spring-Heeled Jack Comes to Town

19 *Morning Chronicle*, 10 January 1838 – this contemporary source is most easily available in a paper by M. Dash: 'Spring-Heeled Jack: To Victorian Bugaboo from Suburban Ghost' in S. Moore, ed., *Fortean Studies 3* (John Brown Publishing, 1996). This excellent paper, by the acknowledged expert on Jack, has been used to provide the general history of Jack's reign of terror and to access the transcripts of several contemporary newspapers contained within it.
20 *The Times*, 9 Jan 1838.
21 *The Sun*, 20 Jan 1838.
22 *The Times*, 22 Feb 1838.
23 R. Whittington-Egan, *Liverpool Colonnade* (Philip, Son & Nephew,1955), p. 140.
24 Rumours referenced online. E.g. http://thomasslemen.tripod.com/springheeledjack.html
25 See *Fortean Times* 238, pp. 44–45, where the two reports are largely reproduced; also online: http://www.jamesmaybrick.org/pdf%20files/Spring-Heeled%20Jack.pdf
26 *Liverpool Citizen*, 29 Oct 1887.
27 *Liverpool Citizen*, 24 Dec 1887.
28 *Liverpool Mercury*, 15 Nov 1887.
29 http://aforteaninthearchives.wordpress.com/2010/02/16/spring-heeled-jack-and-the-terrified-child/
30 *News of the World*, 25 Sep 1904.
31 *Liverpool Echo*, 21 Sep 1904.
32 *London Star*, 24 Sep 1904 .
33 *Liverpool Echo*, 24 Sep 1904.
34 Whittington-Egan, *Liverpool Colonnade*, p. 137.
35 http://www.yoliverpool.com/forum/archive/index.php/t-3174.html
36 Whittington-Egan, *Liverpool Colonnade*, p. 137.
37 *Liverpool Echo*, 19 May 1967.
38 *Morning Post*, 19 Oct 1929.
39 http://www.maghullstar.co.uk/maghull-aintree-news/2008/05/15/jumping-demon-104897-20905947/
40 *Fortean Times* 237, p. 23.

41 W. Barnes, *Ghosts, Mysteries and Legends of Old Warrington* (Owl Books, 1990).
42 http://drdavidclarke.co.uk/2012/02/25/return-of-spring-heeled-jack/

3 The Ghastly Galosher Man
43 Barnes, *Ghosts*, p. 78.
44 See, for example, posts at http://www.purple.dreamhosters.com/common/?blog=1831
 and http://www.sthelens-connect.net/forums/topic/58170-good-words-that-have-
 disappeared/page_st_120
45 http://internalarchive.thisischeshire.co.uk/2001/9/27/207741.html
46 http://internalarchive.thisischeshire.co.uk/2001/10/11/206809.html
47 Barnes, *Ghosts*, p. 78.
48 http://internalarchive.thisischeshire.co.uk/2001/9/28/207554.html
49 http://www.thisischeshire.co.uk/archive/2007/05/24/Whally%27s+World+%28whalleys
 _world%29/1423192.Remember_the_galosher_man_/
50 http://www.thisischeshire.co.uk/archive/2007/06/29/Whalley%27s+World+%28whalle
 ys_world%29/1509379.Look_out_here_s_the_Galosher_Man_/
51 http://www.sthelens-connect.net/forums/topic/58170-good-words-that-have-
 disappeared/page_st_120
52 http://internalarchive.thisischeshire.co.uk/2001/11/22/204947.html
53 *Yorkshire Observer*, 11 Sep 1926.
54 *Sheffield and Rotherham Daily Independent*, 26 May 1873.
55 www.windowsproject.co.uk/publish/minibooks/MPMS15.pdf

4 The Tranmere Terror and Other Merseyside Ghost Panics
56 Whittington-Egan, *Liverpool Colonnade*, p. 199.
57 Barnes, *Ghosts*, pp. 80–82.
58 *Liverpool Mercury*, March 1913.
59 Whittington-Egan, *Liverpool Colonnade*, p. 194.

5 Screeching Ginny and Jenny Greenteeth
60 http://therailwaycentre.com/UK%20News%20Pages%20Oct%/2006/311006_Mersey.
 html
61 http://en.wikipedia.org/wiki/Prince_Rupert's_Tower
62 http://www.yoliverpool.com/forum/archive/index.php/t-5290.html
63 http://www.jtrforums.com/archive/index.php/t-3169.html
64 Barnes, *Ghosts*, p. 72.
65 http://www.plant-lore.com/plantofthemonth/duckweed-and-jenny-greenteeth/
66 C. Burne, *Shropshire Folklore* (1883), p. 79.
67 Barnes, *Ghosts*, p. 72.
68 http://www.plant-lore.com/plantofthemonth/duckweed-and-jenny-greenteeth/
69 R. Vickery, *Garlands, Conkers and Mother-Die: British and Irish Plant-Lore*
 (Continuum, 2010), pp. 61–62.
70 http://www.liverpoolbotanicalsociety.co.uk/Parnassia/1997%20Jul/1997%20Jul.pdf
71 J. Westwood & J. Simpson, *The Lore of the Land* (Penguin, 2005), p. 697.
72 *Notes & Queries* 10s:2, 365. (1904).

73 http://www.yoliverpool.com/forum/archive/index.php/t-8496.html

74 http://www.disused-stations.org.uk/g/garston_dock/index.shtml

75 http://www.railwaysarchive.co.uk/eventsummary.php/eventID=3032&eventID=3095&
 eventid=4868

76 http://americanfolklore.net/folklore/2010/07/screaming_jenny.html

6 Faces in the Windows ... and Jesus in the Dishwasher

77 http://liverpool-schools.co.uk/html/harrington/html

78 Whittington-Egan, *Liverpool Colonnade*, pp. 185–87.

79 Barnes, *Ghosts*, p. 13.

80 P. Hough & J. Randles, *Mysteries of the Mersey Valley* (BCC, 1999), pp. 135–36.

81 http://www.clickliverpool.com/culture/culture/1211027-strange-hand-of-god-
 phenomenon-at-liverpools-walker-art-gallery.html

82 http://www.resologist.net/art06.htm

83 *Fortean Times* 71, p. 11; *Liverpool Echo*, 20 May 1993; *The Sun*, 21 & 22 May 1993.

84 http://www.southportvisiter.co.uk/southport-news/southport-southport-
 news/2008/07/11/southport-couple-raise-funds-to-help-kenyan-village-hit-by-tornado-
 101022-21319026/

Part Two – City of Faith: Merseyside Miracles

1 Satan Lives in Bootle

1 All the information about Teresa is taken from Lady Cecil Kerr, *Teresa Helena
 Higginson, Servant of God, Spouse of the Crucified* (1926), [http://freespace.virgin.
 net/crc.english/thh]. As no page numbers are given in this online document, I give
 chapter numbers and, where appropriate, the number assigned to Teresa's letters in their
 collection in the British Library. This reference: Chapter II, letter 269.

2 Ch II, letter 56.

3 Ch III, testimony of Susan Ryland.

4 Ch IV, letter 55.

5 Ch IV, letter 55a.

6 Ch IV, letter 55a.

7 Ch IV, letter of Susan Ryland.

8 Ch IV.

9 Ch V, testimony of Susan Ryland.

10 Ch V, letter 11.

11 Ch IX.

12 Ch X, letter of Kate Catterall, 26 Aug 1876.

13 Whittington-Egan, *Liverpool Colonnade*, p. 116; I couldn't actually find this part of
 Minnie Catterall's testimony quoted in Kerr's book, though perhaps I just overlooked it.

14 Ch X, letter of Joanna Flynn, 26 Aug 1876.

15 Ch X, letter of Father Powell.

16 Ch XII.

17 Whittington-Egan, *Liverpool Colonnade*, p. 113.

18 http://www.sacredhead.org/id14.html

19 Ch IX.

20 Ch V, testimony of Susan Ryland.
21 Ch IV, letter 56.
22 Ch XI, letter of Father Powell, 17 Aug 1882.
23 Ch IX.
24 Ch IV, letter of Susan Ryland, 27 Jun 1880.
25 Father H. Thurston, *Ghosts and Poltergeists* (Henry Regnery Co 1954), p. 200.
26 Ch XI, letter 141.
27 Ch X.
28 A. Monnin, *Life of the Curé d'Ars* (Burns & Lambert 1862), pp. 109–110.
29 Monnin, *Life of*, p. 114.
30 Ibid., p. 112.
31 Ibid., pp. 80–86.
32 Ch XII, letter from Father Snow, 17 Apr 1886.
33 Monnin, *Life of*, p. 121.
34 Ch III.
35 Ch X, letter 81.
36 Monnin, *Life of*, p. 115.
37 Ibid., pp. 130–131.
38 Ch XII.
39 Ch XII.
40 'Appendix B – Bilocation' in Lady C. Kerr, *Teresa Helena Higginson*.
41 Ch VI, letter from Canon Daly, November 1876.
42 Ch XVI.

2 A Sight for Sore Eyes at Winwick's Holy Well

43 http://en.wikipedia.org/wiki/Oswald_of_Northumbria
44 http://en.wikipedia.org/wiki/St_Oswald%27s_Church,_Winwick#St_Oswald.27s_Well
45 http://www.stoswaldswinwick.com/page_11
46 Westwood & Simpson, *The Lore of the Land*, pp. 411–412.
47 Quoted at http://megalithix.wordpress.com/2010/10/19/st-oswalds-well-winwick/
48 Quoted at http://www.ancestryaid.co.uk/boards/family-history-genealogy-information/776-winwick-st-oswalds-well.html
49 Westwood & Simpson, *The Lore of the Land*, pp. 627, 630.
50 Westwood & Simpson, *The Lore of the Land*, p. 412.
51 J. Harland, *Lancashire Folk-Lore* (1867), http://ebooksread.com/authors-eng/john-harland/lancashire-folk-lore--illustrative-of-the-superstitious-beliefs-and-practices--lra/page-8-lancashire-folk-lore--illustrative-of-the-superstitious-beliefs-and-practices--lra.shtml
52 C. Hardwick, *On some ancient battle-fields in Lancashire and their historical, legendary, and aesthetic associations* (1882), http://www.ebooksread.com/authors-eng/charles-hardwick/on-some-ancient-battle-fields-in-lancashire-and-their-historical-legendary-and-hci/page-8-on-some-ancient-battle-fields-in-lancashire-and-their-historical-legendary-and-hci.shtml
53 Westwood & Simpson, *The Lore of the Land*, p. 412.
54 J. P. Pearce, *The Church of St Oswald, Winwick, in Legend and History* (1935), http://newton-le-willows.com/index.php?option=com_content&task=view&id=563&Itemid=27

55 http://saints.sqpn.com/saint-anthony-the-abbot/
56 http://www.americancatholic.org/features/saints/saint.aspx?id=1263
57 http://www.abcgallery.com/saints/anthony.html

3 The Liverpool Shroud
58 *Daily Mail*, 21 Dec 2011.
59 http://e-forensicmedicine.net/news.htm
60 My account of this case overall is compiled from three main sources: report in *Fortean Times* 51, p. 7–9; article by Father O'Leary: http://www.shroud.com/pdfs/imprint.pdf; report of Dr Zugibe: http://www.shroud.com/pdfs/mattress.pdf

4 Spontaneous Human Combustion in Widnes?
61 The main sources for detail about the case and the subsequent inquest were: *Fortean Times* 44, pp. 41–42; P. Hough & J. Randles, 'The Creation of a Myth? Postmortem on the Jacqueline Fitzsimon SHC Inquest' in *Fortean Times* 47, pp. 60–64.
62 *Liverpool Echo*, 25 Jan 1905.
63 *Louth and North Lincolnshire News*, 28 Jan 1905.
64 C. Fort, *Lo!* (John Brown Publishing, 1997) pp. 118–121.
65 http://www.archive.org/stream/journalofsociety12sociuoft/journalofsociety12sociuoft_djvu.txt
66 http://tonova.typepad.com/thesuddencurve/2005/09/come_on_baby_li.html
67 B. Rickard & J. Michell, *The Rough Guide to Unexplained Phenomena*, (Rough Guides, 2000), p. 153.

5 The Blind Girl Who Could See
68 http://www.oxforddnb.com/view/printable/17352
69 The main source for the details about Margaret's life and illness was T. Renwick, *The Continuation of the Narrative of Miss Margaret M'Avoy's Case* (1820). The details mentioned here are on pp. 122–124.
70 Ibid., pp. 192–195.
71 Ibid., p. 127.
72 Ibid., Appendix p. 191 (the page numbers of the Appendix not being numbered continuously with those of the main part of the book).
73 Ibid., Appendix p. 185.
74 Ibid., pp. 143–144.
75 Ibid., p. 107.
76 Ibid., Appendix pp. 184–186.
77 Ibid., p. 237.
78 Ibid., p. 202.
79 Ibid., p. 8.
80 Ibid., p. 210.
81 Ibid., p. 212.
82 Ibid., p. 240.
83 Ibid., p. 248.
84 Ibid., Appendix p. 27.

85 Ibid., p. 236.
86 Ibid., p. 250.
87 Ibid., Appendix p. 6.
88 Ibid., pp. 107–108.
89 Ibid., p. 162.
90 Ibid., Appendix p. 15.
91 Ibid., pp. 20, 35.
92 Ibid., p. 4.
93 Ibid., p. 101.
94 Ibid., Appendix p. 37.
95 Ibid., Appendix p. 41.
96 Ibid., Appendix p. 53.
97 Ibid., p. 81.
98 Ibid., Appendix, p. 58.
99 Ibid., p. 239.
100 Ibid., pp. 105–106.

6 Trips Down Memory Lane in Bold Street

101 http://en.wikipedia.org/wiki/Bold_Street,_Liverpool
102 http://www.qsl.net/w5www/timeslips.html
103 http://icliverpool.icnetwork.co.uk/0300whatson/0800events/2003/10/30/let-s-do-time-warp-again-50061 13572570/
104 *Fortean Times* 274, p. 47.
105 http://www.maghullstar.co.uk/maghull-aintree-news/2007/05/31/youth-slipped-in-to-1967-104897-19216838/
106 http://www.reocities.com/Area51/Dunes/6561/cheshire.html
107 http://www.yoliverpool.com/forum/archive/index.php/t-27794.html
108 http://icliverpool.icnetwork.co.uk/0300whatson/0800events/2003/10/30/let-s-do-time-warp-again-50061-13572570/
109 http://www.parascience.org.uk/articles/time.htm
110 http://icliverpool.icnetwork.co.uk/0300whatson/0800events/2003/10/30/let-s-do-time-warp-again-50061-13572570/
111 http://www.parascience.org.uk/articles/time.htm
112 http://www.parascience.org.uk/articles/time.htm
113 http://icliverpool.icnetwork.co.uk/0300whatson/0800events/2003/10/30/let-s-do-time-warp-again-50061-13572570/
114 http://www.slemen.com/stlukesabduction.html
115 http://icliverpool.icnetwork.co.uk/0300whatson/0800events/2003/10/30/let-s-do-time-warp-again-50061-13572570/
116 For a good summary of these findings see Paul Devereux, *Earthlights* (Book Club Associates, 1982) pp. 70–74
117 http://icliverpool.icnetwork.co.uk/0300whatson/0800events/2003/10/30/let-s-do-time-warp-again-50061-13572570/
118 http://www.liverpoolecho.co.uk/liverpool-news/local-news/2008/02/27/biggest-earthquake-tremor-in-25-years-hits-merseyside-100252-20530094/

119 http://en.wikipedia.org/wiki/2002_Dudley_earthquake

120 Fort, *Lo!*, p. 29.

Part Three – Scouse Spooks: Merseyside Ghosts, Animal Spirits, Poltergeists and Demons

1 The Pig-Killing Poltergeist of Runcorn

1 *Widnes Weekly News*, 29 Aug 1952; Whittington-Egan, *Liverpool Colonnade*, p. 292; http://www.cc-publishing.co.uk/Archives/runghost.html

2 Whittington-Egan, *Liverpool Colonnade*, p. 294.

3 E. J. Dingwall & T. H. Hall, *Four Modern Ghosts* (Duckworth, 1958), pp. 70–71.

4 Ibid., p. 68.

5 *Widnes Weekly News*, 21 Nov 1952.

6 Dingwall & Hall, *Four Modern Ghosts*, p. 78.

7 *Widnes Guardian*, 26 Sep1952.

8 Dingwall & Hall, *Four Modern Ghosts*, p. 75.

9 Ibid., p. 75.

10 Ibid., p. 71.

11 Ibid., p. 77.

12 Whittington-Egan, *Liverpool Colonnade*, p. 293.

13 Dingwall & Hall, *Four Modern Ghosts*, p. 74.

14 Ibid., p. 75.

15 Ibid., p. 74.

16 Whittington-Egan, *Liverpool Colonnade*, p. 294.

17 http://www.cc-publishing.co.uk/Archives/runghost.html

18 *Sunday Graphic*, 27 Dec 1952 or 1953; *Fortean Times* 267, p. 54.

19 Whittington-Egan, *Liverpool Colonnade*, p. 294–295.

20 *Louth & North Lincolnshire News*, 28 January 1905; Fort, *Lo!*, p. 120.

21 H. Price, *Poltergeist Over England* (Country Life, 1945), p. 79.

22 http://www.cc-publishing.co.uk/Archives/runghost.html

23 Dingwall & Hall, *Four Modern Ghosts*, p. 73.

24 Ibid., p. 73.

25 Whittington-Egan, *Liverpool Colonnade*, p. 295.

26 http://www.cc-publishing.co.uk/Archives/runghost.html

2 Poltergeists Over Merseyside

27 Hough & Randles, *Mysteries*, p. 145; http://www.wok20.pwp.blueyonder.co.uk/pennylane.htm

28 *Fortean Times* 73, p. 19; *Liverpool Echo*, 20 Nov & 4 Dec 1992.

29 Whittington-Egan, *Liverpool Colonnade*, p. 194.

30 J. Reppion, *800 Years of Haunted Liverpool* (The History Press, 2008), p. 33.

31 Hough & Randles, *Mysteries*, pp. 142–143.

32 http://www.dailymail.co.uk/news/article-1361391/Paranormal-Activity-Couple-spend-3-000-hotels-ghosts-force-home.html

33 *Fortean Times* 12, p. 22; *Liverpool Echo*, 8 Oct & 23 Oct 1974; http://www.paranormaldatabase.com/hotspots/liverpool.php

34 Barnes, *Ghosts*, p. 76.

35 J. Pearson, *Haunted Places of Cheshire* (Countryside Books, 2006), pp. 34–36.
36 *Fortean Times* 12, p. 21; http://www.champnews.com/html/newsstory.asp?id=6227; http://en.wikipedia.org/wiki/Birkdale_Palace_Hotel#Paranormal_Activity; http://www.ufodigest.com/article/birkdale-palace-hotel-and-fishermens-rest-haunting
37 http://www.liverpoolecho.co.uk/liverpool-news/local-news/2008/03/25/brookside-ghosts-are-too-real-life-100252-20667990/
38 http://www.osadvertiser.co.uk/news/ormskirk-news/2011/08/25/ghost-blamed-for-car-crash-among-supernatural-999-calls-to-police-in-west-lancashire-and-south-ribble-80904-29297598/

3 The Lady Vanishes

39 http://en.wikpedia.org/wiki/Speke_Hall
40 http://www.ghost-story.co.uk/stories/spekehall.html
41 Reppion, *800 Years*, pp. 35–36.
42 http://words.inpurespirit.com/1467/the-white-lady-of-speke-hall/; http://www.yoliverpool.com/forum/showthread.php?5607-Speke-Hall-and-the-Grey-Lady
43 Pearson, *Haunted Places*, pp. 16–18; http://www.oldwirral.com/brimstage.html
44 Whittington-Egan, *Liverpool Colonnade*, p. 197; http://erin-naillon.suite101.com/reginald-eastons-ghosts-a384475
45 http://www.oldwirral.com/thurstaston_hall.html
46 http://www.oldwirral.com/thursaston_hall.html
47 http://www.trolleyrescue.pwp.blueyonder.co.uk/gof/latest.html
48 http://www.paranormalmagazine.co.uk/2010/09/23/the-lady-of-the-lake/
49 http://newton-le-willows.com/history/viewtopic.php?f=1&t=513
50 http://www.paranormalmagazine.co.uk/2010/09/23/the-lady-of-the-lake/; Hough & Randles, *Mysteries*, pp. 128–129.
51 Information compiled from Hough & Randles, *Mysteries*, p. 109; http://upia.moonfruit.com/#/haunted-wirral/4515914163; http://sufferingsmoke.com/dooby/cdw6.html; http://www.roadghosts.com/Cases%20-%20anecdotes&appeals.htm#Bebington

4 A Liverpool Ghost Tour

52 http://www.mystical-www.co.uk/index.php?option=com_content&view=article&id174&itemid=254
53 http://en.wikipedia.org/wiki/Adeste_Fideles
54 http://www.trueghosttales.com/paranormal/my-brother-and-the-ghostly-monks/
55 P. Chambers, *Sex and the Paranormal* (Blandford, 1999), p. 14.
56 http://planetpreternatural.wordpress.com/
57 Tulloch, *The Story of Liverpool*, pp. 36–37.
58 Reppion, *800 Years*, pp. 39–41.
59 Barnes, *Ghosts*, p. 47.
60 Ibid., p. 74
61 http://en.wikipedia.org/wiki/RAF_Burtonwood
62 Barnes, *Ghosts*, p. 64.
63 http://www.rafburtonwood.org/ghosts.html
64 Hough & Randles, *Mysteries*, p. 67.

65 http://www.rafburtonwood.org/ghosts.html

66 Hough & Randles, *Mysteries*, p. 68.

67 *Northern UFO News (NUFON)* 148, pp. 6–7.

68 http://www.bbc.co.uk/liverpool/content/articles/2005/10/31/halloween_dock_ghosts_feature.shtml

69 *Fortean Times* 71, p. 15.

70 http://www.trueghoststories.co.uk/St%20Georges%20Hall.htm; http://www.liverpoolecho.co.uk/liverpool-entertainment/echo-entertainment/2008/02/26/ghost-hunt-date-in-grand-style-at-st-george-s-hall-100252-20524398/

71 All accounts compiled from: http://www.thefreelibrary.com/Ghostly+goings+on+stage%3B+Joe+Riley+on+the+spooks+that+haunt+city's...-a0153522360; http://www.bbc.co.uk/liverpool/stage/2003/01/haunted/index.shtml; *Liverpool Echo*, 30 Oct 2008.

72 http://eximiusparanormal.wordpress.com/2009/10/09/77/

73 http://www.mersey-gateway.org/server.php?show=ConWebDoc.1351

74 http://ezinearticles.com/?Celebrity-Ghost-Stories---John-Lennon&id=5653720

75 http://ezinearticles.com/?Celebrity-Ghost-Stories---John-Lennon&id=5653720

76 http://www.dailypost.co.uk/news/north-wales-news/2011/05/31/ghost-of-john-lennon-taught-north-wales-man-to-play-guitar-55578-28791074/; http://www.metro.co.uk/weird/864826-john-lennon-songs-written-by-ghost-sent-to-yoko-ono-by-budding-writer

5 Demon Dogs and Curious Cats: Mystery Animals Across Merseyside

77 Whittington-Egan, *Liverpool Colonnade*, pp. 193–94.

78 P. Underwood *This Haunted Isle* (Harrap, 1984).

79 http://www.yoliverpool.com/forum/archive/index.php/t-8522.html

80 J. Bord & C. Bord, *Alien Animals* (Granada, 1985).

81 Bord & Bord, *Alien Animals*, p. 85.

82 M. Harpur, *Mystery Big Cats* (Heart of Albion Press, 2006), p. 9.

83 P. Harpur, *Daimonic Reality* (Pine Winds Press, 2003), p. 73.

84 K. Fields, *Lancashire Magic and Mystery* (Sigma Leisure, 2004), pp. 5–6.

85 http://www.flintshirechronicle.co.uk/flintshire-news/local-flintshire-news/2001/05/17/mystery-beast-putts-off-the-birdies-51352-11056934/

86 http://www.runcornandwidnesweeklynews.co.uk/runcorn-widnes-news/runcorn-widnes-local-news/2011/03/31/plans-to-reopen-st-michael-s-golf-course-in-widnes-hangs-in-balance-55368-28430230/

87 http://iccheshireonline.icnetwork.co.uk/0100news/0100regionalnews/tm_headline=fisherman-s-big-cat-scare&method=full&objectid=19333459&siteid=50020-name_page.html

88 http://www.runcornandwidnesweeklynews.co.uk/runcorn-widnes-news/runcorn-widnes-local-news/2010/02/18/alien-big-cat-sighting-near-norton-priory-manor-park-runcorn-55368-25854511/

89 http://iccheshireonline.icnetwork.co.uk/0100news/runcornandwidnesweeklynews/tm_headline=beast-suspected-in-attack-on-cattle%26method=full%26objectid=19479958%26siteid=50020-name_page.html

90 http://www.runcornandwidnesweeklynews.co.uk/runcorn-widnes-news/runcorn-

widnes-local-news/2010/03/04/unknown-phenomena-investigation-association-investigates-beast-sightings-near-norton-priory-in-runcorn-55368-25962831/

91 Dr K. P. N. Shuker, 'British Mystery Cats – the Bodies of Evidence', in S. Moore, ed., *Fortean Studies* 2 (John Brown Publishing, 1995), pp. 144–145.

92 *Fortean Times* 32, p. 26.

93 http://www.sthelens-connect.net/forums/topic/4982-lion-in-the-clegg/

94 http://www.runcornandwidnesweeklynews.co.uk/runcorn-widnes-news/runcorn-widnes-local-news/2010/11/11/mystery-thickens-following-latest-alleged-sighting-of-the-beast-of-st-michael-s-golf-course-in-sutton-park-55368-27633603/

95 J. Bowker, *Goblin Tales of Lancashire* (1878), p. 78.

96 http://www.warrington.gov.uk/home/leisure_and_culture/walton_hall_and_gardens/lewis_carroll_local_link/

97 http://www.warringtonguardian.co.uk/news/800511.bewsey_old_hall_ghost_hunt/

98 Westwood & Simpson, *The Lore of the Land*, pp. 395–396.

99 *Liverpool Echo*, 9 Feb 2008; *Fortean Times* 237, p. 23.

100 Westwood & Simpson, *The Lore of the Land*, pp. 196–197.

101 Tulloch, *The Story of Liverpool*, p. 1.

102 *The Graphic*, 5 May 1877.

103 *Liverpool Mercury*, 22 Sep 1899.

104 http://en.wikipedia.org/wiki/Liver_bird

105 Westwood & Simpson, *The Lore of the Land*, p. 402.

106 http://en.wikipedia.org/wiki/Liver_bird

107 Westwood & Simpson, *The Lore of the Land*, p. 402.

108 *Liverpool Mercury*, 2 Jul 1824.

6 The Devil and All His Works

109 U. McGovern & B. Rickard, *Chambers Dictionary of the Unexplained* (Chambers, 2007), pp. 258–259.

110 http://en.wikipedia.org/wiki/Alex_Sanders_(Wiccan)

111 http://www.sacred-texts.com/pag/wcwe/wcwe08.htm

112 *Warrington Examiner*, 16 Sep 1876; http://magonia.haaan.com/2011/warrington-witch/

113 http://www.liverpoolecho.co.uk/liverpool-news/local-news/2010/09/03/witch-curse-blamed-for-wirral-magazine-pub-fire-100252-27193227/

114 http://newsblaze.com/story/2008112007013tsop.nb/topstory.html

115 http://www.slemen.com/lennonsoldsoul.html

116 http://en.wikipedia.org/wiki/Robert_Johnson#Devil_legend

117 R. Gandy, 'Cheating the Devil' in *Fortean Times* 263, p. 51.

118 M. Goss, 'The Devil and Barn Hall: Interpreting Changed-Site Legends' in S. Moore, ed. *Fortean Studies* 3, p. 162.

119 http://johnmadjackfuller.homestead.com/Pyramid.html; http://en.wikipedia.org/wiki/John_'Mad_Jack'_Fuller

120 http://www.liverpoolconfidential.co.uk/News-and-Comment/Liverpool-Spooky-St-Andrews-church-set-to-be-student-homes

Part Four – The Albert Space Dock: Merseyside UFOs and Aliens
1 *Liverpool Echo*, 29 Aug 2011.

1 Runcorn's First Space Traveller
2 *Runcorn Weekly News*, 10 Oct 1957; *Flying Saucer Review* (*FSR*) Vol. 4 No. 4, pp. 26–27.
3 *FSR* Vol. 4 No. 4, p. 27.
4 D. Clarke & A. Roberts, *Flying Saucerers: A Social History of Ufology* (Heart of Albion Press, 2009), pp. 94–95.
5 *FSR* Vol. 6 No. 2, p. 16.
6 Clarke & Roberts, *Flying Saucerers*, pp. 94–95.
7 N. Redfern, *Contactees: A History of Alien–Human Interaction* (New Page Books, 2010), pp. 18–21.
8 Redfern, *Contactees*, pp. 22–23.
9 J. Keel, *The Mothman Prophecies* (IllumiNet Press, 1991), p. 113.

2 That's Why Aliens Go to Tesco
10 *NUFON* 103, pp. 14–16; Hough & Randles, 1999, pp. 122–126.
11 The National Archives, DEFE 24/1943/1.
12 http://en.wikipedia.org/wiki/Bidston_Hill
13 http://wordsinpurespirit.com/949/is-there-something-strange-at-bidston-lodge/
14 http://www.uk-ufo.co.uk/2011/09/wirral-over-bidston-hill-22nd-september-2011/
15 A. Bell, 'Guardians of the Motorway', in *FSR* Vol. 27 No. 2.
16 http://en.wikipedia.org/wiki/Bidston_Hill
17 Devereux, *Earthlights* (Book Club Associates, 1982), p. 157.
18 *UFO Brigantia* 52; Hough & Randles, *Mysteries*, p. 122.
19 Hough & Randles, *Mysteries*, p. 124.

3 Silver-Suited Strangeness and Encounters with Extraordinary Entities
20 *Fortean Times* 234, p.31; Hough & Randles, *Mysteries*, pp. 103–104.
21 Hough & Randles, *Mysteries*, pp. 52–59; J. Randles & P. Wetnall, 'Entity Encounter at Risley' in *FSR* Vol. 23 No. 4.
22 Hough & Randles, *Mysteries*, p. 59.
23 *NUFON* 173, p. 14.
24 Clarke & Roberts, *Flying Saucerers*, pp. 197–198.
25 http://magonia.haaan.com/2009/wallasey/
26 http://magonia.haaan.com/2009/wallasey/

4 Paranormal Power Stations
27 J. Randles, 'Humanoid Encounter at Rainford', *FSR* Vol. 23, No. 6.
28 Ibid.; Hough & Randles, *Mysteries*, pp. 107–108.
29 J. Randles, 'Humanoid Encounter at Rainford', *FSR* Vol. 23, No. 6.
30 Ibid.; Hough & Randles, *Mysteries*, p. 68.
31 http://www.sthelensstar.co.uk/archive/2004/08/04/St+Helens+Archive/6677503.Did_UFO_buzz_Bold_/

32 http://www.sthelensstar.co.uk/archive/2003/12/11/Cheshire+Archive/5231892.Did_ UFO_land_in_Rainhill_/

33 J. Randles, *UFO Reality* (Robert Hale, 1983) p. 132.

34 http://www.ufocasebook.com/2009b/fiddlersferry.html

35 Hough & Randles, *Mysteries*, p. 69.

5 A Window into Wonderland

36 Hough & Randles, *Mysteries*, p.87.

37 P. Brookesmith, 'Missing Time', in *Fortean Times* 72, pp. 44–45.

38 *NUFON* 164, p. 10.

39 *NUFON* 100, p. 9.

40 Hough & Randles, *Mysteries*, pp. 144–45.

41 *Merseyside Unidentified Flying Objects Research Group (MUFORG) Bulletin*, June 1966.

42 *Fortean Times* 275, p. 27; Hough & Randles, Mysteries, pp. 107–108.

43 *FSR* Vol. 6 No. 2, p. 16.

44 Hough & Randles, *Mysteries*, p. 139; Randles, *UFO Reality*, p. 80.

45 http://airminded.org/scareships/category/location/england/merseyside/

46 *NUFON* 186, pp. 10–11.

47 Hough & Randles, *Mysteries*, pp. 65–66.

48 *NUFON* 177, p. 13.

49 *NUFON* 147, p. 12.

50 *NUFON* 144, pp. 13–14.

51 *Runcorn Weekly News*, 6 Jul 1967; http://planetpreternatural.wordpress. com/2011/10/23/a-brief-ufo-history-of-halton-1957-2003/

52 *Runcorn Weekly News*, 6 Jul 1967; *MUFORG Bulletin*, Aug 1967.

53 http://planetpreternatural.wordpress.com/2011/10/23/a-brief-ufo-history-of-halton- 1957-2003/

54 *Fortean Times* 273, p. 27.

55 *Daily Post*, 23 Oct 1967. See *MUFORG Bulletin*, Feb 1968, for a fuller coverage of this 'flap'.

56 *Liverpool Echo*, 25 Oct 1967.

57 *Liverpool Echo*, 26 & 28 October 1967.

58 *Liverpool Echo*, 27 October 1967.

59 Clarke & Roberts, *Flying Saucerers*, pp. 140–141, 156–157.

60 S. Jenkins, *The Undiscovered Country* (Abacus, 1978), pp. 28–29.

61 http://internalarchive.thisischeshire.co.uk/1998/5/14/240457.html

62 Hough & Randles, *Mysteries*, pp. 93–94; *Fortean Times* 273, p. 27.

63 *Widnes World*, 2 Mar 1995; *NUFON* 170, p. 14; http://internalarchive.thisischeshire. co.uk/1998/5/14/240457.html

64 *Widnes World*, 9 Mar 1995.

65 http://drdavidclarke.co.uk/national-archives-ufo-files-7/national-archives-ufo-files-4/; http://planetpreternatural.wordpress.com/2011/10/23/a-brief-ufo-history-of-halton- 1957-2003/

66 http://www.ellesmereportpioneer.co.uk/ellesmere-port-news/local-ellesemere-port- news/2001/04/06/ufo-spotted-over-bridge-55940-11016455/

67 *Fortean Times* 277, p. 31; *Widnes Weekly News*, 12 May 2011.
68 *FSR* Vol. 2. No. 5, p. 5.
69 *NUFON* 182, p. 13.
70 Hough & Randles, *Mysteries*, pp. 88–89.
71 Pearson, *Haunted Places*, pp. 42–43.
72 Hough & Randles, *Mysteries*, p. 98.
73 Ibid., pp. 99–100.
74 *NUFON* 169, p. 13.
75 http://planetpreternatural.wordpress.com/2011/10/23/a-brief-ufo-history-of-halton-1957-2003/
76 *NUFON* 186, p. 8.
77 Hough & Randles, *Myseries*, pp. 102–103.

6 We All Live in a Yellow Space Machine

78 http://en.wikipedia.org/wiki/Magic_Alex & http://lifeofthebeatles.blogspot.com/2006/09/magic-alex-world-of-inventions.html
79 Clarke & Roberts, *Flying Saucerers*, p. 185.
80 http://www.67notout.com/2010/09/john-lennons-ufo-sighting-and-abduction.html
81 http://www.urigeller.com/megg.htm
82 http://www.beatlesbible.com/features/paul-is-dead/

Conclusion

1 http://www.playbackarts.co.uk/meryfela/sftol.htm